W9-AKE-636

01/2012

THE
Vietnam War
Day by Day

THE
Vietnam War
Day by Day

Leo Daugherty

CHARTWELL
BOOKS, INC.

This edition published in 2011 by
CHARTWELL BOOKS, INC.
A division of BOOK SALES, INC.
276 Fifth Avenue Suite 206
New York, New York 10001
USA

ISBN-13: 978-0-7858-2857-0
ISBN-10: 0-7858-2857-5

Produced by
Windmill Books Ltd
First Floor
9-17 St.Albans Place
London N1 ONX

Editors: Peter Darman, Vanessa Unwin
Picture Research: Andrew Webb, Peter Darman
Designer: Jerry Udall
Map Artworks: Bob Garwood
Production Director: Alastair Gourlay

Printed in China

DEDICATION

To all the US Soldiers, Marines, Sailors,
Airmen and Coast Guardsmen
Who Served in the Republic of Vietnam
1954–1975

"You all are the real American Heroes"

CONTENTS

INTRODUCTION

With the signing of the Geneva Peace Accords (May 1954), Vietnam was divided into two halves. The United States replaced the French as guarantor of a democratic Republic of Vietnam (RVN) – South Vietnam – while the Soviet Union and the People's Republic of China performed a similar role with the northern half, known as the Democratic Republic of Vietnam (DRVN) led by Ho Chi Minh. Besides the massive economic and political support provided by the United States, the most visible sign of growing US involvement in South Vietnam in the 1950s was the influx of military advisors provided through the Military Assistance Group, Vietnam. Starting as early as 1950 and reaching its peak prior to the commitment of US ground forces in March 1965, US military advisors from the army, navy, air force and Marine Corps went to Vietnam to instruct and train the Army of the Republic of Vietnam (ARVN) in both conventional and unconventional warfare.

As the fledgling Republic of Vietnam struggled to maintain its independence, in late 1957 North Vietnamese leaders agreed upon a three-phased strategy designed to unify the country under the banner of Communism. Fuelled by his anti-Communism and with growing US backing, South Vietnamese President Ngo Dinh Diem tightened his already authoritarian rule, which in turn alienated both his generals and the Buddhist majority living in the South. Even as US military advisors sought to regain the initiative in what was becoming a deeper American commitment to South Vietnam, events both in South Vietnam and Washington, D.C.,

began to out-pace the war as US personnel and equipment poured into the South at unprecedented levels.

On November 2, 1963, both Diem and his brother Nhu were brutally murdered in a coup led by South Vietnamese General Duong Van Minh and a faction of military officers. Diem's assassination began a series of events that would eventually lead to the full-scale commitment of US combat troops. Even as the United States sought to stabilize the situation in South Vietnam's capital, Saigon, President John F. Kennedy, Jr., was likewise assassinated while visiting Dallas, Texas, on November 22, 1963. His successor, President Lyndon B. Johnson, inherited from the Kennedy Administration a growing US commitment to the stability and survivability of South Vietnam. By the end of 1963, there were reportedly 16,500 US serviceman and advisors serving in South Vietnam, with over 489 of them having been killed in action while "advising" the ARVN.

As the political situation in South Vietnam deteriorated, the Johnson Administration struggled to find a military solution to what was now turning into a full-scale invasion by the combined forces of the National Liberation Front (NLF), or Viet Cong, and North Vietnamese Army (NVA). When North Vietnamese vessels allegedly fired on two US warships in the Gulf of Tonkin off the North Vietnamese coastline in August 1964, the Johnson Administration ordered the first bombings of North Vietnam in what would be termed Operation Rolling Thunder. This was the codeword for the massive US air offensive designed to punish the North for its incursions, and halt its support of the Viet Cong.

Despite the massive bombings by US bombers and fighter/attack aircraft launched from US Navy aircraft carriers offshore and airfields in Thailand and Guam, the war in South Vietnam continued to deteriorate. When Viet Cong and North Vietnamese sappers attacked two US air bases at Bien Hoa (November 1, 1964) and Quinhon (February 10, 1965), the Johnson Administration not only stepped up the growing bombing campaign against the supply and infiltration routes used by North Vietnamese forces, but agreed to the request by General William C. Westmoreland, Commanding General, US Military Assistance Command, Vietnam (MACV), to send in two battalions of US Marines to guard the vital airfield at Da Nang along South Vietnam's coast. The dispatching of US ground and air forces signalled the commencement of the US involvement in a war that would last nearly a decade (1965–75).

This account of the United States' war in Vietnam is a day by day examination of a conflict that was fought in rice paddies, jungles and on rivers by soldiers, sailors, Marines and airmen. This book is about the battles and the men and women who fought them, and is to them that this study is dedicated. Starting in the early 1950s and ending atop the US Embassy in Saigon in April 1975, this chronology surveys a struggle that stands as a testament to the bravery and fortitude of the American service personnel who fought there, against an enemy that was both resourceful and brave. The war cost hundreds of thousands of service lives and two million Vietnamese civilians. Its legacy is with us still.

1954-1964
A WAR IN PEACE

The United States' involvement in Vietnam grew out of the war in Korea (1950–1953), and from US military and political support of the French efforts to defeat the Viet Minh in French Indochina. As early as 1950, the US Government had established the US Military Assistance Advisory Group (US MAAG). The Geneva Accords, ending the fighting between the French and Viet Minh, divided Vietnam along the 17th Parallel, with a Communist government in the North and anti-Communist regime in the South. From 1954 until 1964, the Viet Minh and the National Liberation Front (NLF), or Viet Cong, waged a guerrilla war in the South, supported by North Vietnam and its allies in Moscow and Beijing. At the end of 1954, the US agreed to support the new Army of the Republic of Vietnam (ARVN) and, after the French withdrew in 1957, trained, equipped, and advised it in the war against the NLF and, later, the North Vietnamese Army (NVA).

Spurred on by Soviet Premier Nikita Khrushchev's avowed support of so-called "Wars of National Liberation", the newly elected President of the United States, John F. Kennedy, Jr, (1961–63) sought to actively counter the growing Soviet aid to Third World guerrilla movements by preventing the NLF from overthrowing the government of South Vietnam. Acting upon recommendations of General Maxwell Taylor, who conducted an extensive survey of the situation in South Vietnam, particularly the ARVN, President Kennedy "directed the implementation of a series of military and political measures to strengthen the South Vietnamese regime." These measures included a large increase in the amount of military equipment, military advisors and support units sent to South Vietnam. By mid-1962, the US had established the United States Military Assistance Command, Vietnam, led by General Paul D. Harkins. By the end of 1962, there were more than 12,000 American military personnel (Air Force, Army Special Forces or "Green Berets," Marines and Navy) advising and working with their South Vietnamese counterparts. An 18-man US Marine contingent worked with the South Vietnamese Marine Corps (VNMC), as

▼ French troops watch reinforcements parachute into the besieged fortress of Dien Bien Phu.

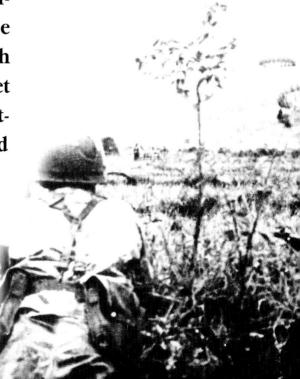

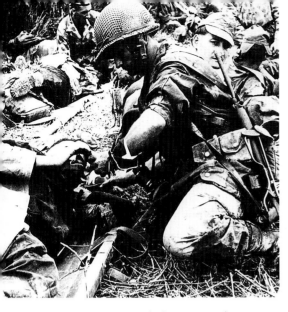

◀ *A French paratrooper tends a wounded colleague during the siege of Dien Bien Phu. The Viet Minh surrounding the base used heavy artillery to break the French lines.*

well as a Marine helicopter task group, codenamed Shu Fly, comprising a helicopter squadron and support elements.

Despite the influx of a massive amount of US military assistance and personnel, the political situation inside South Vietnam continued to deteriorate. South Vietnam's President Ngo Dinh Diem faced both an NLF insurgency and growing dissatisfaction with his rule by the Buddhists that comprised the bulk of the population in the South. After a failed crackdown of Buddhist monks, who staged self-immolation protests to dramatize their opposition to Diem, the South Vietnamese

Army (with tacit American approval) launched a coup d'état against the president and his brother, both of whom were killed in the first week of November 1963. However, coup after coup failed to bring stability to the political situation in Saigon. In spite of political instability, growing enemy strength and a change of leadership in Washington, D.C., after the death of President John F. Kennedy, the US response to the continued aggression from the Viet Cong and North Vietnam was to increase its military support to South Vietnam. By the end of 1964, the United States Military Assistance Command, under General Westmoreland, had grown to over 20,000 men.

In 1964 the US Marine contingent numbered over 800 men in Vietnam. The bulk of these were located in South Vietnam's I Corps Tactical Zone (ICTZ), which consisted of the five northern provinces nearest to the so-called Demilitarized Zone (DMZ), next to North Vietnam. Some 60 Marine advisors had been attached to the ARVN's

1st and 2nd Divisions, and the Shu Fly unit, reinforced with a US Marine rifle company, provided airfield perimeter security at the Da Nang Air Base, south of the city of Da Nang along South Vietnam's extended coastline. Twenty US Marines served with the Vietnamese Marine Corps, and a detachment of Marines served in the Marine Embassy Guard and on the MACV staff in Saigon.

With President Lyndon B. Johnson now committed to the defence and preservation of South Vietnam's territorial integrity, and the 1964 presidential election against conservative candidate Barry Goldwater looming, there was increasing talk in Washington, D.C., of sending US combat troops to South Vietnam to defend US installations there. After the Gulf of Tonkin incidents in August 1964, the USA became drawn into the ground fighting and Johnson ordered the first air strikes against targets in North Vietnam in Operation Rolling Thunder. After South Vietnamese Army units suffered a series of defeats, General Westmoreland and the US Joint Chiefs of Staff approved the dispatch of two battalions of US Marines to South Vietnam in order to guard the US air facility at Da Nang. The US commitment to South Vietnam was now complete.

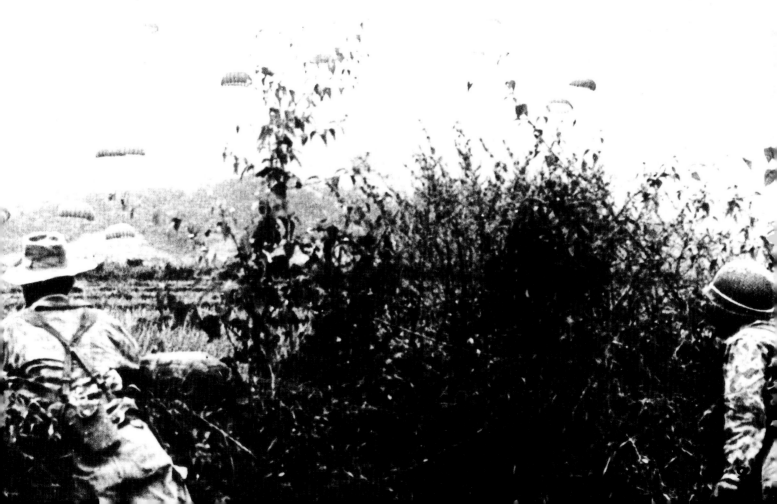

March 20, 1954

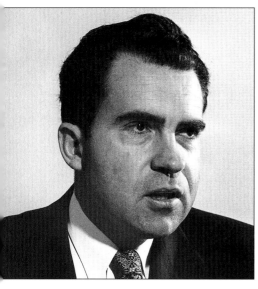

▲ Vice-President Richard M. Nixon, who voiced his opinion that the US should oppose Communism in Vietnam.

March 20, 1954

VIETNAM, GROUND WAR

The US ponders intervention as General Vo Nguyen Giap's forces surround the French paratroopers at Dien Bien Phu. Chairman of the US Joint Chief of Staff Admiral Arthur Radford proposes to use tactical nuclear weapons to prevent a French defeat at Dien Bien Phu. After further discussions, Admiral Radford modifies his proposal by suggesting the use of carrier-based air strikes in what is called Operation Vulture.

March 25, 1954

USA, MILITARY STRATEGY

The National Security Council approves Admiral Radford's plan for air strikes.

March 31, 1954

VIETNAM, US AID

Lieutenant-General John O'Daniels assumes command of the US Military Assistance and Advisory Group (US-MAAG), and states that he has "lost faith in General Henri Navarre's ability to command." To General O'-Daniels and other Americans in Vietnam, Navarre appears gloomy and increasingly unsure of himself. O'Daniels himself states: "I have supported him in the past based upon his statements and his integrity . . . however, circumstances have led me to conclude that he fails to measure up to wage war here on the scale necessary to win."

April 6, 1954

USA, US ARMY

Hero of Korean War cautions on war in Southeast Asia. Led by Army Chief of Staff General Matthew B. Ridgway, the US Army continues to protest strongly against intervention in Indochina to stave off a French defeat. The Army Chief of Staff asserts that "the use of American forces in Vietnam aside from any local success they might achieve would constitute a dangerous strategic diversion of limited American military capabilities and would commit our armed forces in a non-decisive theatre to the attainment of non-decisive local objectives." General Ridgway likewise believes that an American commitment would greatly increase the risk of general war and would play into the hands of the Soviet Union and China, who could stand aside while vital American military reserves were dissipated in inconclusive fighting.

April 7, 1954

USA, IDEOLOGY

In order to build up support for a possible war in Indochina, US President Dwight D. Eisenhower tells a group of newspaper editors that by supporting the French at Dien Bien Phu, the United States of America will succeed in preventing Communist domination of Southeast Asia. To the waiting press, the President uses the analogy of "falling dominoes" to illustrate his point. Thus is born the Domino Theory: "Knock one [regime] over and they all will fall over in time."

▶ World War II veteran General Matthew B. Ridgway (right) was opposed to an unplanned US intervention in Indochina.

April 11, 1954

USA, DIPLOMACY

Arriving in Europe with the avowed purpose of building a united front to resist Communist aggression in Southeast Asia, Secretary of State John Foster Dulles finds out that British Foreign Secretary Anthony Eden will engage in no discussion concerning a regional security arrangement until after the Geneva Conference, deciding Indochina's fate, concludes.

April 17, 1954

USA, STRATEGY

Many American leaders continue to raise the prospects of doing something to save Indochina from the Communists. Vice President Richard M. Nixon tells a press conference: "the United States as a leader of the free world cannot afford further retreat from Asia . . . If the French withdrew, the United States might have to take the risk now by putting our own boys in." Although the Vice President was speaking for himself, he knows that many administration leaders, including Secretary of State Dulles, share his views.

April 21, 1954

FRANCE, MILITARY STRATEGY

When Secretary of State Dulles arrives in Paris for the pre-Geneva Conference talks, he is met by renewed French plans and also suggestions for the US

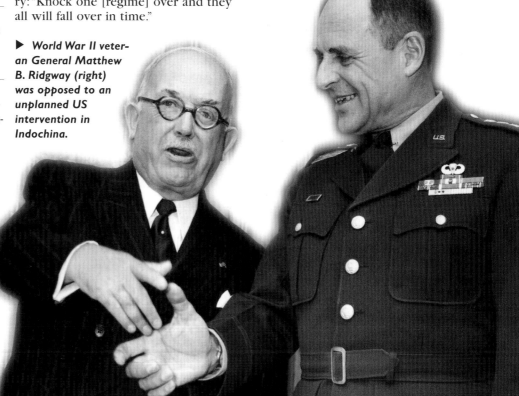

REGIONAL POLITICS

FRENCH INDOCHINA

The term Indochina is attributed to the Danish cartographer Konrad Malte-Brun, and was applied collectively to Burma, Thailand, Tonkin, Annam, Cochin-China, Laos and Cambodia. Catholic missions had been established in Vietnam during the seventeenth century, but it was the Vietnamese emperors' attempt to root out Christian missionaries in the nineteenth century that provided the excuse for French intervention (though trade was in fact the crucial factor). French naval actions in the 1840s and 1850s resulted in the emperor, Tu Duc, signing a treaty with France in 1862 confirming French interests. Between 1862 and 1887 France established control over Indochina, but resistance continued until the early twentieth century.

French Indochina was officially created in 1887, with Laos being added in 1893. Technically only Cochin-China was an outright colony, the rest being protectorates. The reality was that all were ruled by the French governor-general, who in turn answered to the minister of colonies in Paris. There was no consistent French policy toward Indochina, but a series of haphazard measures that often changed with the appointment of different officials. Little money was spent on public works or education for the indigenous population, while the small French community

Map:
CHINA
TONKIN 1885
Gulf of Tonkin
ANNAM 1893
Hainan
THAILAND
DMZ 1954
LAOS 1893
ANNAM 1893
CAMBODIA 1863
COCHIN-CHINA 1867
Gulf of Thailand
South China Sea
Dates denote time of French colonization

of 50,000 dominated the economy. By 1940 there were only 14 secondary schools and one university in Vietnam, and even those who did graduate were denied opportunities by the French colonials. Such actions inevitably created alienation and bitterness.

Nationalist uprisings between 1930 and 1931 organized by the Vietnam National Party were easily crushed, but the result was

that the more militant Indochinese Communist Party became stronger. By the outbreak of World War II it was the dominant nationalist force in Indochina. The fall of France to the Germans in 1940 fatally weakened French power in Indochina, and the subsequent Vichy Government was in no position to offer serious resistance to the Japanese when they arrived in Indochina in 1940. This uneasy alliance existed until March 1945, when the Japanese arrested all the French administrators and military personnel. When Japan surrendered, Ho Chi Minh declared himself president of Vietnam on August 16, 1945. Following elections in the north in January 1946, Ho became the president of the Democratic Republic of Vietnam (DRV). On March 6, 1946, he signed an agreement with France that recognized the DRV as a free state within the French Union. However, France refused to deal with nationalist leaders, reneged on a pledge to allow a plebiscite in the South that would decide the issue of unification, and proceeded to set up a provisional government in the South – the Republic of Cochin-China – under Emperor Bao Dai as a focal point for anti-Viet Minh nationalists, which failed. This led to the outbreak of war in December 1946. The subsequent fighting would last a total of 29 years.

intervention in Indochina. An American air attack at Dien Bien Phu, French Premier Joseph Laniel tells another American diplomat, "will galvanize and dramatically change the situation" there. French Foreign Minister Georges Bidault urges that the United States "gives most serious consideration to armed intervention promptly as the way to save the situation." Bidault predicts correctly that a French defeat at Dien Bien Phu would make the French public feel that further efforts in Indochina were futile. Dulles, however, could only reiterate that the United States could not take military measures without the consent of Congress and the support of Great Britain.

APRIL 29, 1954

USA, *STRATEGY*
After consultations with British Foreign Secretary Anthony Eden and British Prime Minister Winston Churchill, who rejects the US plan as a formula that will result in a major war between the East and West, the Eisenhower Adminis-

tration backs away from any commitment to the beleaguered French garrison at Dien Bien Phu.

MAY 7, 1954

VIETNAM, *US AID*
US military assistance begins in Indochina. The last outpost at Dien Bien Phu falls to the Viet Minh. France loses an estimated 35,000 killed in the war as a whole and suffers an humiliating defeat.

JULY 20, 1954

VIETNAM, *US AID*
As the Geneva Agreements are being finalized, the United States has committed an estimated 342 military personnel to serve in the Military Assistance and Advisory Group, Indochina. This group of advisors, whose activities had so far been restricted to assisting the French with donations of equipment and supplies, could at this point only "advise" the French and their South Vietnamese allies in the use of their equipment.

▲ *The US Secretary of State John Foster Dulles was a strong opponent of Communism in Indochina.*

DECISIVE MOMENTS

DIEN BIEN PHU

In late 1953, as both sides prepared for peace talks in the Indochina War, French military commanders chose Dien Bien Phu, the village in northwestern Vietnam near the Laotian and Chinese borders, as the place to engage and defeat the Viet Minh.

"It was an attempt to interdict the enemy's rear area, to stop the flow of supplies and reinforcements, to establish a redoubt in the enemy's rear and disrupt his lines." (Douglas Johnson, research professor at the US Army War College's Strategic Studies Institute) "The enemy could then be lured into a killing ground. There was definitely some of that thinking involved."

Hoping to draw Ho Chi Minh's guerrillas into a classic battle, the French began to build up their garrison at Dien Bien Phu. The stronghold was located at the bottom of a bowl-shaped river valley, about 10 miles (16 km) long. Most French troops and supplies entered from the air, either landing at the fort's airstrip or dropping in via parachute.

Dien Bien Phu's main garrison was supported by a series of fire bases, :strongpoints that could bring down fire on an attacker. The strongpoints were given women's names, supposedly after the mistresses of the French commander, General Christian de Castries. The French thought assaults on their fortified positions would fail or be broken up by their artillery.

The size of the French garrison at Dien Bien Phu swelled to somewhere between 13,000 and 16,000 troops by March 1954. About 70 percent of that force was made up of members of the French Foreign Legion, soldiers from French colonies in North Africa, and loyal Vietnamese.

Viet Minh guerrillas and troops from the People's Army of Vietnam surrounded Dien Bien Phu during the buildup within the French garrison. Their assault on March 13 proved almost immediately how vulnerable and flawed the French defences were. Dien Bien Phu's outlying fire bases were overrun within days of the initial assault, and the main part of the garrison was amazed to find itself coming under heavy, withering artillery fire from the surrounding hills. In a major logistical feat, the Viet Minh had dragged scores of artillery pieces up steep hillsides the French had written off as impassable. The French artillery commander, distraught at his inability to bring counterfire on the well-defended and well-camouflaged Viet Minh batteries, went into his dugout and killed himself. The

heavy Viet Minh bombardment also closed Dien Bien Phu's airstrip. French attempts to resupply and reinforce the garrison via parachute were frustrated as pilots attempting to fly over the region found themselves facing a barrage from antiaircraft guns. It was during the resupply effort that two civilian pilots, James McGovern and Wallace Buford, became the first Americans killed in Vietnam combat. The supply aircraft were forced to fly higher, and their parachute drops became less accurate. Much of what was intended for the French forces – food, ammunition and, in one case, intelligence – landed instead in Viet Minh territory. Meanwhile, the Viet Minh steadily reduced the French-held area using what their commander, General Vo Nguyen Giap, called "a tactic of combined nibbling and full-scale attack."

Closed off from the outside world, under constant fire, and flooded by rains, conditions inside Dien Bien Phu became intolerable. Casualties piled up inside the garrison's hospital. Dien Bien Phu fell to the Viet Minh on May 7. At least 2200 French troops died, with thousands more taken prisoner. Of the 50,000 Vietnamese who besieged the garrison, there were 23,000 casualties, including an estimated 8000 killed.

JULY 21, 1954

SWITZERLAND, *INTERNATIONAL TREATIES*

The Geneva Accords are signed. Most of the governments participating in the Geneva Conference – including the Soviet Union, the People's Republic of China, France, Great Britain, Cambodia, Laos and the Viet Minh – adopt a final declaration confirming the military agreements by adding a provision that general elections are to be held in July 1956, under the supervision of the commission. Neither the United States nor the Bao Dai Government (known as the State of Vietnam) concur in the final declaration, but the United States does pledge to refrain from the threat or use of force to disturb the agreements while warning "it would view any renewal of aggression in violation of the agreements with grave concern and as seriously threatening international peace and security."

AUGUST 2, 1954

USA, *STRATEGY*

General Matthew B. Ridgway, who has long been opposed to US intervention

in Indochina, recommends "before the United States assumes responsibility for training the forces of any of the associated states, four essential conditions should be met." These include a "reasonably strong and stable civil government be in control; that the US is formally asked by the government of the Associated States; and that arrangements be made with the French for their withdrawal before any US training mission arrives; finally, the size and composition of the forces of each of the Associated States should be dictated by local military requirements and overall US interests."

AUGUST 20, 1954

USA, *STRATEGY*

US policy review on war in Southeast Asia. President Dwight D. Eisenhower approves a National Security Memorandum entitled *Review of US Policy in the Far East*, which supports the hard-

▶ *Viet Minh troops raise their flag at Dien Bien Phu following the fortress's fall in May 1954. The defeat signalled the end of French power in Indochina.*

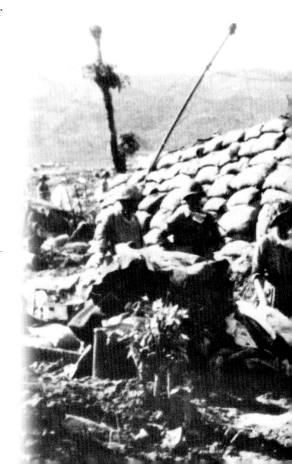

line views of Secretary of State John Foster Dulles that the United States should offer both military and economic support to South Vietnamese President Ngo Dinh Diem, while at the same time encouraging him to broaden his ruling coalition.

SEPTEMBER 8, 1954

INTERNATIONAL TREATIES, *SEATO*
The United States, Great Britain, Australia, Pakistan, Thailand, New Zealand, the Philippines and France sign the Manila Treaty, becoming informally

◀ *The French Tricolour is lowered in Saigon for the last time in September 1954, watched by Premier Diem.*

known as the Southeast Asia Treaty Organization (SEATO). Among the terms of the SEATO Treaty, both Laos and Cambodia, as well as the territory under the jurisdiction of the State of Vietnam (RVN) become areas subject to the provisions of the treaty. In effect, the United States is openly declaring that an attack (by North Vietnam or China) on South Vietnam, Laos, or Cambodia is an attack on the United States and the members of SEATO. The Manila Treaty serves as the justification of the United States to openly support South Vietnam and other anti-Communist governments in Southeast Asia.

OCTOBER 13, 1954

SOUTH VIETNAM, *US AID*
By a presidential decree, the Vietnamese Marine Corps (VNMC) is formally organized. US Marine Corps Colonel Victor J. Croizat is appointed senior US advisor to the new service in South Vietnam. Initially a two-battalion force, the VNMC would grow into one of the most disciplined, effective combat units formed in the Republic of Vietnam

ARMED FORCES

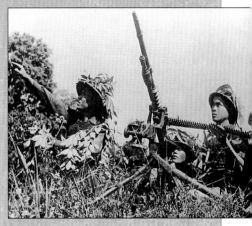

VIET MINH

The *Viet Nam Doc Lap Dong Minh Hoi* (League For The Independence Of Vietnam, commonly known as the Viet Minh) organization that led the struggle for Vietnamese independence from French rule was formed in China in May 1941 by Ho Chi Minh. Although led primarily by Communists, the Viet Minh operated as a national front organization open to persons of various political persuasions. In late 1943 members of the Viet Minh, led by General Vo Nguyen Giap, began to launch guerrilla operations against the Japanese, who occupied the country during World War II. The Viet Minh forces liberated considerable portions of northern Vietnam, and after the Japanese surrender to the Allies, Viet Minh units seized control of Hanoi and proclaimed the Democratic Republic of Vietnam.

The French promised to recognize the new government as a free state but failed to do so. On November 23, 1946, at least 6000 Vietnamese civilians were killed in a French naval bombardment of the port of Haiphong, and the first Indochina War began. The Viet Minh had popular support and dominated the countryside, whereas the French strength lay in urban areas. As the war neared an end, the Viet Minh was succeeded by the *Lien Viet*, or Vietnamese National Popular Front. In 1951 most Viet Minh leaders were absorbed into the Lao Dong, or Vietnamese Workers' Party (later Vietnamese Communist) Party, and this remained the dominant force in North Vietnam. Viet Minh elements joined with the Viet Cong against the US-supported government of South Vietnam and the United States in the Vietnam War (or Second Indochina War) in the late 1950s, 1960s and early 1970s. Vietnam reunified in 1976, and Viet Minh leaders continued their active role in Vietnamese politics.

OCTOBER 24, 1954

with a reputation for toughness and battlefield effectiveness.

OCTOBER 24, 1954

SOUTH VIETNAM, *POLITICS*

In order to emphasize the need to create a more broad-based government in South Vietnam and an adherence to democratic principles, President Eisenhower sends President Diem a letter that assures continued US support only if democratic reforms continue uninterrupted. In later years, President Lyndon B. Johnson will cite this letter as being the starting point of the US commitment to South Vietnam.

NOVEMBER 3, 1954

SOUTH VIETNAM, *US AID*

US Army General Lawton J. Collins is sent to Saigon by President Eisenhower in order to "coordinate" all of the military and economic assistance programmes then in operation in the South. Collins pledges US support for the South.

NOVEMBER 20, 1954

SOUTH VIETNAM, *US AID*

After the visit of French Premier Mendes-France to Washington, D.C., it is announced that all US assistance will now go directly to the South Vietnamese Government and not to the French training establishments working with the ARVN. Part of this agreement states that the US military will, from now onward, assume full responsibility for the training of the South Vietnamese military. Premier Mendes-France also announces that the French Expeditionary Corps will depart Indochina.

▶ *In July 1954, following the defeat of the French, the Geneva Agreement partitioned Vietnam along the line of the 17th Parallel, which became a Demilitarized Zone (DMZ).*

DECEMBER 1954

SOUTH VIETNAM, *US AID*

The United States announces its willingness to support the Vietnamese Armed Forces at a level of 90,000 men. This offer will be strongly opposed in Saigon and, in early 1955, the figure would be revised to 100,000. This figure will be revised again in late 1955, as it now appears that fighting in the South will continue indefinitely. Also, as US involvement in South Vietnam continues to grow, all US military personnel (US Army, Navy, Marine Corps and Air Force) belonging to the US Military Advisory and Assistance Group are brought under one organization known as ATOM – Advisory, Training, and Operations Mission – under Lieutenant-General John O'Daniels.

JANUARY 1, 1955

USA, *STRATEGY*

Military assistance and advisors arrive in Vietnam. The Pentagon announces an increase in its military assistance to the South Vietnamese Armed Forces. Also, Lieutenant-General John O'-Daniels as head of the Military Assistance and Advisory Group, Indochina, is assigned the task of organizing and training the South Vietnamese Armed Forces into an effective military organization. In a related move, the United States promises to provide direct military and economic assistance to its South Vietnamese "allies".

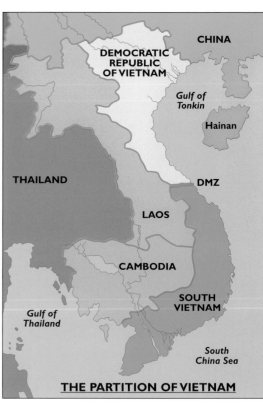

THE PARTITION OF VIETNAM

JANUARY 15, 1955

SOUTH VIETNAM, *ARMED FORCES*

The US member of the Senior Team, ATOM, proposes missions for the South Vietnamese Navy and Marine Corps that include limited amphibious operations and river and coastal patrols, as well as mine-sweeping, fire support, and logistics support for military forces. The force levels in ships and

▼ *The fruits of victory: a column of motorized Viet Minh troops parades past Communist leader Ho Chi Minh in Hanoi in January 1955.*

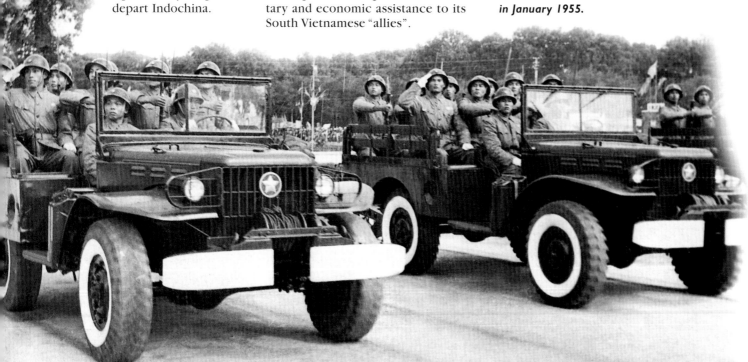

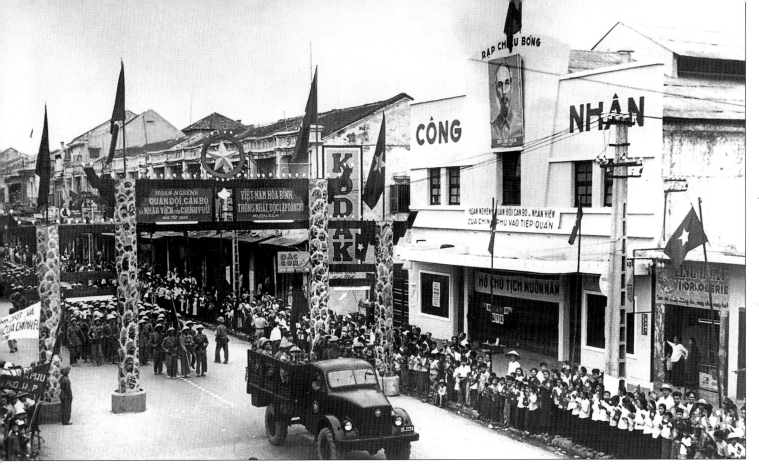

▲ *Following the formal partition of Vietnam into two states, Viet Minh troops take possession of Haiphong in early 1955 watched by crowds of civilians.*

craft recommended, however, are far less than those required for the missions. These efforts, however, were some attempt to organize the Vietnamese Navy and Marine Corps into the 3000-man ceiling which had been imposed under the overall Vietnamese Armed Forces' strength of 100,000 set by the United States at that time.

FEBRUARY 1, 1955

SOUTH VIETNAM, *US AID*
The Training Relations and Instruction Mission (TRIM) is formed in place of ATOM in order to coordinate the training and advising of all South Vietnamese military units. TRIM consists of 225 French and 120 US military personnel. The naval version of TRIM is headed by a French Navy captain who also commands the Vietnamese Navy and is staffed by three American (two Navy and one Marine) officers and two French officers.

FEBRUARY 8, 1955

NORTH VIETNAM, *REFUGEES*
Elements of the 3rd Marine Division and the 1st Marine Aircraft Wing assists in the evacuation of some 300,000 Vietnamese refugees, 69,088 tonnes

(68,000 tons) of cargo, and some 8000 vehicles from North to South Vietnam in the face of advancing Viet Minh forces. This mass exodus is provoked after Premier Ngo Dinh Diem asks for the deadline for civilians moving from North to South Vietnam to be extended.

FEBRUARY 12, 1955

SOUTH VIETNAM, *US AID*
The United States' Military Assistance Group takes over completely from the French the responsibility of training the South Vietnamese Army.

FEBRUARY 19, 1955

SOUTHEAST ASIA, *SEATO TREATY*
The Southeast Asia Treaty Organization or SEATO, with its important protocols concerning the defence of Vietnam, Cambodia and Laos, goes into effect from this date.

MARCH 29, 1955

SOUTH VIETNAM, *POLITICS*
An armed revolt against Diem is precipitated in Saigon by the Binh Xuyen political bandit group. This revolt then grows into large-scale dissidence in the southern provinces, with the participation of the Cao Dai and the Hoa Hoa religious sects.

▶ *Emperor Bao Dai ("Keeper of Greatness"), whose monarchy was ended in Vietnam by a referendum.*

MAY 16, 1955

USA, *DIPLOMACY*
The United States signs an agreement with Cambodia for direct military aid to replace the aid which was formerly provided by the French.

JULY 6, 1955

SOUTH VIETNAM, *POLITICS*
Premier Ngo Dinh Diem announces in a nationwide address that South Vietnam is not bound by the terms of the Geneva Accords which had called for elections by 1956, due to the fact that neither the United States nor South Vietnam signed the agreements agreed upon by the major European powers in Geneva in 1954.

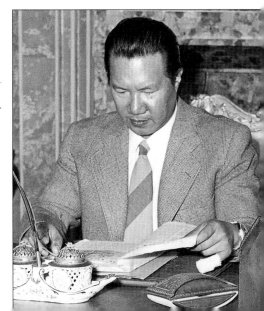

JULY 7, 1955

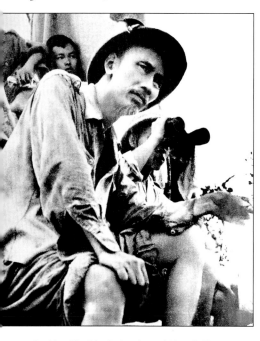

▲ *Ho Chi Minh, leader of North Vietnam and one of the twentieth century's great Communists. He stressed the role of the peasantry in the revolutionary struggle.*

JULY 7, 1955

NORTH VIETNAM, *CHINESE AID*
The People's Republic of China announces provision of economic aid to North Vietnam's Communist government in the form of 800 million yuan ($200 million US) after a visit to Peking by Ho Chi Minh and his senior advisors.

JULY 18, 1955

NORTH VIETNAM, *SOVIET AID*
Soviet Premier Nikita Khrushchev announces that the USSR (Union of Soviet Socialist Republics) will provide Hanoi with about 400 million rubles ($100 million US) in military and economic assistance.

JULY 20, 1955

VIETNAM, *GENEVA ACCORDS*
Talks were scheduled to begin in accordance with the Geneva Accords about the preparation of an all-Vietnam election to be held on July 20, 1956, in order to re-unite the country. The government of South Vietnam rejects the North Vietnamese Government's invitation to discuss these elections, on the grounds that, in North Vietnam, the people would not be allowed to express their political will freely, and that North Vietnamese officials would falsify their votes which, in turn, would overrule those votes cast by the people of South Vietnam.

OCTOBER 1955

SOUTH VIETNAM, *POLITICS*
The Binh Xuyen revolt is crushed by the South Vietnamese Armed Forces.

OCTOBER 23, 1955

SOUTH VIETNAM, *POLITICS*
Ngo Dinh Diem becomes Chief of State in South Vietnam following a nationwide referendum which effectively ends the monarchy of Bao Dai. In elections that are very clearly rigged, Diem proclaims that an overwhelming majority of the South Vietnamese people support him.

KEY PERSONALITY

VO NGUYEN GIAP

The son of an ardent anticolonialist scholar, as a youth Giap began to work for Vietnamese autonomy. He attended the same high school as Ho Chi Minh, the Communist leader, and while still a student in 1926 he joined the Tan Viet Cach Menh Dang, the Revolutionary Party of Young Vietnam. In 1930, as a supporter of student strikes, he was arrested by the French and sentenced to three years in prison, but he was paroled after serving only a few months. He studied at the Lycée Albert-Sarraut in Hanoi, where in 1937 he received a law degree. Giap then became a professor of history at the Lycée Thanh Long in Hanoi, where he converted many of his fellow teachers and students to his political views. In 1938 he married Minh Thai, and together they worked for the Indochinese Communist Party. When in 1939 the party was prohibited, Giap escaped to China, but his wife and sister-in-law were captured by the French police. His sister-in-law was guillotined; his wife received a life sentence and died in prison after three years.

In 1941 Giap formed an alliance with Chu Van Tan, the guerrilla leader of the Tho, a minority tribal group of northeastern Vietnam. Giap hoped to build an army that would drive out the French and support the goals of the Viet Minh, Ho Chi Minh's Vietnamese independence movement. With Ho Chi Minh, Giap marched his forces into Hanoi in August 1945, and in September Ho announced the independence of Vietnam, with Giap in command of all police and internal security forces and Commander-in-Chief of the armed forces. Giap sanctioned the execution of many non-Communist nationalists, and also censored nationalist newspapers. In the French Indochina War, Giap's brilliance as a military strategist and tactician led to the decisive victory at Dien Bien Phu on May 7, 1954.

On the division of the country in July, Giap became deputy prime minister, minister of defence and Commander-in-Chief of the Armed Forces of North Vietnam. He led the north to victory in the Vietnam War, compelling the Americans to leave the country in 1973 and bringing about the fall of South Vietnam in 1975. From 1976 to 1980 he was minister of national defence, and he became a deputy prime minister in 1976. He was a member of the Politburo of the Vietnamese Communist Party until 1982. He is now in retirement.

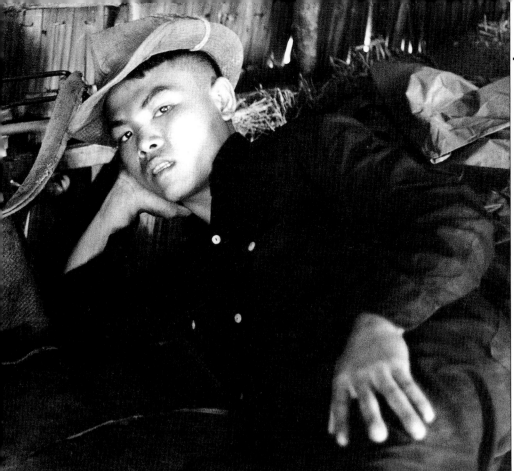

Lieutenant-General John O'Daniels as Chief of United States Military Advisory and Assistance Group, Vietnam.

JANUARY 3, 1957

VIETNAM, *INTERNATIONAL TREATIES*
The International Control Commission reports that between December 1955 and August 1956, neither the government of North Vietnam nor that of South Vietnam have been fulfilling their obligations as set out under the 1954 armistice agreement.

MAY 5–19, 1957

USA, *DIPLOMACY*
President Diem visits the United States. During his visit, he addresses a joint session of Congress on May 9. In a joint communiqué issued on May 11, both President Eisenhower and President Diem declare that their countries will work towards a "peaceful unification" of Vietnam, and that they intend to stand firm against Communism.

JUNE 1957

SOUTH VIETNAM, *FRENCH AID*
The French Naval and Air Force training missions are withdrawn from South Vietnam.

▲ *A young Viet Cong member takes a rest during training (note the French MAT 49 submachine gun). The North supplied the Viet Cong operating in South Vietnam.*

OCTOBER 26, 1955

SOUTH VIETNAM, *POLITICS*
Ngo Dinh Diem, following up his election victory, proclaims the Republic of Vietnam, with himself as president. The United States, Great Britain, France, Australia, New Zealand, Italy and Japan, as well as Thailand and South Korea, recognize the new government in Saigon.

DECEMBER 12, 1955

USA, *DIPLOMACY*
The United States closes its embassy in Hanoi, effectively severing diplomatic relations with North Vietnam. Relations will not be restored until 1998, by President Bill Clinton.

JANUARY 1956

SOUTH VIETNAM, *COUNTERINSURGENCY*
South Vietnamese Army units occupy Tay Ninh, the principal Cao Dai political centre, which leads to the breakup of the organized Cao Dai armed insurgency. An agreement with Cao Dai leaders on February 28 legalizes the Cao Dai religious practices but forbids all of its political activities as a religious sect.

APRIL 28, 1956

SOUTH VIETNAM, *US AID*
The United States Military Assistance and Advisory Group assumes responsibility for the training and equipping of the Army of the Republic of Vietnam.

JULY 6, 1956

USA, *DIPLOMACY*
Vice President Richard M. Nixon visits Vietnam and hands President Diem a letter from President Dwight D. Eisenhower. In this letter the US President declares he is looking forward to many years of partnership between the two countries. As a guest speaker in the Vietnamese Constituent Assembly, Nixon declares that the "march of Communism has been halted."

SEPTEMBER 19, 1956

SOUTH VIETNAM, *RVNAF*
The French Air Force hands over its last base in Touraine to the South Vietnamese Air Force.

NOVEMBER 1956

SOUTH VIETNAM, *US AID*
Lieutenant-General Samuel T. Williams, US Army, replaces

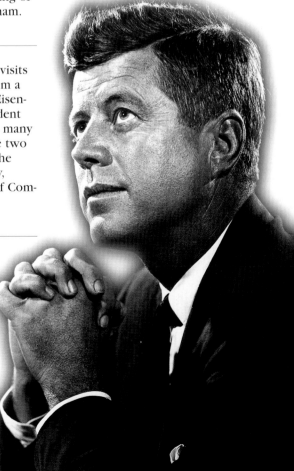

▶ *John F Kennedy would be the American president who would escalate US involvement in South Vietnam.*

JULY 29, 1957

JULY 29, 1957

USA, *DIPLOMACY*
The United States establishes a consulate in the old Imperial capital of Hue.

OCTOBER 1957

SOUTH VIETNAM, *INSURGENCY*
There is a noticeable increase in Communist guerrilla activity after North Vietnamese leaders decide to raise an estimated 37 companies of troops for actions in the Mekong Delta region.

OCTOBER 29, 1957

SOUTH VIETNAM, *TERRORISM*
Terrorist bombs go off at the United States' Military Assistance and Advisory Group and United States Information Services installations in Saigon. A total of 37 US military and civilian personnel are wounded in the attacks.

JANUARY 4, 1958

SOUTH VIETNAM, *GROUND WAR*
North Vietnam chooses war to reunify the country. Large Communist guerrilla forces attack a plantation north of Saigon. This attack is part of a general increase in armed activity by the Communist groups in South Vietnam since mid–1957.

▼ *Ngo Dinh Nhu, President Diem's brother and political advisor, inspects members of the Youth Corps in Saigon.*

JUNE 1958

SOUTH VIETNAM, *COMMUNIST ORGANIZATION*
Communist guerrillas in the Mekong Delta form a coordinated command structure to direct the war against Diem's regime.

DECEMBER 1958

USA, *INTELLIGENCE*
The US Central Intelligence Agency acquires a document that indicates that the North Vietnamese leadership in Hanoi has decided to adopt an "overt" strategy against the South Vietnamese Government.

APRIL 4, 1959

USA, *STRATEGY*
In a landmark speech from his farm in Gettysburg, P.A., President Dwight D. Eisenhower talks of the "inescapable conclusion that US interests are linked to those of South Vietnam." For the first time, President Eisenhower has clearly linked US national security with that of Ngo Dinh Diem's South Vietnamese regime.

MAY 1959

SOUTH VIETNAM, *US AID*
US military advisors are assigned to the regimental level of South Vietnamese Armed Forces.

NORTH VIETNAM, *STRATEGY*
During a meeting of the Communist

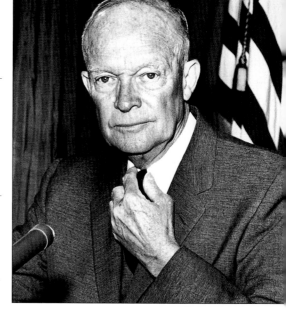

▲ *President Dwight D. Eisenhower believed that the interests of the USA and South Vietnam were closely linked.*

Party's top leadership, the decision is made by North Vietnamese leaders to assume full control of the growing insurgency in the South. North Vietnamese leaders propose to begin supplying Viet Cong guerrillas through a route that goes through Laos and Cambodia. This route will become known as the Ho Chi Minh Trail.

MAY 1, 1959

SOUTH VIETNAM, *GROUND WAR*
South Vietnamese Marines launch their first major operation against the Viet

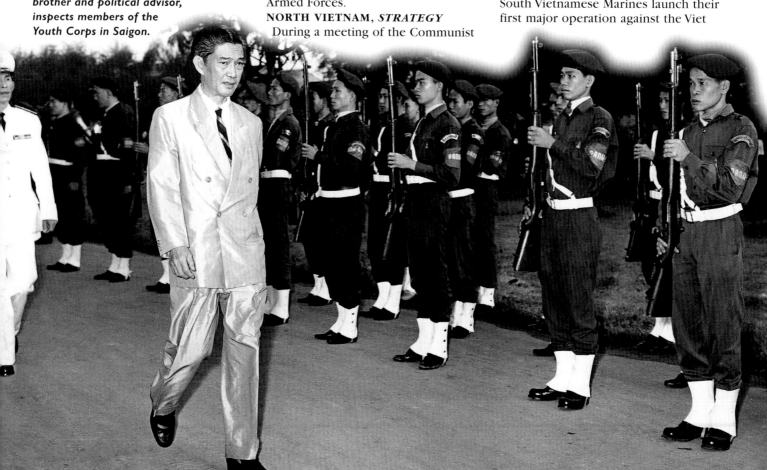

Cong in An Xuyen Province, while the 2nd Battalion Landing Team conducts a similar operation against Communist guerrillas in the Vinh Binh Province.

JUNE 1, 1959

SOUTH VIETNAM, *GROUND WAR*
The Vietnamese Marine Corps is expanded to a Marine Corps Group of 2276 officers and men. A 3rd Landing Battalion is formed and the battalions are reorganized into four infantry companies. United States Marine officers and noncommissioned officers are actively assisting the VNMC.

JULY 11, 1959

SOUTH VIETNAM, *US CASUALTIES*
The first two American members of the United States' Military Assistance and Advisory Group are killed in actions against Viet Cong guerrillas near the US compound located at the ARVN base at Bien Hoa. Major Dale R. Buis and Master Sergeant Chester M. Ovnand are the first US combat casualties of the Second Indochina War.

OCTOBER 30, 1959

SOUTH VIETNAM, *GROUND WAR*
A spokesman for the Army of the Republic of Vietnam discloses that a major campaign against Communist guerrillas in that country's southernmost region, the Camou Peninsula, has resulted in heavy guerrilla losses.

APRIL 17, 1960

NORTH VIETNAM, *DIPLOMACY*
North Vietnam issues protests to both Great Britain and the Soviet Union (chairmen of the 1954 Geneva Conference) against what they consider to be a "formidable" increase in the American Military Assistance and Advisory Group in South Vietnam. North Vietnamese leaders also accuse the United States of turning South Vietnam into a "US military base for the preparation of a new war."

APRIL 30, 1960

SOUTH VIETNAM, *PROTESTS*
An opposition group of 18, calling themselves the Committee for Progress and Liberty, send a letter to President Diem demanding that he undertake drastic economic, administrative and military reforms.

MAY 5, 1960

SOUTH VIETNAM, *US AID*
The United States announces that at the request of the government of South Vietnam, the United States Military Assistance and Advisory Group will be increased from 327 to 685 members by the end of the year.

JUNE 1–2, 1960

USA, *STRATEGY*
A top-level meeting is held in Hawaii between US military and government officials to discuss the situation in South Vietnam.

JULY 20, 1960

SOUTH VIETNAM, *DIPLOMACY*
A Vietnamese National Assembly Delegation leaves Saigon for a six-week visit to the United States to rally support for the Republic of Vietnam.

SEPTEMBER 1960

SOUTH VIETNAM, *US AID*
Lieutenant-General Lionel C. McGarr, US Army, relieves Lieutenant-General Samuel T. Williams, US Army, as US-MAAG, Vietnam.

OCTOBER 26, 1960

USA, *DIPLOMACY*
President Dwight D. Eisenhower assures South Vietnamese President Ngo Dinh Diem, in a letter of good wishes on the anniversary of South Vietnam's fifth year as a nation state, that "for so long as our strength can be useful, the United States will continue to assist Vietnam in the difficult yet hopeful struggle ahead."

NOVEMBER 8, 1960

USA, *POLITICS*
John F. Kennedy, Jr, is elected President of the United States, defeating Richard M. Nixon.

▶ *Soviet Premier and General Secretary Nikita Khrushchev supported so-called "Wars of National Liberation".*

NOVEMBER 11, 1960

SOUTH VIETNAM, *POLITICS*
An abortive military coup is launched in Saigon against President Diem by ARVN paratroop battalions led by Colonel Nguyen Van Thi and Lieutenant-Colonel Vuong Van Dong. The paratroopers besiege the presidential palace. An order of the day issued by Colonel Thi declares that the struggle against the Communist guerrillas will be intensified and that President Diem has been guilty of autocratic rule and nepotism and has thus shown himself "incapable of saving the country from Communism and protecting national unity."

NOVEMBER 12, 1960

SOUTH VIETNAM, *POLITICS*
Troops loyal to President Diem re-enter Saigon and subdue the rebels after an estimated 200 soldiers and civilians are killed in the fighting.

NOVEMBER 13, 1960

USA, *DIPLOMACY*
The United States State Department expresses satisfaction at the failure of the coup against President Diem and hopes that "his powers will be established on

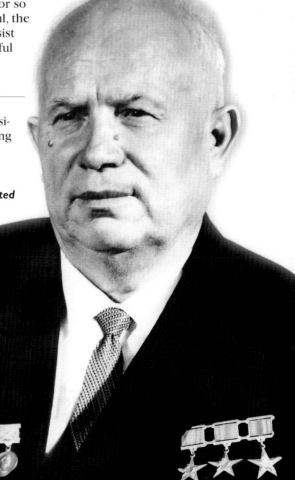

November 16, 1960

a wider basis with rapid implementation of radical reforms and energetic action against both corruption and suspected elements."

November 16, 1960

SOUTH VIETNAM, *POLITICS*

Ngo Dinh Nhu, President Diem's brother and political advisor, announces that President Diem plans to appoint a new government as well as to introduce a far-reaching reform programme based on reports from the US-based Ford Foundation.

December 20, 1960

NORTH VIETNAM, *VIET CONG*

The North Vietnamese leadership in Hanoi announces the formation of the National Liberation Front, or NLF. A broad-base coalition of Communists, Cao Dai, Hoa Hoa and Binh Xuyen rebels, it is in actuality the revival of the Viet Minh which overthrew the French. The group controlled by the Communists will become known as the

▼ *The infamous punji stakes. These sharpened pieces of wood could cause fearful casualties, especially when camouflaged. These ones surround a strategic hamlet.*

Viet Cong from the words *Viet Nam Cong San* (Vietnamese Communists).

January 6, 1961

USSR, *DIPLOMACY*

Soviet Premier and General Secretary Nikita Khrushchev declares that the Soviet Union will support what he calls "Wars of National Liberation" around the world. This will greatly influence both the Kennedy and Johnson Administrations' foreign policies regarding South Vietnam and Southeast Asia in general.

January 28, 1961

USA, *STRATEGY*

In keeping with the theme of his inaugural address to "bear any burden", President John F. Kennedy approves the main provisions set out in the Counter-Insurgency Plan (CIP) formulated by the US Joint Chiefs of Staff. The CIP calls for the support of a 20,000-man increase in the size of the South Vietnamese Armed Forces, as well as a 32,000-man increase in the Civil Guard.

March 23, 1961

LAOS, *AIR WAR*

On an intelligence-gathering mission, a United States SC-47 aircraft is shot

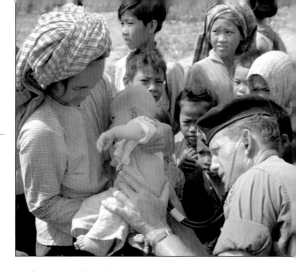

▲ *Sergeant First Class F. Edwards, a US Special Forces A-Team medic, treats locals at Ha Tien near the Rach Gia River.*

down over Laos. Henceforth, the United States will fly only those planes supplied by the Republic of the Philippines and painted with Laotian identification markings.

March 28, 1961

USA, *INTELLIGENCE*

President Kennedy is briefed by members of his intelligence staff about the deteriorating situation now occurring in South Vietnam. This is the first report to question President Diem's ability to defeat the insurgency at large in his own country.

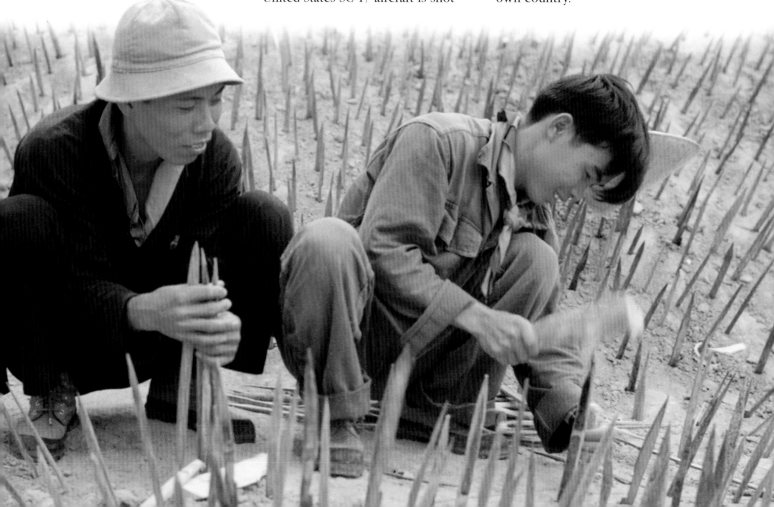

APRIL 26–29, 1961

USA, *STRATEGY*

After internal debates between the military and his National Security advisors, President Kennedy orders the dispatch of an additional 100 US military advisors to South Vietnam to assist the ARVN.

MAY 1961

SOUTH VIETNAM, *US AID*

A new programme of familiarization with combat conditions and counterinsurgency warfare is introduced to US Marine officers and staff noncommissioned officers of the 3rd Marine Division, which is based on Okinawa. From now on, 20 US Marines per month will enter South Vietnam to observe the combat operations.

MAY 5, 1961

USA, *STRATEGY*

Kennedy holds out the possibility of sending US troops to South Vietnam. At a press conference, President John F. Kennedy declares that serious consideration is being given to the introduction of US combat troops into South Vietnam in order to assist the beleaguered South Vietnamese Government in dealing with the Commu-

▲ *Chinese Premier Chou En-lai accused the United States of aggression and intervention in South Vietnam.*

nist threat. He also tells the waiting reporters that he is sending Vice President Lyndon B. Johnson to Saigon to assess the situation there.

MAY 11, 1961

SOUTH VIETNAM, *US AID*

Vice President Lyndon B. Johnson is in Saigon to assess the military situation there. In a Joint Communiqué issued on May 13, the Vice President and President Diem declares that the United States will provide additional military and economic aid to Saigon in its fight against Communist guerrillas.

MAY 16, 1961

SWITZERLAND, *INTERNATIONAL CONFERENCES*

A 14-nation conference meets up in Geneva, Switzerland, in order to discuss the situation in Laos.

JUNE 4, 1961

AUSTRIA, *INTERNATIONAL RELATIONS*

President John F. Kennedy and Soviet Premier Nikita Khrushchev meet up in Vienna, Austria, and re-affirm their support of a neutral and independent Laos and of all international agreements that guarantee Laos' continued neutrality.

JUNE 9, 1961

SOUTH VIETNAM, *ARVN*

South Vietnamese President Ngo Dinh Diem requests US military aid and also economic assistance in increasing the size of the ARVN by 100,000 men. While Washington approves a modest increase of 30,000 men, it postpones a decision on increasing the number of advisors to the ARVN.

JUNE 12, 1961

CHINA, *DIPLOMACY*

Communist Chinese Premier Chou En-lai and North Vietnamese Premier Phan Van-dong while in Beijing accuse the

STRATEGY & TACTICS

HANOI'S STRATEGY

Hanoi military schools commonly classify warfare into three general types: general war (which includes nuclear war); limited war (the difference between the two is one of magnitude); and wars of national liberation. This third type is also described as a category three war, anti-imperialist war, special war (the 1962–65 period in Vietnam), and most popular of all, perhaps, the Maoist People's War. All of these terms, except special war, have been used in Vietnamese Communist literature more or less interchangeably. The doctrine of People's War which in its proper usage is a technical not a propaganda term. It does not mean the people against the landlords and other exploiters; rather, it means the people as an instrument of war. The process is organization, mobilization, motivation. First control the people, then forge them into a weapon, then hurl them into battle in military and/or political activity.

Mao's People's War, as viewed by Hanoi, resembles Revolutionary War, in that both types seek to shape the people into a weapon to accomplish the destruction of the existing society, and both emphasize the importance of exploiting contradictions in the enemy camp. Both make full use of the united front; and both employ the national salvation propaganda theme. But Revolutionary War does not base the struggle more or less exclusively in the rural area, nor does it endorse the principal of self-reliance, i.e. it requires assistance by allies. Revolutionary War is political, as any revolution is political. Violence is mandatory, but not the essence. The mission is to seize political power by disabling society using both military and political techniques. Organization counts for as much if not more than political ideology or battlefield tactics. The united front, attributed to Lenin and certainly the greatest political invention of the twentieth century, permits a web of organizations to be thrown over the people, enmeshing them. These front groups become channels of communication. Their rational appeals to self-interest are shored up by instruments of coercion. From the organization comes mobilization of the people. Through mobi-

lization, and only then, comes motivation. Thus is the trinity forged: organization, mobilization and motivation. Now organized, mobilized, and motivated, the people are set against their own society to drain it of its organized strength. The struggle thus becomes a war of competing systems of organization.

Revolutionary War, unlike earlier, narrower forms of warfare, is no simple insurgency of limited objective, such as national independence or change of government or redress of grievances. Neither is it the usual revolutionary stirrings reflecting inadequate living standards, oppressive government, or some major inequity. Action comes from the central planner, not the heart. Revolutionary War seeks a totally new social order, and it levies on the participant the demand of total involvement, total immersion. It touches all persons of the society at all points of their existence. In the 1960s the Hanoi leadership set about implementing Revolutionary War for military and political victory. It was a strategy that neither the regime in Saigon nor the United States had the means or ideology to combat.

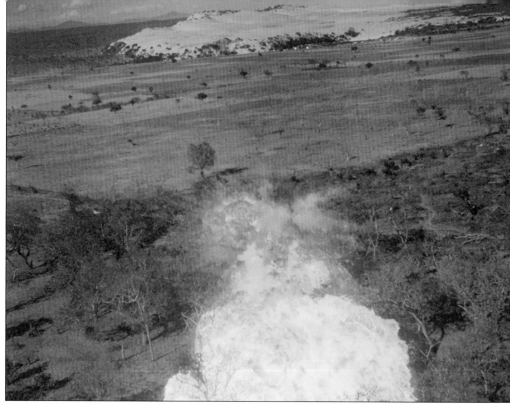

AUGUST 2, 1961

United States of "aggression and intervention in South Vietnam."

AUGUST 2, 1961

USA, *STRATEGY*
President Kennedy asserts that the United States will do all it can to support and save South Vietnam from Communist aggression.

SEPTEMBER 1–4, 1961

SOUTH VIETNAM, *GROUND WAR*
A series of attacks against South Vietnamese positions by an estimated 1000 guerrillas takes place in Kontum Province. An ARVN Communiqué reports that in August alone there were 41 registered attacks by NLF forces.

SEPTEMBER 17, 1961

SOUTH VIETNAM, *COUNTERINSURGENCY*
A British advisory team headed by British counterinsurgency expert Robert G. K. Thompson (former Permanent Defence Secretary in Malaya) leaves for South Vietnam. He will introduce the concept of the "Strategic Hamlet" as a means of combating the Viet Cong in the countryside.

SEPTEMBER 21, 1961

USA, *SPECIAL FORCES*
In keeping with President Kennedy's call for forces to battle guerrillas and re-orientation towards counterinsurgency to battle Communist influence in the Third World, the US Army activates the 5th Special Forces Group at

Fort Bragg, North Carolina. This force is soon dubbed the "Green Berets," denoting their special headgear: a green beret. The Green Berets will become an important part of the counterinsurgency campaign in South Vietnam.

SEPTEMBER 25, 1961

USA, *DIPLOMACY*
President John F. Kennedy in addressing the United Nations' General Assembly in New York declares that the threat to peace is "the smouldering coals of war in Southeast Asia."

OCTOBER 1, 1961

THAILAND, *SEATO*
Military experts of SEATO meet in Bangkok, Thailand, to consider the increasing Communist menace to South Vietnam. US Admiral Harry D. Felt, US Navy, Commander-in-Chief in the Pacific (CinC-Pac), declares that there is no immediate prospect of using US troops to stop the Communist advances in Southeast Asia, but he indicates that among the plans evolved for "every eventuality," some do call for the use of American troops.

OCTOBER 2, 1961

SOUTH VIETNAM, *STRATEGY*
President Diem declares at the opening of the National Assembly's budgetary session that "it is no longer a guerrilla

▲ A US warplane drops napalm on a suspected Viet Cong position in South Vietnam in early 1962.

▼ Villagers brandishing swords and spears in Ta Keo Province, on the border with Cambodia, vow to fight Communist North Vietnamese invaders, October 1961.

◄ A young Viet Cong soldier cleans his bolt-action rifle. North Vietnamese support for the Viet Cong meant the latter's soldiers were reasonably well equipped.

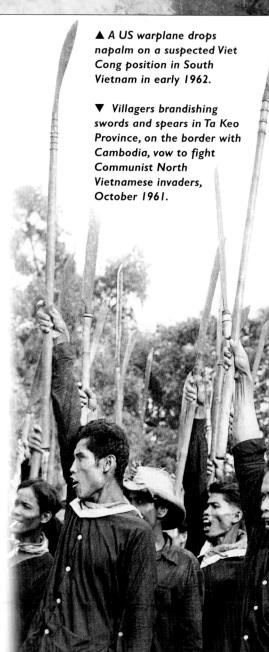

war but one waged by an enemy who attacks us with regular units fully and heavily equipped and who seeks a decision in Southeast Asia in conformity with the orders of the Communist international." The president also says that the United States Committee headed by Dr Eugene Sledge recommended an increase in aid for both military measures and economic development in South Vietnam.

OCTOBER 11, 1961

SOUTH VIETNAM, *US AID*
In announcing the sending of his special envoy, General Maxwell D. Taylor, to South Vietnam President Kennedy, at a meeting of the National Security Council, is presented with a Joint Chiefs of Staff study that indicates that it will take 40,000 US combat troops to defeat the Viet Cong, while another 120,000 would need to be situated along the borders of North and South Vietnam in order to deal with any threat which would be posed by the North Vietnamese Army (NVA) or the Communist Chinese troops.

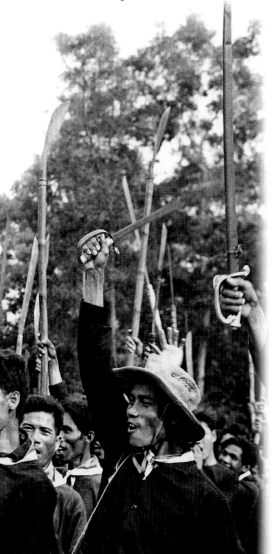

OCTOBER 18, 1961

SOUTH VIETNAM, *DIPLOMACY*
General Maxwell D. Taylor and President Ngo Dinh Diem meet in Saigon to discuss the military situation. General Taylor would report to President Kennedy that the US might consider sending in a limited number of ground troops and that the US military assistance group presently in Saigon be upgraded to a theatre-level command.

NOVEMBER 16, 1961

USA, *STRATEGY*
President Kennedy, after reading the results of General Taylor's meetings with President Diem, decides to bolster South Vietnam's military strength with tactical fixed- and rotary-wing aviation and more advisors. He still refuses to commit US combat troops at this time.

DECEMBER 1961

SOUTH VIETNAM, *US AID*
United States Military Assistance and Advisory Group, Vietnam, approves the creation of a new 18-man US Marine Advisory Division.

DECEMBER 8, 1961

USA, *STRATEGY*
The United States' State Department publishes the claim in a "white paper" that South Vietnam is threatened by a "clear and present danger" of Communist conquest by the North.

DECEMBER 11, 1961

SOUTH VIETNAM, *US AID*
The first direct contingent of US military forces arrives in South Vietnam. These are 400 US Army troops and two helicopter companies.

DECEMBER 14, 1961

SOUTH VIETNAM, *US AID*
President John F. Kennedy pledges increased aid to South Vietnam.

JANUARY 1962

SOUTH VIETNAM, *US AID*
Detachment A, 1st Radio Company, Fleet Marine Force, Pacific, arrives in Vietnam to support government forces.

JANUARY 1, 1962

SOUTH VIETNAM, *VNMC*
The South Vietnamese Marine Corps (VNMC) is expanded to 6109 officers

and men, is redesignated the Vietnamese Marine Brigade, and a new amphibious support battalion is formed.

JANUARY 3, 1962

SOUTH VIETNAM, *US AID*
The first elements of the United States Air Force (USAF) transport aircraft arrive in South Vietnam to support government forces.

JANUARY 4, 1962

SOUTH VIETNAM, *SOCIAL POLICIES*
A joint United States-South Vietnamese communiqué announces an economic and social programme which will bolster the living standards of the average South Vietnamese citizen, as well as

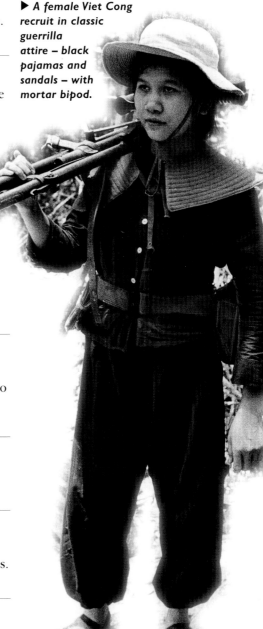

▶ A female Viet Cong recruit in classic guerrilla attire – black pajamas and sandals – with mortar bipod.

measures to strengthen South Vietnam's defence in the military field.

JANUARY 20, 1962

SOUTH VIETNAM, *US AID*
Admiral Harry D. Felt, USN, Commander in Chief, Pacific, authorizes all advisors from Military Assistance and Advisory Group, Vietnam, to accompany their Vietnamese units into combat.

FEBRUARY 3, 1962

SOUTH VIETNAM, *SOCIAL POLICIES*
President Diem issues a decree which formalizes the initiation of the Strategic Hamlet Program.

FEBRUARY 7, 1962

SOUTH VIETNAM, *US AID*
Two US Army air support companies totalling 300 men arrive in Saigon, thereby increasing the US military personnel total in South Vietnam to 4000.

FEBRUARY 8, 1962

SOUTH VIETNAM, *US ARMED FORCES*
The United States reorganizes its South Vietnam military command from the United States Military Assistance and Advisory Group to that of US Military Assistance Command, Vietnam, under General Paul D. Harkins. Major-General Richard G. Weede, USMC, becomes Military Assistance Command, Vietnam's chief of staff.

▼ *US Secretary of State Averell Harriman, who stated that the United States had no plans to become embroiled in the ongoing conflict in Laos.*

REGIONAL POLITICS

LAOS
France formally recognized the independence of Laos within the French Union on July 19, 1949, and Laos remained a member of the French Union until 1953. From 1954 until 1957, pro-Western governments held power. The first coalition government, the Government of National Union, led by Souvanna Phouma, was formed in 1957. It consisted of the Communist Pathet Lao, rightists and neutrals. It collapsed in 1958 with the imprisonment of Prince Souphanouvong and other Pathet Lao leaders by the government. A pro-Western regime took over the Royal Lao Government. The Pathet Lao insurgency resumed after 1959, when Souphanouvong and other leaders escaped from prison. In 1960, Kong Le, a paratroop captain, seized Vientiane in a coup, demanding the formation of a neutralist government to end the fighting. Kong Le and the neutralist government, again under Souvanna Phouma, were driven from Vientiane later in the year by rightist forces under General Phoumi Nosovan, and they then formed an alliance with the Pathet Lao. By early 1961, the Pathet Lao, with North Vietnamese military support, threatened to take over the entire country. US military advisors and supplies were sent to the Royal Army. A 14-country conference in Geneva addressed the issue of Laos, reaching an agreement in 1962 which provided international guarantees for Laos' independence and neutrality. But the Pathet Lao ceased cooperating with the government in 1964, and fighting intensified against the neutralists and rightists. In 1972, Lao Communists proclaimed the existence of the Lao People's Revolutionary Party (LPRP). A new coalition, with Communist participation, and a ceasefire were arranged in 1973, but the struggle between the political factions continued. The collapse of Saigon and Phnom Penh in April 1975 hastened the decline of the coalition. On December 2, 1975, the monarchy was abolished and the Communist Lao People's Democratic Republic (LPDR) was established.

FEBRUARY 24, 1962

CHINA, *PROPAGANDA*
In a Beijing Radio Broadcast, Communist China declares that its security is seriously threatened by an "undeclared war" being waged by the United States in South Vietnam. The broadcast demands the withdrawal of US military personnel and equipment.

FEBRUARY 27, 1962

SOUTH VIETNAM, *POLITICS*
Two fighter aircraft, piloted by airmen from the South Vietnamese Air Force, bomb and strafe the Presidential Palace in Saigon for a half an hour in an attempted coup against President Diem. Neither President Diem nor any of his staff are injured.

MARCH 17, 1962

USSR, *PROPAGANDA*
The Soviet News Agency, TASS, publishes a Soviet Ministry note which is addressed to the signatories of the 1954 Geneva Accords and charges the United States with creating a "serious danger to peace" by its interference in South Vietnam, in contravention of the Geneva Agreements. It demands an immediate withdrawal of US troops.

MARCH 22, 1962

SOUTH VIETNAM, *GROUND WAR*
Operation Sunrise, a comprehensive plan to eliminate all Viet Cong guerrillas in South Vietnam, begins with a mopping-up operation by troops in Binh Duong Province.

APRIL 9, 1962

SOUTH VIETNAM, *US AID*
The leading elements of US Marine Task Unit 79.3.5 known as Shu Fly, led by Colonel John F. Carey, USMC, arrives at Soc Trang, Republic of Vietnam.

▶ *US Special Forces A-Team members train Montagnards at the Heiyit Commando Training Centre.*

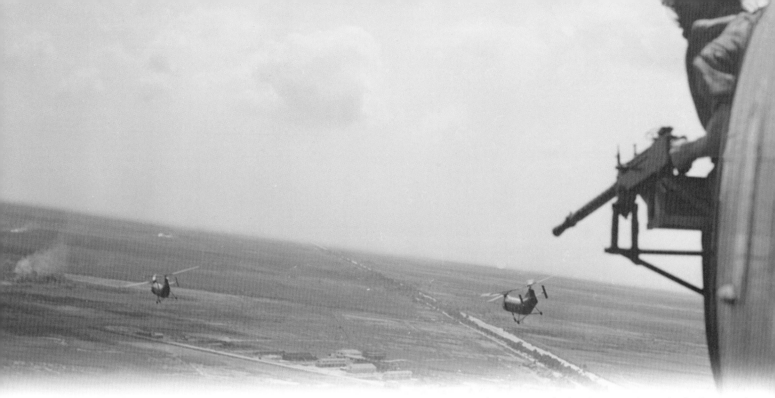

▲ *A South Vietnamese machine gunner watches for Viet Cong activity while flying over a suspected area northeast of Saigon in April 1962.*

APRIL 15, 1962

SOUTH VIETNAM, *US AID*

US Marine Helicopter Squadron HMM-362 (Reinforced), a Marine medium transport helicopter squadron, arrives at Soc Trang to support the ARVN.

APRIL 20, 1962

SOUTH VIETNAM, *SOCIAL POLICIES*

The Vietnamese National Assembly pledges full support to President Diem's plan to establish thousands of strategic hamlets in the Communist-controlled and infested Mekong Delta during the current year.

APRIL 22, 1962

SOUTH VIETNAM, *AIR WAR*

HMM-362 helicopters set out on their first combat support missions for the ARVN in South Vietnam.

MAY 6, 1962

LAOS, *GROUND WAR*

Communist forces in Laos initiate a major offensive that will last until May 27, and will result in their gaining control of a large area. About 2000 Royal Laotian troops flee across the Mekong River into Thailand.

MAY 9, 1962

SOUTH VIETNAM, *GROUND WAR*

Eight US Marine helicopters of HMM-362 are hit by small-arms fire while landing ARVN troops on the Ca Mau Peninsula during an operation.

MAY 15, 1962

THAILAND, *US AID*

In response to a request from the government of Thailand, President Kennedy announces that due to "recent attacks by Communist units in Laos and the subsequent movement of Communist military units toward the Thai border," he has ordered US military forces to Thailand, including a 5000-strong unit, the Marine Expeditionary Force.

MAY 18, 1962

THAILAND, *US AID*

The 3rd Marine Expeditionary Unit (3rd MEU) begins moving into position at Udorn, Thailand, in response to the deteriorating situation in Laos. The 3rd MEU is part of Joint Task Force 116, organized for just such a crisis requiring rapid deployment. Brigadier-General Ordmond R. Simpson, USMC, assumes command of the 3rd MEU.

JUNE 2, 1962

NORTH VIETNAM, *INTERNATIONAL RELATIONS*

Canadian and Indian members of the International Control Commission (ICC) find North Vietnam guilty of subversion and covert aggression against South Vietnam. The Polish delegation, following the Soviet line, rejects this.

JUNE 12, 1962

LAOS, *POLITICS*

Three Laotian factions sign an agreement for the establishment of a neutralist regime under Souvanna Phouma with the cabinet posts to be divided between the three competing political factions.

JUNE 18, 1962

SOUTH VIETNAM, *GROUND WAR*

Eagle Flight is first employed in combat

July 1, 1962

by US Marine helicopters operating from Soc Trang.

July 1, 1962

THAILAND, *US AID*

The first US Marine combat units are withdraw from Udorn, Thailand.

July 6, 1962

USA, *POLITICS*

United States Secretary of Defense Robert S. McNamara declares that while a final victory over the Communists in South Vietnam may take years, he is nonetheless encouraged by the increased effectiveness of the ARVN forces due to the assistance provided by the United States.

July 23, 1962

LAOS, *INTERNATIONAL RELATIONS*

The declaration and protocol on the neutrality of Laos is signed by a 14-nation conference. The North Vietnamese, however, will ignore Laos' neutrality and continue to use it as a conduit for sending men and equipment into South Vietnam.

July 31, 1962

THAILAND, *US AID*

The United States completes the withdrawal of the 3rd Marine Expeditionary Unit from Udorn in Thailand.

August 1, 1962

SOUTH VIETNAM, *AIR WAR*

US Marine helicopters are now armed with door-mounted machine guns in Vietnam. Also, HMM-163 replaces HMM-362 as the operational squadron assigned to Shu Fly.

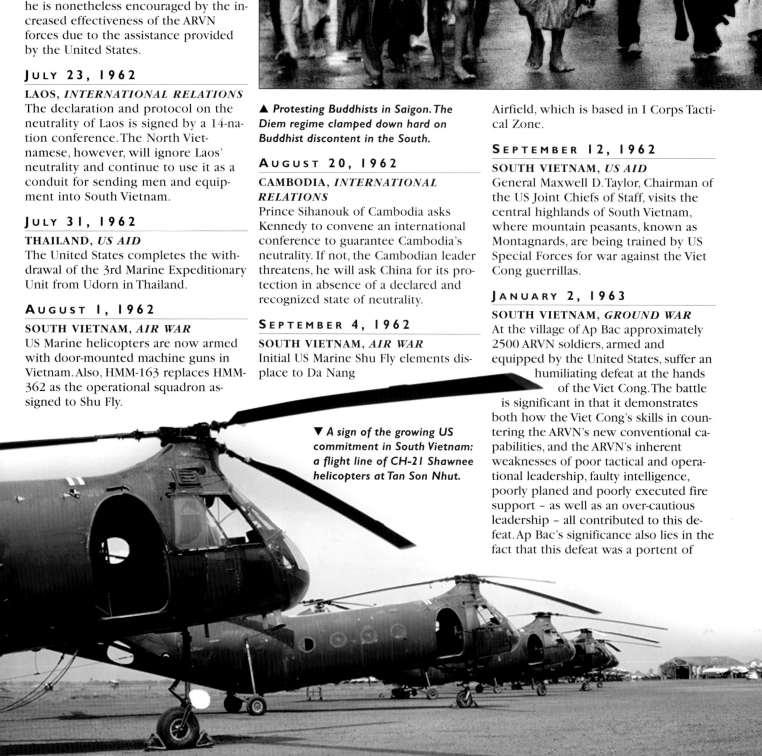

▲ *Protesting Buddhists in Saigon. The Diem regime clamped down hard on Buddhist discontent in the South.*

August 20, 1962

CAMBODIA, *INTERNATIONAL RELATIONS*

Prince Sihanouk of Cambodia asks Kennedy to convene an international conference to guarantee Cambodia's neutrality. If not, the Cambodian leader threatens, he will ask China for its protection in absence of a declared and recognized state of neutrality.

September 4, 1962

SOUTH VIETNAM, *AIR WAR*

Initial US Marine Shu Fly elements displace to Da Nang

▼ *A sign of the growing US commitment in South Vietnam: a flight line of CH-21 Shawnee helicopters at Tan Son Nhut.*

Airfield, which is based in I Corps Tactical Zone.

September 12, 1962

SOUTH VIETNAM, *US AID*

General Maxwell D. Taylor, Chairman of the US Joint Chiefs of Staff, visits the central highlands of South Vietnam, where mountain peasants, known as Montagnards, are being trained by US Special Forces for war against the Viet Cong guerrillas.

January 2, 1963

SOUTH VIETNAM, *GROUND WAR*

At the village of Ap Bac approximately 2500 ARVN soldiers, armed and equipped by the United States, suffer an humiliating defeat at the hands of the Viet Cong. The battle is significant in that it demonstrates both how the Viet Cong's skills in countering the ARVN's new conventional capabilities, and the ARVN's inherent weaknesses of poor tactical and operational leadership, faulty intelligence, poorly planed and poorly executed fire support – as well as an over-cautious leadership – all contributed to this defeat. Ap Bac's significance also lies in the fact that this defeat was a portent of

things to come for the ARVN. Never before able to challenge ARVN units of equal strength in quasi-conventional battles, the signs all point to a major effort by the Viet Cong and Hanoi to move the war into a more semi-conventional, semi-revolutionary warfare mode.

JANUARY 9–11, 1963

USA, *STRATEGY*

Admiral Harry D. Felt, USN, Commander in Chief of US forces in the Pacific, confers with General Paul D. Harkins, and declares before his departure that the Viet Cong guerrillas face "inevitable defeat." He further states: "I am confident the Vietnamese are going to win the war."

JANUARY 19, 1963

SOUTH VIETNAM, *GROUND WAR*

HMM-162 conducts its first combat troop lift in Vietnam.

MARCH 6, 1963

SOUTH VIETNAM, *NAVAL WAR*

US military sources report that the South Vietnamese Navy has taken over the patrol of the South's coastal waters from the US Seventh Fleet.

MARCH 10–13, 1963

SOUTH VIETNAM, *AIR WAR*

HMM-162 helicopters participate in search-and-rescue attempts for a US Army OV-1 Mohawk helicopter and crew that crashed. Two Marine helicopters crash in the high mountains of Northern II Corps Zone.

APRIL 8–10, 1963

FRANCE, *SEATO*

The SEATO Ministerial Council Meeting in Paris discussing the Communist threat to Southeast Asia issues a communiqué on April 10, expressing concern over the continuing and widening threats to the security of the treaty area. It takes note of the progress made in South Vietnam against Communist subversion and rebellion; emphasizes that effective measures to "prevent and counter subversion continues to be a major task facing the member countries;" and notes "the improvement in the plans for defensive action, in the light of changing and anticipated situations."

APRIL 10, 1963

FRANCE, *SEATO*

The SEATO Ministerial Council meeting in Paris calls on the signatories to the 14- nation Geneva Conference "to assure the maintenance of peace, neutrality and national unity" in Laos.

APRIL 13, 1963

SOUTH VIETNAM, *AIR WAR*

US Marine transport helicopters conduct their first operation, on this occasion with US Army UH-1B heavily armed gunship helicopters.

APRIL 14, 1963

USA, *STRATEGY*

United States Secretary of State Averell Harriman, during a television interview, states that President John F. Kennedy has decided that the United States must not become involved in the continuing conflict in Laos. He says that there are no plans to commit US troops and that US military supplies will only be sent there if they are directly requested by the Lao Government.

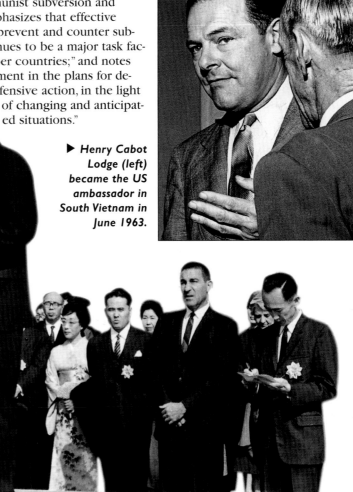

▶ Henry Cabot Lodge (left) became the US ambassador in South Vietnam in June 1963.

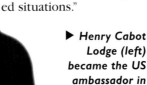

▶ US Secretary of State Dean Rusk (centre) warned of a potentially long struggle in South Vietnam.

APRIL 17, 1963

SOUTH VIETNAM, *PROPAGANDA*
In order to induce the Viet Cong to surrender, President Diem proclaims an "open arms" campaign. He also asks that the Viet Cong give up their weapons and return to the side of South Vietnam.

APRIL 22, 1963

USA, *STRATEGY*
United States Secretary of State Dean Rusk calls the situation in South Vietnam "difficult and dangerous," and says that the United States "cannot promise or expect a quick victory". and that its role is "limited and supporting".

JUNE 3, 1963

SOUTH VIETNAM, *POLITICS*
Buddhist demonstrations break out in Hue. In their wake, a stringent martial law is swiftly imposed.

JUNE 8, 1963

SOUTH VIETNAM, *US AID*
US Marine helicopter squadron HMM-261 replaces HMM-162, the operational squadron for Shu Fly.

JUNE 11, 1963

SOUTH VIETNAM, *PROTESTS*
Buddhist monk Thich Quang Duc commits suicide by setting himself alight in front of the Cambodian legation, further aggravating the crisis between the Diem government and the Buddhists.

JUNE 15, 1963

SOUTH VIETNAM, *PROTESTS*
Tentative agreement is reached between Ngo Dinh Diem, the Buddhist leaders and representatives of President Diem to end alleged religious discrimination and meet the Buddhists' demands.

JUNE 27, 1963

USA, *DIPLOMACY*
While in Ireland, President John F. Kennedy announces the appointment of Henry Cabot Lodge as the next ambassador to South Vietnam, effective September 1963, as the successor to Ambassador Frederick Nolting.

JULY 11, 1963

USA, *DIPLOMACY*
US ambassador to Saigon Frederick Nolting returns to South Vietnam after consultations in Washington and issues a statement assuring the Diem regime of continued US support.

JULY 17, 1963

SOUTH VIETNAM, *POLITICS*
As South Vietnamese policeman suppress a riot by 1000 Buddhists protesting religious discrimination by the Diem regime, President Kennedy says at a news conference that a religious crisis in South Vietnam is interfering with the war effort against the Viet Cong guerrillas, and expresses hope that President Diem and the Buddhist leaders will reach an agreement on the civil disturbances and also in respect for the rights of others.

AUGUST 21, 1963

SOUTH VIETNAM, *POLITICS*
Martial law is proclaimed throughout South Vietnam by President Diem after hundreds of armed police and government troops raid the main Buddhist Pagoda in Saigon.

AUGUST 26, 1963

USA, *DIPLOMACY*
Newly appointed US Ambassador Henry Cabot Lodge presents his diplomatic credentials to President Diem.

SEPTEMBER 2, 1963

SOUTH VIETNAM, *INTELLIGENCE*
The Times of South Vietnam charges that the United States' Central Intelligence Agency had planned a coup d'état for August 28 to overthrow President Diem.

USA, *STRATEGY*
President Kennedy declares in a TV interview with CBS news correspondent Walter Cronkite that the United States is prepared to continue to assist the

KEY PERSONALITY

NGO DINH DIEM

Diem was born on January 3, 1901, into one of Vietnam's noble families. His ancestors in the seventeenth century had been among the first Vietnamese converts to Roman Catholicism. He was on friendly terms with the Vietnamese imperial family in his youth, and in 1933 served as the Emperor Bao Dai's minister of the interior, but he resigned that same year in frustration at French unwillingness to countenance his legislative reforms. Relinquishing his titles and decorations, he spent the next 12 years living quietly in Hue. In 1945 Diem was captured by the forces of the Communist leader Ho Chi Minh, who invited him to join his independent government in the North, hoping that Diem's presence would win Catholic support. But Diem rejected the proposal and went into self-imposed exile, living abroad for a decade.

In 1954 Diem returned at Bao Dai's request to serve as prime minister of the US-backed government in South Vietnam. After defeating Bao Dai in a government-controlled referendum in October 1955, he ousted the emperor and made himself president of the new Republic of Vietnam (South Vietnam). Diem refused to carry out the Geneva Accords, which had called for free elections to be held throughout Vietnam in 1956 for a national government. With the South torn by dissident groups and political factions, Diem established an autocratic regime, staffed at the highest levels by members of his family. With US military and economic aid, he resettled hundreds of thousands of refugees from North Vietnam in the South, but his own Catholicism and the preference he showed for fellow Roman Catholics made him unacceptable to Buddhists, an overwhelming majority in South Vietnam. During his rule, Communist influence and appeal grew among southerners as the Viet Cong launched an increasingly intense guerrilla war against his government. Diem's tactics against the insurgency were heavy handed and ineffective, only serving to deepen his government's unpopularity and isolation.

Diem's imprisoning and killing of hundreds of Buddhists, who he alleged were abetting Communist insurgents, finally persuaded the United States to withdraw its support, and Diem's generals assassinated him in a coup d'état on November 2, 1963.

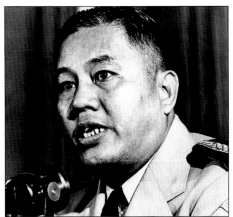

▲ *Major-General Duong Van "Big" Minh headed the generals who ousted President Diem and then murdered him.*

South Vietnamese Government in its war against the Viet Cong, but says: "I don't think that the war can be won unless the people support the war effort and, in my opinion, in the last two months, the government has gotten out of touch with the people."

SEPTEMBER 5, 1963

SOUTH VIETNAM, *POLITICS*
President Diem declares in a press interview that the "government considers the Buddhist affair closed."

SEPTEMBER 8, 1963

SOUTH VIETNAM, *US AID*
The US Administrator for the US Agency for International Development, David Bell, warns in a television interview that the US Congress may cut back aid to South Vietnam unless the Diem government changes its policies.

SEPTEMBER 9, 1963

USA, *STRATEGY*
President John F. Kennedy in a televised interview says that "he doesn't think it would be helpful at this time" to reduce US aid to South Vietnam, because that might bring about a collapse similar to that of Chiang Kai-shek's government in China after World War II. On this same day US Ambassador Henry Cabot Lodge confers with President Diem.

SEPTEMBER 21, 1963

SOUTH VIETNAM, *US AID*
President Kennedy orders Secretary of Defense Robert S. McNamara and General Maxwell D. Taylor, Chairman of the Joint Chiefs of Staff, to go to South Vietnam to review the efforts against the Viet Cong. Both McNamara and Taylor will conduct an extensive review of the South Vietnamese progress to date.

▲ *A flight of CH-21s peels off for a landing at An Binh airstrip, 200km (125 miles) southwest of Saigon, in April 1963.*

OCTOBER 2, 1963

SOUTH VIETNAM, *US AID*
Secretary of Defense McNamara and General Taylor report to President Kennedy on their fact-finding mission to Saigon. The statement they issue says that the United States will continue its policy of working with the government and people of South Vietnam in order to deny the South to the Communists, and to suppress the externally stimulated and supported insurgency of the Viet Cong as soon as

▼ *Lyndon Johnson (centre) becomes President of the United States following the assassination of John F. Kennedy in Dallas. A grief-stricken Mrs Kennedy is at his side.*

OCTOBER 2, 1963

▶ *South Vietnamese Marines exit CH-21 helicopters during an operation against the Viet Cong in the Plain of Reeds. The South suffered major defeats in 1963.*

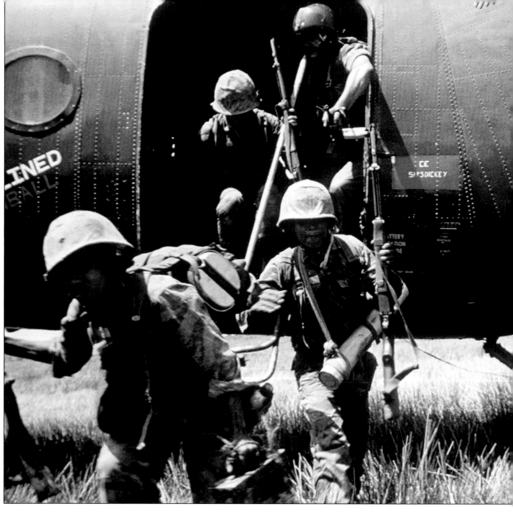

possible. "Effective performance in this undertaking is the central object of our [United States] policy in South Vietnam."

OCTOBER 2, 1963

SOUTH VIETNAM, *AIR WAR*
HMM-361 replaces US Marine Squadron HMM-261 as the Shu Fly operational squadron.

OCTOBER 27, 1963

SOUTH VIETNAM, *POLITICS*
A Buddhist monk sets himself on fire in Saigon, the seventh immolation since June 11.

NOVEMBER 1, 1963

SOUTH VIETNAM, *POLITICS*
A military coup, organized by generals of the armed forces against the Diem regime takes place. Rebels lay siege to the presidential palace in Saigon which is captured by the following morning. Both President Diem and his brother, Ngo Dinh Nhu, escape from the palace but a few hours later are taken prisoner by the rebels and, while being transported in an armoured vehicle, both are brutally murdered. A broadcast by the leaders of the coup (a council of generals headed by Major-General Duong Van "Big" Minh) declares that they "have no political ambitions", and that the fight against the Communists must be carried on to a successful conclusion.

NOVEMBER 2, 1963

SOUTH VIETNAM, *POLITICS*
Military leaders in South Vietnam set up a provisional government headed by former Vice President Ngo Nguyen Ngoc (a Buddhist) as premier. The country's constitution is suspended and the National Assembly dissolved. Buddhists, students and other political prisoners arrested by the Diem regime are released.

NOVEMBER 4, 1963

SOUTH VIETNAM, *POLITICS*
Premier Ngo Nguyen Ngoc of South Vietnam announces that the formation of a mixed military-civilian Cabinet has been approved by military leaders.
USA, *DIPLOMACY*
The United States recognizes the new provisional government of South Vietnam.

During a press conference US Secretary of State Dean Rusk rejects French President Charles de Gaulle's proposals for a neutral, independent Vietnam, stating that the proposal would lead to a Communist-dominated peninsula.

NOVEMBER 14, 1963

USA, *POLITICS*
President Kennedy reaffirms his support for General Paul D. Harkins in a news conference. The president denied reports that Harkins fell out of favour due to the general's identification with the ousted Diem regime.

NOVEMBER 15, 1963

SOUTH VIETNAM, *US AID*
A US military spokesman in Saigon reports that 1000 US servicemen will be withdrawn from South Vietnam, and that this will begin on December 8.

NOVEMBER 20, 1963

USA, *STRATEGY*
US Secretary of Defense Robert S. McNamara and Secretary of State Dean Rusk confer in Honolulu, Hawaii, with US Ambassador to Saigon, Henry Cabot Lodge, and commander of US military operations in South Vietnam, General Paul D. Harkins, to discuss the deteriorating military situation in South Vietnam.

NOVEMBER 22, 1963

USA, *POLITICS*
President John F. Kennedy is assassinated while visiting Dallas, Texas. He is succeeded by Vice President Lyndon B. Johnson. President Johnson re-affirms on November 24 the United States' intentions to continue its military and economic support of South Vietnam's struggle against the Communist Viet Cong.

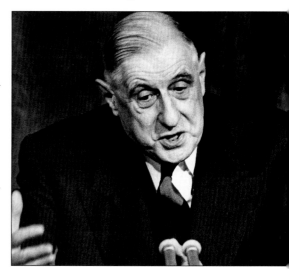

▲ *French President Charles de Gaulle put forward proposals for an independent Vietnam, which were rejected by the USA.*

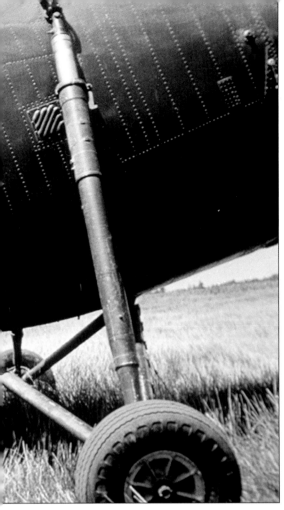

DECEMBER 14, 1963

SOUTH VIETNAM, *GROUND WAR*
A United States military spokesman in Saigon reports on stepped-up guerrilla attacks on hamlets, outposts and also patrols in November, estimating that the ARVN's casualties are at 2800, while the Viet Cong have suffered 2900. The spokesman claims that the ARVN has captured enough weapons from the Viet Cong to arm five 300-man battalions.

DECEMBER 19–20, 1963

SOUTH VIETNAM, *US AID*
United States Defense Secretary Robert S. McNamara and the Director of the Central Intelligence Agency, John A. McCone, fly to Saigon in order to evaluate the new government's war efforts against the Viet Cong.

JANUARY 1, 1964

SOUTH VIETNAM, *US AID*
General Wallace M. Greene, Jr., USMC, replaces General David M. Shoup, USMC, as Commandant of the US Marine Corps. General Greene would leave the next week for a tour of his Pacific commands and Vietnam.

JANUARY 2, 1964

SOUTH VIETNAM, *GROUND WAR*
Secretary of State Dean Rusk announces in a news conference that "a Vietnamese Army group seized in the Delta region of South Vietnam some 300,000 rounds of small-arms ammunition, weapons like mortars, recoilless rifle ammunition, made in China," and that almost certainly Hanoi was primarily responsible for their infiltration into South Vietnam. ARVN forces in the Mekong Delta region seize a huge cache of arms of Chinese Communist origin, including mortars and 300,000 rounds of small-arms ammunition.

JANUARY 6, 1964

SOUTH VIETNAM, *ARMED FORCES*
The South Vietnamese Government decrees a three-man military command over the Vietnamese forces and government that consists of Major-General Duong Van Minh (Chief of State), Major-General Tran Van Don and also Major-General Le Van Kim.

JANUARY 18, 1964

SOUTH VIETNAM, *GROUND WAR*
The ARVN is transported into battle by 115 assault helicopters, the largest airlift of the war in Vietnam to date. Some 1100 ARVN soldiers are airlifted into the critical War Zone D region north of Bien Hoa. Despite the magnitude of this operation, no enemy contact is made, as the Viet Cong forces withdraw from the area.

JANUARY 27, 1964

SOUTH VIETNAM, *US AID*
General William C. Westmoreland takes over command of the Military Assistance Command, Vietnam.

JANUARY 30, 1964

SOUTH VIETNAM, *POLITICS*
A military coup, which has been organized by Major-General Nguyen Khanh, succeeds in ousting the government of Major-General Duong Van Minh from power in South Vietnam.

FEBRUARY 1, 1964

SOUTH VIETNAM, *US AID*
Marine Helicopter Squadron HMM-364 replaces HMM-361 as the Shu Fly squadron assisting South Vietnamese forces against the Viet Cong.

FEBRUARY 3, 1964

SOUTH VIETNAM, *GROUND WAR*
Violence erupts in the vicinity of Kontum City when enemy forces attack the compound of the US Military Assistance Advisory Group.

FEBRUARY 3–6, 1964

SOUTH VIETNAM, *GROUND WAR*
The Viet Cong launches an offensive in Tay Ninh province and the Mekong Delta; in the ensuing fighting, hundreds of government troops are reported dead or missing.

FEBRUARY 7, 1964

USA, *INTERNATIONAL RELATIONS*
When asked at a press conference about certain neutralization proposals regarding South Vietnam, Secretary of State Dean Rusk reiterates US policy that: "If the agreements which have already been reached, and which have been signed by those in the North would be fulfilled, there could be peace in Southeast Asia."

SOUTH VIETNAM, *TERRORISM*
The Viet Cong initiate a series of terrorist attacks in Saigon, during which 3 US personnel are killed and 50 are wounded by a Viet Cong bomb explosion in the Capital-Kinh Do Theater, occupied primarily by American personnel and their families.

FEBRUARY 8, 1964

SOUTH VIETNAM, *POLITICS*
Major-General Khanh, leader of the military junta, announces the formation of a new South Vietnamese Government, with himself named as premier,

▲ *Major-General Nguyen Khanh, who ousted the regime of Major-General Duong Van Minh in a military coup.*

Major-General Duong Van Minh as nominal Chief of State, and a mixed civilian-military cabinet which will be in charge of administration.

MARCH 1964

USA, *US MARINES*

US Marine Lieutenant-General Victor H. Krulak is named Commanding General, Fleet Marine Forces, Pacific. General Krulak is one of the US Marine Corps' most noted experts on counterinsurgency warfare.

MARCH 3–4, 1964

SOUTH VIETNAM, *GROUND WAR*

ARVN forces achieve an encouraging victory. Vietnamese airborne and mechanized troops operating on the Plain of Reeds near the Cambodian border kill over 100 Viet Cong soldiers and capture another 300 of them. During the mopping-up opera-

DECISIVE MOMENTS

GULF OF TONKIN RESOLUTION

A resolution put before the US Congress by President Lyndon Johnson on August 5, 1964, in reaction to two allegedly unprovoked attacks by some North Vietnamese torpedo boats on the destroyers *Maddox* and *C. Turner Joy* of the US 7th Fleet in the Gulf of Tonkin on August 2 and August 4, respectively. Its purpose was to approve and support the determination of the president, as Commander-in-Chief, in taking all necessary measures to repel any armed attack against the forces of the United States and to prevent further aggression. It also declared that the maintenance of international peace and security in Southeast Asia was vital to American interests and world peace. Both houses of Congress passed the resolution on August 7, the Representatives by 414 votes to nil, and the Senate by a vote of 88 to 2. It was the principal constitutional authorization for the escalation of US military involvement in the Vietnam War. Several years later, when the American public became disillusioned with the war, many congressmen saw the resolution as giving the president a blanket power to wage war, and it was repealed in 1970. In 1995 Vo Nguyen Giap, North Vietnam's military commander during the war, admitted the August 2 attack on the *Maddox* but denied the Vietnamese attack of August 4, which the Johnson administration had cited.

tions the Vietnamese units cross over into Cambodia in the vicinity of the village of Chantrea, which results in a sharp exchange of words between the two countries.

MARCH 8–12, 1964

SOUTH VIETNAM, *US AID*

US Secretary of Defense Robert S. McNamara and General Maxwell Taylor go to Saigon to assess the military situation there.

MARCH 23, 1964

SOUTH VIETNAM, *GROUND WAR*

Despite the chaotic politics of South Vietnam, the ARVN achieves another victory over the enemy by trapping a Viet Cong battalion in a fortified village and killing 120 of the enemy.

APRIL 3–6, 1964

SOUTHEAST ASIA, *INTERNATIONAL RELATIONS*

The ministerial meeting of SEATO issues a communiqué declaring that the defeat of the Viet Cong is "essential" to the security of Southeast Asia, and reemphasizes SEATO's commitment to fulfill its treaty obligations.

APRIL 19, 1964

LAOS, *POLITICS*

A military coup by right-wing generals against the government of Souvanna Phouma takes place in Laos. The United States, the Soviet Union, Great Britain and France strongly protest against the coup as a violation of the Geneva Accords.

APRIL 25, 1964

SOUTH VIETNAM, *US AID*

General William C. Westmoreland officially assumes command of MACV. He replaces General Paul D. Harkins as Commanding General, United States Military Assistance Command, Vietnam (CG, USMACV).

MAY 2, 1964

SOUTH VIETNAM, *NAVAL WAR*

An explosion in the harbour of Saigon sinks the helicopter carrier USNF *Card* while it is berthed in the port. The USNF *Card* is carrying aircraft for use by the South Vietnamese Air Force.

MAY 12, 1964

USA, *DIPLOMACY*

Secretary of State Dean Rusk asks NATO members to give greater support to the South Vietnamese Government.

MAY 12–13, 1964

SOUTH VIETNAM, *US AID*

Secretary of Defense McNamara and General Taylor make an on-the-spot review of South Vietnam. McNamara tells Khanh that bombing the North has not been ruled out by the US.

MAY 13, 1964

CAMBODIA, *DIPLOMACY*

Prince Sihanouk calls for an urgent meeting of the UN Security Council in order to initiate a discussion about

▼ *Captain Roger Donlon surveys the wreckage of the Special Forces camp at Nam Dong following the Viet Cong attack in July 1964.*

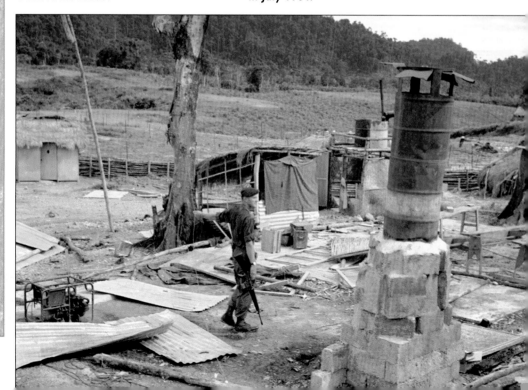

ARMED FORCES

CIDG

The Civilian Irregular Defense Group (CIDG) was the brainchild of the Central Intelligence Agency (CIA) office of the Military Assistance Advisory Group, Vietnam (MAAG-Vietnam) in late 1961. The aim was to train and arm the various hill tribes so they could defend their villages against Viet Cong attack. The CIA started the programme, but after July 1, 1963, the US Special Forces took over. The first CIDG forces were recruited from Montagnard tribesmen, with the Special Forces assuming the role of advisors. Actual command of the CIDG lay with the *Luc Luong Dac Biet* (LLDB), the South Vietnamese Special Forces (unfortunately, the South Vietnamese hated the Montagnards). Essentially, CIDG forces were local security units who were hired on a contractual basis and were exempt from the draft. In combat they came a poor second to Viet Cong and North Vietnamese units, though they were useful for patrolling and screening.

The villages were somewhat isolated, thus the US Special Forces developed the CIDG reaction Mike Force companies in all four

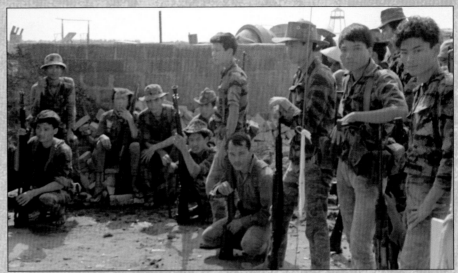

tactical zones. These units comprised more highly trained CIDG personnel led by US Special Forces personnel. The Mike Forces were expanded in 1968 and, renamed Mobile Strike Force Commands, were battalion- and brigade-sized formations capable of engaging the Viet Cong and North Vietnamese.

As part of the "Vietnamization" programme, most CIDG camp units were converted into South Vietnamese Army border ranger battalions by the end of 1970. At the height of the CIDG programme, the number of men mustered was the equivalent of four infantry divisions.

the alleged "repeated acts of aggression by the United States and South Vietnamese forces."

MAY 15, 1964

SOUTH VIETNAM, *US MARINES*
The United States Marine Advisory and Assistance Group (USMAAG), the Marine Advisory Division, is renamed the Marine Advisory Unit and made a part of the Naval Advisory Group, Military Assistance Command, Vietnam.

MAY 17, 1964

LAOS, *GROUND WAR*
Pathet Lao forces begin overrunning government forces on the Plain of Jars.

MAY 20, 1964

SOUTH VIETNAM, *US MARINES*
A US Marine Advisory Team arrives at the port of Da Nang.

MAY 21, 1964

LAOS, *AIR WAR*
The United States Air Force initiates reconnaissance flights over Laos.

MAY 22, 1964

USA, *STRATEGY*
Secretary of State Rusk spells out the choices available as a result of the conflict in Vietnam, saying that, "a third

choice would be to expand the war. This can be the result if the Communists persist in their course of aggression."

MAY 27, 1964

LAOS, *AIR WAR*
The United States announces that US Air Force T-28 aircraft have flown missions over Laos.

JUNE 6–7, 1964

LAOS, *AIR WAR*
Two United States Air Force reconnaissance planes are shot down by Pathet Lao ground fire from the Plain of Jars.

JUNE 12, 1964

FRANCE, *DIPLOMACY*
President Charles de Gaulle of France calls for an end to all foreign intervention in South Vietnam.

JUNE 19, 1964

SOUTH VIETNAM, *AIR WAR*
In a sign of growing operational capability, US Marine squadron HMM-364 turns over its helicopters and maintenance facilities to the VNAF's 217th squadron.

JUNE 23, 1964

USA, *DIPLOMACY*
President Lyndon Johnson announces the appointment of General Maxwell

Taylor as the United States Ambassador to South Vietnam, with Alexis Johnson as his Deputy Ambassador.

JULY 7, 1964

SOUTH VIETNAM, *GROUND WAR*
HMM-162 participates in the relief of the Nam Dong Special Forces camp.

JULY 27, 1964

SOUTH VIETNAM, *US AID*
General Westmoreland's headquarters in Saigon announces that several thousand additional military advisors will be sent to Vietnam. General Westmoreland wants to strengthen US advisory effort at the province level. He also sees an expansion to the district level as being crucial.

AUGUST 1964

SOUTH VIETNAM, *VIET CONG*
By August 1964 the Viet Cong, strongly supported by regular army units from North Vietnam, hold the military initiative in South Vietnam. The VC and NVA control much of the countryside, and seriously reduce the effectiveness of the Strategic Hamlet Program.

The NVA and VC appeared to be building up its strength for a final offensive against the largely demoralized armed forces and unstable government

August 2, 1964

in South Vietnam. The VC and NVA were accomplishing all of this, despite the massive infusion of US military and economic assistance, and the presence of US advisors was having a negligible effect on the ARVN's ability to deal with the insurgency.

August 2, 1964

SOUTH VIETNAM, *GULF OF TONKIN*
Late in the afternoon of August 2, about 45km (28 miles) off the North Vietnamese coastline in international waters and heading away from the coast and radar, the radar screens of the USS *Maddox* detect three boats closing in fast on the ship at high speed. Despite taking evasive action, the boats by their manoeuvre indicated hostile intent, prompting the captain of the *Maddox* to order three warning shots be fired across their bows. The boats proceeded towards the *Maddox* with the result that the ship's 5in guns opened fire on the approaching intruders. One boat was disabled but managed to launch what appeared to be two torpedoes, which missed by approximately 183m (200 yards). Another retreated to the north and lost power. The third boat, hit by at least one shot, passed across the bow of the *Maddox* and sprayed it with 12.7mm machine-gun fire. One of the bullets from the enemy machine gun struck one of *Maddox*'s ready service magazines. Aircraft from the USS *Ticonderoga*, then in the Gulf of Tonkin, joined in on the action and the *Maddox* eventually broke off contact and proceeded into the South China Sea.

August 3, 1964

USA, *INTERNATIONAL RELATIONS*
President Lyndon B. Johnson warns

North Vietnam that "United States ships have traditionally operated freely on the high seas in accordance with the rights guaranteed by international law within the set limits of territorial waters." He warns Hanoi that US ships "will take whatever steps are necessary that are appropriate for their defense." He adds that "the United States Government expects that . . . North Vietnam will be under no misapprehension as to the grave consequences which would inevitably result from any further unprovoked military action against the United States."

August 3–4, 1964

GULF OF TONKIN, *US NAVY*
The warship USS *Maddox* is joined by the USS *C. Turner Joy* and enters the Gulf of Tonkin.

August 4, 1964

GULF OF TONKIN, *US NAVY*
On the evening of August 4, the two destroyers are heading on an easterly course and shortly after dark the task group commander aboard USS *Maddox* observes on the radar screen at least five suspected contacts about 58km (36 miles) away from the US ships. These were thought to be torpedo boats. Eventually, the US ships manoeuvred 97km (60 miles) into the Gulf of Tonkin, clearly in international waters, when enemy craft appeared to be heading towards the destroyers in attack formation. In self-defence, the US ships opened fire. When the *Maddox*'s sonar detected enemy torpedoes having been fired at it and the *C. Turner Joy*, both ships took evasive action. In the confusion that occurred, the *C. Turner Joy* and *Maddox* opened fire with their 5in naval guns, sinking one, possibly two, North Vietnamese boats.

August 5, 1964

NORTH VIETNAM, *AIR WAR*
The Commander-in-Chief Pacific authorizes United States Military Assistance Command in Saigon that authority has been granted to launch limited air strikes against North Vietnamese targets. A message reaches General

◀ *General Paul Harkins (right) with his successor, General William Westmoreland.*

▲ *President Lyndon Johnson authorized an increase in the scale of American military aid to South Vietnam in 1964.*

al Westmoreland's headquarters that the strikes are to take place shortly after sunrise. At the same time that this strike is authorized by the Joint Chiefs of Staff, a series of comprehensive air and sea movements is undertaken by US forces to discourage further North Vietnamese attacks.

August 5, 1964

NORTH VIETNAM, *AIR WAR*
President Johnson announces to the public that the United States was making a measured response to the North Vietnamese attacks but did not intend to provoke a war. Sixty-four aircraft are launched from the decks of the US Navy's aircraft carriers USS *Ticonderoga* and *Constellation*. They inflict severe damage to the North Vietnamese gunboat and torpedo fleet, destroying 8 and damaging 21 others. Smoke from the Vinh petroleum storage areas rose 4267m (14,000ft) into the air. US Navy planes estimate that they have destroyed over 90 percent of the fuels stored there. The US Navy loses two jets from the USS *Constellation* due to enemy antiaircraft fire at Hon Gai, while two other jets are hit, but these are nonetheless later recovered.

USA, *STRATEGY*
After the air strikes against the Vinh storage facilities, Secretary of State Dean Rusk states that the United States made these retaliatory air strikes against North Vietnam in order to "prevent a 'miscalculation' on the part of the Communists that we would not reply in kind." President Johnson also warns the government of North Vietnam as well as the People's Republic of

China against being "tempted . . . to widen the present aggression."

AUGUST 7, 1964

USA, *POLITICS*

The United States Congress approves the Southeast Asia Resolution (Senate vote 88-2, and House of Representatives 414-0). This is the so-called "Gulf of Tonkin Resolution," which gives President Johnson the permission to take all the steps that he deems necessary in order to protect US personnel and US interests within Vietnam. General Khanh declares a state of emergency in Saigon.

NORTH VIETNAM, *AIR WAR*

Operation Rolling Thunder begins: the Air War, Phase One. Two days after the US retaliatory air strikes against North Vietnamese gunboats and fuel stores in Vinh have taken place, US aerial reconnaissance indicates that the Phuc Yen Airfield near Hanoi shows the arrival of

▼ *A South Vietnamese soldier questions a suspected Viet Cong member during an operation in 1964.*

Chinese-supplied MiG-15 and MiG-17 fighter jets. All indications therefore point to Hanoi's preparations for an imminent war with the United States.

AUGUST 11, 1964

USA, *POLITICS*

President Johnson signs the Southeast Asia (Gulf of Tonkin) Resolution into law. It is known as Public Law 88-408, and it will serve as the primary document, to be cited by Johnson and later Nixon Administration officials, that Congress gave the White House a de facto declaration of war against North Vietnam.

AUGUST 16, 1964

SOUTH VIETNAM, *POLITICS*

The Military Revolutionary Council, meeting in closed session, elects General Khanh as Vietnamese president. Khanh then ousts Duong Van Minh as chief of state and then makes him advisor to the council. Khanh also introduces a new constitution, claimed to be based on that of the United States, and denies that he has become a dictator.

AUGUST 27, 1964

SOUTH VIETNAM, *POLITICS*

The new Vietnam constitution is withdrawn; the Military Revolutionary Council disbands; Generals Khanh, Duong Van Minh and Tran Thien Khiem are named provisional leaders.

AUGUST 29, 1964

SOUTH VIETNAM, *POLITICS*

Nguyen Xuen Oanh is named acting premier of Vietnam to head a caretaker government for two months. He states General Khanh has suffered a mental and physical breakdown.

SEPTEMBER 3, 1964

SOUTH VIETNAM, *POLITICS*

General Khanh resumes the premiership. Ambassador Taylor meets with him and reports to Washington that Khanh is "rested and recovered."

SEPTEMBER 4, 1964

SOUTH VIETNAM, *AIR WAR*

A US Army helicopter crewman is killed by the Viet Cong while flying in support of an ARVN operation near

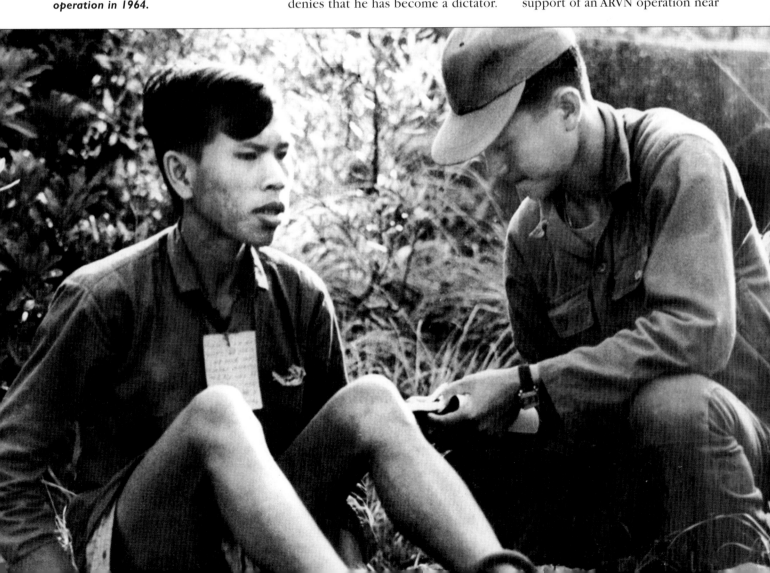

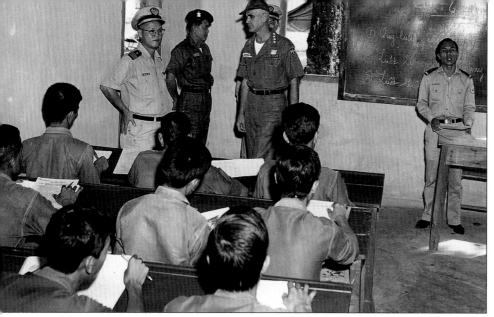

Quang Ngai Province, where the South Vietnamese Army claims that it has killed over 70 Viet Cong as a result of combat operations.

SEPTEMBER 13, 1964

SOUTH VIETNAM, *POLITICS*
A bloodless coup takes place against General Khanh conducted by Brigadier-General Lam Van Phat. However, forces loyal to General Khanh soon manage to regain control of South Vietnam's government.

SEPTEMBER 18, 1964

GULF OF TONKIN, *NAVAL WAR*
US Defense Department reports that US destroyers in the Tonkin Gulf fired on, and presumably hit, four or five hostile targets.

SEPTEMBER 19, 1964

SOUTH VIETNAM, *POLITICS*
South Vietnam's government makes sweeping changes in military command following the bloodless and abortive coup of September 13.

OCTOBER 1964

SOUTH VIETNAM, *US AID*
Throughout October, several elements of the 1300-man 5th Special Forces Group – or Green Berets – arrived in Vietnam with the mission of assisting the South Vietnamese Government. Their task at this point was to help develop the Civilian Irregular Defense Groups (CIDG) throughout the Vietnamese countryside.

OCTOBER 11, 1964

SOUTH VIETNAM, *GROUND WAR*
Three Viet Cong battalions engage South Vietnamese Army forces along Highway 1 in Tay Ninh Province and inflict heavy casualties on the government units. A week later, government troops partially compensate for this de-

▲ *General Westmoreland, MACV, on a tour of the River Defense Training Center, Saigon, in November 1964.*

feat by killing 123 of the enemy along the border between Ba Xuyen and Ban Lieu Provinces.

OCTOBER 21, 1964

SOUTH VIETNAM, *GROUND WAR*
The United States charges that Cambodian troops have crossed over into South Vietnam and seized a US military advisor.

OCTOBER 24, 1964

CAMBODIA, *AIR WAR*
A US Air Force C-123 cargo aircraft loaded with ammunition is shot down over Cambodia.

OCTOBER 25, 1964

CAMBODIA, *AIR WAR*
The United States charges that the Cambodians have fired on a US search and rescue helicopter looking for the missing US Army advisor.

OCTOBER 27, 1964

CAMBODIA, *AIR WAR*
The Cambodians admit to shooting down the US Air Force C-123 cargo aircraft. The United States admits that the plane accidentally violated Cambodian airspace due to a map-reading error.

NOVEMBER 1964

NORTH VIETNAM, *DIPLOMACY*
In early November 1964 North Vietnamese Premier Pham Van Dong visits Moscow ostensibly to celebrate the 47th anniversary of the Bolshevik Revolution. However, his primary mission was to request major material and technical support for building a major air defence system.

SOUTH VIETNAM, *GROUND WAR*
Enemy action throughout the month centres on Binh Dinh Province, where two Viet Cong and NVA regiments mount a sustained and highly effective offensive throughout that heavily populated central coastal province. In a series of attacks and ambushes, ARVN forces are either overrun, destroyed or are driven back into their fortified camps. Control of the countryside is lost and the military initiative is passed to the Viet Cong. By the end of October, most of this second largest province in South Vietnam falls under the control of the Viet Cong, and the government presence is limited to some district towns and the capital city, Qui Nhon.

NOVEMBER 1, 1964

SOUTH VIETNAM, *POLITICS*
Tran Van Huong is named as the South Vietnamese premier.

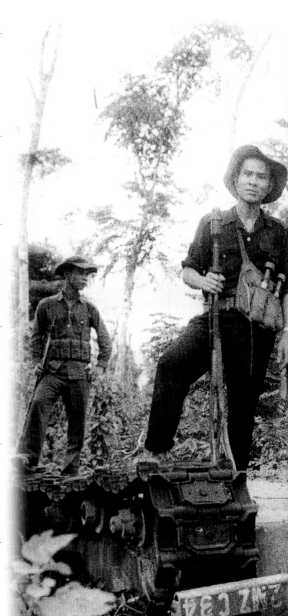

ARMED FORCES

VIET CONG

The *Viet Nam Cong San* (Vietnamese Communists) was a guerrilla force that, with the support of the North Vietnamese Army, fought against both South Vietnam (late 1950s to 1975) and the United States (early 1960s to 1973). Though beginning in the mid-1950s as a collection of various groups opposed to the government of President Diem, the Viet Cong became in 1960 the military arm of the National Liberation Front (NLF). In 1969 the NLF joined other groups in the areas of South Vietnam that were controlled by the Viet Cong to form the Provisional Revolutionary Government (PRG). The movement's principal objectives were the overthrow of the South Vietnamese Government and the reunification of Vietnam.

Early insurgent activity in South Vietnam against Diem's government was initially conducted by elements of the Hoa Hao and Cao Dai religious sects. After 1954 they were joined by former elements of the southern Viet Minh, a Communist-oriented nationalist group. Most Viet Cong were subsequently recruited in the South, but received weapons, guidance and reinforcements from North Vietnamese Army soldiers who had infiltrated into South Vietnam. During the Tet Offensive of 1968, the Viet Cong suffered devastating losses, and their ranks were later filled primarily by North Vietnamese soldiers. For the most part, the Viet Cong fought a guerrilla war of ambush, terrorism and sabotage, using small units to hold the countryside, leaving the main population centres to government authorities. Under the terms of the peace ne-

gotiations held in Paris between 1971 and 1973, the PRG gained the acknowledgment of its authority in areas under its control, pending general elections to determine the future of South Vietnam. The peace agreement broke down, and both the South Vietnamese Government and the PRG began to try to improve their military and territorial positions at each other's expense. Following the full-scale North Vietnamese invasion of South Vietnam and the rapid collapse of South Vietnamese president Nguyen Van Thieu's government in the spring of 1975, the PRG assumed power as the government of South Vietnam. In 1976, after reunification, the PRG was part of the National United Front. Real governmental power was exercised by the Vietnamese Communist Party and its North Vietnamese leadership.

NOVEMBER 3, 1964

USA, *POLITICS*

Lyndon B. Johnson is elected President of the United States in a landslide victory over Senator Barry Goldwater (Republican, Arizona).

DECEMBER 5, 1964

SOUTH VIETNAM, *ARMED FORCES*

Air Vice Marshal Nguyen Cao Ky, commanding the Vietnamese Air Force, issues an ultimatum to General Khanh to support Premier Huong or face removal. After a long debate and much political manoeuvring, the High National Council is dissolved on December 20 in another bloodless coup.

DECEMBER 20, 1964

SOUTH VIETNAM, *POLITICS*

The South Vietnamese military launches another coup and dissolves the civilian High National Council, which was a provisional legislature. The United States opposes the takeover of the military and dissolution of the civilian parliament.

DECEMBER 24, 1964

SOUTH VIETNAM, *TERRORISM*

On Christmas Eve a terrorist bomb, set off by Viet Cong sappers, explodes in the Brinks Bachelor Officer's Quarters in downtown Saigon. A second aircraft carrier is ordered to the Gulf of Tonkin

◀ *The Viet Cong were a dedicated, well trained foe who mastered the techniques of rural guerrilla warfare.*

and retaliatory air strikes are readied but not executed. US losses include 2 killed and 52 wounded, while a total of 13 Vietnamese are killed.

DECEMBER 28, 1964

SOUTH VIETNAM, *GROUND WAR*

The ARVN 21st Division in Ba Xuyen Province attacks three Viet Cong battalions, killing 87 and making the largest capture of enemy weapons to date. The Viet Cong's 9th Division with two regiments also seizes the Catholic village of Binh Gia. Over the next four days the enemy ambush and destroy the ARVN Ranger 33rd Battalion and the VNMC's 4th Marine Battalion and inflict heavy casualties on the other relieving armoured and mechanized forces. For the Viet Cong, the classic "mobile" phase of the war has begun.

For the South Vietnamese Government, it was the start of an intensive military challenge which it lacked the resources or will to meet. US intelligence had detected three regular North Vietnamese regiments leaving their bases in North Vietnam and moving south for possible commitment to the ongoing war in South Vietnam.

DECEMBER 31, 1964

SOUTH VIETNAM, *US AID*

US military strength in South Vietnam is 23,000 officers and men and women (Army, Air Force, Marines and Navy). MACV intelligence reports that North Vietnamese infiltration in 1964 stood at 12,500, a substantial increase over 1963.

1965
FROM ADVISING TO FIGHTING

After increased fighting at the end of 1964, in January 1965 Saigon remained wracked by political instability. The bulk of the Army of the Republic of Vietnam (ARVN) was tied to static security missions, protecting villages and hamlets from Viet Cong infiltration. While US military and civilian advisors trained the ARVN in the techniques of modern military operations, large-scale offensives were ineffective due to poor tactical abilities and the ARVN leadership of its field commanders. This reflected low morale and indecision stemming, Westmoreland recalled, "from the political upheavals and uncertainty in the minds of the Vietnamese regarding the future of the country." An example of this occurred in January 1965, when Tran Van Huong's government was ousted and replaced by a military government established by the Armed Forces Council.

For the United States and, more specifically, the Johnson administration, 1965 was a year of "momentous decision," and one of a major commitment of ground forces in a war that became "America's war". Concerned about the political instability and deteriorating situation of the ARVN in its war with the Viet Cong, during the first two months of 1965 the Johnson administration began to look at the serious possibility of sending American combat troops to Vietnam in order to prevent the total collapse of the South. By February 1965, it became apparent to General Westmoreland and President Johnson's advisors that only with US troops could the Viet Cong be defeated. In fact, General Westmoreland wrote in his summation of his tenure as Commanding General, United States Military Assistance Command: "It was my estimate that the Government of Vietnam could not survive this mounting enemy military and political offensive for more than six months unless the United States chose to increase its military commitment. Substantial numbers of US ground combat forces were required."

General Westmoreland and Ambassador Maxwell D. Taylor concluded, and President Johnson and Secretary of Defense McNamara concurred that in South Vietnam, the "United States was faced with a momentous and far-reaching decision." In keeping with the stated US policy of "defeating aggression so that the people of South Vietnam will be free to shape their own destiny," Westmoreland believed that this goal could not be achieved "without the deployment of US forces." Westmoreland and Ambassador Taylor shared this view. Starting with the first deployment of US Marines to guard the Da Nang Air Facility, and

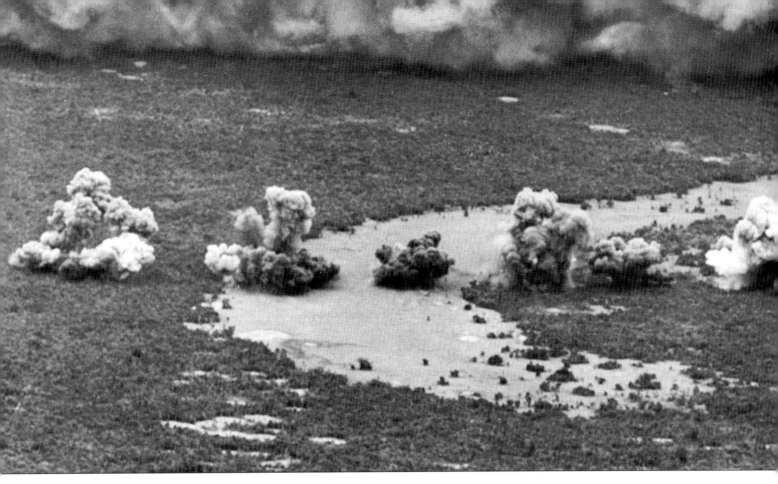

continuing on through the late spring and into the summer of 1965, substantial numbers of US Army and Marine ground forces, together with their supporting air and naval forces, began their deployment to South Vietnam and into the adjacent waters. Employed as independent "fire brigades", Westmoreland's request seemed appropriate to meet what seemed like a major enemy offensive designed to cut South Vietnam in half along a line from Pleiku in the Central Highlands to Qui Nhon on the central coast. With the initial commitment of North Vietnamese troops in these same areas, the threat was real and immediate. In order to counter the North Vietnamese Army (NVA), Westmoreland and his subordinate commanders sent the 1st Cavalry Division (Airmobile) to the Central Highlands at An Khe, which was located in a blocking position between Pleiku and Qui Nhon. Its mission was to open – and to hold open – Route 19, the major artery in this sector.

Meanwhile, the mission of the US Marines changed as they began active patrols beyond the Da Nang perimeter and to engage the Viet Cong in battle. The first major battle fought between US forces and the Viet Cong took place between the US Marines during Operation Starlite, just south of Chu Lai, during August. In this battle, the 3rd Ma-

rine Division detected and engaged the Viet Cong 2nd Regiment in the coastal lowlands of Quang Ngai Province. During the ensuing battles, the Marines pinned this force against the sea in a classic "anvil and hammer" operation, killing over 700 enemy in the two-day battle. Even as the Marines fought the Viet Cong, the 1st Cavalry Division shortly thereafter launched the first test of the air mobile concept. In the fight for the Ia Drang Valley, near the Chu Pong Massif, in a major battle the air cavalrymen defeated the veteran Viet Cong and North Vietnamese troops. As General Westmoreland would later write: "The ability of Americans to meet and defeat the best troops the enemy could put on the field of battle was once more demonstrated beyond any possible doubt, as was the validity of the Army's air mobile concept."

Even as the United States Army and Marines fought and defeated the Viet Cong and North Vietnamese, US Air Force and Navy jets pounded North Vietnamese targets in a sustained bombing campaign called Operation Rolling Thunder. US Navy and Marine fighter-bombers likewise provided close air support for US Marines and soldiers in ground actions. Flying off the decks of the US aircraft carriers in the South China Sea, or based at Da Nang, fighter-bombers supported

▲ *US firepower on show: 750lb bombs dropped by B-52 bombers explode among Viet Cong positions 29km (18 miles) north of Saigon in late 1965.*

Marines and soldiers as they cornered and defeated numerous units of the Viet Cong and NVA. US Marines likewise began an extensive pacification programme in the Vietnamese countryside, designed to protect the population from the outrages committed by the Viet Cong, who often extorted and murdered South Vietnamese officials and villagers in their terror campaign. These pacification campaigns, which were called "County Fairs", proved to be very effective, and became an important part of the Marine Corps' mission during the first two years of the war in South Vietnam.

By the time 1965 came to an end, the war in Vietnam had clearly become "America's War", with the deployment of over 148,300 combat and support troops to South Vietnam. From the Central Highlands to the coastal plains, United States soldiers and Marines battled the elusive Viet Cong and NVA, while the airmen and sailors conducted an extensive and sustained bombing campaign of North Vietnam, as well as its line of supply which ran through Laos and Cambodia and which became infamous as the Ho Chi Minh Trail.

JANUARY

▲ *US National Security Advisor McGeorge Bundy visited Saigon in early February.*

JANUARY

SOUTH VIETNAM, *GROUND WAR*
As the year opened, a major portion of South Vietnam's military force was tied down in static security missions. Most efforts at large-scale offensive operations had proven ineffective and had been abandoned. This lack of military activity reflected low morale and indecision which in large part stemmed from political upheavals and uncertainty in the minds of the South Vietnamese people regarding the future of their country.

SOUTH VIETNAM, *POLITICS*
In January, the Tran Van Huong Government was ousted and was soon replaced by a military-civilian government which was established by the Armed Forces Council. As 1965 began, both the US Departments of State and Defense remained reluctant to commit US troops to the war. They believed that stringent reprisal bombings and extensive raids against North Vietnam would constitute the best response to any form of Communist aggression against the United States.

NORTH VIETNAM, *AIR WAR*
The US Joint Chiefs of Staff drew up a list of likely targets in North Vietnam and named the proposed mission Operation Flaming Dart. President Johnson at first declined to approve these operational attacks, but he also recognized that the loss of South Vietnam would

▶ *As the war grew in intensity throughout South Vietnam, US air power became crucial to the support of ground units. These are American napalm strikes.*

result in a destructive debate within the United States that might well destroy his domestic programmes, as well as his effectiveness as president. Temporizing, he ordered his National Security Advisor, McGeorge Bundy, to travel to Saigon along with a team of military and civilian experts in order to take a hard look at the situation.

JANUARY 8

SOUTH VIETNAM, *SOUTH KOREAN AID*
The South Korean Government sends 2000 military advisors to South Vietnam in order to assist US military personnel in training the South Vietnamese Armed Forces.

JANUARY 13

LAOS, *AIR WAR*
The US Defense Department acknowledges that two US Air Force jets have been shot down over Laos by Pathet Lao forces.

JANUARY 27

SOUTH VIETNAM, *POLITICS*
Premier Huong is ousted by the South Vietnamese military. The Armed Military Council establishes General Khanh as de facto head of state.

JANUARY 28

SOUTH VIETNAM, *POLITICS*
General Khanh places a civilian, Nguyen Xuen Oanh, as premier, but General Khanh will remain the "power behind the throne".

FEBRUARY 3

SOUTH VIETNAM, *US AID*
US National Security Advisor McGeorge

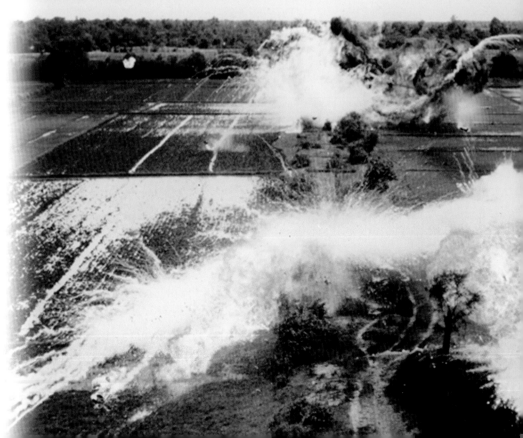

Bundy and his team of military and civilian experts arrive in Saigon. They have gone there in order to meet with South Vietnamese officials and to discuss with them a whole range of US and Vietnamese policy options, with particular regard to putting renewed pressures on the North to halt its aggression. Bundy concludes in a report to President Johnson that the situation there is, in fact, as bad as everyone had originally thought.

FEBRUARY 7

SOUTH VIETNAM, *GROUND WAR*

Viet Cong guerrillas launch attacks on a US outpost at Camp Holloway, Pleiku. In retaliation to this attack, US warplanes strike several targets in North Vietnam. USMACV orders the withdrawal of all US dependents from South Vietnam.

KEY WEAPONS

B-52 STRATOFORTRESS

The Boeing B-52F was the first Stratofortress model to participate in combat. Ten years after becoming operational, the B-52 bomber (shown at left) saw action when 27 B-52Fs from Andersen AFB, Guam, hit Viet Cong strongholds at Ben Cat, 64km (40 miles) north of Saigon on June 18, 1965. This raid was part of a campaign, known as Operation Arc Light, which used B-52F aircraft taken from the 7th and 320th Bomb Wings, and which was supported by KC-135As stationed at Kadena AFB on Okinawa. By the year's end, Arc Light had involved flying more than 1500 sorties in South Vietnam, raining tons of bombs on enemy troop concentrations, bases and supply dumps. Laotian raids were to follow in December 1965, with raids to North Vietnam added in April 1966.

While some military leaders thought highly of Arc Light, many US Air Force commanders thought using B-52s for tactical purposes diverted them from their principal mission of strategic deterrence. Others thought they were being used ineffectively, and simply blowing holes in the jungle.

The June 18 raid was not an outstanding success, and it is not at all certain that anything of military value was actually inside the target area that was bombed. The accuracy of the bombing was less than spectacular, with only about half the bombs actually landing in the target area. In addition, a general pall was cast over the entire operation. Although there were no B-52F losses in actual combat, two B-52Fs had been destroyed in a mid-air collision on their way to the target during the first mission. This accident killed eight crew members.

In spite of the poor results of the first strikes, these raids continued. Although there was initially some scepticism about the usefulness of a high-altitude radar bomb drop against guerrilla forces, nevertheless, within a few months, there was a universal acceptance of the power of the B-52 raids as a new type of artillery.

FEBRUARY 8

NORTH VIETNAM, *AIR WAR*

South Vietnamese Air Force (VNAF) jets accompany US warplanes on an air mission into North Vietnam.

NORTH VIETNAM, *INTERNATIONAL RELATIONS*

President Johnson indicates that peace depends on the Communists. The Indian Foreign Ministry requests a "Geneva" style conference to discuss the problem. Soviet Premier Alexi Kosygin announces that the Soviet Union will provide military aid if North Vietnam is invaded.

▲ *Soviet Premier Alexi Kosygin committed the USSR to the support of North Vietnam.*

FEBRUARY 10

SOUTH VIETNAM, *GROUND WAR*

The Viet Cong blows up a US military billet in the coastal South Vietnamese city of Quinhon, killing 23 US soldiers and wounding 21. President Johnson retaliates once again with air strikes. The president tells the American public: "We must clear the decks and make absolutely clear our determination to back South Vietnam in its fight to maintain its independence."

FEBRUARY 13

NORTH VIETNAM, *AIR WAR*

President Johnson authorizes the commencement of Operation Rolling Thunder, a programme of sustained and gradually increasing air attacks against North Vietnam.

The graduated nature of Rolling Thunder disturbed some within the military, particularly the air power advocates in the US Air Force. They also urged Johnson to begin an all-out campaign targeting airfields, powerplants, field-storage facilities and other strategic sites, so that North Vietnam would understand the seriousness of the message the United States was sending. President Johnson's civilian advisors disagreed with this, thinking that besides stimulating the antiwar sentiment at home and abroad, an all-out approach

FEBRUARY 15

might prompt North Vietnam's allies – notably the Soviet Union and the People's Republic of China – to take a more active hand in the war. Seeking to preserve his own operations, while giving the North Vietnamese President Ho Chi Minh every possible chance to ask for negotiations, President Johnson sided with his civilian advisors.

FEBRUARY 15

CHINA, *DIPLOMACY*
The Communist Chinese threaten to enter the war if American troops invade North Vietnam.

FEBRUARY 18

SOUTH VIETNAM, *POLITICS*
South Vietnamese Army and Marine units stage a bloodless coup against General Khanh and oust him.

FEBRUARY 19

SOUTH VIETNAM, *POLITICS*
General Khanh regains temporary control of the government in South Vietnam.
SOUTH VIETNAM, *AIR WAR*
After the US Air Force gains all the necessary clearances and permissions from South Vietnamese officials, 24 B-57 Canberra bombers attack enemy targets which are situated in South Vietnam. This strike constitutes the first such attack to be carried out on South Vietnamese soil.

▲ *General Khanh, the South Vietnam leader who was ousted by a February coup.*

FEBRUARY 20

SOUTH VIETNAM, *POLITICS*
The South Vietnamese Armed Forces Council demands the resignation of General Khanh.

FEBRUARY 21

SOUTH VIETNAM, *POLITICS*
General Khanh finally bows to the pressure of the South Vietnamese Armed Forces Council, and agrees to submit to its members' demands. After tendering his resignation, he is made the South Vietnamese representative to the United Nations. The council appoints Phan Huy Quat premier.

FEBRUARY 24

SOUTH VIETNAM, *GROUND WAR*
A company of South Vietnamese Rangers and a company of Civilian Irregular Defense Group soldiers, along with a US Army Special Forces A-Team, become entrapped in an enemy ambush near the Mang Yang Pass on Route 19 between An Khe and Pleiku. This is the same area in which the Viet Minh had destroyed the French Group Mobile 100 in 1954.

In this case, General Westmoreland exercises the emergency authority which was granted to him by President Johnson in January for the employment of US jet aircraft to avoid defeat. Twenty-four F-100 Super Sabres, with B-57 Canberra bombers and helicopter gunships, attack the ambush site, while US Army troop-carrying helicopters manage to extract the beleaguered South Vietnamese force without the loss of single man. However, the Viet Cong lose 150 men killed in action.

Thereafter, under procedures which are developed by the 2nd Air Division, then commanded by Major-General Joseph Moore, the use of US jet fighters in order to support the South Vietnamese Army when heavily engaged would become standard practice.

FEBRUARY 25

NORTH VIETNAM, *DIPLOMACY*
Hanoi announces that it will consider negotiations if the United States Government agrees to remove its troops from South Vietnam.
SOUTH VIETNAM, *SOUTH KOREAN AID*
A 600-man Republic of Korea engineer unit arrives in South Vietnam as part of the Free World military effort to assist the South Vietnamese. This unit, with its own security force attached, is known as the Korean "Dove Force", and will, in future, engage in civic action projects of an engineering nature – such as road and bridge repair – as well as various construction tasks.

FEBRUARY 26

SOUTH VIETNAM, *US AID*
President Johnson approves General William C. Westmoreland's request for a US Marine battalion to guard the Da Nang Air Base. At this point, President Johnson stresses that these troops are to have a "limited" defensive role, and few officials see the troops' deployment as the commencement of an American-controlled and dominated ground war.

KEY WEAPONS

F-105 THUNDERCHIEF

Over 20,000 combat missions were flown by Thunderchiefs, nicknamed the "Thud", in Vietnam. A total of over 350 Thunderchiefs (Ds and Fs) were lost in combat, most of them to North Vietnamese antiaircraft artillery (AAA). This was over half of all Thunderchiefs built. Some 126 F-105s were lost in 1966 alone, 103 of them to AAA. At one point between 1965 and 1968, it was calculated that an F-105 pilot stood only a 75 percent chance of surviving 100 missions over North Vietnam. Although the total number of losses was rather high, the actual loss rate was not that bad considering the total number of missions that were flown.

The Thunderchief made an excellent tactical bomber. The internal bomb bay had originally been designed with nuclear weapons in mind, but for operations in Southeast Asia the F-105D's internal bay rarely carried any ordnance, but was fitted with a 365-gallon auxiliary fuel tank. With the exception of the ammunition for the

M61A1 cannon, all the ordnance was carried externally. With multiple ejector racks, the F-105D could carry an impressive load of external fuel, as well as up to eight 750lb bombs on long-range missions. On short-range missions, it could carry 16 750lb bombs. Alternative combat loads were two 3000lb bombs or three drop tanks.

On a typical mission over North Vietnam, the F-105D would carry six 750lb bombs or five 1000lb bombs, along with two 450-gallon drop tanks. It could also carry the Martin AGM-12 Bullpup air-to-surface missile. It could carry 70mm rocket pods, napalm canisters, as well as four AIM-9 Sidewinder infrared homing air-to-air missiles. The M61A1 Gatling 20mm cannon proved invaluable in the dual role of air-to-air combat and ground strafing. With its size and range, the F-105D could carry twice the bomb load, and farther and faster, of the F-100. All in all, the Thunderchief provided excellent service during the Vietnam War.

FEBRUARY 28

USA & SOUTH VIETNAM, *INTERNATIONAL RELATIONS*

Both United States and South Vietnamese leaders declare that President Lyndon B. Johnson has decided to open continuous limited air strikes against North Vietnam in order to bring about a negotiated settlement.

MARCH 1

SOUTH VIETNAM, *INTERNATIONAL RELATIONS*

South Vietnamese President Phan Huy Quat rules out any peace settlement unless North Vietnam agrees to end its infiltration of troops and supplies to the Viet Cong in South Vietnam.

SOUTH VIETNAM, *US AID*

The US Secretary of Defense, Robert S. McNamara, sets a new tone to policy deliberations in a memorandum to Secretary of the Army, Stephen Giles, that, "I want it clearly understood that there are unlimited appropriations available for the financing of aid to Vietnam." McNamara stresses that "under no circumstances is a lack of money to stand in the way of aid to that Nation." Also, President Johnson dispatches the Army Chief of Staff General Harold K. Johnson to Saigon to evaluate the war and the American effort to determine what might shift the balance in South Vietnam's favour.

MARCH 5–12

SOUTH VIETNAM, *US AID*

General Johnson arrives in South Vietnam and spends seven days conferring with Ambassador Taylor, General Westmoreland and various members of their respective staffs. Early on, when speaking to senior American military officers in Saigon, he tells those below the

▲ *Phan Huy Quat linked a peace settlement with the cessation of Northern aid.*

rank of general to leave the room and then informs those who remain that he comes not as the Army Chief of Staff but as a representative of President Johnson with a "blank check", and asks them: "What do you need to win the war?" General Johnson then discusses a wide range of military options: how much they would cost, and also what personnel or equipment might be required. Consideration is also given to General Westmoreland's planned invasion of southern Laos in order to cut

▼ *North Vietnamese leader Ho Chi Minh surrounded by young recruits to the North Vietnamese Army (below). At left is a Viet Cong flag captured by the South's forces.*

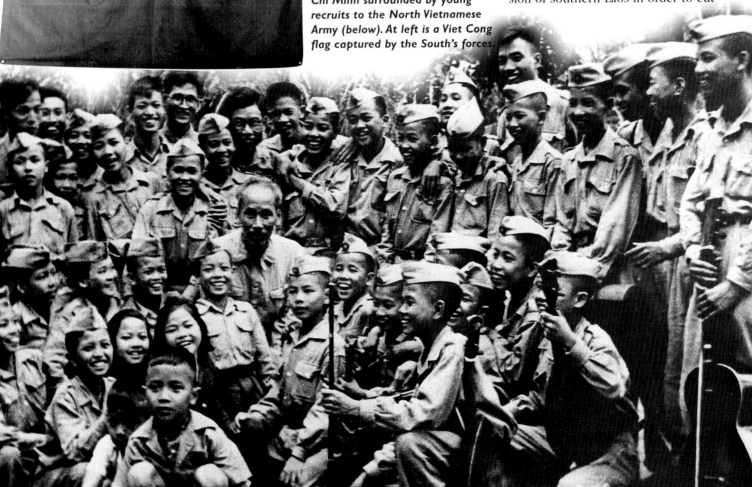

the Ho Chi Minh Trail and stop infiltration from the North. Also, General Johnson holds out the possibility that for this invasion an airmobile division might be available.

MARCH 6

SOUTH VIETNAM, *US AID*
The first major commitment of US ground troops occurs as two battalions of US Marines land at Da Nang in order to guard the US air facility which is based there. The Pentagon announces that the Marines are being landed at the request of the South Vietnamese Government.

MARCH 7

SOUTH VIETNAM, *US AID*
US Secretary of State Dean Rusk tells a national television and radio audience that the "Marines would shoot back if shot at", and that the mission of the Marines is to tighten the security belt around Da Nang and to free the ARVN to go after the Viet Cong. Two batteries of the 1st Light Antiaircraft Missile Battalion (LAAM) fly into Da Nang in order set up an air defence of the perimeter there.

MARCH 8

UNITED NATIONS, *DIPLOMACY*
Secretary General of the United Nations U Thant proposes the US, USSR, Great Britain, France, Communist China and North and South Vietnam participate in a preliminary conference in order to find a settlement to the war in Vietnam.

▲ *The first major commitment of US ground forces in Vietnam: Marines land at Da Nang to guard the US air facility there. The landings (below) were uneventful.*

▲ *Vietnamese troops board helicopters of Marine Helicopter Squadron Medium 163 at Tam Ky for a strike against the Viet Cong in March 1965.*

SOUTH VIETNAM, *US AID*
The 9th Marine Expeditionary Brigade (MEB) arrives off the coast of Da Nang from bases in Okinawa and lands that same morning. The US Joint Chiefs of Staff, in a statement issued from the Pentagon, make it very clear that this is in order to assist South Vietnam, and that "US Marine Forces will not, repeat, not engage in day-to-day actions against the Viet Cong." General Westmoreland gives the 9th MEB the responsibility of protecting the vital Da Nang Air Base from enemy attack, but he also reiterates that the overall responsibility for the defence of the Da Nang area remains a RVNAF (Republic of Vietnam Air Force) concern. The landing of the 9th Marine Expeditionary Brigade now brings the total US Marine strength at Da Nang to 5000.

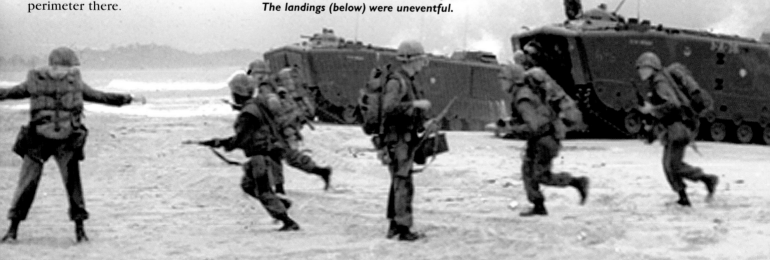

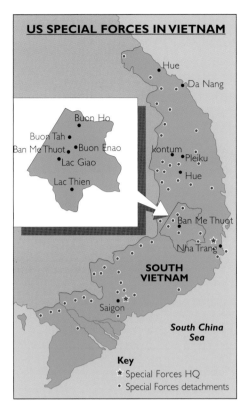

US SPECIAL FORCES IN VIETNAM

Hue
Da Nang
Buon Ho
Buon Tah
Ban Me Thuot • Buon Enao
Lac Giao
Lac Thien
kontum
Pleiku
Hue
Ban Me Thuot
Nha Trang

SOUTH VIETNAM

Saigon

South China Sea

Key
★ Special Forces HQ
• Special Forces detachments

▲ By 1965, the US Special Forces were established throughout South Vietnam. Their role was to train local tribesmen and prevent enemy infiltrations.

MARCH 9

USA, *DIPLOMACY*
The United States rejects U Thant's offer until North Vietnam stops its aggression against South Vietnam.

SOUTH VIETNAM, *NAVAL WAR*
General Westmoreland and Rear Admiral Roger W. Mehle, Director of the US Navy's Strike Warfare Division in the Office of the Chief of Naval Operations, arrive aboard the USS *Ranger* in order to discuss naval participation in the war with the commander of the Navy's Task Force 77, Rear-Admiral Henry L. Miller, USN. Westmoreland suggests that carri-

er aircraft operating from Yankee Station, in the South China Sea off Vietnam's coast, should conduct aerial reconnaissance of suspected enemy ammunition and supply caches in Quang Ngai Province. Once the Viet Cong were found, US aircraft could then be directed to strike the targets.

MARCH 10

SOUTH VIETNAM, *NAVAL WAR*
The Seventh Fleet receives approval to use its carrier-based air units against enemy forces in South Vietnam.

SOUTH VIETNAM, *AIR WAR*
Reflecting the change in the air war in Southeast Asia, air operations over South Vietnam are given priority over those in Laos and North Vietnam.

▲ As the US Marines consolidated their positions and fanned out into the countryside, they began to run into Viet Cong units, prompting a series of engagements.

MARCH 11

SOUTH VIETNAM, *NAVAL WAR*
The US Seventh Fleet inaugurates a joint United States–South Vietnamese Navy coastal patrol operation. This operation is soon to be given the designation Market Time. Rear Admiral Miller is instructed to dispatch two of his destroyers, USS *Higbee* (DD-806), and USS *Black* (DD-666), and proceeds to the South Vietnamese coast between Hue and Nha Trang. From this vantage point, they will be able to monitor maritime traffic.

STRATEGY & TACTICS

FREE FIRE ZONES

This was a term used early in the war by the US Department of Defense for bombing and artillery strikes against Viet Cong (VC) strongholds and personnel. South Vietnamese district and province chiefs designated specific areas Free Fire Zones, after which the locals were warned by loudspeakers, leaflets and infantry sweeps to evacuate their homes. After the area had been cleared of "friendlies", it could be shelled and bombed at will. Unfortunately, the evacuation process was less than thorough, and many of those evacuated (many forcibly) returned to their homes and were killed as VC suspects. In 1965, following public outcry in the USA, the term was changed to "specified strike zones". However, the damage had already been done.

MARCH 12

SOUTH VIETNAM, *AIR WAR*

US Marine Helicopter Squadron HMM-162, commanded by Lieutenant-Colonel Oliver W. Curtis, becomes operational and replaces HMM-163. By the end of March both HMM-163 and HMM-162 were flying in support of both the Marines at Da Nang and the ARVN. While flying in support of the ARVN, the Marines pilots flew both resupply and strike missions, with the resupply missions consuming the bulk of the missions. Strike missions airlifted ARVN forces into battle and provided fire support.

MARCH 14

SOUTH VIETNAM, *US ARMED FORCES*

Lieutenant-Colonel Bain's 1st Battalion, 3rd Marines, relieves the ARVN force guarding the perimeter around the Da Nang Air Base.

MARCH 15

NORTH VIETNAM, *AIR WAR*

US Navy jets enter Operation Rolling Thunder as the aircraft carriers USS *Hancock* and USS *Ranger* launch their squadrons for an attack on the Phu Qui ammunition depot, which is located halfway between Vinh and Than Hoa. At a United States National Security Council meeting, President Johnson relaxes some of the restrictions of "Rolling Thunder" so that it becomes militarily more effective.

This reflected a key shift in US strategic policy towards the war in Southeast Asia. It was no longer necessary that each air strike be a joint US-South Vietnamese air strike; that under no circumstances were actions to be taken that might result in air-to-air combat with North Vietnamese MiG fighters; that air operations were restricted below the 20th Parallel; or that Washington had final approval for alternate targets as local situation demanded it.

MARCH 20

USA, *STRATEGY*

General Harold K. Johnson submits his report to President Johnson on his findings while in Saigon. In his *Report on the Survey of the Military Situation in Vietnam,* Johnson concurs with General Westmoreland's and the Joint Chiefs of Staff's estimates that additional US Marines should be sent to Vietnam and a US Army division to the Central Highlands, as well as the sending of a South Korean Army division, if obtainable. General Johnson likewise reports that if the US intervenes militarily, the objective should be the destruction of the enemy.

MARCH 22

SOUTH VIETNAM, *US AID*

The US Department of Defense states that it has provided the South Vietnamese Army with certain types of non-lethal gases.

MARCH 23

NORTH VIETNAM, *SOVIET AID*

The Russian Communist Party Secretary Leonid Brezhnev hints at possible Russian participation in the Vietnam War on the side of the North Vietnamese.

MARCH 25

NORTH VIETNAM, *US AID*

President Lyndon Johnson proposes in a speech to North Vietnam to give it economic aid if peace is secured.

MARCH 26

USA, *STRATEGY*

General Westmoreland submits his *Commander's Estimate of the Military Situation in South Vietnam,* focusing on the need for American forces to stabilize the situation until either a planned South Vietnamese buildup is completed or Rolling Thunder persuades the North Vietnamese to halt their attacks. Westmoreland stresses that either a regular army infantry division or, preferably, the new airmobile division General Johnson had advocated in his report should either go to the region between Qui Nhon and Pleiku, or to enclaves along the coast in the same area. In addition, a separate US

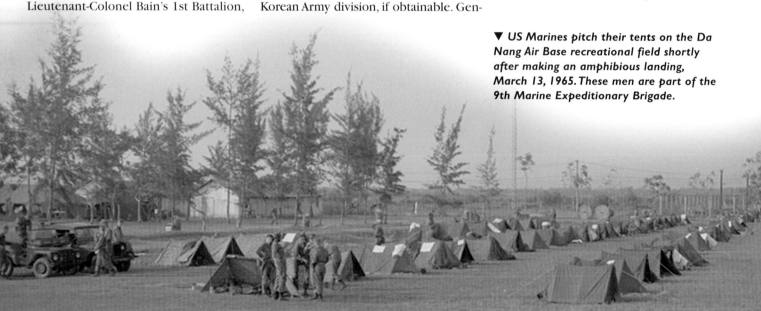

▼ US Marines pitch their tents on the Da Nang Air Base recreational field shortly after making an amphibious landing, March 13, 1965. These men are part of the 9th Marine Expeditionary Brigade.

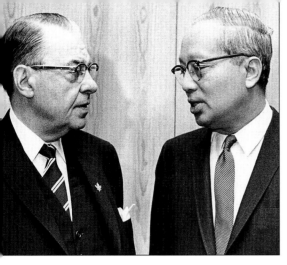

▲ *United Nations Secretary General U Thant (right) proposed a conference involving the permanent members of the Security Council to find a settlement in Vietnam.*

Army brigade is needed to conduct mobile operations in support of efforts to provide security for the local inhabitants and to secure the airfields at Bien Hoa and Vung Tau. Finally, a US Marine Battalion Landing Team (BLT) should reinforce the Marines already at Da Nang in order to secure the airfield where an army intelligence unit is stationed. Westmoreland warns that additional deployments should be considered in the middle of the year if Operation Rolling Thunder fails. Westmoreland judges the idea of blocking enemy infiltration through Laos to be impractical because it would take nine months or more to amass enough troops and equipment in order to begin the effort. In addition, he writes that the introduction of American troops into Laos would spark a heated debate in the United States as well as around the world.

MARCH 29

SOUTH VIETNAM, *TERRORISM*
Two bombs explode outside the US Embassy in Saigon, causing severe damage but no casualties.

APRIL 2

SOUTH VIETNAM, *US AID*
The United States announces its intention to send several thousand more combat troops to South Vietnam.

APRIL 7

USA, *DIPLOMACY*
President Johnson once again offers North Vietnam financial aid. In a speech at Johns Hopkins University he stresses the United States' desire to find a negotiated settlement to the Vietnam War and offers Hanoi a $1 billion US aid programme to develop the Mekong Delta region and Southeast Asia if it will cease infiltration into South Vietnam.

APRIL 8

CHINA, *DIPLOMACY*
The Communist Chinese reject President Johnson's offer to negotiate, and call it a "trick".

APRIL 11

NORTH VIETNAM, *DIPLOMACY*
North Vietnamese leaders follow Beijing's lead and denounce Johnson's offer to negotiate a peaceful settlement to the war in the South.

APRIL 14

SOUTH VIETNAM, *US STRATEGY*
General Westmoreland provides the 3rd

and 9th Marine Expeditionary Brigades with a concept of operations which he divides into four phases; (1) establishment of defensive bases, (2) deep reconnaissance patrols of the enemy's avenues of approach; (3) offensive action as a reactionary force in coordination with the ARVN; (4) in coordination with the ARVN in the I Corps Tactical Zone (ICTZ), an intensified programme of offensive operations to "fix and destroy" the Viet Cong in the general area of Da Nang.

APRIL 20

SOUTH VIETNAM, *GROUND WAR*
The US Marines begin patrols around their Tactical Area of Responsibility at Da Nang and Phu Bai as far as 9.6km (6 miles) in front of their former positions. These patrols include ARVN troops and Civil Affairs Officers in order to avoid incidents with any South Vietnamese villagers. These extended patrols result in the first firefights with the Viet Cong.

USA, *STRATEGY*
A high-level conference convenes in Honolulu, Hawaii, between Secretary of Defense, Robert S. McNamara, his assistant Secretary for International Security Affairs, John McNaughton, Ambassador Maxwell Taylor, General Earl Wheeler, Chairman of the Joint Chiefs of Staff,

KEY WEAPONS

HELICOPTERS

Helicopters were first used to transport Vietnamese troops in January 1962. They played an ever-growing role in the conflict in Southeast Asia from that time until the American withdrawal. In 1965, the first airmobile division, the 1st Cavalry Division (Airmobile), was organized and sent to Vietnam. With the arrival of the UH-1 (Huey), other turbine-powered aircraft, and two airmobile US Army divisions, helicopter warfare became the most important innovation of the conflict. The armed helicopter in the tactical role of fire support to the infantry was developed and perfected. Armed helicopters became essential for providing direct fire support to units operating outside the range of their own artillery.

The workhorse of the Vietnam War was the UH-1 Huey, which was used to transport troops and supplies and evacuate the wounded. The standard cargo helicopter of the US Army was the CH-47 Chinook, and the CH-46 Sea Knight for the US Navy and

Marine Corps. Observation helicopters, which were used to oversee ground combat operations, included the OH-13 Sioux and OH-23 Raven and, after 1969, the OH-58 Kiowa and OH-6 Cayuse.

During the early part of the war helicopter gunships comprised modified Hueys and Chinooks, but in 1968 the AH-1 Cobra entered the fray. It had a narrow silhouette to present a narrow target to the enemy, and was armed with a bow-mounted 40mm grenade launcher and minigun, plus wingpods of machine guns and rockets.

Vietnam was a helicopter war: US Army, Navy, Air Force and Marine Corps flew 3,932,000 attack (gunship) sorties, 7,547,000 assault (troop landing) sorties, 3,548,000 cargo sorties and 21,098,000 command-and-control, artillery observation, battlefield reconnaissance, search-and-rescue and other sorties. Losses were 10 helicopters over North Vietnam, 2066 over South Vietnam and 2566 lost in non-hostile air crashes. In total, 1069 helicopter pilots died in the war.

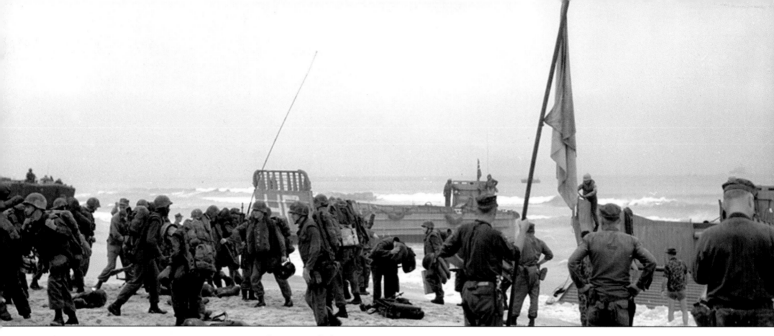

General Westmoreland and Admiral Ulysses Grant Sharp. The delegates reach a consensus that the relatively light Viet Cong activities are the proverbial "lull" before the storm and thus recommend the deployment of an additional 42,000 US troops to Vietnam, including 5000 more Marines, to meet the anticipated attack.

APRIL 22

SOUTH VIETNAM, *GROUND WAR*
A Marine patrol from Company D, 3rd Reconnaissance Battalion, accompanied by 38 ARVN troops, encounters a 105-man Viet Cong force near the village of Binh Thai, situated 14km (9 miles) southwest of Da Nang.

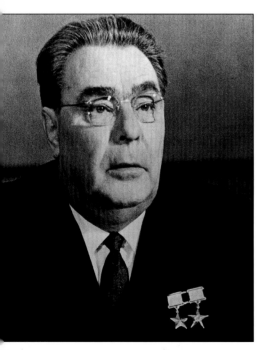

▲ *Soviet leader Leonid Brezhnev hinted at Russian participation in Vietnam.*

APRIL 24

SOUTH VIETNAM, *GROUND WAR*
An undetermined-sized force of Viet Cong attacks a Marine Reconnaissance platoon on a hilltop 2000m (6565ft) high near Phu Bai. The Marines kill two Viet Cong, though they suffer two dead themselves in the firefight.

APRIL 25

SOUTH VIETNAM, *US AID*
President Johnson approves the recommendation of the Honolulu Conference to land additional Marines at Chu Lai for the construction of an airfield there and the establishment of a third US Marine enclave in Vietnam.

MAY 3

CAMBODIA, *DIPLOMACY*
Cambodia breaks diplomatic relations with the United States.

MAY 4

SOUTH VIETNAM, *US AID*
President Johnson requests a further $700 million US in supplemental appropriations for the Department of Defense for the war effort in South Vietnam from Congress.

SOUTH VIETNAM, *GROUND WAR*
In accordance with the new guidelines from Washington authorizing offensive combat operations, the Marines begin to place increasing pressure on the Viet Cong, starting in the village of Le My in Quang Nam Province, 13km (8 miles) northwest of Da Nang, by conducting repeated patrols throughout the area.

MAY 5

SOUTH VIETNAM, *US AID*
SEATO condemns the Communist aggression in South Vietnam. The US Joint Chiefs of Staff relay the approval of the

▲ *More US Marines pour ashore at Da Nang, April 12, 1965. The lack of Viet Cong opposition on the beach meant there were no Marine casualties.*

president for the deployment to Da Nang of a Marine "force/division/wing headquarters to include the 3rd Marine Division and the 1st Marine Aircraft Wing [1st MAW]."

MAY 5–7

SOUTH VIETNAM, *US AID*
The bulk of the US Army's 173rd Airborne Brigade of the 101st Airborne Division arrives at the Bien Hoa Air Base aboard 153 C-130 Hercules transport aircraft and 11 C-124 Globemaster aircraft. The brigade is commanded by Brigadier-General Ellis W. Williamson, US Army.

MAY 6

SOUTH VIETNAM, *US AID*
The United States Senate passes the $700 million US appropriation supplement requested by President Johnson for the war effort in South Vietnam. Two additional US Marine battalions are sent to Vietnam. This is the first deployment of troops to be used specifically in combat operations.

MAY 7

SOUTH VIETNAM, *US FORCES*
The III Marine Expeditionary Force becomes the III Marine Amphibious Force following General Westmoreland's recommendation to the Joint Chiefs that the word "expeditionary" had unpleasant connotations for the Vietnamese, stemming from the days of the French Expeditionary Corps. General Wallace M. Greene, the Commandant of the US Marine Corps, substitutes the

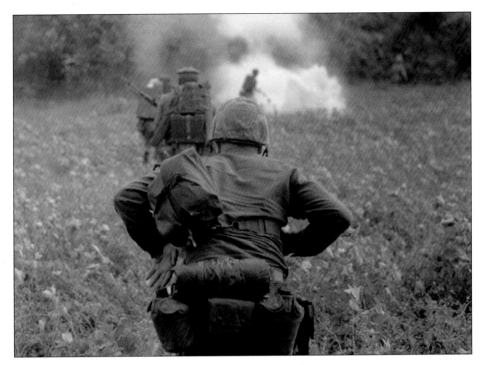

"Seabees" and Marine engineers lay the first strips of the temporary all-metal airfield at Chu Lai. In order to assist better take-offs for its jet fighters, the US Marines build an arresting gear for landing.

MAY 19

NORTH VIETNAM, *AIR WAR*
The United States resumes air attacks on North Vietnamese targets.

MAY 25

NORTH VIETNAM, *SOVIET AID*
The Soviet Union announces that it will construct antiaircraft missile sites in and around Hanoi, the capital of North Vietnam, for SA-2 missiles.

MAY 26–27

SOUTH VIETNAM, *GROUND WAR*
Soldiers from the 173rd Airborne Brigade stationed at Vung Tau conduct

word "expeditionary" with that of "amphibious." This was extended to the Marine Amphibious Brigades.

MAY 12

CHINA, *STRATEGY*
The Chief of Staff of the Chinese People's Liberation Army (PLA) calls for the preparation for atomic war. President Johnson declares that Beijing is preventing Hanoi from agreeing to talk.
SOUTH VIETNAM, *GROUND WAR*
Soldiers of the US Army's 173rd Airborne Brigade conduct combat operations near the Bien Hoa Air Base. The soldiers encounter no enemy contact.

MAY 13

NORTH VIETNAM, *AIR WAR*
The United States temporarily suspends bombing missions over North Vietnam.

▼ US Marines board a helicopter prior to airlifting to Hill 327 near Da Nang in April.

MAY 15

SOUTH VIETNAM, *GROUND WAR*
The 173rd Airborne Brigade carries out its first combat air assaults aboard 18 UH-1s flying in two airlifts. Two companies of the 2nd Battalion of the 503rd Infantry Regiment are lifted to landing zones northeast of the Bien Hoa Air Base, its base camp. The paratroopers of the 173rd Airborne Brigade work their way back to pre-selected target areas before being picked up by their helicopters.

MAY 16

SOUTH VIETNAM, *US BASES*
Under the direction of the sailors belonging to the Naval Construction Battalion NMCB-10, the

MAY 31

▶ *The US Marines brought their artillery, such as this M109 self-propelled howitzer.*

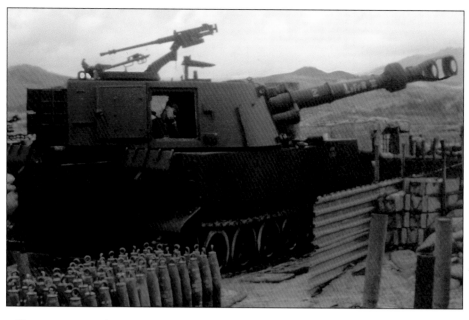

a large-scale operation when intelligence reports confirm the presence of the enemy. Elements of the 3rd Battalion, 319th Artillery, provide fire support for the paratroopers. For two days US paratroopers of the 1st Battalion, 503rd Infantry Regiment, engage the Viet Cong in a series of pitched battles. The Viet Cong break off their contact with the Americans after suffering seven dead or wounded. The soldiers of the 173rd Airborne suffer eight wounded in action, none of which are fatal.

MAY 31

SOUTH VIETNAM, *US BASES*
The "Seabees" of NMCB-10 complete nearly 1219m (4000ft) of runway and about 350m (1000ft) of taxiway at Chu Lai. The airstrip is now ready for US Marine combat aircraft use.

JUNE 1

SOUTH VIETNAM, *SOCIAL POLICIES*
US Marine pacification efforts consist largely of an embryonic civic action programme, which began a few months earlier as an offshoot of the former Marine task element's people-to-people programme, as well as a medical assistance programme.

JUNE 7

SOUTH VIETNAM, *US AID*
The US Defense Department releases figures that disclose the number of US

military personnel in South Vietnam. The number shows 50,000 US servicemen and women in South Vietnam, comprising: Army, 21,500; Marines 16,500; Air Force 9500; and US Navy 3500. III Marine Amphibious Force publishes an order which establishes the Marine Corps' civic action policy in South Vietnam.

JUNE 8

SOUTH VIETNAM, *US AID*
A United States State Department spokesman announces that General Westmoreland's command in South Vietnam has been authorized to send American troops into combat alongside

South Vietnamese forces if "combat support" is requested by South Vietnam.

JUNE 10

SOUTH VIETNAM, *US AID*
In the western sector of the Da Nang Tactical Area of Responsibility (TAOR), a Ma-

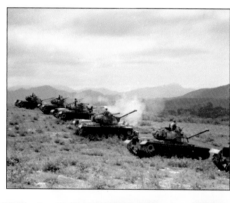

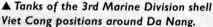
▲ *Tanks of the 3rd Marine Division shell Viet Cong positions around Da Nang.*

◀ *US Marines on a search and destroy operation against the Viet Cong in June.*

begin search and destroy operations in the general area of the Marines' enclaves, provided that these operations contribute to the defence of the base. The MACV commander further directs that the Marines at Chu Lai go on to conduct operations to the west of the tactical area of responsibility and into the suspected area of Do Xa.

With this new authority, General Walt, along with the concurrence of ARVN General Thi, the Commander of I Corps Tactical Zone, enlarges the TAORs of all three Marine enclaves. This enlargement gives the units of the US Marine divisions more room in order to conduct offensive operations, as well as providing distinguishable lines of demarcation on the ground, since the boundaries of the TAORs follow natural terrain features.

rine company patrol from the 3rd Marine Division discovers a Viet Cong camp which is capable of supporting 150 people. The Marines destroy the camp.

JUNE 11

USA, *STRATEGY*

General Westmoreland tells Admiral Sharp to "prepare for the long haul" by assembling enough forces to wear the enemy down in what US Com MACV tells Sharp has become "a war of attrition."

JUNE 14

USA, *STRATEGY*

General Walt, III MAF commanding general, holds a meeting with 25 of his senior officers and reiterates III MAF's commitment to civic action programmes. General Walt's goal is to stabilize the political situation and also to build up the ARVN's control of the countryside by providing it with the respect and loyalty of its citizens through security measures.

JUNE 15

SOUTH VIETNAM, *GROUND WAR*

A significant change in the role of the US Marines takes place when General Westmoreland finally grants General Lewis Walt the permission he needs to

JUNE 18

SOUTH VIETNAM, *GROUND WAR*

US Marine Lieutenant-Colonel Clements draws up a plan for a three-company action, to be executed in conjunction with the ARVN and Popular Forces. Three days later, the Marine battalion and Vietnamese forces move through the hamlets of Pho Nam and Nam Yen and, in the process, bring out an estimated 350 villagers, who are moved into the Le My complex.

▼ *The work horse of America's air war in Vietnam: the McDonnell Douglas F-4 Phantom. These aircraft are in the service of the United States Air Force (USAF).*

June 21

June 21

SOUTH VIETNAM, GROUND WAR
During the morning hours, two reinforced US Marine squads from the 2nd Battalion, 3rd Marines, are attacked while patrolling in the Da Nang TAOR by a squad of eight Viet Cong who are carrying only small arms and grenades. One Marine is killed and three wounded in the firefight that follows. The Viet Cong lose four men killed and two captured; those captured turn out to be women.

June 22

SOUTH VIETNAM, GROUND WAR
In a brief firefight at an outpost manned by US Marines from C Company, 1st Battalion, 3rd Marines, in the southern portion of the Da Nang enclave, two Viet Cong are killed with no Marine casualties.

June 24

SOUTH VIETNAM, GROUND WAR
Elements of the 1st Battalion, 9th Marines, under operational control of the 3rd Marines and the 1st Battalion,

▼ As well as US soldiers, other nations of the Free World sent their troops to fight Communism in South Vietnam. These are Australian troops arriving in the South.

4th ARVN Regiment, conduct a combined sweep and clearing operation south of Da Nang Air Base along the Song Cau Do River. Marines from the 1st Battalion, 9th Marines, apprehend 19 suspected Viet Cong, while the soldiers from the 1st Battalion, 4th ARVN Regiment, kill two Viet Cong. There are no Marine casualties.

June 27–30

SOUTH VIETNAM, GROUND WAR
General Westmoreland directs that the 173rd Airborne Brigade join with South Vietnamese units in a combined invasion of War Zone D where a vast enemy redoubt starts near the bends of the Dong Nai River 10km (6.2 miles) north of Bien Hoa.

The plan General Williamson has devised requires his two US battalions to conduct an airmobile assault into Landing Zone North, some 25km (16 miles) north of Bien Hoa. Then, moving southwards, the force will conduct a four-day search and destroy mission in the same area. At the same time, two battalions from the South Vietnamese Airborne Brigade will move into Helicopter Landing Zone (HLZ) South, about 5km (3 miles) to the southwest of Landing Zone North, and remain in the field for about 24 hours in order to seek out enemy forces. Fire support will come

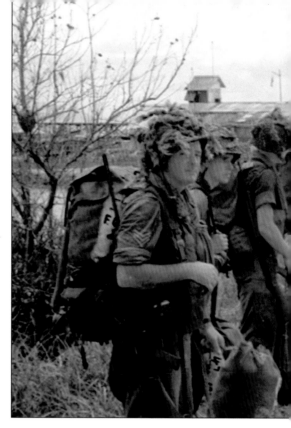

▲ Australians wait to be transported to Bien Hoa in June 1965. Canberra believed its interests would be best served by supporting American military efforts in South Vietnam.

from the 173rd's artillery, located less than 2km (1.2 miles) west of the landing zone. The command element for the operation will be covered by the 173rd's Armored Company and cavalry troops. Elements of the South Vietnamese 48th Regiment, 10th ARVN Infantry Division, will escort the artillery and command post units to their positions. Remaining at Bien Hoa, the Australian units will be a reserve force ready to move at an hour's notice.

Following artillery and air preparations, the Americans and South Vietnamese units deploy to their landing zones

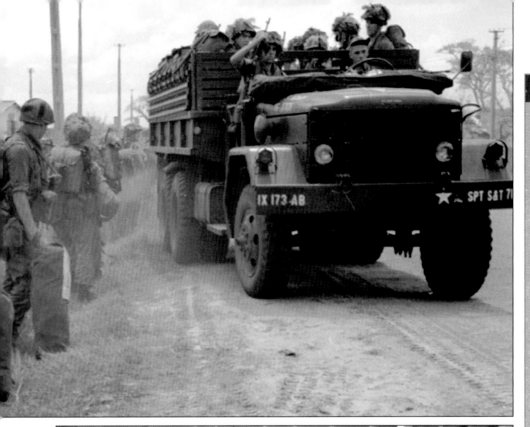

ARMED FORCES

NORTH VIETNAMESE ARMY

During the course of nearly 30 years of conflict, the North Vietnamese Army (NVA) grew from a small insurgency force into one of the world's largest armed forces. Ho Chi Minh's Communist Party established the first Armed Propaganda Team in 1944, led by Giap. In 1945 Giap's members combined with other guerrilla bands to form the Vietnam Liberation Army. Although it was capable of launching only small-scale actions, it grew during the war against the French, aided by the People's Republic of China. Now designated the People's Army of Vietnam, it formed its first infantry division in 1949. Following victory at Dien Bien Phu in 1954, the army numbered 380,000 soldiers, 120,000 being regulars.

After the division of Vietnam into North and South, the army became more professional and conventional, with officer and noncommissioned officer (NCO) training and the establishment of armour and artillery units, thanks to weapons provide by China and the USSR. Until 1965 the NVA fought a low-level guerrilla war against the army of South Vietnam, but with the commitment of US forces, it too was forced to commit more and more units, especially after the 1968 Tet Offensive, which resulted in heavy Viet Cong losses. The 1972 spring offensive in South Vietnam was conducted mainly by regular NVA divisions, and it was the NVA that defeated the army of the South and entered Saigon in 1975.

Recruits to the NVA were not fanatics, but rather highly motivated and well trained individuals They received four months of basic training before deployment to units and further training. NCOs and technical personnel received very intensive training, which resulted in an army that was well led, highly trained and closely knit. Tactics ranged from guerrilla actions to large-scale conventional warfare, depending on the conditions at hand. When fighting US units, NVA formations pressed in close to negate US artillery and air support. Above all, the NVA's military strategy was integrated with the political objectives of Hanoi; they were one and the same. In 1975 the NVA numbered 1.1 million members, including the Viet Cong in the South. In 1978 the NVA invaded Cambodia and defeated the Khmer Rouge, and in 1979 repulsed a Chinese invasion of Vietnam. By that time it was a thoroughly professional and battle-hardened formation.

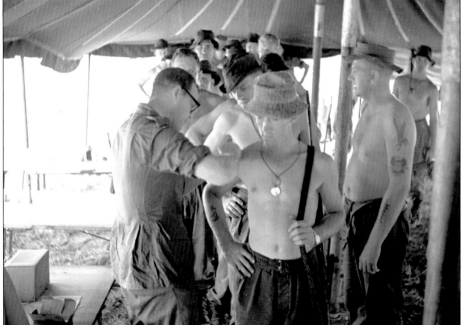

▲ *Australian troops being inoculated against smallpox at Bien Hoa Air Base at the end of June 1965.*

during the late morning and early afternoon of June 28. For the next two days they and the Australians comb their assigned areas for Viet Cong. They uncover many caches of ammunition and weapons, over 203 tonnes (200 tons) of rice and large quantities of dried milk, tea, corn, barley and tobacco. Except for scattered sniping and occasional enemy contacts, as well as a few mortar rounds being lobbed at the American and Allied troops, the enemy keeps its distance. Consequently, on the 30th, the operation ends early and the troops are able to return to their base.

Despite the fact that the operation ended with little enemy contact, it nonetheless represented a number of "firsts" in the war in Vietnam for the US forces involved. Involving over 140 UH-1s, flying several sorties each to transport the two American and two South Vietnamese battalions to their targets, the attack was not only the largest troop helicopter lift to date, but also the first major ground combat operation conducted by US forces in the

JULY 6–9

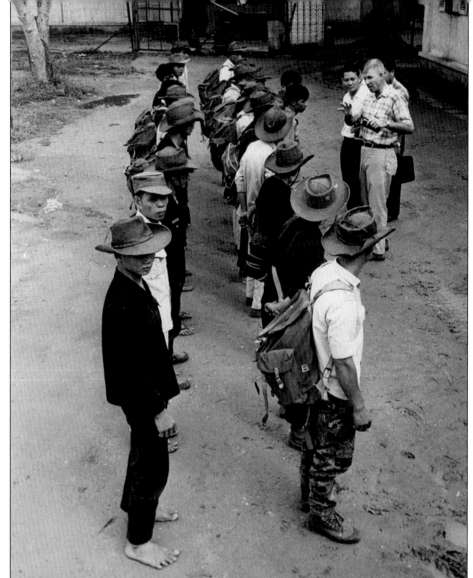

▶ *A US Field Information Officer explains to Viet Cong defectors the reasons for US involvement in Vietnam. After training, the defectors will return to contested areas to explain government policy to the locals.*

Vietnam War. As a test of cooperation conducted by US forces, it was a resounding success; as a test of combat, it proved very little. As later reported by one of the Australians who participated in the operation, a significant number of Viet Cong refused to "give battle." The first major foray into War Zone D had therefore been successful, but not contested.

JULY 6–9

SOUTH VIETNAM, *GROUND WAR*
Battalions of the 173rd Airborne Brigade re-enter War Zone D again and conduct interdiction operations. Between July 6 and 9, its battalions search for the enemy in the area that was covered only a week before. A larger than usual firefight occurs on July 7, when A Company, 1st Battalion, 503rd Infantry, walks into an L-shaped ambush. The American troops fight their way out of the ambush, killing over 50 Viet Cong troops.

JULY 8

USA, *DIPLOMACY*
President Johnson formally nominates Henry Cabot Lodge to resume his post as ambassador to South Vietnam, replacing Ambassador Taylor, who has submitted his resignation over the employment of US combat troops in Vietnam.

JULY 28

USA, *STRATEGY*
President Johnson outlines his decisions concerning the ongoing war in Vietnam. In a nationally televised press conference, he announces that US military strength will increase from 75,000 to 125,000 "almost immediately." This includes the dispatching of the 1st Cavalry Division (Airmobile), which is in the process of loading out from the Gulf Coast and Southeastern coast ports. He also states that the reserves will not be mobilized.

Instead, President Johnson announces, the draft will now be doubled and the voluntary enlistment programmes will be intensified. After the initial buildup reaches 125,000, President Johnson states, additional forces will be sent to Vietnam as required. He reiterates that these moves are necessary in order to convince

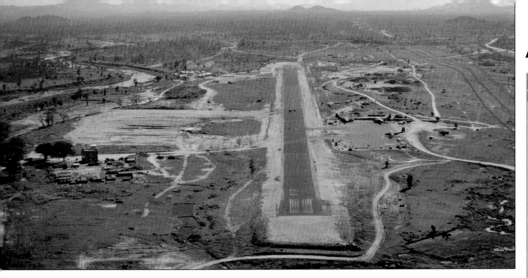

North Vietnam and the Viet Cong that the "United States cannot be defeated by force of arms," and that he intends to meet General Westmoreland's needs.

JULY 28 – AUGUST 2

SOUTH VIETNAM, *GROUND WAR*
Elements of the 173rd Airborne Brigade mount an operation designed to cut a supposed Viet Cong supply route. This route is believed to run from the Hie Rung Sat Special Zone, located in the mangrove swamps southeast of Saigon, through Phuoc Tuy Province to various sections of III Corps. The paratroopers of the brigade search the area but meet no opposition, just, as General Williamson notes, "extremely thick vegetation."

▲ *As the US became more heavily involved in the South, it built bases around the country to support military air and ground operations. This is the C-130 Hercules strip at An Khe.*

JULY 30

SOUTH VIETNAM, *US ARMED FORCES*
On an official visit to the III MAF commander Lieutenant-General Lewis W. Walt, General Westmoreland informs him that he is now to have operational control of all US ground elements in the I Corps Tactical Zone (ICTZ). Most notably, he will have operational control of the I Corps Advisory Group, in order to provide an effective bridge between all US combat forces in I Corps and the ongoing advisory effort. General Westmoreland also informs General Walt that he has a "free hand" in the conduct of combat operations in ICTZ, and that he expects the Marine general to work closely with his ARVN counterpart, General Thi, in order to undertake large-scale offensive operations at greater distances from his base area.

AUGUST 3

SOUTH VIETNAM, *US ARMED FORCES*
General Walt advises General Westmoreland by a formal message that III MAF stands ready to undertake offensive operations.

AUGUST 6

SOUTH VIETNAM, *US ARMED FORCES*
General Westmoreland, the US Com MACV, grants III MAF permission to undertake full-scale combat operations. Westmoreland likewise appoints General Walt Senior Advisor, I Corps.

◀ *A napalm strike against the Viet Cong. Anti-personnel munitions (napalm, cluster bomb units and strafing) were regarded as effective in the neutralization of personnel and military equipment.*

DECISIVE MOMENTS

STUDENTS FOR A DEMOCRATIC SOCIETY

SDS, founded in 1959, had its origins in the student branch of the League for Industrial Democracy, a social democratic educational organization. An organizational meeting was held in Ann Arbor, Mich., in 1960, and Robert Alan Haber was elected president of SDS. Initially SDS chapters throughout the nation were involved in the Civil Rights Movement. Operating under the principles of the *Port Huron Statement*, a manifesto written by Tom Hayden and Haber and issued in 1962, the organization grew slowly until the escalation of US involvement in Vietnam (1965). SDS organized a national march on Washington, D.C., in April 1965 and, from about that period, it grew increasingly militant, especially about issues relating to the war, such as the drafting of students. Tactics included the occupation of university and college administration buildings on campuses across the country. By 1969 SDS had split into several factions, the most notorious of which was the "Weathermen," or "Weather Underground," which employed terrorist tactics in its activities. Other factions turned their attention to the developing world or to the efforts of black revolutionaries. Increasing factionalism within the ranks of SDS and the winding down of the Vietnam War were but two of the reasons for the dissolution of SDS. By the mid-1970s it was defunct.

AUGUST 18–24

SOUTH VIETNAM, *GROUND WAR*
US Marines launch Operation Starlite against the 1st Viet Cong Regiment south of Chu Lai in Quang Ngai Province. It is a converging operation using a river crossing in LVTP-5s (Landing Vehicle Tanks, Personnel) from the north and a helicopter-borne assault in

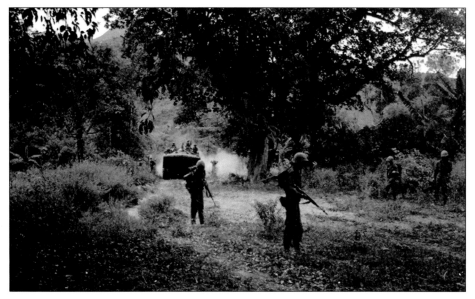

◄ *Men of the 2nd Battalion, 3rd Marine Division, conduct a search and destroy mission near the village of Pho Thuong against the Viet Cong.*

the west or inland side, and an amphibious landing with naval lift provided by Task Force-76 on the southeast beach of the Van Tuong Peninsula. By August 24, at least 964 Viet Cong have been killed, frustrating a possible enemy attack against the Marine base at Chu Lai, and also rendering the 1st Viet Cong Regiment ineffective. A more permanent result was that the Viet Cong discovered that they could not defeat the Marines in a stand-up battle. This offensive likewise forced the Viet Cong away from their

bases along the coastline, where they had previously found sanctuary from their enemies. This operation took place over six days.

SEPTEMBER 7

SOUTH VIETNAM, *GROUND WAR*
The US Marines launch a near-simultaneous operation on the heels of Starlite, called Operation Piranha. The target this time is the Batangan Peninsula, 13km (8 miles) southwest of Van Tuong, where a buildup from among the battered remnants of the 1st Viet

Cong Regiment is reported to be taking place. The Batangan Peninsula is likewise reported to be a place of entry for the seaborne infiltration of supplies for the Viet Cong forces in the area.

Operation Piranha was a coordinated operation with sizable elements of the 2nd ARVN Division and the Vietnamese Marine Corps (VNMC). The operation took longer than Starlite as the intelligence was not quite as good, nor were the results as good as for Starlite. Nevertheless, during the days Piranha took place, the Marines managed to kill over 183 Viet Cong in action; this total included 66 men found

▼ *Demonstrators against the war in Wisconsin are removed by police officers.*

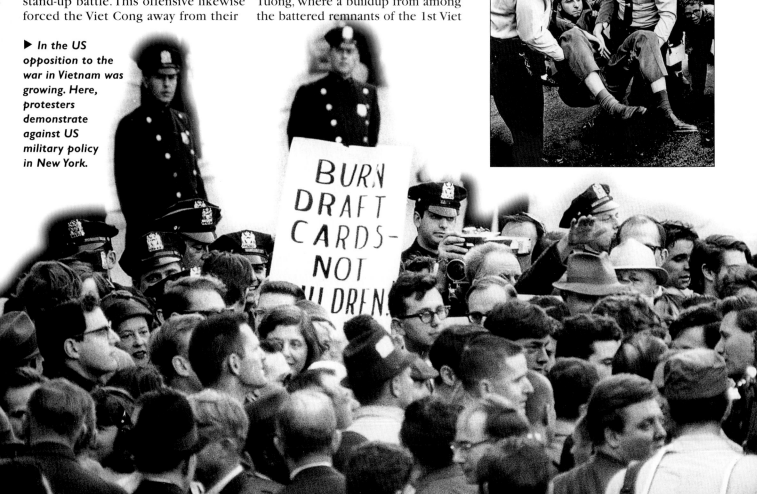

▶ *In the US opposition to the war in Vietnam was growing. Here, protesters demonstrate against US military policy in New York.*

BURN
DRAFT
CARDS-
NOT
HILDREN.

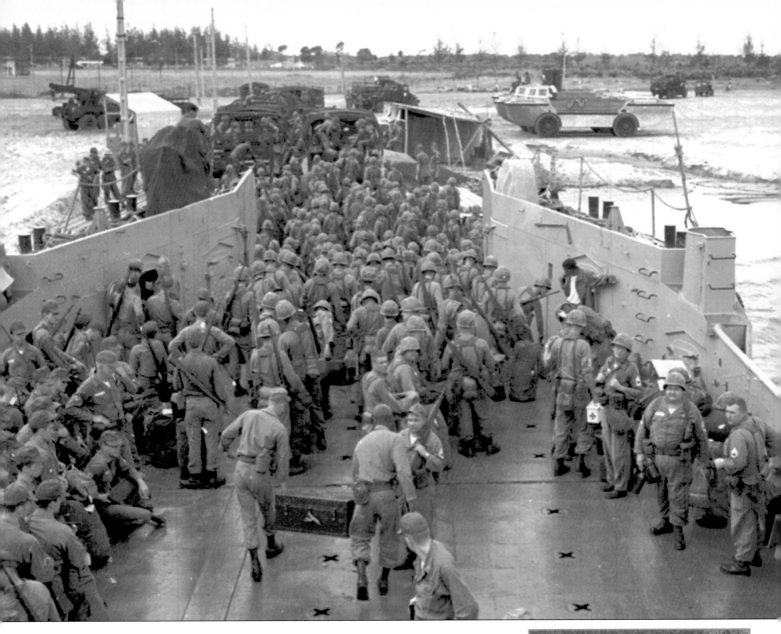

in a single cave. The South Vietnamese forces killed an additional 66 Viet Cong.

SEPTEMBER 18

SOUTH VIETNAM, *US AID*
The US Senate approves a $1.7 billion US supplementary appropriation for military operations in Vietnam.

SOUTH VIETNAM, *GROUND WAR*
A battalion from the 1st Brigade, 101st Airborne Division, begins operations in the rugged Son Con Valley, 29km (18 miles) northeast of An Khe, and runs into heavy enemy fire in a treeline around the landing zone. Four helicopters are lost and their company commanders killed. Reinforcements cannot land because of the intensity of the enemy fire. With this fight at close quarters, the Americans are unable to call in close air support, armed gunships and artillery fire except without endangering their own lives. But as the enemy presses them back, supporting artillery fire is placed on top of the

▲ *US military aid continued to pour into South Vietnam. These are signals and medical staff who are being offloaded from USN* **Breckenridge.**

enemy. By dusk the fighting subsides as the paratroopers prepare for a night attack. The Viet Cong, hard hit by about 100 air strikes and 11,000 rounds of artillery, begin to slip away. Inspection of the battlefield the next day reveals that the Americans had landed in the midst of a heavily bunkered enemy base.

The fight at Son Con Valley was significant in that it had many of the hallmarks of the highland battles that were to come. Americans had little intelligence on either the enemy or on the area of operation; the Viet Cong employed for the first time the "hugging" tactics that prevented Americans from employing either close-in air support or artillery fire without endangering themselves. The Viet Cong, for their part, underestimated the accuracy of such fires and

ARMED FORCES

MARINE CORPS COMBINED ACTION PLATOONS AND CIVIC AFFAIRS IN VIETNAM

Both General Wallace M. Greene, Jr, the Commandant of the US Marine Corps, and Lieutenant-General Lewis W. Walt, Commanding General, III Marine Amphibious Force, acknowledged that the civic actions programmes undertaken in I Corps was by far the single most important mission of US forces in Vietnam. In fact, both the Marine officers disagreed with General Westmoreland's often over-emphasized search and destroy operations that, while killing vast numbers of the enemy, failed to stop the Viet Cong and North Vietnamese from terrorizing the South Vietnamese villagers. During the summer and the fall of 1965, the Marine Corps experimented with concepts of rural pacification and development, as well as creating what they later called "Combined Action Companies" or "Combined Action Platoons." According to the Marine Corps' official history of the Vietnam War for 1966, the first so-called "Joint Action Company" was established under the command of Lieutenant Paul R. Ek, who spoke Vietnamese and was selected to lead a hand-picked platoon of Marine "volunteers." Volunteers were given not only extensive training in counterinsurgency operations but also in Vietnamese customs and traditions, history, and military and governmental organization: in effect, civic affairs. Afterwards, a squad of 10 to 12 Marines along with a US Navy corpsmen was assigned to each of the five Popular Forces platoons

formed in the villages and hamlets. These Marines, assigned to what were at first called Combined Action Companies (later changed to Combined Action Platoons), entered into the life of the village where they were assigned. In time, the Marines and corpsmen became an integral part of each village's defences. Providing the Popular Forces with weapons training and tactics, they also trained them in the use of communications, vital for calling in air or artillery support, as well as the security of people in general when they worked in the fields. The US Navy corpsman who were attached to the Marines provided medical assistance to the villagers, as well as assisting in sanitation and other projects.

The terms most associated with civic affairs included "Pacification", "Revolutionary Development" and "Nation Building". The first was defined by MACV as "the military, political, economic and social process of establishment or re-establishment of local government responsive to and involving the participation of the local inhabitants." This included the provision of sustained, credible territorial security, and the destruction of the enemy's underground government, and assertion of political control and involvement of the peoples in the governing process. Revolutionary Development, on the other hand, was provision of local security for the villages and hamlets in a particular area. Nation building was a process which "builds on the results of pacification through the establishment of a viable economic and social community."

the willingness of US commanders to call in air or artillery support when fighting at close quarters. The Viet Cong forces, pressed too hard, fled the battlefield. Pursuit was impossible.

SEPTEMBER 19

USA, *CASUALTIES*
The Defense Department reports that 561 Americans have been killed, 3024 have been wounded and 44 missing in action in Vietnam between January 1 and August 16, 1965.

OCTOBER 14

USA, *CONSCRIPTION*
The Defense Department orders a military draft call for 45,224 men for December, the largest quota of men drafted since the Korean War in 1950.

OCTOBER 15–16

USA, *PEACE MOVEMENT*
The student-run National Coordinating Committee To End the War in Vietnam sponsors a series of nationwide demonstrations against the Vietnam War on colleges and campuses and in major US cities. A number of sympathetic demonstrations are also staged in foreign cities.

OCTOBER 19

SOUTH VIETNAM, *GROUND WAR*
The North Vietnamese Army (NVA) opens its campaign against the Americans with an attack on the Plei Mei US Special Forces camp 40km (25 miles) northwest of Pleiku. The NVA attacks the camp with a regiment while holding the bulk of its division-size force in reserve. The South Vietnamese Army counters this attack with the assistance of concentrated US close air support strikes. General Westmoreland orders one brigade of the 1st Cavalry Division (Airmobile) into the area south and west of Pleiku to block any further enemy advances and to stand in readiness as a reactionary force.

OCTOBER 21

USA, *CASUALTIES*
A US Defense Department casualty report shows that the Viet Cong have suffered 25,000 killed in action while 830 US military personnel were killed in combat in South Vietnam from January to October 18, 1965.

OCTOBER 23

SOUTH VIETNAM, *GROUND WAR*
Operation Silver Bayonet. The 1st Cavalry Division (Airmobile) and ARVN units

operate in Pleiku Province. The operation includes the 3rd Brigade's Battle of the Ia Drang Valley. It results in 1771 enemy casualties, and takes place over 29 days.

SOUTH VIETNAM, *US AID*

US military strength in Vietnam reaches a total of 148,300, comprising 89,000 US Army; 8000 US Navy; 37,000 US Marines; 14,000 US Air Force; and 300 US Coast Guard.

OCTOBER 27

SOUTH VIETNAM, *GROUND WAR*

General Westmoreland directs the 1st Cavalry Division (Airmobile) to seek out and destroy the enemy force in western Pleiku Province.

SOUTH VIETNAM, *SOUTH KOREAN AID*

The Korean Capital (Tiger) Division arrives in South Vietnam and assumes the mission of providing security in the area of Qui Nhon and adjacent areas in the Binh Dinh Province. The Korean 2nd Marine Brigade (Blue Dragons) also arrives in order to undertake a similar mission at Cam Rahn Bay. Within a very short period of time both Korean units established a well-earned reputation for combat prowess.

NOVEMBER 4

SOUTH VIETNAM, *GROUND WAR*

The North Vietnamese Army (NVA) attacks a Special

Forces camp near Plei Mei. When this attack is repulsed, General Westmoreland directs the 1st Cavalry Division to launch an offensive to find and destroy enemy regiments that have been identified in the vicinity of the US Special Forces camp.

The result of this action will be the Battle of the Ia Drang Valley, named after the small river that flowed through the area of operation. For 35 days the division pursued and fought the North Vietnamese 32nd, 33rd and 66th Regiments until the enemy, suffering heavy casualties, returned to base in Cambodia. With scout platoons of the air cavalry, each battalion of the division's 1st Brigade established company-size bases from which patrols searched for enemy ground forces. For several days the scouts of the 1st Brigade failed to spot the enemy, until November 4, when they uncovered an enemy force at what appeared to be a regimental aid station several miles west of Plei Mei. Platoons of quick-reacting air cavalrymen converged on the site,

while UH-1B helicopter gunships attacked the North Vietnamese forces. Operating beyond the range of artillery support, the air cavalrymen engaged the enemy in an intense firefight. Once again the North Vietnamese troops attempted to "hug" American forces and then broke contact as soon as the US reinforcements arrived.

NOVEMBER 14–18

SOUTH VIETNAM, *GROUND WAR*

As the 1st Cavalry Division (Airmobile) begins the second stage of General Westmoreland's search and destroy mission, enemy forces begin to move out of their bases in the Chu Pong Massif, a mountain near the Cambodian border. Units of the 1st Cavalry Division advance to establish artillery or fire support bases (FSBs) and landing zones at the base of the Chu Pong Massif. Landing Zone X-Ray is one of several US positions which remain vulnerable to attack by enemy forces occupying the surrounding high ground.

Fighting begins on November 14, pitting three US Army battalions against elements

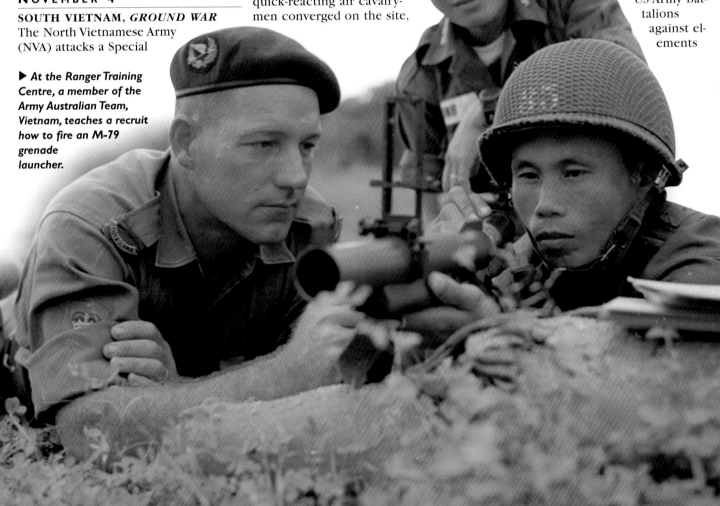

▶ At the Ranger Training Centre, a member of the Army Australian Team, Vietnam, teaches a recruit how to fire an M-79 grenade launcher.

NOVEMBER 14–18

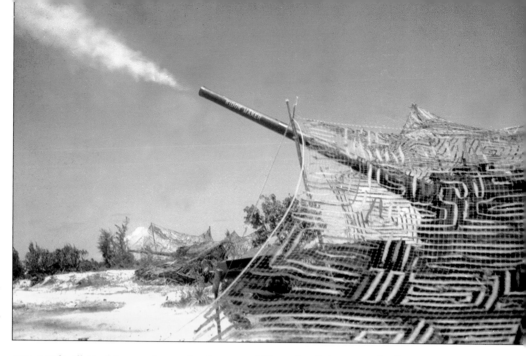

▶ *A 105mm self-propelled howitzer of the 3rd Marine Division shells Viet Cong positions. US artillery and air strikes took a heavy toll of the enemy in 1965.*

of two NVA regiments. Withstanding repeated mortar attacks and infantry assaults, the American troops use all means of firepower at their disposal, including the division's own gunships, massive artillery bombardments, hundreds of bombing and strafing attacks by tactical aircraft, and the earth-shattering "arc light" strikes by B-52 Stratofortress bombers based on Guam, and eventually turn back the determined enemy. The Communists lose an estimated 600 troops while the Americans suffer 79 killed in action. Although badly mauled, the NVA does not retreat.

Elements of the 66th North Vietnamese Regiment move east towards Plei Mei and encounter an American battalion on November 17, a few miles north of Landing Zone X-Ray. The fight that results is a stark reminder of the North Vietnamese mastery of the ambush. The Communists quickly trap three US Army infantry battalions. As the trapped units struggle to fight their way

out, nearly all semblance of organized combat disappears in confusion. Neither reinforcements nor firepower can be brought in; combat is reduced to hand-to-hand and small-unit fighting in order to avert total annihilation.

When the fighting ends, 60 percent of the Americans are casualties, with one of every three soldiers in the battalions engaged killed or wounded. Notwithstanding the many problems associated with the fighting in the Ia Drang Valley, General Westmoreland and his staff express their satisfaction with the outcome of what is heralded as the first major United States victory of the Vietnam War.

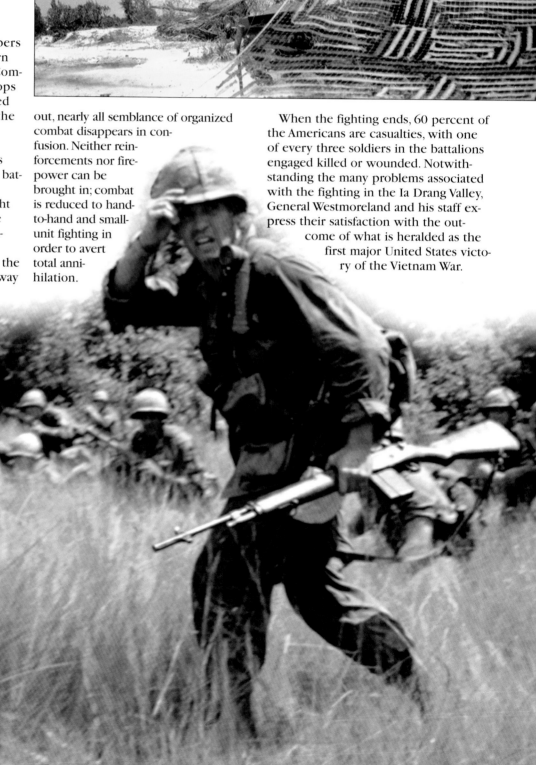

NOVEMBER 17

SOUTH VIETNAM, *GROUND WAR*
The 1st Viet Cong Regiment with all three of its battalions – the 50th, 80th and 90th – overruns the small Regional Forces garrison located at Hiep Duc, west of Tam Ky. The enemy units are identified from some captured documents and by the interrogation of an enemy defector. Hiep Duc District leaders report 174 of the 433 defenders missing and 315 weapons lost to the enemy.

Shortly after the fall of Hiep Duc, Marine F-4B Phantom jets from Marine Air Group 11 and A-4 Skyhawks from Marine Air Group 12 arrive over the outpost and conduct strikes against enemy positions in the surrounding hills. At the same time, two Marine helicopter groups (MAG-16 and MAG-36) prepare to helilift two ARVN battalions into the battle area.

NOVEMBER 19

SOUTH VIETNAM, *GROUND WAR*
By the end of November 19, South Vietnamese forces reoccupy Hiep Duc but the 1st Viet Cong Regiment still controls the terrain to the northwest of the village. Two ARVN battalions kill 141

◄ *Soldiers of the US 1st Infantry Division, the "Big Red One", under sniper fire near Bien Hoa during a search and destroy operation in late 1965.*

KEY PERSONALITY

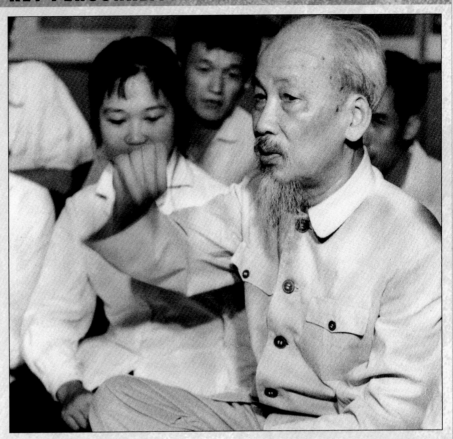

HO CHI MINH

Ho's original name was Nguyen Sinh Cung, also called Nguyen Tat Thanh, or Nguyen Ai Quoc. In 1911, under the name of Ba, he found work as a cook on a French steamer. During the six years that he spent in France (1917–23) he became an active socialist, known as Nguyen Ai Quoc ("Nguyen the Patriot") and organized a group of Vietnamese living there. After his years of militant activity in France, where he became acquainted with most of the French working-class leaders, Ho went to Moscow at the end of 1923. In December 1924, under the assumed name of Ly Thuy, he went to Canton, a Communist stronghold, where he recruited the first cadres of the Vietnamese nationalist movement, organizing them into the *Vietnam Thanh Nien Cach Menh Dong Chi Hoi* ("Vietnamese Revolutionary Youth Association"), which would become famous under the name *Thanh Nien*.

When France was defeated by Germany in 1940, Ho and his lieutenants, Vo Nguyen Giap and Pham Van Dong, plotted to use this turn of events to advance their own cause. About this time, Ho began to use the name Ho Chi Minh ("He Who Enlightens"). With Japan's defeat in 1945, commandos formed by Vo Nguyen Giap, under Ho's direction, entered Hanoi on August 19. However, on October 6, the French general Jacques Leclerc landed in Saigon, followed a few days later by a strong armoured division, and within three months had control of South Vietnam. Ho Chi Minh's strategy was to get the French to make the Chinese in the north withdraw and then to work for a treaty with France assuring recognition of independence, evacuation of Leclerc's forces, and reunification of the country.

However, the French were intransigent and the First Indochina War broke out on December 19, 1946. It ended with French defeat, Vietnam divided at the 17th Parallel, and Ho presiding over an impoverished North Vietnam, which became repressive and totalitarian. Ho deserves his place in history because of all of the twentieth-century revolutionaries, he waged the longest and most costly battle against the Western powers. He is closely linked with "national Communism", an ideology that developed in the 1960s and emphasized the role of the peasantry in the revolutionary struggle. But perhaps his greatest achievement was to create doubt and disharmony in the United States over its involvement in Vietnam. He certainly helped to humble a superpower. Ho Chi Minh died on September 2, 1969.

KEY PERSONALITY

WILLIAM WESTMORELAND

William Childs Westmoreland was born in Spartanburg County, South Carolina, on March 26, 1914; he graduated from the US Military Academy in 1936. Commander of the Strategic Army Corps and XVIII Airborne Corps from 1963 to 1964, he was then deputy commander and acting commander of the United States Military Assistance Command, Vietnam, in 1964, before ultimately becoming the commander of the United States Military Assistance Command, Vietnam, and United States Army, Vietnam, at the peak of the Vietnam War from 1964 to 1968.

Under Westmoreland's strategy, US divisions would seek out and destroy the North Vietnamese and Viet Cong formations, while air power carried the war to the North, attacking both the will of Hanoi's leaders to continue the fight and, to an increasing extent, their ability to do so. The list of targets was expanded to include transportation, oil storage and the nation's few industries. The theory behind Westmoreland's strategy of search and destroy was that it would force the Communists to expend supplies and thus make the logistics establishment in North Vietnam all the more vulnerable to bombing. He was chief of staff of the US Army from July 3, 1968, to June 30, 1972, supervising the army's disengagement from Vietnam, the transition from the draft to an all-volunteer footing, and the employment of troops in a period of active civil disturbance. He speeded up efforts to improve service life, officer professionalism, job attractiveness and public understanding of the military. He retired from active service in July 1972.

Viet Cong and capture 87 weapons while suffering 33 killed in action and 73 wounded. American military advisors working with the ARVN estimate that Marine Corps air support has accounted for an additional 300 Viet Cong killed.

NOVEMBER 27

SOUTH VIETNAM, *GROUND WAR*
The South Vietnamese Army suffers a major defeat as the ARVN 7th Regiment operating in the Michelin Rubber Plantation northwest of Saigon engages the Viet Cong's 271st Regiment in battle. While the ARVN troops inflict a major blow against the Viet Cong, heavy casualties, including the death of the regimental commander, render the force ineffective.

DECEMBER 1

SOUTH VIETNAM, *GROUND WAR*
Operation Bloodhound (later renamed Bushmaster) begins. Two US Army infantry battalions, including the 2nd Battalion of the 2nd Infantry Regiment, move to Landing Zone Dallas inside the Michelin Rubber Plantation. The site will, from now onwards, serve to function as a staging base for the two infantry battalions for its search and destroy mission and will also act as a command post for the brigade.

▶ *Keeping up the morale of the boys in Vietnam: the comedian Bob Hope and Miss USA at the Bob Hope Christmas Show at An Khe on Christmas Eve 1965.*

DECEMBER 2–5

SOUTH VIETNAM, *GROUND WAR*
Colonel William D. Brodbeck's 3rd Brigade of the 1st Infantry Division's task force searches towards the southeast of Landing Zone Dallas in a rectangle-sized area of heavy undergrowth that extends for about 13km (8 miles) west to east and 20km (12 miles) to the south. Two infantry battalions manoeuvre methodically over several days from phase line to phase line in search of the elusive enemy, but fail to find the Viet Cong.

DECEMBER 5

SOUTH VIETNAM, *GROUND WAR*
Lieutenant-Colonel George M. Shuffer's 2nd Battalion of the 2nd Infantry Regiment finally makes contact with the elusive Viet Cong. The battalion begins the day searching along a jungle road in a southerly direction. Towards midday, just north of the hamlet of Nha Mat and also about 9km (5 miles) west of Bau Bang, Lieutenant-Colonel Shuffer's lead companies come under small-arms, mortar, machine-gun and recoilless rifle fire from the surrounding trees. This encounter soon turns into a major firefight and is only resolved when artillery from the 1st Division's 8th Battalion, 6th Artillery, and the 23rd Group's 2nd Battalion, 32nd Artillery, mounting 175mm self-propelled guns, lay down heavy fire. As the Viet Cong try to "hug" the American troops by moving in close, Shuffer's troops maintain a heavy volume of fire, keeping them at a distance. Eventually, the Viet Cong break off the firefight and abandon the battlefield, leaving their dead, weapons and equipment behind them.

DECEMBER 9

SOUTH VIETNAM, *GROUND WAR*
Elements of the 60th and 80th Viet Cong Battalions attack the ARVN's 1st

Battalion, 5th Regiment, at Que Son. In the heavy fighting that follows, both the1st Battalion and its regimental command group are overrun. The regimental commander is killed and the ARVN force is scattered to the south and east. At the same time, another Viet Cong battalion attacks the 1st Battalion, 6th ARVN Regiment, to the northeast, but it manages to hold its ground.

DECEMBER 15

NORTH VIETNAM, *AIR WAR*
US Air Force aircraft bomb and destroy a North Vietnamese thermal power plant at Uongbi in the first American air raid on a major North Vietnamese industrial target.

DECEMBER 17–21

SOUTH VIETNAM, *GROUND WAR*
Operation Smash I starts when paratroopers of the 173rd Airborne Brigade

▼ *Pacifists demonstrate against the war in front of the White House on November 30, 1965. Across the United States the antiwar movement was growing in strength.*

move into position west of Highway 15. The operation began in this way in order to deter an enemy attack, which was expected near Saigon during the Christmas Holiday truce.

Lieutenant-Colonel George E. Dexter leading the 2nd Battalion of the 503rd Infantry Regiment soon finds the enemy. It is December 18 and, operating from the battalion's base – southeast of the Courtenay Plantation area about 9km (5.6 miles) west of Route 2 – the 2nd Battalion of the 503rd Infantry carries out a company sized search and destroy operation, one each to the northeast and west. Shortly after 10:30 hours that day, and about 0.5km (0.3 miles) from the base camp, the company which is operating to the northeast encounters the dug-in Viet Cong.

When the Viet Cong opens up with machine-gun and antitank fire, the company under Lieutenant-Colonel Dexter returns fire and also calls in artillery and air support. As reinforcements help the forward companies, US Air Force F-105 Thunderchiefs and F-4 Phantom jets fly 14 close air support sorties, and US artillery fires a total of 1000 rounds at the Viet Cong positions. Finally, the

Viet Cong break off the attack and leaves behind 62 of their soldiers dead, and numerous small arms and ammunition scattered over the battlefield. Lieutenant-Colonel Dexter's force counts six of its own men killed in action. Operation Smash I officially ends on December 21.

DECEMBER 18–23

SOUTH VIETNAM, *GROUND WAR*
During Smash II Lieutenant-General Jonathan O. Seaman's 2nd Brigade of the 1st Infantry Division encounters no Viet Cong forces, but the soldiers do find an enemy base camp, as well as a large quantity of ammunition; the brigade destroys it. What the effects of Operations Smash I and Smash II will have on the enemy's plans cannot be immediately determined.

Meanwhile, US commanders believe that they have prevented a probable enemy holiday offensive. More importantly, the presence of the American units at this short distance from the South's capital serves notice to the Viet Cong and NVA that the Americans are now here to stay in III Corps Tactical Zone (IIICTZ).

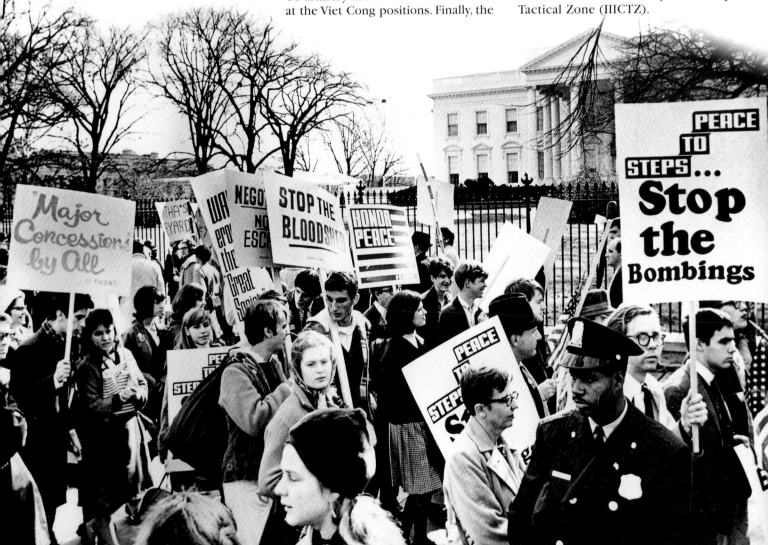

1966
A WAR IN TRANSITION

By 1966, the war in Vietnam had become "America's War". Soldiers, sailors, Marines and airmen now engaged in battle with the Viet Cong and, for the first time, elements of the North Vietnamese Army (NVA). The new year brought with it the introduction into Vietnam of the US 1st Marine Division; by mid-March 1966 two-thirds of this division worked with the 2nd ARVN Division in Quang Tin and Quang Ngai provinces. As the leathernecks prepared for combat operations, the Marine Corps' pacification programmes were in full operation to win "the hearts and minds" of the South Vietnamese peasants, sparking a debate about the merits of General Westmoreland's "search and destroy" missions versus Lieutenant-General Walt's focus on civic affairs. While III Marine Amphibious Force pursued the combined action platoon concept, US Marines, South Vietnamese Popular Forces and Civilian Irregular Defense Group (CIDG) units conducted joint patrols and operations in outlying villages and hamlets.

General Westmoreland's strategy of conducting large search and destroy missions, however, resulted in drawing both the Viet Cong and the NVA into battle. As the 1st Cavalry Division had demonstrated in the Battle of the Ia Drang Valley, as well as the 173rd Airborne Brigade's combat operations in the Central Highlands and the 1st Infantry Division's actions in III Corps Tactical Zone, once discovered, the Viet Cong and North Vietnamese could not match US firepower or manoeuvrability. As the US Army sent more units to South Vietnam, the attrition rate of inflicted casualties on the enemy increased rapidly, though it did not stop the flow of men and material from North Vietnam from entering South Vietnam via the infamous Ho Chi Minh Trail. However, the US Army proved that it still was the master of the battlefield when it cornered the Viet Cong and NVA.

As the year progressed, the US Air Force's (USAF's) Operation Rolling Thunder, the sustained bombing of North Vietnam and targets in South Vietnam and along the South Vietnamese-Laotian border, increased in tempo and intensity. USAF B-52 Stratofortress bombers, based primarily on the island of Guam, likewise increased their assistance to tactical air strikes in South Vietnam against enemy ground targets in "arc light" missions. F-105 Thunderchiefs and F-4B Phantom jets, from bases in Thailand and South Vietnam, pummelled North Vietnamese and Viet Cong positions with 250lb and 500lb bombs. US Navy jets and their Air Force and US Marine counterparts flew tactical and strategic air strikes off the aircraft carriers on "Yankee Station".

▼ *The A-1 Skyraider was an American aircraft that provided ground troops with close air support. Here, a chain hoist is being used to load up an A-1 with 500lb bombs.*

The US Navy patrolled the many rivers and waterways in southern Vietnam and along that country's long coastline with their South Vietnamese allies. Operation Market Time began to have an effect on the flow of weapons and men reaching the Viet Cong operating in the Mekong Delta. The "Seabees" of the Naval Construction Battalions undertook major civic affairs-type missions, as well as military construction projects. Navy doctors, nurses and corpsmen brought their healing skills to US Marines and soldiers, as well as ARVN and other Free World troops, and gave Allied troops possibly the best medical care ever provided to soldiers in the field. Also,

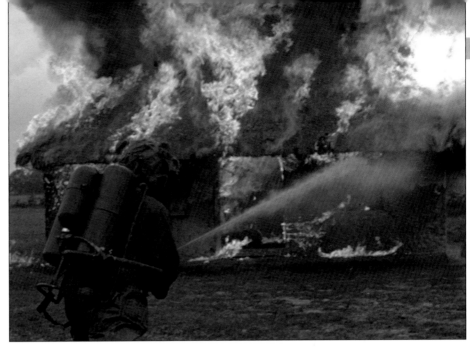

▲ *Burning out "Charlie". A US soldier equipped with a flamethrower destroys a Vietnamese hut during Operation Thayer II in December 1966.*

members of the US Coast Guard provided harbour and port defence and management, as well as patrols with their US Navy counterparts.

The year 1966 witnessed a tenfold increase in activity for the US military as it met a brave and determined enemy. By mid-1966, American troops found themselves fighting North Vietnamese Army troops equipped with the AK-47 Kalashnikov assault rifle and RP-2s (rocket-propelled grenade launchers) in ever-increasing numbers.

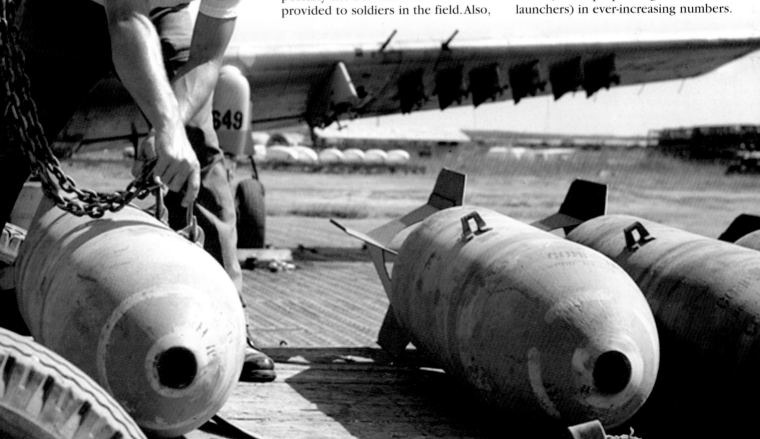

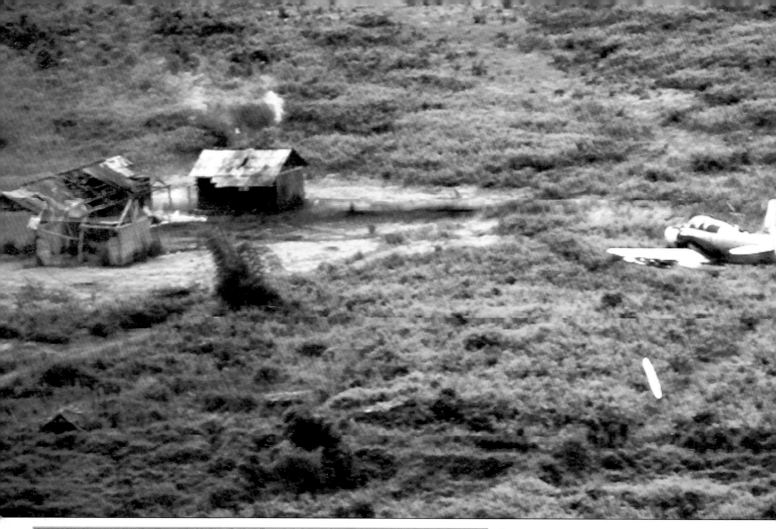

KEY PERSONALITY

LYNDON B. JOHNSON

Born on August 27, 1908, Johnson was a moderate Democrat and vigorous leader in the United States Senate. He was elected vice president in 1960 and became president in 1963 upon the assassination of President John F. Kennedy. During his administration he signed into law the Civil Rights Act (1964), the most comprehensive civil rights legislation since the Reconstruction era, and initiated major social service programmes, as well as bearing the brunt of national opposition to his vast expansion of the American involvement in the Vietnam War.

Despite his campaign pledges not to widen American military involvement in Vietnam, Johnson increased the number of American troops and expanded their mission there. As each new American escalation met with fresh enemy response, and as no end to the combat appeared in sight, the president's public support declined steeply. American casualties gradually mounted, reaching nearly 500 a week by the end of 1967. On March 31, 1968, Johnson startled television viewers with a national address that included three announcements: he had ordered major reductions in the bombing of

North Vietnam, he was requesting peace talks, and he would neither seek nor accept his party's renomination for the presidency. In January 1973, less than one week before all of the belligerents in Vietnam signed an agreement in Paris to end the war, Johnson died of a heart attack.

USA, *MILITARY STRATEGY*

During the bombing halt ordered by President Johnson, a detailed discussion took place inside the administration and Pentagon concerning the relationship of the military operations in North Vietnam to the overall strategy of the war in South Vietnam. In this discussion, Admiral Ulysses Grant Sharp, Commander-in-Chief, Pacific, recommended that plans be made to resume effective operations against North Vietnam if negotiations did not bring a ceasefire. Also, by the start of 1966 General Westmoreland, having received the promise of additional soldiers with which to attack the enemy, was now ready to take the war to the Viet Cong. Rather than change tactics, however, he planned to consolidate his hold on Saigon while pushing his units deeper into I, II and III Corps Tactical Zones. The general took a cautious approach to combat operations, due mainly to the fact that the new infantry battalions promised him would not be ready for deployment to Vietnam until the late summer of 1966. He therefore would "husband" his resources until all the means were at hand to wage the relentless campaign he had wanted. With this increas-

▲ *Death from above – an A-1E Skyraider of the 1st Air Commando Squadron releases a napalm bomb against a Viet Cong target near Ban Me Thout.*

ing role by the United States in the ongoing war in Vietnam and the buildup of American forces, Westmoreland, in conjunction with Admiral Sharp and the Joint Chiefs of Staff, upgraded several

of his component commands. Early in 1966, General Westmoreland first established the US Naval Forces, Vietnam, to direct the naval advisory effort and command the task forces that patrolled South Vietnam's coast and rivers. At the same time, Military Assistance Command, Vietnam's (MACV's) air force component, the 2nd Air Division, became the Seventh Air Force. Separated from the naval forces, Vietnam, was III Marine Amphibious Force (III MAF) which functioned, in effect, as a service component command as well as a corps-level field headquarters.

JANUARY 1–8

SOUTH VIETNAM, *GROUND WAR*
Phase II of General Westmoreland's strategy of attrition begins as Brigadier-General Williamson's 173rd Airborne Brigade, located in III Corps Tactical Zone, begins with a series of spoiling attacks and launches Operation Marauder I, an air assault on the Viet Cong's 506th Local Force Battalion operating along the Van Co Dong River in Hau Nghai Province, northwest of Saigon. General Westmoreland's orders to Brigadier-General Williamson are to "locate and destroy the enemy unit and establish a measure of control over the hostile area near the river."

JANUARY 2

SOUTH VIETNAM, *GROUND WAR*
As part of Operation Marauder I, US Army Lieutenant-Colonel Dexter's 2nd Battalion, 503rd Infantry Regiment, helicopters into Landing Zone

Whiskey near Bao Trai, and just 1km (0.6 miles) from the east bank of the Vam Co Drang River. Communist infantry open fire on the American helicopters as they touch down in the landing zone. The entire battalion lands safely and the American forces attack the enemy, who shortly thereafter pulls back from the battlefield towards the river with Lieutenant-Colonel Dexter's troops in hot pursuit. Unfortunately, Marauder I fails to provide any major engagement with the enemy.

JANUARY 2–3

USA, *DIPLOMACY*
US Ambassador to the United Nations, Arthur Goldberg, and Vice-President Hubert H. Humphrey return from their foreign tours, representing part of a concerted US campaign to achieve a ceasefire and peace in Vietnam. Their efforts are denounced by

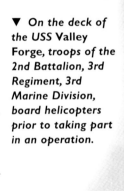

▼ *On the deck of the USS Valley Forge, troops of the 2nd Battalion, 3rd Regiment, 3rd Marine Division, board helicopters prior to taking part in an operation.*

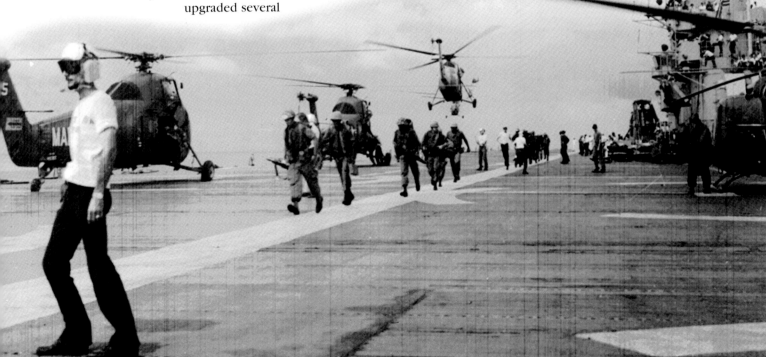

JANUARY 4

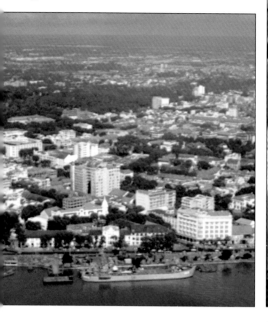

▲ *Downtown Saigon. The multi-storey buildings are hotels that were constructed as a consequence of the huge influx of Americans into South Vietnam.*

the state-controlled newspaper *Nhan Dan* in North Vietnam as "a noisy propaganda campaign."

▶ *Marshal Nguyen Cao Ky, South Vietnam's premier since mid-1965. He stated before his appointment that his hero was Nazi dictator Adolf Hitler.*

JANUARY 4

SOUTH VIETNAM, *GROUND WAR*
The Viet Cong and North Vietnamese Army attack a US Army Special Forces camp located at Khe Sanh in Quang Tri Province with Soviet-supplied and manufactured 120mm mortars. This is the heaviest weapon yet used in the Vietnam War by the enemy.

JANUARY 7–11

SOUTH VIETNAM, *GROUND WAR*
Even before Marauder I has ended, General Westmoreland launches Operation Crimp with the 173rd Airborne Brigade and other elements of the 1st Division. General Williamson's mission is to hunt down and destroy enemy units. As B-52 preparatory bomber strikes "soften" up the Ho Bo Woods, Colonel Brodbeck's 3rd Brigade command group and support elements reach Trung Lap, located on the western edge of the area of operations, by midday.

In the meantime, two of the three manoeuvre battalions deploy by helicopter to the southwest corner of the objective. One battalion blocks off the south side of the woods, while the other searches for the enemy. The third battalion moves by truck from Di An to Trang Lap and then moves on foot to the sector of the sweeping action to which it has been assigned.

By the evening of January 11, Colonel Brodbeck's

▲ *The Free World's growing commitment to the South: soldiers of the 3rd Brigade, Republic of Korea Marines, check their weapons in early February 1966.*

3rd Brigade's part in Operation Crimp is over, with a cost of 6 Americans killed in action and 45 wounded. The Americans kill 22 Viet Cong and inflict an unknown number of casualties. Operation Crimp and its successor, Operation Mastiff (February 1966), serve as frustrating reminders to the American commanders that the Viet Cong is able to avoid battle with large formations if it so desires.

JANUARY 7–12

NORTH VIETNAM, *SOVIET AID*
A Soviet mission, led by Communist Party Central Committee member Aleksander Shelepin, visits Hanoi and agrees to increased Soviet military aid to North Vietnam.

ARMED FORCES

ARVN

Trained along French and then American lines, the Army of the Republic of Vietnam (ARVN) was provided with lavish supplies of US equipment throughout the 1960s. The army was well trained, but was generally infested with corruption that seriously weakened its operational effectiveness. For example, senior positions were awarded on the basis of social position. This resulted in a force that was over 60 percent Buddhist led by a senior officer corps almost exclusively Catholic. The pay of privates was very low, which resulted in widespread looting during operations; while senior officers operated their units for their own financial benefit.

By early 1963 the Viet Cong had learned to cope with the army's weapons and tactics, becoming adept at countering helicopters and slow-flying aircraft and learning the vulnerabilities of armoured personnel carriers. In addition, their excellent intelligence, combined with the predictability of the ARVN's tactics and pattern of operations,

enabled the Viet Cong to evade or ambush government forces. US weapons did not compensate for the stifling influence of poor leadership, dubious tactics and inexperience, and so the much-publicized defeat of government forces at the Delta village of Ap Bac in January 1963 demonstrated both the Viet Cong's skill in countering the ARVN's new capabilities and the latter's inherent weaknesses. Faulty intelligence, poorly planned and executed fire support, and overcautious leadership contributed to the outcome. Ap Bac was a portent of things to come.

As the Viet Cong became even stronger and even bolder, the South Vietnamese Army became more cautious and less offensive-minded. By this point government forces were increasingly reluctant to respond to Viet Cong depredations in the countryside, and whenever they could, ARVN forces avoided night operations, instead resorting to ponderous sweeps against vague military objectives, during which they rarely made contact with their enemies.

Vietnamization was disastrous for the ARVN. It involved three overlapping phases: redeployment of American forces and the assumption of their combat role by the South Vietnamese; improvement of the ARVN's combat and support capabilities, especially firepower and mobility; and replacement of the Military Assistance Command by an American advisory group. At its height the ARVN numbered one million troops organized into three echelons: 450,000 troops of the regular army (the best), Regional Forces (akin to a National Guard), and the Civilian Irregular Defense Group. However, following the massive reductions in US military aid to South Vietnam after 1973, any major Communist offensive was bound to succeed. The ARVN suffered from morale and logistics problems, and much of its leadership was abysmal. In addition, the best troops and officers were siphoned off into élite units. Units were often squandered in poor tactics and ineffective deployments, which did nothing for morale, or winning the war.

▼ *A machine-gun team of the 2nd Platoon, E Company, 2nd Battalion, 4th US Marine Regiment, engaging the Viet Cong northwest of Chu Lai.*

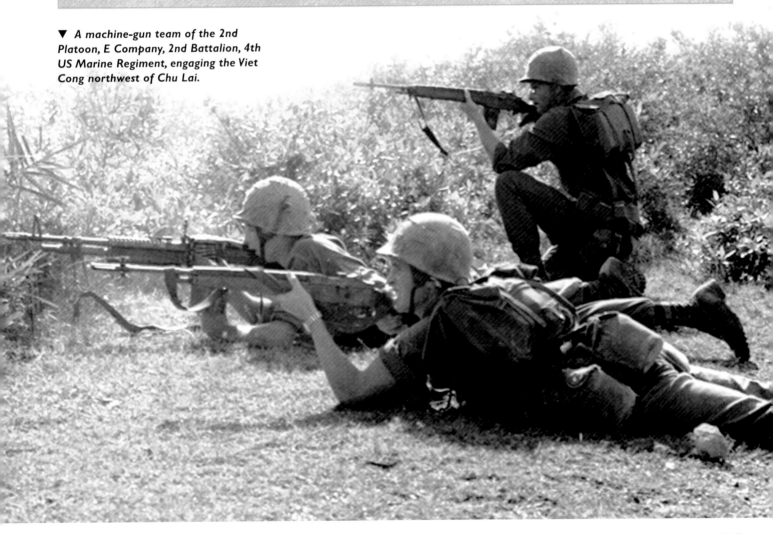

JANUARY 7

JANUARY 7

SOUTH VIETNAM, *US BASES*

General Lewis W. Walt orders the establishment of the 3rd Marine Division Reconnaissance Base at the Ba To US Special Forces Camp.

JANUARY 10

SOUTH VIETNAM, *US BASES*

Six US Air Force Sikorsky CH-3C helicopters ferry four 105mm howitzers and crews from Battery H, 3rd Battalion, 12th Marines, and two platoons of the 1st Force Reconnaissance Company from Chu Lai to the camp at Ba To.

JANUARY 12

SOUTH VIETNAM, *GROUND WAR*

Marine Captain William C. Shaver, the commanding officer of the Reconnaissance Company, deploys his first patrols from the company's new base at Ba To.

JANUARY 17–FEBRUARY 9

HAWAII, *CONFERENCES*

The Honolulu Conference convenes on January 17, while President Johnson's bombing halt remains in effect, operating on a commission appointed by President Johnson to come up with a "better military programme and a better pacification programme," as well as a better peace programme. The first conference opens with 450 civilians and military staff members from MACV, the Office of the Joint

▼ *US Marine Ontos aboard a Tank Landing Ship in the Mekong Delta during an operation to clear river banks of Viet Cong.*

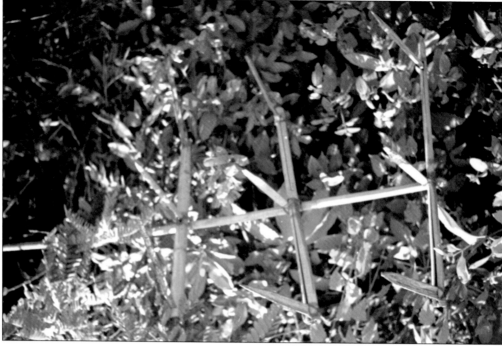

Staff, US Pacific Command, and the other commands concerned and deals with planning and troop deployments for the coming year. The second session of the conference, with President Johnson, South Vietnamese Chief of State Lieutenant-General Nguyen Van Thieu, and the nation's premier, Marshal Nguyen Cao Ky, covers general political questions. A multitude of civilian and military dignitaries also participate: National Security Advisor McGeorge Bundy, Secretary of State Dean Rusk, Secretary of Agriculture Orville L. Freeman, US Ambassador to Saigon Henry Cabot Lodge, former US Ambassador to Saigon Maxwell Taylor,

▲ *A Viet Cong booby trap. Traps were easy to construct and conceal, and had a lasting psychological effect on US troops who fought in Vietnam.*

General Earle K. Wheeler, Admiral U.G. Sharp, and General Westmoreland. The first meetings or staff meetings concern Admiral Sharp's and General Westmoreland's request for 102 battalions. During the second or political session and in the final conference communiqué, President Johnson and General Thieu, as well as Marshal Ky, mainly focus on the human dimension of the war, especially pacification and the need for political and social

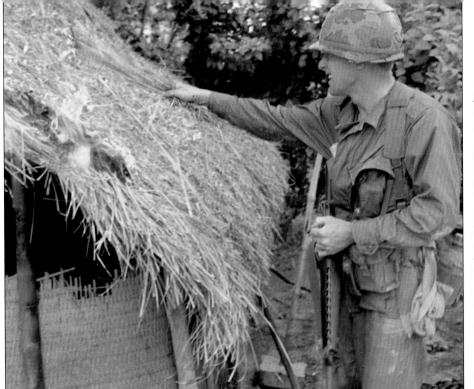

◀ *Setting fire to huts may have seemed a good way of denying the Viet Cong shelter, but such actions alienated large sections of the South's rural population.*

and North Vietnamese in order to off-set their gains in strength through recruitment and infiltration. General Westmoreland's war of attrition now becomes the first priority of US forces in Vietnam.

JANUARY 18

SOUTH VIETNAM, *US AID*
Advance elements of the US 1st Marine Division's 1st Marine Regiment arrive in South Vietnam from Camp Pendleton, CA., to the US Marine base at Chu Lai.

JANUARY 18–FEBRUARY 19

SOUTH VIETNAM, *GROUND WAR*
The US Marines' 2nd Battalion, 4th Marines, which is known as Task Force Delta, initiates Operation Double Eagle in southern Quang Ngai Province.

JANUARY 19

SOUTH VIETNAM, *GROUND WAR*
The 1st Brigade, 101st Airborne Division, along with the Korean 2nd Marine

reform in South Vietnam. They also make important divisions on strategy and troop commitments. The goals they seek include increases in the percentage of the population of Vietnam who are living in government-controlled areas, and enlargement of the proportion of road and rail networks under full gov-ernment control, as well as the pacification of selected territories. They also want General Westmoreland to inflict enough casualties on the Viet Cong

▼ *The F-100 Super Sabre had its combat debut in Vietnam, where it was used extensively as a fighter-bomber in ground-support missions.*

JANUARY 24

Brigade and the ARVN 4th Brigade, launch Operation Van Buren to locate and destroy the NVA's 95th Regiment in the Tuy Hoa Valley, and to protect the important rice harvest in the coastal region. The success of this major combined operation is measured from the 679 enemy soldiers killed, 49 captured and 177 who defect to the Americans and Koreans, as well as to the South Vietnamese.

JANUARY 24
SOUTH VIETNAM, *GROUND WAR*
Four battalions of the US Army 1st Cavalry Division begin Operation Masher near Bong Son in the coastal region of Binh Dinh Province, 85km (53 miles) north of Qui Nhon. Six battalions of ARVN airborne and six ARVN infantry battalions from the 22nd ARVN Division (Reinforced), an airmobile division, begin Operation Thang Phong II, the South Vietnamese companion operation to Masher in Binh Dinh Province. Farther north in I Corps, General Lam's

▼ *UH-1D helicopters airlifting troops of the 2nd Brigade, 25th Infantry Division, during Operation Garfield against the Viet Cong on February 17.*

▶ *A Skyraider drops a phosphorus bomb on a target in February 1966. Phosphorus is very damaging to the skin since it continues to burn upon exposure to oxygen.*

2nd ARVN Division makes preparations to launch Operation Lien Kiet 22 with the two-battalion Marine Task Force Bravo attached to his command. General Lam plans a five-battalion advance from a line of departure 13km (8 miles) south of Quang Ngai City to blocking positions in the Song Ve Valley and the coastal regions north of the US Marines' Double Eagle operation. Lien Kiet 22 was the equivalent of three divisions, and the area of operation covers more than 5180 square kilometers (2000 square miles).

JANUARY 26–MARCH 1
SOUTH VIETNAM, *GROUND WAR*
Operation Task Force Delta begins, the most ambitious amphibious operation yet undertaken. It is coordinated in unison with not only those forces in I Corps, but also with II Corps and the US Army's Field Force Victor. The target is the NVA's 325A Division, believed to be straddling the border between the provinces of Quang Ngai and Binh

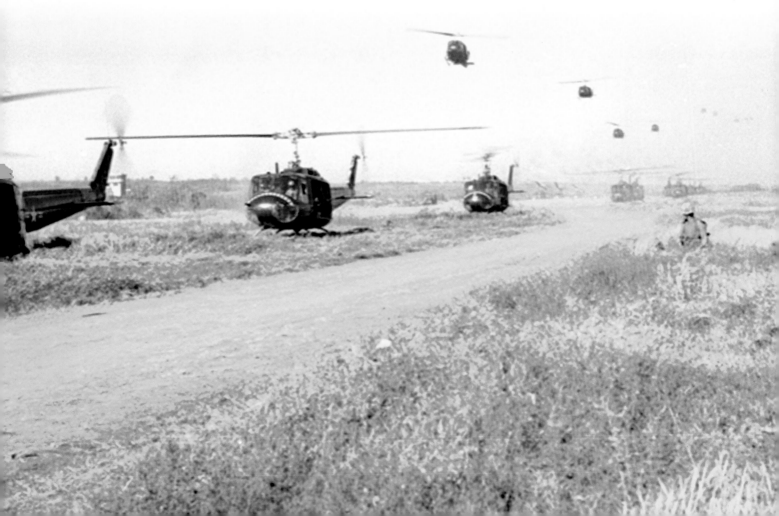

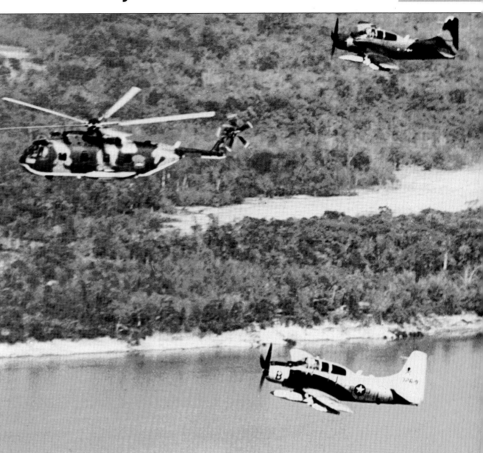

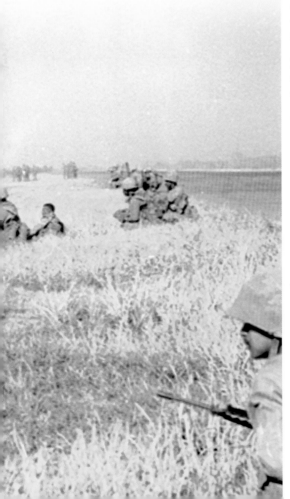

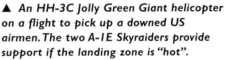

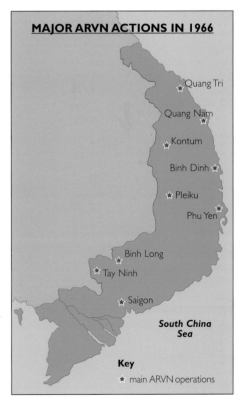

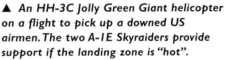
▲ *An HH-3C Jolly Green Giant helicopter on a flight to pick up a downed US airmen. The two A-1E Skyraiders provide support if the landing zone is "hot".*

Dinh. When the operation concludes on March 1, the US Marines and soldiers of Field Force Victor count 437 confirmed enemy dead. Task Force Delta coordinates its operation with Operation Double Eagle, undertaken by E Company, 2nd Battalion, 4th Marines, and led by Captain Brian D. Moore in nine UH-34D helicopters from HMM-261, which carry the 190 Marines of E Company from the Ky airfield at Chu Lai to the Nui Dau ARVN outpost 13km (8 miles) south of the Double Eagle landing beach.

JANUARY 28–FEBRUARY 6

SOUTH VIETNAM, *GROUND WAR*
Northeast of Saigon, General Westmoreland inaugurates Operation Mallett, aimed at the enemy forces between Bien Hoa and Ba Ria, the capital of Phuoc Tuy Province. General Seaman, commanding general of the 1st Infantry Division, assigns Colonel Albert E. Milloy's 2nd Brigade, 1st Infantry Division, during Phase I of this search and destroy operation the area in Nhon Truch

MAJOR ARVN ACTIONS IN 1966

Quang Tri
Quang Nam
Kontum
Binh Dinh
Pleiku
Phu Yen
Binh Long
Tay Ninh
Saigon

South China Sea

Key
★ main ARVN operations

▲ *During 1966 the ARVN fought a series of engagements in the north and Central Highlands of South Vietnam, and in the area immediately north of Saigon, against both the Viet Cong and NVA.*

STRATEGY & TACTICS

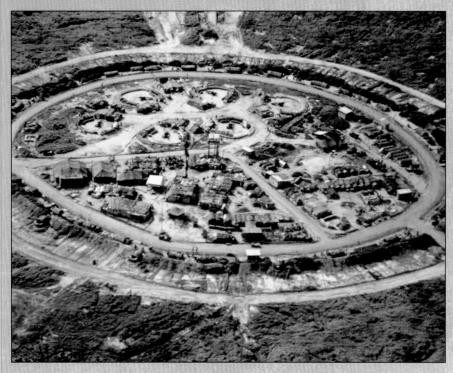

FIRE SUPPORT BASES

A consequence of the lack of frontlines in Vietnam, fire support bases were established to support infantry operations. The fire bases themselves had to be fortified, and were often assigned infantry units if located in a dangerous area. Knowing the importance of fire support bases, North Vietnamese Army (NVA) and Viet Cong (VC) units often launched major assaults to overrun them. Artillery support was and still remains extremely important to US Army operations, and in Vietnam the army deployed 65 battalions of artillery, comprising 32 battalions of 105mm towed artillery, 2 battalions of self-propelled 105mm artillery, 7 battalions of 155mm towed artillery, 5 battalions of 155mm self-propelled howitzers, 5 battalions of mixed 155mm and 8in howitzers, 12 battalions of mixed 175mm guns and 8in howitzers, and 2 aerial rocket artillery battalions. The US Marine Corps deployed the First Field Artillery Group to Vietnam, comprising the 11th and 12th Marine Artillery Regiments, with 10 battalions and 5 separate batteries of artillery.

District, west of Highway 15, and then moves his forces to Long Thanh District, east of the same highway. Phase I of Mallett begins on January 28 with an infantry and artillery battalion, air cavalry troops, and civil affairs and psychological operations teams south of Bien Hoa, about 4km (2.5 miles) below the town of Long Than. The US infantrymen conduct sweeps to the south while two battalions of another infantry brigade make unopposed air assaults several miles to the south and begin manoeuvring north.

The patrols continue through February 2 but uncover only a few enemy base camps and supply caches. The following day Colonel Milloy, using his three infantry battalions, launches an attack on an enemy dominated hamlet located in the northern part of Nhon Trach District. Two of the infantry battalions, supported by helicopter gunships and Regional Forces, seal off the hamlet, while a third battalion of Milloy's, using helicopters, attacks from the west. A thorough search once again manages to find only a few enemy soldiers.

Phase II begins on February 7 while two battalions travel by truck to the hamlet of Binh Son about 10km (6.2 miles) east of Long Thanh, and strike out to the east. Over the next eight days

US infantrymen attached to Mallett discover rice caches and a network of base camps, one of which was used to accommodate up to a regiment of enemy troops, but the Viet Cong once again escape before the soldiers of the 2nd Brigade arrive. Disappointed with the total lack of enemy contact, on February 15 Colonel Milloy ends Mallett. During the operation, US soldiers kill 47 Viet Cong while the Americans suffer 10 killed in action. Later, the number of Viet Cong dead rises as the ARVN troops discover the bodies of 94 enemy soldiers after an "arc light" air strike. Operation Mallett nonetheless succeeds in that it opens Highway 15 and also establishes an Allied presence in the area, as well as permitting government officials to enter a number of hamlets which have long been controlled by the Viet Cong.

FEBRUARY 1

SOUTH VIETNAM, *GROUND WAR*
The war in the northern provinces at the beginning of February assumes a new and ominous aspect as III MAF and MACV intelligence officials identify two regular NVA Divisions, the 324B and 341st, as they threaten an invasion from across the Demilitarized Zone into the northernmost province of Quang Tri.

FEBRUARY 6

HAWAII, *CONFERENCES*

Conference in Hawaii with Premier Ky. President Johnson and other US officials arrive in Honolulu for discussions with Premier Ky and South Vietnamese officials concerning the Vietnam War. In his remarks upon arrival in Hawaii, President Johnson declares that those who "counsel retreat" from the war in Vietnam "belong to a group that has always been blind to experience and deaf to hope."

FEBRUARY 8

USA, *POLITICAL STRATEGY*

At the conclusion of the Honolulu Conference, President Johnson states his determination to stay the course in Vietnam and to fight not only the battle of aggression in South Vietnam but also the battle against both poverty and ignorance there too.

FEBRUARY 11

SOUTH VIETNAM, *GROUND WAR*

Operation Rolling Stone gets under way. The purpose of this operation is to provide security for the 1st Engineer

STRATEGY & TACTICS

SEARCH AND DESTROY

An American tactic developed by General Westmoreland and his deputy, Brigadier-General William Depuy. Their premise was that US firepower, if brought to bear in sufficient quantities, could inflict severe casualties upon North Vietnamese Army (NVA) and Viet Cong (VC) units. Essentially search and destroy advocated heliborne ground forces locating and destroying enemy forces, being supported by artillery and air power, rather than seizing land. US units would "find, fix, and finish" their enemy. It was an aggressive tactic, but largely failed. It was the Communists who usually initiated contacts, and invariably at a time and place of their choosing, and breaking off combat when they saw fit. In addition, 200,000 North Vietnamese males reached draft age every year, thus Westmoreland's aim of wearing down the enemy through attrition was never a reality. After Tet in 1968 search and destroy began to disappear from the language of the Military Assistance Command, Vietnam (MACV), to be replaced by the phrase "reconnaissance in force", though the change was mainly one of semantics.

Battalion as its builds an all-weather road linking Highway 13 with Route 16 north of Saigon in Bing Duong Province. The new thoroughfare will improve communications between the 1st Division bases at Phuoc Vinh and Lai Khe, as well as allowing the South Vietnamese Government to extend its current authority over the intervening territory.

▼ *Artillery provided invaluable support to infantry units in battle. Here, a 105mm battery from the US 77th Artillery Regiment opens up during Operation White Wing, February 19.*

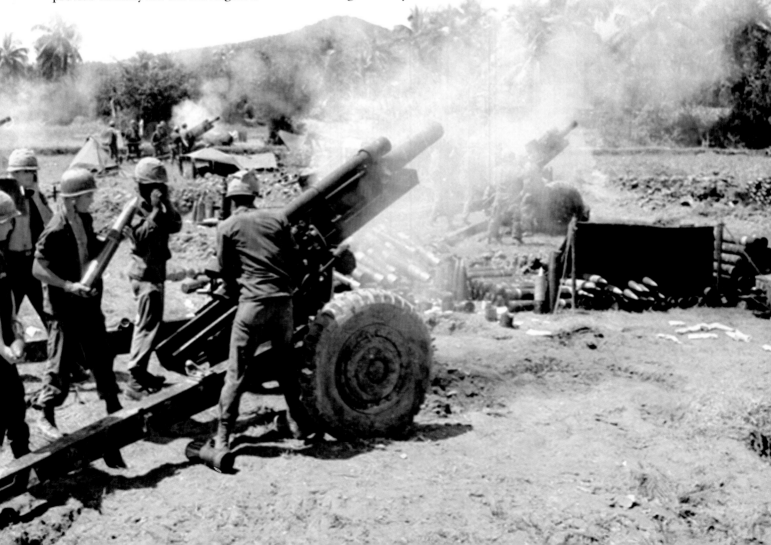

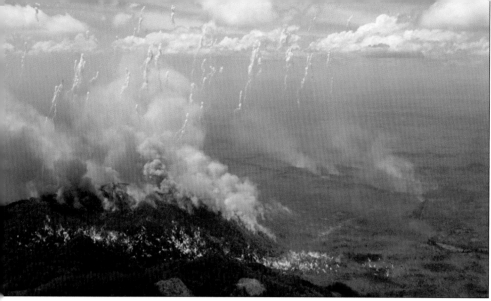

▲ *Strategic bombers used in the tactical role: bombs dropped by B-52 Stratofortresses rain down on enemy positions southwest of Pleiku in early March.*

FEBRUARY 27–MARCH 3

SOUTH VIETNAM, *GROUND WAR*
Operation New York begins in I Corps Tactical Zone when the 2nd Battalion, 1st Marines, is alerted that the 1st Battalion, 3rd ARVN Regiment, has been ambushed by the Viet Cong's 810th Main Force Battalion northwest of Phu Bai.

The first wave of a night helicopter assault was off the ground at Phu Bai within minutes of being alerted at 23:20 hours. By 02:00 hours on February 28, three Marine rifle companies were in the objective area. The Marines attacked across the Phu Thu Peninsula. The Viet Cong were waiting for them and had prepared an elaborate defence-in-depth series of positions. The operation continued with intermittent contact until its conclusion on March 3. The Marines and the ARVN confirmed that over 122 Viet Cong were killed in the operation, and 6 crew-served and 63 individual weapons were captured.

MARCH

SOUTH VIETNAM, *SOUTH KOREAN AND AUSTRALIAN AID*
In March 1966, the Republic of Korea announced its plans to increase its commitment to Vietnam by another division and an additional regiment. Australia revealed plans to triple its forces in Vietnam.

MARCH 2

SOUTH VIETNAM, *US AID*
General Westmoreland reports that US forces in South Vietnam now number 215,000, with another 25,000 troops en route to Southeast Asia.

MARCH 4–8

SOUTH VIETNAM, *GROUND WAR*
Operation Utah/Lien Kiet 26 begins as a combined operation with the US Marines and ARVN in the vicinity of Quang Ngai City, against the North Vietnamese and Viet Cong main forces. Marine helicopters, covered by Marine Corps close air support, takes the 1st ARVN Airborne Battalion to a point

southeast of Chau Nhai (3), a hamlet in South Vietnam that bears the same name as two others and is numbered for convenience. The landing zone is hot with enemy automatic fire as a Marine F-4 Phantom jet is shot down, but the Vietnamese battalions land and go immediately into the attack in good order. It is followed mid-morning by the 2nd Battalion, 7th Marines, which

▲ *Its bomb racks empty, a B-52 returns to base after a mission over South Vietnam. A B-52 could carry up to 42 750lb bombs internally and another 24 externally.*

KEY PERSONALITY

ROBERT McNAMARA

After graduating from the University of California at Berkeley in 1937, McNamara developed logistical systems for bomber raids and statistical systems for monitoring troops and supplies in World War II. After the war he became president of the Ford Motor Company but in 1960 resigned to join the Kennedy administration as secretary of defense. Initially he supported the deepening military involvement of the United States in Vietnam. On visits to South Vietnam in 1962, 1964 and 1966, the secretary publicly expressed optimism that the National Liberation Front and its North Vietnamese allies would soon abandon their attempt to overthrow the US-backed Saigon regime. He became the government's chief spokesman for the day-to-day operations of the war and acted as President Lyndon B. Johnson's principal deputy in the war's prosecution.

By 1966, however, McNamara had begun to question the wisdom of the widening US military involvement in Vietnam and, by 1967, was openly seeking a way to launch negotiations for peace. After initiating a full-scale investigation of the American commitment to Vietnam (later published as *The Pentagon Papers*), he came out in opposition to continued bombing of North Vietnam, for which he lost influence in the Johnson administration. In February 1968 he left the Pentagon to become president of the World Bank.

moves into the ARVN's right flank, while in the mid-afternoon the 3rd Battalion, 1st Marines, lands north of the action. The 2nd ARVN Division also puts in additional battalions. The last opening in the ring is closed the next day by the 2nd Battalion, 4th Marines, landing to the south and cutting off any enemy escape, and finally the Task Force Reserve comprising the 1st Battalion, 7th Marines, and a company of ARVN scouts take up blocking positions 6km (3.7 miles) southwest of Binh Son. Most of the action is over by dawn of March 6 after a short, hard fight.

About one-third of the NVA's 36th Regiment's original strength has been decimated by the US Marines and ARVN, whose part of the operation is designated Lien Kiet 26. US Marine and ARVN forces confirm 632 enemy casualties in the operation.

MARCH 7

SOUTH VIETNAM, *US AID*
Marine Helicopter Squadron HMM-164 under Lieutenant-Colonel Warren C. Watson arrives in the Republic of Vietnam, and is the first CH-46 Sea Knight squadron to be assigned to the South. The tandem-rotor, twin-engined Sea Knight aircraft carries almost twice the load of the UH-34.

◀ *Children and adults watch a television in a neighbourhood of Saigon. Television operated for two hours a day: between 19:00 hours and 21:00 hours.*

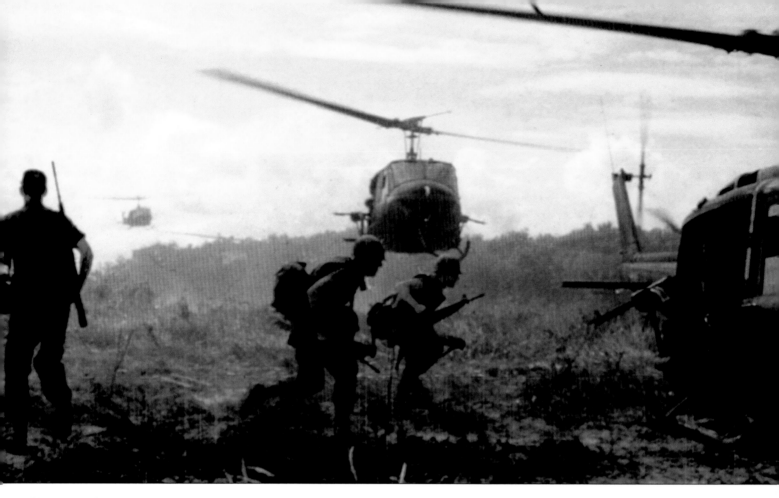

MARCH 9–11

SOUTH VIETNAM, *GROUND WAR*
The US Army's Special Forces camp at A Shau near the Laotian border, garrisoned by 17 Green Berets and about 400 Vietnamese soldiers (ARVN, CIDG, and Popular Forces), comes under heavy attack by what is later estimated to be three NVA battalions. In flying conditions that can be described as

marginal at best, US Marine and Air Force aircraft provide close air support and fly out casualties under intense enemy fire. The Marines lose three UH-34 helicopters and one A-4C.

The majority of CIDG troops in the camp were originally recruited from the Montagnard tribes. The Vietnamese camp commander was working with US and ARVN Special Forces advisors.

▲ *Troops of the US 14th Infantry Regiment are evacuated by UH-1D helicopters following a mission against the Viet Cong in early March.*

As the action commenced, many of the CIDG troops either fled or refused to fight and, as the relief helicopters landed, they panicked and threw down their weapons. The brunt of the attack was borne by the Green Berets and some native troops flown into the camp the day before as reinforcements. The fighting went on for two more days, with the defenders gradually being pushed back into the corner of their camp.

There was no saving the camp, for on March 11 the decision was made to evacuate the Green Berets and CIDG troops. A total of 12 Green Berets and 172 Vietnamese were withdrawn on March 12.

MARCH 10–MAY 31

SOUTH VIETNAM, *POLITICS*
In Saigon there is a meeting of the National Leadership Council, the military junta that has ruled since last June with Marshal Ky as premier. General Thi, the commanding general of I Corps Tactical Zone, is ousted as commander, accused of insubordination. Nguyen van Chaun, the general of the 1st ARVN Division, is named I Corps

REGIONAL POLITICS

THAILAND

One of the 40 nations that sent aid to South Vietnam, Thailand was ostensibly neutral but was suspicious of Communist intentions in Southeast Asia. The Royal Thai Assistance Group was set up in early 1966, and later that year 5000 Thais volunteered when the government declared it was considering sending military aid to South Vietnam. The first elements of the Royal Thai Volunteer Regiment – the "Queen's Cobras" – arrived in Vietnam in September 1967. They were in action in October of that year, involved in Operation Narasuan, and proved to be good soldiers. In July 1968 the "Cobras" were replaced by the Royal Thai Army Expeditionary Division, the so-called "Black Panthers". The latter's strength would eventually include two brigades of

infantry, three battalions of 105mm field artillery, and an armoured cavalry regiment. The Thai area of operation was in III Corps Tactical Zone, and here the troops conducted search-and-clear missions, as well as psychological warfare operations.

By 1969 there were 12,000 Thai troops in Vietnam, and the Black Panthers Division became the Royal Thai Army Volunteer Force in August 1970, a name it retained until the end of its time in Vietnam. The last Thai troops left the South in April 1972, though Bangkok also fought actions against Communist guerrillas along its northeastern border with Laos, actions which were assisted by US Special Forces personnel, and the US Air Force also had several bases in Thailand, from which missions were launched against Vietnamese targets.

commander. Pro-Thi, anti-government demonstrations erupt in Saigon, Hue and Da Nang. The agitation leaders begin to call themselves "The Military and Civilian Struggle Committee", shortened to "Struggle Force".

On April 3, a total of 3000 soldiers of the 1st ARVN Division march through the streets of Hue, demanding the overthrow of Air Marshal Cao Ky's government. In Saigon, Ky announces that he will use loyal troops to liberate Dan Nang and Hue. On the night of April 4/5, Ky airlifts three Vietnamese Marine battalions to Da Nang to suppress the rebellion.

On April 9 American non-combatants are evacuated from both Hue and Da Nang. This is done very efficiently as US Marines are able to evacuate 750 non-combatants as gunships and Marines provide cover overhead and on the ground. During the rebellion between the two warlords, which takes place in areas held by the Marines, the leathernecks provide a sort of "insulation", doing what they can to prevent unnecessary bloodshed by either side.

The same day (April 9) Major-General Chaun resigns as I Corps commander and is replaced by the more flamboyant Lieutenant-General Ton That Dinh. By May 31, order is finally restored.

SOUTH VIETNAM, *GROUND WAR*
Even as the rebellion by the "Struggle Force" goes on, General Chaun presses General Westmoreland to carry out a large search and destroy operation in the A Shau Valley and to re-establish a Special Forces Camp in the area. Explaining that he already has committed most of his reserve forces into the strategic areas around Hue, General Chaun wants the US Marines to make up the bulk of the attacking forces into the A Shau Valley itself. However, Allied commanders reject the idea of direct assault at this time in the valley. Chaun nonetheless requests that III MAF provides a Marine Company for a combined operation with a South Vietnamese unit

▼ *Dead Viet Cong. For the Americans and South Vietnamese, one way of measuring the success of their operations was the body count of enemy dead.*

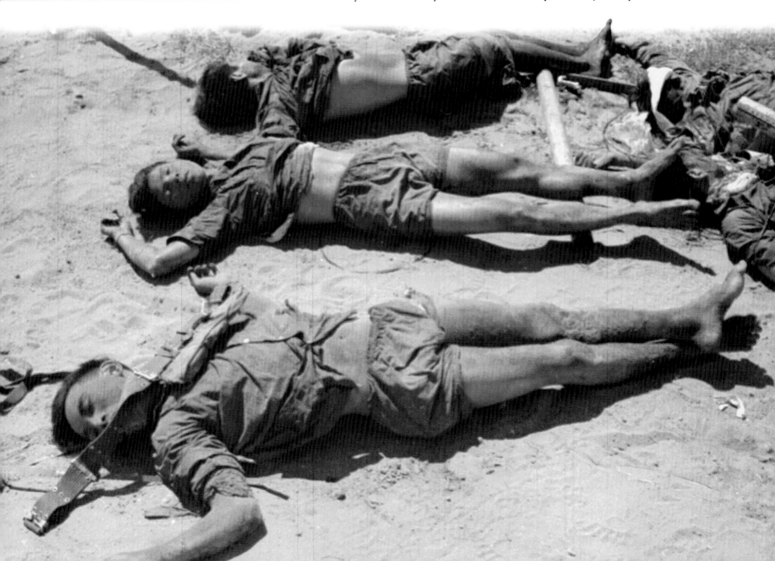

in the area south of Phong Dien, the district capital where the ARVN had killed about 50 enemy troops from the 804th Viet Cong Battalion.

On the following day, General Walt directs Colonel Thell H. Fisher, commanding officer of Task Force Foxtrot, to make liaison with the ARVN 1st Division. That afternoon, Colonel Fisher visits division headquarters in Hue where he learns that the target area was in the coastal plain between Route 1 and the sea, some 8km (4.9 miles) north of Phong Dien, rather than south of the town as originally indicated. With the concurrence of both Generals Walt and Chaun, Colonel Fisher decides upon a battalion-size operation and to hold in reserve both a US Marine and South Vietnamese battalion.

His plan for Operation Oregon, as the operation is named, calls for the insertion by helicopter of Lieutenant-Colonel Sullivan's command group and A and B Companies into the landing zones designated Robin and Eagle, south and north respectively of Route 597 which parallels Route 1, on the morning of March 19. The two Marine companies are to advance to the southeast on the other side of the road and clear the hamlets of Ap Phu An and Ap Tay Hoang, some 4km (2.5 miles) from the landing zones. Allied intelligence places two companies of the Viet

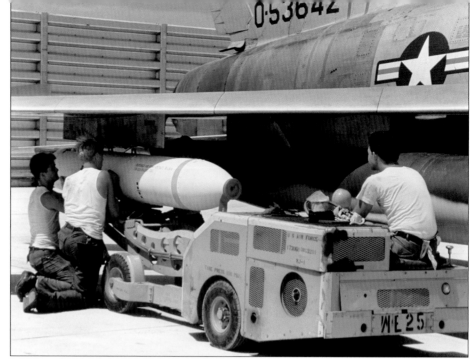

▲ *Ground crew personnel fix a cluster bomb unit to a USAF F-100 Super Sabre at Bien Hoa Air Base prior to a ground-support mission.*

Cong's 802nd Battalion with some local Viet Cong local forces, at an approximate strength of some 250 men, in the two hamlets. If Sullivan's companies make contact with the enemy, Colonel Fisher plans to reinforce the battalion with Lieutenant-Colonel Hannifer's 2nd Battalion, 1st Marines, and, if need be, with the 3rd ARVN Regiment. Other ARVN units, meanwhile, are con-

ducting Lam Son-245 to the north and west of the Marines' proposed area of operations. US Marine air, artillery and naval gunfire are available to support the Marine infantry.

MARCH 15

SOUTH VIETNAM, *US FORCES*

With the deployment of the US Army's 25th Division to South Vietnam, an administrative change takes place, calling for the establishment of II Field Force, Vietnam, headquartered at Bien Hoa. II Field Force is a corps-level headquarters responsible for coordinating the

STRATEGY & TACTICS

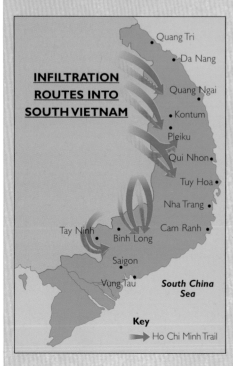

INFILTRATION ROUTES INTO SOUTH VIETNAM

Quang Tri
Da Nang
Quang Ngai
Kontum
Pleiku
Qui Nhon
Tuy Hoa
Nha Trang
Tay Ninh
Cam Ranh
Binh Long
Saigon
Vung Tau

South China Sea

Key
→ Ho Chi Minh Trail

HO CHI MINH TRAIL

The trail was an elaborate system of mountain and jungle paths and trails used by North Vietnam in order to infiltrate troops and supplies into South Vietnam, Cambodia and Laos during the Vietnam War. The trail was in operation from 1959, after the North Vietnamese leadership decided to use revolutionary warfare to reunify the South with North Vietnam. Accordingly, work was undertaken to connect a series of old trails leading from the panhandle of North Vietnam southwards along the upper slopes of the Annamese Cordillera into eastern Laos and Cambodia, and thence into South Vietnam. Starting south of Hanoi in North Vietnam, the main trail veered southwestwards to enter Laos, with periodic side branches or exits running east into South Vietnam.

◀ *South Vietnamese and US military efforts to close the trail failed. The trail was invaluable to the Viet Cong.*

The main trail continued southwards into eastern Cambodia and finished in South Vietnam. The network of trails and volume of traffic expanded significantly beginning in the 1960s, but it still took more than one month's march to travel from North to South Vietnam using it (traffic on the trail was little affected by repeated American bombing raids).

Efforts were gradually made to improve the trail, which by the late 1960s was wide enough to accommodate heavy trucks in some sections, and was supplying the needs of several hundred thousand regular North Vietnamese troops active in South Vietnam. By 1974, the trail was a well-marked series of jungle roads, some paved, and underground support facilities, such as hospitals and fuel-storage tanks, as well as weapons and supply caches. In 1975 the Ho Chi Minh Trail was the major supply route for the North Vietnamese forces that successfully invaded and overran South Vietnam.

◄ *A phosphorus bomb explodes in the jungle in the Central Highlands. White phosphorus, in addition to causing casualties, was also a good target marker.*

moted to the rank of major-general, commensurate with his new assignment.

MARCH 18

SOUTH VIETNAM, *GROUND WAR*
Major-General Wood B. Kyle assumes command of the 3rd Marine Division from General Walt. General Walt continues as Commanding General, III Marine Amphibious Force. Also the 3rd Battalion, 4th Marines, arrives in the Republic of Vietnam. F Company, 9th Marines, under Captain Carl H. Reckwell, conducts a routine search-and-clear mission along the northern bank of the Tre-Ha-Tho River, east of the railroad. At 16:30 hours the Marines come under 81mm and 60mm mortar fire. After the mortar bombardment, a Viet Cong company launches three ground assaults against the Marines. Captain Reckwell's men repulse each of the enemy's attacks and later find 10 enemy bodies nearby.

US ground war throughout III Corps Tactical Zone. Lieutenant-General Stanley R. Larson's Field Force, Vietnam, based at Nha Trang and filling the same function in II Corps Tactical Zone, re-

▼ *UH-1B crew members load up their bird with ammo for the XM31 machine gun, which fired 650 rounds per minute.*

ceives a new name: I Field Force, Vietnam. General Westmoreland selects Lieutenant-General Jonathan O. Seaman to be in charge of the new headquarters which, within a month, will move to a new building at nearby Long Binh. Brigadier-General William E. Depuy replaces General Seaman as Commander of the 1st Infantry Division and he is pro-

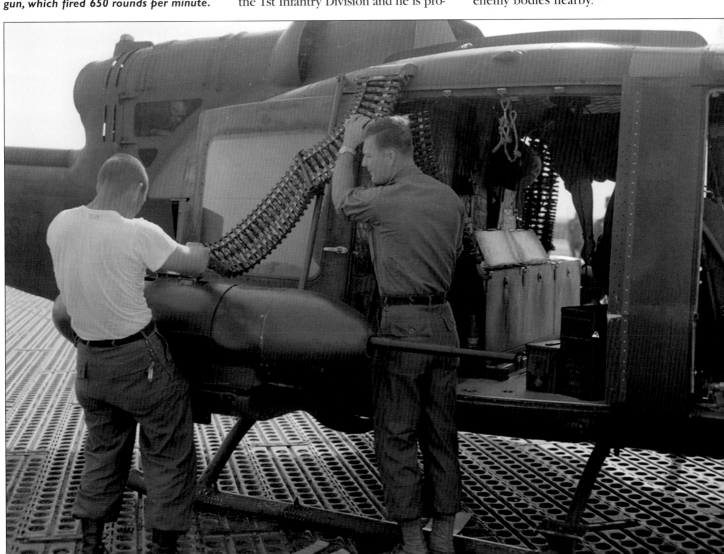

MARCH 19

SOUTH VIETNAM, *GROUND WAR*
For the next three days, Task Group Foxtrot and two Marine infantry battalions, reinforced on March 22 by two South Vietnamese Ranger Battalions, stay in the Oregon objective area. The 2nd Battalion operates as the southwest battalion and advances to the southwest as originally planned, towards blocking positions established by the South Vietnamese battalion. Encountering only stragglers, neither battalion returns to Phu Bai, while Sullivan's unit remains in the Oregon sector for a few days. In the four-day operation the Marines sustain casualties of 11 dead and 45 wounded, while killing at least 48 of the enemy and taking 8 prisoner. Estimates of enemy casualties are 100 dead. Supporting arms (artillery, air and mortars) account for most of them.

In his assessment of the operation, US Marine Lieutenant-Colonel Sullivan grudgingly compliments the North Vietnamese, declaring that they "were a seasoned, well-trained adversary, and the tactics they utilize were not uncommon to good soldiering."

MARCH 20–24

SOUTH VIETNAM, *GROUND WAR*
The five-day Operation Texas/Lien Kiet

▼ *Troops of the US 1st Infantry Division leave their helicopter during an operation against the Viet Cong in the Xa Cam My area of South Vietnam.*

▶ *US Marines exit a CH-46 Sea Knight under enemy fire. The CH-46 was procured in 1964 to meet the medium-lift requirements of the Marines in Vietnam.*

28, a search-and-clear "reaction" operation, is launched by the US Marines, ARVN and Vietnamese Marine Corps in order to retake the An Hoa outpost in Quang Ngai Province. The Marines and ARVN claim 623 enemy casualties.

MARCH 26–APRIL 6

SOUTH VIETNAM, *GROUND WAR*
The US Marines' Special Landing Force (SLF), the 1st Battalion, 5th Marines, begins Operation Jack Stay in the Rung Sat Special Zone about 43km (27 miles) southeast of Saigon. This is the first operation by American troops in the Saigon River Delta.

MARCH 26

SOUTH VIETNAM, *GROUND WAR*
US Marine CH-46 Sea Knight helicopters from the newly arrived HMM-166 helicopter squadron bring two companies from the 3rd Battalion, 3rd Marines, into landing zones south of Route 4. After artillery and fixed-wing preparation of the landing zones, Captain William F. Lee's company lands at 07:30 hours just north of the Ky Lam River and about 3.7km (2.3 miles) southwest of where E Company has been attacked by the Doc Lap Battalion. K Company, led by Marine Captain Lyndell M. Orsburn, lands two hours later, 1.5km (0.9

miles) north of L Company's landing zone. The two Marine companies advance in a northeasterly direction towards Route 4. After meeting heavy resistance from an entrenched enemy, Marine jets from MAG-11 and MAG-12 attack the Viet Cong positions, dropping general-purpose bombs and napalm, as well as strafing them with 20mm cannon fire. Enemy opposition is extinguished.

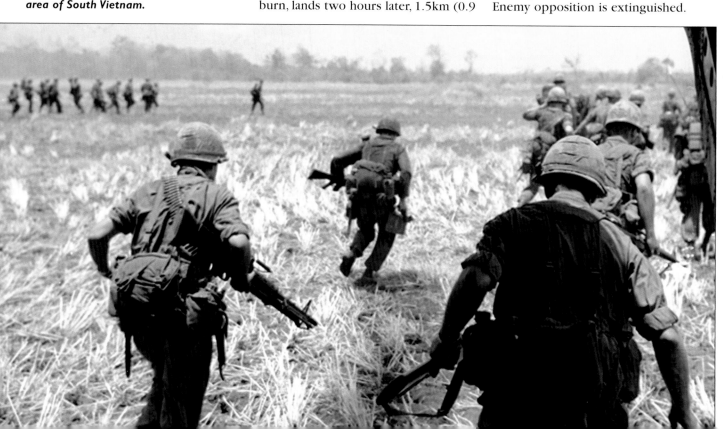

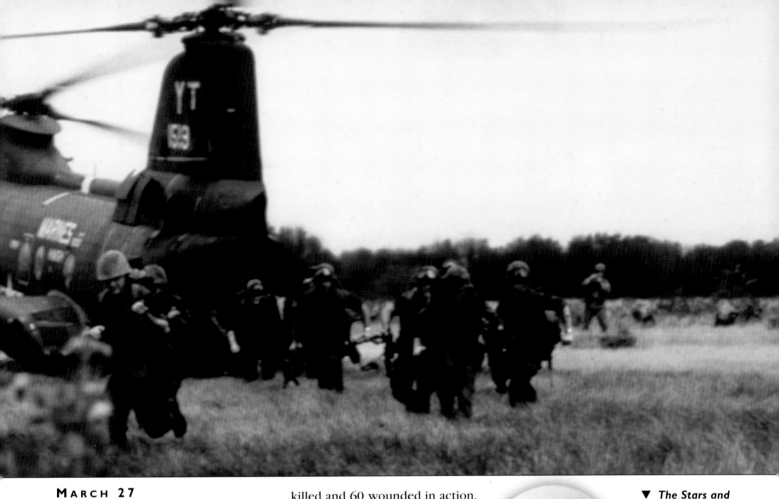

MARCH 27

SOUTH VIETNAM, *GROUND WAR*
The two 3rd Battalion, 3rd Marines, companies renew their advance towards Route 4, experiencing the same pattern of fighting of the previous day. Once again, both companies meet stiff enemy resistance from a well-entrenched Viet Cong. Again, air support destroys the dug-in enemy, allowing the Marines to carry on with their mission. In what was known as Operation Kings, the Marines, whose companies operate in pairs of not less than four at a given time, kill 58 Viet Cong, while suffering 8 Marines killed and 60 wounded in action. More importantly, however, the Viet Cong are by and large cleared from an area they had previously dominated, which

▼ *The Stars and Stripes flies over the South. The morning flag-raising ceremony at the US 1st Marine's headquarters at Chu Lai.*

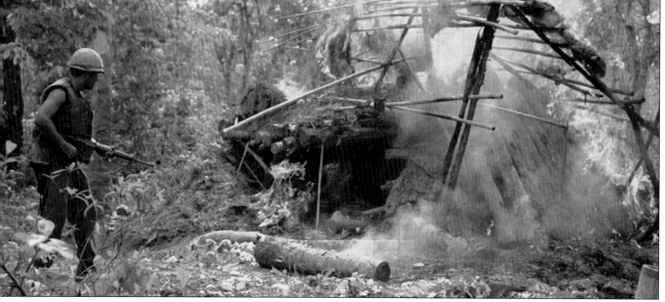

▲ *Soldiers of the US 25th Infantry Division fire a hut suspected of being used by Viet Cong guerrillas. Cu Chi area, early April 1966.*

permits General Kyle to push ahead with his plans aimed at pacification.

MARCH 29

SOUTH VIETNAM, *US GROUND FORCES*
The 9th Marines have a major enlargement of their tactical zone of operation south of Cau Do. The 9th Marines now operate in an area below Route 4.

While Lieutenant-Colonel Downey moves his battalion command post back to Hill 55, US Marine engineers construct a regimental command post there. Major-General Lewis J. Fields establishes the 1st Marine Division Headquarters at Chu Lai.

APRIL 1

SOUTH VIETNAM, *US NAVAL FORCES*
General Westmoreland's command establishes the US Naval Forces, Vietnam, taking control of the Naval Support Activity, Da Nang, from III MAF.

APRIL 4

SOUTH VIETNAM, *SOCIAL POLICIES*
Pacification continues in the Vietnamese countryside. Major-General Wood B. Kyle, commanding general of the 3rd Marine Division, issues an operations order extending the civic action programme known as Golden Fleece II to all new harvesting areas in the 3rd Marine Division's TAOR.

ARMED FORCES

MONTAGNARDS

The word is from the French meaning "Highlander" or "Mountain Man" and denotes any member of the hill-dwelling peoples of the Indochinese Peninsula. In Vietnam the Montagnards include speakers of Mon-Khmer languages such as the Bahnar, Mnong and Sedang and speakers of Austronesian (Malayo-Polynesian) languages, such as the Jarai, Roglai and Rade (Rhade). They mostly grow rice, using shifting cultivation. They have a unique culture. For example, religious beliefs involve spirits associated with nature and ancestors, and they maintain shamans and sorcerers to intercede with them. Among the Jarai, Mnong, Roglai and Rade, descent is traced through the mother. The typical household is a longhouse inhabited by the women of a maternal line with their husbands and children.

The Montagnards constitute one of the largest minority groups in Vietnam and number more than 100 tribes of primitive mountain people, numbering from 600,000 to a million and spread over all of Indochina. In South Vietnam there are some 29 tribes, all told more than 200,000 people. Even within the same tribe, cultural patterns and linguistic characteristics can vary considerably from village to village. In spite of their dissimilarities, however, the Montagnards have many features in common that distinguish them from the Vietnamese who inhabit the lowlands. The Montagnard tribal society is centred on the village and the people depend largely on slash-and-burn agriculture for their livelihood.

Montagnards have in common an ingrained hostility toward the Vietnamese and a desire to be independent. Throughout the course of the French Indochina War, the Viet Minh worked to win the Montagnards to their side. Living in the highlands, these mountain people had long been isolated by both geographic and economic conditions from the developed areas of Vietnam, and occupied territory of strategic value to an insurgent movement. The French enlisted and trained Montagnards as soldiers, and many fought on their side. The Montagnards long sought to preserve their cultural identities, and during the Vietnam War sided with the South Vietnamese and Americans against the North. They have struggled for autonomy within Vietnam since the country was reunited in 1975.

▲ *"Charlie" leaves his calling card: a C-47 Skytrain aircraft at Tan Son Nhut Air Base burns during a Viet Cong mortar attack that took place on April 13, 1966.*

APRIL 12

SOUTH VIETNAM, *US AID*
The 2nd Battalion, 4th Marines, arrives in the Republic of Vietnam.

APRIL 16

SOUTH VIETNAM, *GROUND WAR*
The Viet Cong's R-20 Doc Lap Battalion attacks a US Marine rifle company which belongs to Lieutenant-Colonel William F. Donahue, Jr's, 3rd Battalion, 9th Marines, in position north of the abandoned ARVN 39th Ranger outpost at Phong Thu. H Company, 2nd Battalion, 9th Marines, commanded by Captain Everett R. Roane, establishes defensive positions north of Route 4 and places a squad in ambush positions south of the road. Suddenly, at 04:00 hours, the Viet Cong opens up with recoilless rifle and mortar fire. Simultaneously, the enemy launches a two-company sized assault, one from the southeast and the other from the southwest. The attack from the southwest consisting of 100 soldiers runs into a Marine ambush and stalls. According to a Marine squad leader afterwards, his men shot 12 to 15 Viet Cong for sure, most likely more. At dawn the following morning, the squad discovers two enemy bodies.

A 150-man Viet Cong force attacking from the southeast reaches the northside of Route 4 but finds itself unable to penetrate the Marine company's

ARMED FORCES

THE AUSTRALIANS
Australia's initial commitment to supporting the American stance in Vietnam consisted of deploying a team of military advisors. On July 26, 1962, the Minister for Defence announced that Australia's intention to send 30 instructors to the Republic of Vietnam, 4 going to the Military Aid Council Vietnam (MACV) Headquarters in Saigon, 22 to regional locations in the Hue area and 4 to Duc My. This team would be headed by Colonel F.P. Serong, former Commanding Officer at the Jungle Training Centre, Canungra, Queensland, and would fall under the command of the Australian Army Forces, Far Eastern Landing Forces Headquarters, in Singapore.

The Australian Army Training Team Vietnam (AATTV) arrived in the Republic of Vietnam in August 1962, its primary role being to train the ARVN and other forces to use weapons, jungle warfare tactics and strategy. In addition, especially after the Australian Government allowed them to serve in battalion- and smaller-size formations, they took liaison roles, calling for air strikes and arranging logistical support as well as medevac facilities. They usually operated as individuals or in small groups of two or three. After 1963, the AATTV came under operational control of MACV HQ in Saigon.

The Australians were eager to operate in their own tactical area, so were placed under the control of II Field Force in Phuoc Tuy Province. The First Australian Task Force was eventually reinforced by a tank squadron, helicopter squadron plus artillery and logistical support. The Australians were good soldiers: witness their victory over the Viet Cong at Long Tan on August 18, 1966. At first all professional soldiers, gradually Canberra was forced to resort to conscription in order to maintain troop levels. This was unpopular at home and brought pressure to bear on the government to reduce troop levels. As a result, by December 1971 the vast majority of Australian forces had been withdrawn from South Vietnam, having lost 423 men killed and 2398 wounded in the conflict.

perimeter. As soon as the Viet Cong cross, they are, as one Marine observed, "like ducks in a shooting gallery," as many of them are shot crossing the road. At one point, the same Marine states, he alone counted 22 Viet Cong bodies in that vicinity. As the Viet Cong try to remove their dead the Marines

▼ *More damage at the Tan Son Nhut Air Base. In the background a fuel storage tank burns following the Viet Cong attack. The aircraft is a B-47 Stratojet.*

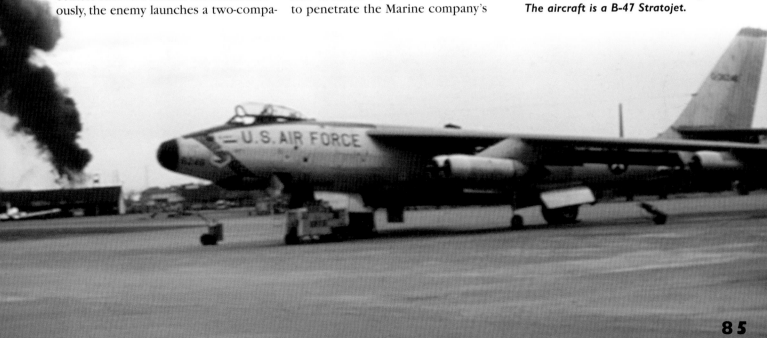

continue to fire on them, adding more bodies to the road. As Marine aerial observers arrive shortly overhead, and the Marine artillery lays down an extensive barrage, the enemy's supporting mortars are silenced. The Viet Cong's grand assault slowly dissipates and the attacks break up into small groups. The Viet Cong probing attacks continue along the Marine's company perimeter, most likely launched to cover the collection of casualties and the withdrawal of the main force. While the Marines count 12 enemy killed in action, signs indicate that they have, in fact, killed as many as 63. The US Marine rifle company suffers 7 dead and 37 wounded as a result of the enemy's recoilless rifle and mortar attack.

APRIL 21

SOUTH VIETNAM, *GROUND FORCES*
In preparation for Operation Georgia in the vicinity of the An Hoa industrial complex, Lieutenant-Colonel William Taylor establishes a forward base at the An Hoa airstrip, while helicopters from Marine Air Group 16 lift the command group and L Company from their base

at Marble Mountain, where US Air Force C-123s fly in an artillery battery, Battery F, 12th Marines.

APRIL 21–MAY 10

SOUTH VIETNAM, *GROUND WAR*
Operation Georgia commences as Lieutenant-Colonel William W. Taylor's 3rd Battalion, 9th Marines, moves out. The rear headquarters and two rifle companies, supported by a platoon of LVTHs from B Company, 1st Amphibian Tractor Battalion, move overland towards the objective area. A third company, I Company, 9th Marines, arrives at An Hoa by helicopter, and US Air Force transports bring in a second 105mm howitzer battery, Battery B, 12th Marines. Both fixed-wing transports and helicopters continue to fly in supplies for the An Hoa buildup. On April 22, L Company links up with the LVT convoy after it crosses the Thu Bon River. With the establishment of the An Hoa base, the battalion begin the second phase of the operation. Lieutenant-Colonel Taylor divides the entire An Hoa Region into 20 well-defined company sized TAORs and the Marines, with local ARVN and South

▲ *Phosphorus bombs explode among Viet Cong positions during Operation Georgia in May 1966, a mission that involved the US 9th Marine Regiment.*

Vietnamese Popular Forces, begin a series of actions in order to secure the hamlets around the An Hoa bases. Despite receiving intelligence reports of the presence of the Viet Cong's V-25 (5th Viet Cong) Battalion in the western sector of Operation Georgia's TAOR, or of actions in the Vu Gia and Thu Bon River areas, the Marines encounter little opposition through the end of April, generally only harassing fire and mines.

APRIL 24

SOUTH VIETNAM, *GROUND WAR*
The 1st Infantry Division enters War Zone C near the Cambodian border in Tay Ninh Province, the first major Allied foray into the enemy stronghold since 1962. Known as Operation Birmingham, during this action the soldiers uncover vast quantities of arms, clothing, medicine and miscellaneous supplies inside the South Vietnamese border,

though there is evidence to suggest that these supplies have in fact come from Cambodia.

APRIL 25–MAY 18

SOUTH VIETNAM, *GROUND WAR*
In Operation Austin VI, the 1st Brigade, 101st Airborne Division, kills 101 enemy soldiers and completely routs the NVA's 3rd Battalion, 141st Regiment, forcing that unit to retreat to its Cambodian sanctuary. In and around Bu Gia Map airstrip, the American paratroopers successfully use their famous "checkerboard tactics".

MAY 3

SOUTH VIETNAM, *GROUND WAR*
The heaviest action of Operation Georgia occurs when Captain George R. Griggs' M Company, 3rd Battalion, 9th Marines, which had only recently relieved another company during the operation, prepares to cross the Thu Bon. Its objective is the hamlet of Phu Long (1) on the northern bank of the river in the north-central sector of the Georgia area. While Captain Griggs' company crosses the river, an enemy force, later determined by Marine intelligence to be the élite Viet Cong R-20 Battalion, opens fire on the Marine company. Reinforced by two Marine rifle companies and supported by air and artillery, the leathernecks secure Phu Long (1). LVTHs which accompany the Marines in the river crossing fire upon the enemy positions, and are instrumental in neutralizing enemy fire and preventing more casualties. During the engagement the Marines suffer 5 dead and 54 wounded in action. They kill over 15 of the Viet Cong and estimate that they have inflicted a further 100 casualties on the enemy.

MAY 10

SOUTH VIETNAM, *GROUND WAR*
Although technically ending on May 10, Operation Georgia, like Operation Kings, is an operation undertaken to extend the Marine area of operations. Lieutenant-Colonel Trammell places his command post and two rifle companies, reinforced by an artillery battery from the 12th Marines, at the An Hoa base. The final tally of confirmed Viet Cong dead for Operation Georgia is 103, while the Marines suffer 9 men killed in action and a further 94 wounded in combat operations.

▼ *Airmen of the US 303rd Munitions Maintenance Squadron fill aerial tanks with napalm at Bien Hoa Air Base in May 1966 for use against the enemy.*

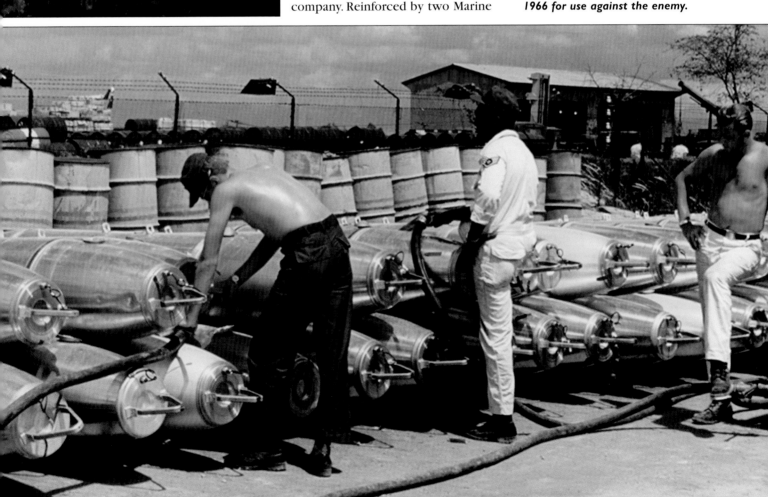

MAY 10–JULY 30

SOUTH VIETNAM, *GROUND WAR*
Operation Paul Revere/Than Phong 14. The 3rd Brigade, US 25th Infantry Division, and ARVN forces participate in an operation for border-screening and area control in Pleiku Province. The US soldiers and ARVN inflict 546 confirmed enemy casualties. The operation takes place over 82 days.

MAY 21

SOUTH VIETNAM, *VIET CONG CASUALTIES*
General Westmoreland's headquarters in Saigon estimates that for the entire month, the 9th Marines alone have killed more than 270 Viet Cong, while 75 Marines have died in combat actions and 328 are wounded, due primarily to mines and explosive devices, many of them made from equipment which was abandoned by the ARVN forces south of Da Nang. Colonel Edwin H. Simmons, USMC, commanding officer of the 9th Marines, states that the considerable increase in enemy incidents during the month has been due to the increased freedom of movement enjoyed by the Viet Cong in many outlying rural areas. This in turn has been due to the Vietnamese Government's diminished military activities during its period of frequent political instability. As a result, the Marines fail to reach their new objective, Phase Line Brown, by May 31.

MAY 28

SOUTH VIETNAM, *US GROUND FORCES*
The US Marine 1st Military Police Battalion arrives at Da Nang from the US and relieves the 3rd Battalion, 3rd Marines, of its airfield security mission. The 3rd Battalion, 3rd Marines, returns to the operational control of its parent regiment, the 3rd Marines.

JUNE 1

SOUTH VIETNAM, *US GROUND FORCES*
The 1st Marine Division at Chu Lai consists of over 17,000 US Marines and sailors in two infantry regiments of three battalions each, an artillery regiment of four battalions, and other supporting units, including engineer, tank, amtrac, antitank and reconnaissance battalions, as well as other separate detachments. Future plans call for the deployment to Chu Lai of the 3rd Battalion, 5th Marines, and reinforcements from the Korean Marine Brigade later in the summer.

▼ *The port of Da Nang, which from May 28 became the home of the US Marine 1st Military Police Battalion. This unit carried out airfield security missions.*

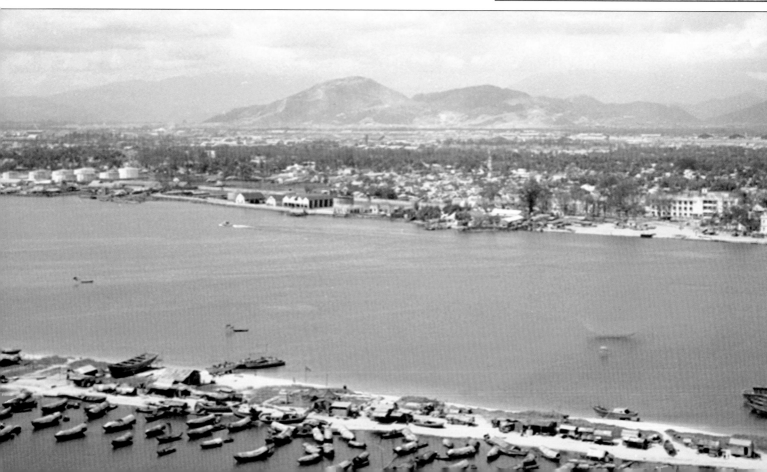

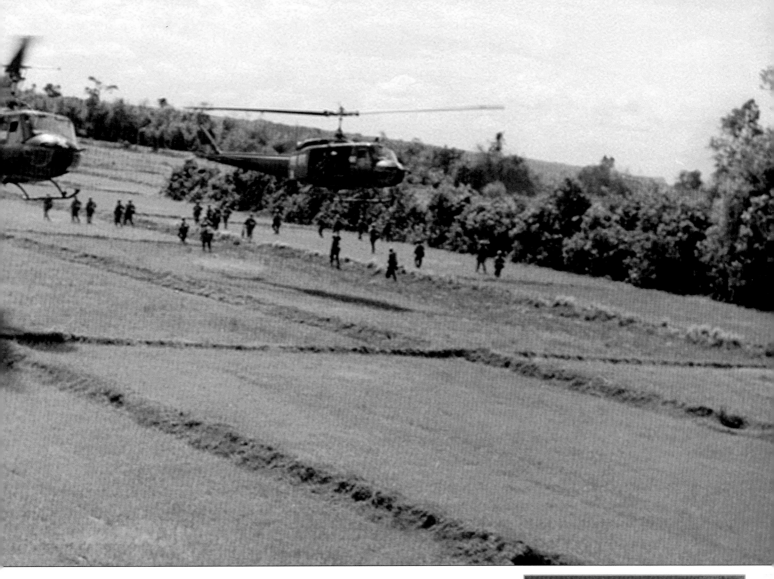

▲ *The endless hunt for "Charlie". Soldiers of the 14th Infantry Regiment are airlifted by UH-ID helicopters during a search and destroy mission northeast of Cu Chi.*

JUNE 2-21

SOUTH VIETNAM, *GROUND WAR*

Operation Hawthorn/Dan Tang 61. The 1st Brigade, 101st Airborne Division, and ARVN units mount operations in Kontum Province. There are 531 confirmed enemy casualties.

JUNE 2-JULY 13

SOUTH VIETNAM, *GROUND WAR*

Operation El Paso II. The US Army's 1st Infantry Division and the 5th ARVN Division engage in combat against the Viet Cong 9th Main Division in Binh Long Province. The American and South Vietnamese soldiers kill over 855 enemy soldiers over a 40-day period.

JUNE 5

SOUTH VIETNAM, *GROUND WAR*

During Operation El Paso a battalion commander and his small mobile command group embark in three Ontos – a fully tracked and lightly armed mobile carrier mounting six 106mm recoilless rifles and four .50-calibre spotting rifles, as well as one .30-calibre machine gun, with a crew of three, the primary weapon of the Marine antitank battalion – and find themselves stalled on the northern fringes of Phong Ho (2), a hamlet 10km (6.2 miles) south of the Marble Mountain Air Facility in an area which is noted for its hostility towards the Government of Vietnam.

As Lieutenant-Colonel Van D. Bell, Jr, and his command group take off for Marble Mountain, the Viet Cong opens up with a hail of weapons fire. Using his command group with its Ontos as a blocking unit, Lieutenant-Colonel Bell orders reinforcements from his B Company, which is supported by LVTs and tanks brought up from the south of Phong Ho (2). The result is a sound beating of the Viet Cong by the US Marines, after which it is discovered that a total of 11 enemy soldiers have been killed and left on the battlefield. A number of weapons are also captured.

KIT CARSON SCOUTS

The idea of using former Communists to aid the US military effort started in May 1966 when some Viet Cong (VC) soldiers surrendered to the 9th US Marines in I Corps Tactical Zone. Two of the VC were persuaded to speak to local villagers to contradict rumours of US atrocities. So successful were they that it was decided to use other VC defectors to help the Americans and the régime in Saigon. The Kit Carson Scout programme was established by the US Marines in October 1966, and so successful was it that Westmoreland encouraged all US units to create similar units. By mid-1968 more than 700 former VC were serving with US forces, many serving with US Army Special Forces long-range reconnaissance patrols. The Scouts proved very effective when dealing with peasant villagers, and after the US withdrew from Vietnam in 1975, most of them volunteered to serve within ARVN units.

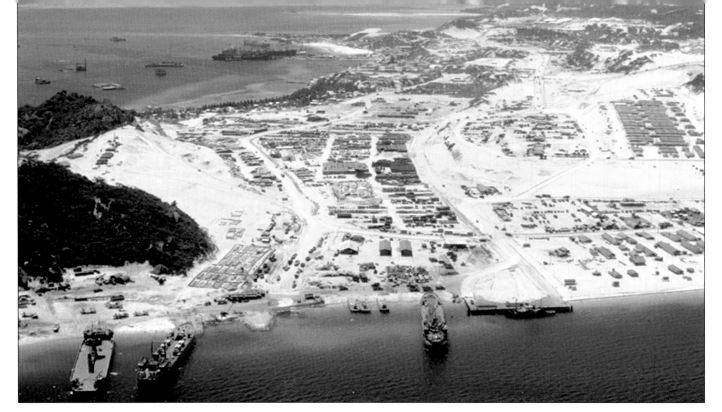

▲ *The Americans built a base at Cam Ranh Bay as part of their logistical support for army and air force units. The base was used by the Soviets after the war.*

JUNE 7–30

SOUTH VIETNAM, *GROUND WAR*
A US Marine operation, Operation Liberty, begins with heavy preparatory fires. Marine artillery neutralizes 35 objective areas in front of the advancing Marine infantry. Initially, the enemy counters the Marine offensive with only small-arms fire and mines, the mines being the more deadly of the two. The most significant mine incident occurs on June 11 in the 9th Marines' sector. Captain Carl H. Reckwell's F Company, 2nd Battalion, 9th Marines, walks into a large minefield located in a grassy area south of the La Tho River. Two mine detonations kill 3 Marines and wound 21 others. On June 30, the operation ends.

JUNE 18–27

SOUTH VIETNAM, *GROUND WAR*
US Marine amphibious forces launch Operation Deckhouse I, the first in a series of operations conducted by the Special Landing Force (SLF) on Viet Cong coastal strongholds. Marines conduct this operation in the Phu Yen Province, 19.3km (12 miles) northwest of Tuy Hoa in II Corps Tactical Zone. The Marines will conduct four such amphibious-type operations of this nature in 1966 alone.

JULY 4–OCTOBER 27

SOUTH VIETNAM, *GROUND WAR*
Operation Macon begins, a US Marine Corps security operation for the An Hoa industrial complex located in Quang Nam Province. There are 507 confirmed enemy casualties in an operation that takes place over 116 days.

JULY 7–AUGUST 2

SOUTH VIETNAM, *GROUND WAR*
Operation Hastings, the single largest operation to date, a search and destroy mission conducted 88km (55 miles) northwest of Hue under the command

▼ *Massive quantities of ammunition were needed in Vietnam. These pallets at the Qui Mion depot hold 81mm mortar shells.*

◀ *M48 Patton tanks of the 11th Armored Cavalry Regiment are moved by barge to Long Binh as part of the US military commitment to South Vietnam.*

Marines and ARVN, the Allied commanders are "able to position their forces in areas where they could achieve noticeable results. Many enemy positions are overrun and large quantities of equipment, clothing and other supplies are captured by the Marines and ARVN troops. The NVA initially chooses to stand and fight, but soon tries to avoid contact with the Marines and ARVN. The Marines uncover several recently abandoned company sized bivouac areas with everything except the weapons. Included in this find is a regimental-sized command post large enough to hold 500 men in the Dong Ha Mountains."

MACV concluded later that Operation Hastings had pre-empted a major enemy attack. US forces, together with their South Vietnamese allies, held the initiative throughout the entire offensive, forcing the North Vietnamese 324B Division across the border area along the DMZ back into North Vietnam. Over a period of 28 days, the Marines, ARVN and Vietnamese Marines kill over 882 Viet Cong. Operation Hastings involved 8000 US Marines, 3000 South Vietnamese, and perhaps as many as 12,500 enemy troops.

AUGUST 1

SOUTH VIETNAM, *SOUTH KOREAN FORCES*
Advance echelons of the 2nd Korean Marine Brigade arrive in I Corps Tactical Zone, 4.8km (3 miles) south of Chu Lai.

of Task Force Delta in order to counter the growing threat of the North Vietnamese 324B Division's movement across the Demilitarized Zone (DMZ). On July 11, Marine and South Vietnamese commanders met in Hue in order to plan the operation. In addition, the Battalion Landing Team, 3rd Battalion, 5th Marines, would conduct Operation Deckhouse II, which would be an amphibious landing.

Placed under the command of Brigadier-General Lowell E. English, USMC, Hastings begins at 08:00 hours on July 15 when the Marines launch a heliborne attack in order to secure landing sites in the enemy's rear areas. The heliborne lift at first enjoys a relatively uneventful landing, but contact becomes heavy as subsequent lifts touch down. Through the heavy use of intelligence-gathering reconnaissance teams from the

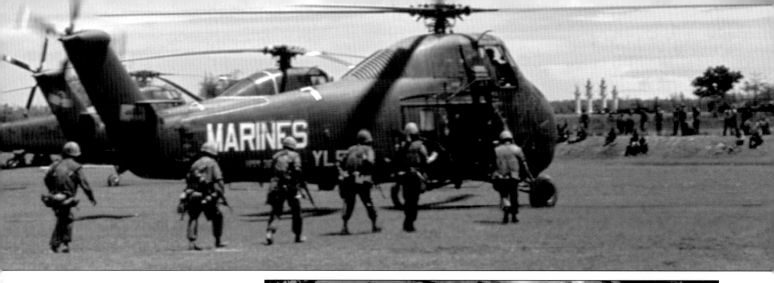

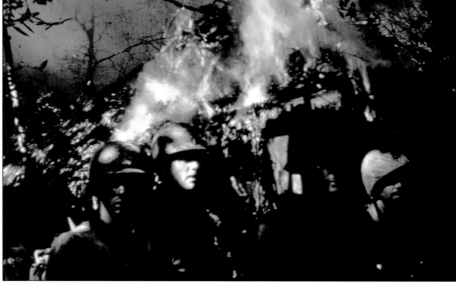

AUGUST 1–25

SOUTH VIETNAM, *GROUND WAR*
Operation Paul Revere II is conducted by the sky soldiers of the 1st Cavalry Division (Airmobile) and ARVN in Pleiku Province. In 25 days the Allies kill over 809 enemy soldiers.

AUGUST 3

SOUTH VIETNAM, *GROUND WAR*
The Marines begin Operation Prairie in the Operation Hastings Area of Operations. Starting as a one-battalion, but soon expanding into a multi-battalion campaign, it continues through the year end. Marines meet elements of the 324B and the 341st NVA divisions.

AUGUST 6–21

SOUTH VIETNAM, *GROUND WAR*
Operation Colorado/Lien Kiet 52 commences, involving elements of the US Marine Corps and ARVN in Quang Nam/Quang Tin Provinces. In the 16-day operation the Marines and ARVN inflict 674 enemy casualties.

AUGUST 26–JANUARY 20

SOUTH VIETNAM, *GROUND WAR*
The 1st Cavalry Division (Airmobile) conducts a 513-day operation labelled

Operation Byrd, which is an economy-of-force operation in Binh Thuan Province. At any given time, one to two battalions conduct simultaneous operations. When the operation concludes in January 1968, the sky soldiers confirm 849 enemy dead.

AUGUST 26

SOUTH VIETNAM, *POLITICS*
The campaign for election to South Vietnam's Constituent Assembly officially opens with 540 candidates running.

SEPTEMBER 11

SOUTH VIETNAM, *POLITICS*
Of the 718,024 eligible voters in I Corps Tactical Zone 87.4 percent vote in South Vietnam's Constituent As-

sembly election. Over 80 percent of those who register vote throughout polling places in South Vietnam.

SEPTEMBER 13–18

SOUTH VIETNAM, *GROUND WAR*
The US Marines conduct DeckHouse IV, an amphibious search and destroy operation in conjunction with the ongoing Prairie I Operation, 12.8km (8 miles) northeast of Dong Ha in I Corps Tactical Zone.

SEPTEMBER 14–NOVEMBER 24

SOUTH VIETNAM, *GROUND WAR*
Operation Attleboro in War Zone C, Tay Ninh Province, takes place over a 72-day period and is initiated by the 196th Light Infantry Brigade. There is no significant contact with the enemy until October 19 when a sizeable enemy base area is uncovered. By November, the 1st Infantry Division, 3rd Brigade, 4th Infantry Division, and several ARVN battalions are involved.

A major action takes place on November 3, involving the US 1st and 25th Infantry Divisions, 196th Light Infantry Brigade, 173rd Airborne Brigade and two South Vietnamese battalions.

As it ends, US MACV reports that there are 1106 confirmed enemy casualties. This figure is the largest number of enemy casualties recorded to date as the result of a US military operation.

SEPTEMBER 19

SOUTH VIETNAM, *SOUTH KOREAN FORCES*
The 2nd Battalion of the 2nd Brigade, Republic of Korea Marine Corps, arrives at Chu Lai from Cam Ranh Bay, where they were stationed to operate as a security force.

SEPTEMBER 23–NOVEMBER 9

SOUTH VIETNAM, *GROUND WAR*
Operation Maeng Ho is conducted by the élite Republic of Korea Capital Division which is operating in Binh Dinh Province. It is later reported that in this operation, which continues over a period of 48 days, the ROK soldiers kill more than 1161 enemy soldiers.

SEPTEMBER 25

SOUTH VIETNAM, *US AID*
Marine Air Group 13 arrives at the Marine Air Facility at Chu Lai, having come from its base in Iwakuni, Japan.

▲ A voter leaves the booth after voting in the Constituent Assembly election. In the background, a Revolutionary Development team member uses a public address system to announce that the polls are open.

▼ Men from the 4th Marine Regiment cross a stream while on their way to their objective in Quang Tri Province, northwest of Dong Ha, during Operation Hastings.

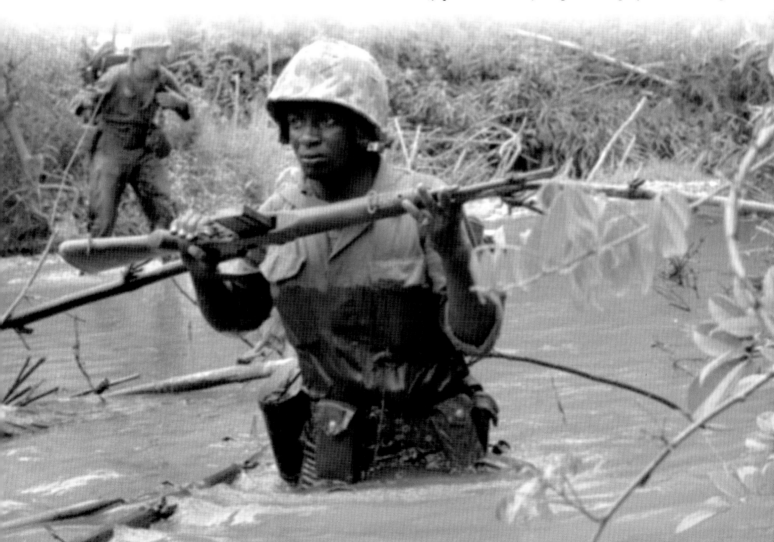

OCTOBER 1

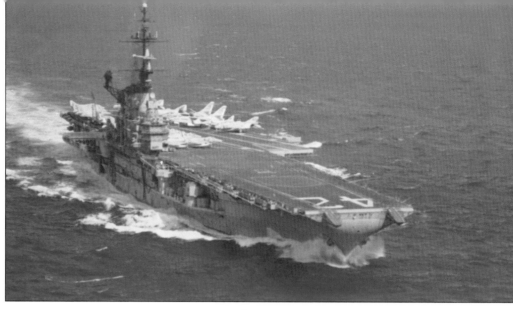

▶ *USS Franklin D. Roosevelt in the Gulf of Tonkin in October 1966. This Midway class carrier had a crew of 4500 and could deploy up to 70 aircraft.*

OCTOBER 1

SOUTH VIETNAM, *US GROUND FORCES*

General Herman Nickerson, Jr, replaces Major-General Lewis J. Fields as the Commanding General of the 1st Marine Division.

OCTOBER 2

SOUTH VIETNAM, *US GROUND FORCES*

Equipped with 175mm guns, Battery C, 6th Battalion, 27th Field Artillery Regiment, comes under the control of Task Force Delta in I Corps Tactical Zone.

OCTOBER 2–24

SOUTH VIETNAM, *GROUND WAR*

Operation Irving, lasting 23 days, is carried out by the sky soldiers of the 1st Cavalry Division (Airmobile), ARVN, and Republic of Korea troops against the NVA 610th Division in Binh Dinh Province with 681 enemy casualties.

OCTOBER 8

SOUTH VIETNAM, *US AID*

The 4th Battalion, 503rd Airborne Infantry, 173rd Airborne Brigade, arrives at Da Nang.

OCTOBER 10

SOUTH VIETNAM, *US GROUND FORCES*

The US 3rd Marine Division is ordered to deploy to Thua Thien and Quang Tri Provinces in the north of South Vietnam in order to conduct offensive operations as directed, and continue current offensive operations in the Phu Bai

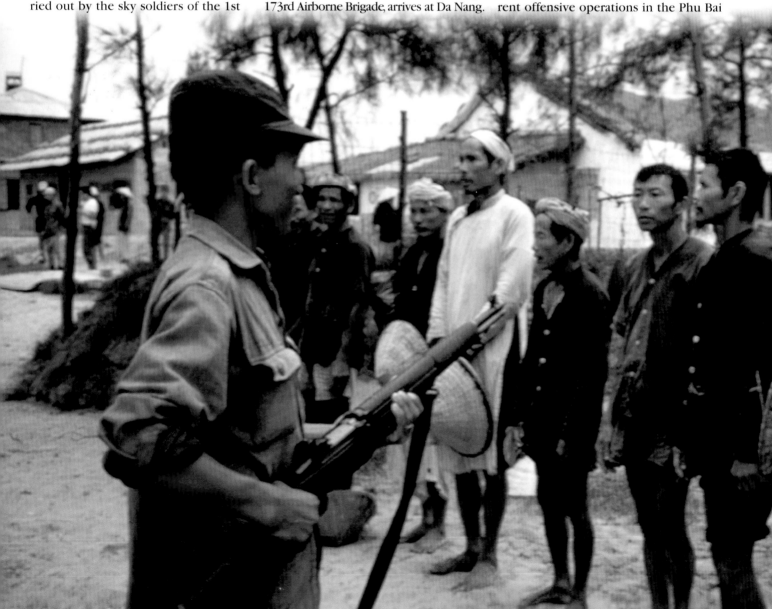

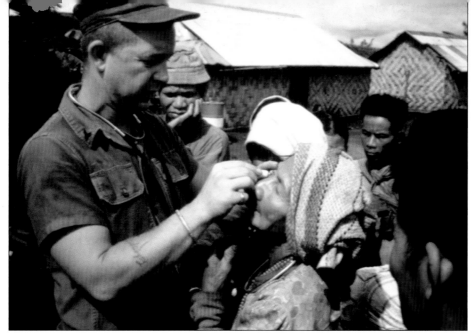

◀ *"Hearts and Minds" in action: an elderly Montagnard woman has her eyes treated by a US Navy medical officer during sick call for the residents of the village of Sui Thong.*

operation, sees the soldiers of the US Army's recently arrived 4th Infantry Division – along with elements of the 25th Infantry Division and 1st Air Cavalry Division – conduct an operation near the Cambodian border in Pleiku Province. The US soldiers inflict a total of 809 casualties on the enemy, and the operation takes place over 74 days altogether.

TAOR. Task Force Delta is ordered deactivated; Task Force X-Ray is activated at Chu Lai under the 1st Marine Division. The 1st Marine Division is now responsible for all three southern provinces around Chu Lai against an enemy growing in numbers.

OCTOBER 12–18

SOUTH VIETNAM, *US GROUND FORCES*

The US Army's 1st Battalion, 40th Field Artillery Regiment, which consists of 105mm self-propelled howitzers, arrives at Da Nang, and the next day the US Army's 2nd Battalion, 94th Artillery Regiment, consisting of self-propelled 175mm guns, also arrives.

OCTOBER 18–DECEMBER 30

SOUTH VIETNAM, *GROUND WAR*
Operation Paul Revere IV, a continuing

◀ *A member of a South Vietnam coastal division stands guard over a batch of suspects at the Cua Viet junk base until the local village chief arrives.*

▼ *Explosions on the ground as US Marine aircraft strafe the enemy with conventional iron bombs during Operation Colorado just north of Tam Ky.*

OCTOBER 24–25

USA, *DIPLOMACY*
At a conference in Manila, President Johnson holds a meeting with leaders from six other nations: South Vietnam, New Zealand, Australia, Korea, Thailand and the Philippines. The conferees issue a four-point statement called the *Declaration of Peace*, which demands the peaceful settlement of the Vietnam War.

OCTOBER 25–FEBRUARY 12

SOUTH VIETNAM, *GROUND WAR*
Operation Thayer I begins. This is an operation in Binh Dinh Province conducted by elements of the 1st Cavalry Division (Airmobile). It is followed by Operation Thayer II and in turn by Operation Pershing in the rich northern coastal plain and Kim Son and Loi Ci Valley to the west. There is a total of 1757 confirmed enemy casualties and the operation takes place over 111 days.

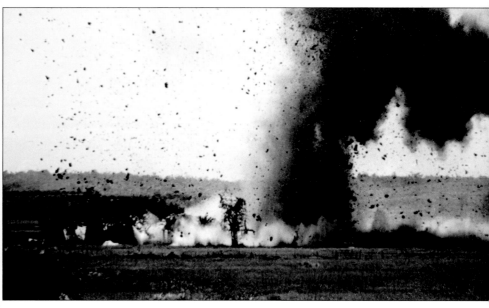

KEY PERSONALITY

LIEUTENANT-GENERAL LEWIS W. WALT, USMC

Lieutenant-General Lewis William Walt, winner of the Navy Cross who led Marines in three wars (World War II, Korea, and Vietnam) was, at the time of his appointment as Commanding General of III Marine Amphibious Force (III MAF) on June 4, 1966, the youngest major-general in the Marine Corps. A graduate of Colorado State University in 1936, he entered the Marine Corps as a second lieutenant on July 6, 1936. After attending the Basic School at the Philadelphia Navy Yard, he served in various assignments, prior to joining the 1st Marine Raider Battalion.

After the outbreak of World War II he served briefly on the island of Samoa prior to the deployment of the 1st Raider Battalion to the island of Tulagi on August 7, 1942, where he served as a company commander with the 1st Marine Raider Battalion and was awarded the Silver Star for conspicuous gallantry in actions against a force of fanatical Japanese infantrymen. Transferred to Guadalcanal, Captain Walt participated in the defence and capture of the island from the Japanese in command of the 2nd Battalion, 5th Marines, 1st Marine Division. In October 1942, Major Walt was wounded in action on Guadalcanal but continued to lead his Marines in combat until evacuated. On December 22, 1942, he was meritoriously promoted to the rank of lieutenant-colonel for distinguished leadership under fire. In December 1943, he assumed command of the 2nd Battalion, 5th Marines, again and participated in operations in the assault on Cape Gloucester. During combat operations there Walt received his first of two Navy Crosses for personally hauling into position

a 75mm pack howitzer atop Aogori Ridge. In honour of Walt's heroic actions, General Lemuel C. Shepherd, Jr., 1st Marine Division commanding general, renamed Aogori Ridge "Walt's Ridge". In subsequent actions on the island of Peleliu, Walt assumed command of the 5th Marines when both the commanding and executive officers were killed by enemy fire. Lieutenant-Colonel Walt quickly assumed command of the regiment and seized the assigned objective in the face of murderous enemy fire.

After World War II, Lieutenant-Colonel Walt served on various assignments until once again he served with the 1st Marine Division as commanding officer of the 5th Marines and in staff assignments. During the 1950s and early 1960s he served in a variety of assignments until being assigned to the Republic of Vietnam as Chief of Naval Forces, commander of III Marine Amphibious Force, and the 3rd Marine Division. General Westmoreland later made Major-General Walt Senior Advisor, I Corps, and I Corps Coordinator, Republic of Vietnam. During his tenure as Commanding General of III MAF, Lieutenant-General Walt firmly believed that the pacification programme should receive top priority.

Recalling his training as a young Marine officer, Lieutenant-General Walt believed that the Marine Corps would have to "develop pacification tactics to meet the conditions unique to South Vietnam." Drawing upon the Marine Corps' *Small Wars Manual*, Lieutenant-General Walt introduced two innovative programmes, "County Fair" and "Golden Fleece", to "win the hearts and minds" of the Vietnamese. Throughout his tour as Commanding General III MAF, General Walt believed that by denying the Viet Cong access to the villages and influence over the South Vietnamese peasants, government officials of the Republic of Vietnam could re-assert their authority. He disagreed with General Westmoreland's "search and destroy" operations, as they drew the Marines and ARVN away from the villages which oftentimes came back under local Viet Cong control.

General Walt left Vietnam in June 1967 and served in a variety of assignments at Headquarters Marine Corps prior to his appointment as Assistant Commandant of the Marine Corps, where he became the first four-star general in that billet. He retired from the Marine Corps in 1971. He died on March 26, 1989, in Gulfport, Mississippi, and was laid to rest with full military honours.

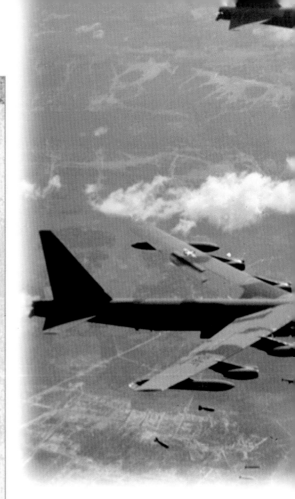

▲ *A flight of B-52 Stratofortress bombers drop their ordnance on enemy positions 40km (25 miles) from Bien Hoa Air Base.*

NOVEMBER 23

SOUTH VIETNAM, *US SOCIAL POLICIES*
The Office of Civil Operations is established in South Vietnam. This is a US Embassy activity which has been founded in order to direct US civilian support of revolutionary development.

NOVEMBER 29

SOUTH VIETNAM, *US AID*
The Headquarters Battery of the US Army's 1st Field Artillery Group arrives at the Marine base at Chu Lai. It has been sent there in order to provide the Marines, soldiers from the US Army, ARVN and other Free World forces with artillery support against the Viet Cong and NVA forces.

NOVEMBER 30–DECEMBER 14

SOUTH VIETNAM, *GROUND WAR*
Operation Fairfax is undertaken by three battalions – one each from the 1st, 4th and 25th Infantry Divisions – in and around Saigon. This operation will be taken over by the 199th Light Infantry Brigade in January 1967, with an emphasis on joint US/ARVN operations. Upon withdrawal of the 199th Light Infantry Brigade, the area of operations is

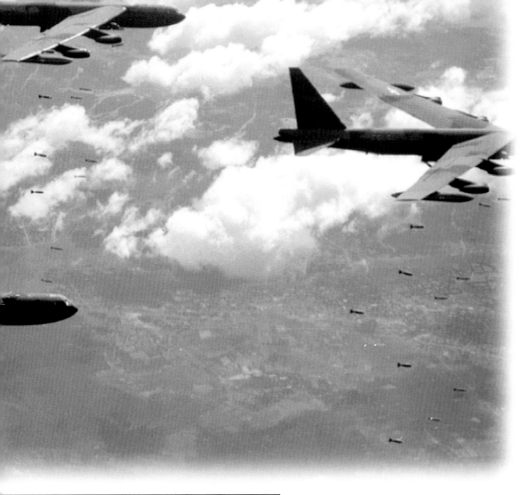

taken over by the 5th ARVN Ranger Group. During the 380-day operation, US and South Vietnamese soldiers are able to inflict a total of 1043 casualties on the Viet Cong enemy.

DECEMBER 3

SOUTH VIETNAM, *US GROUND FORCES*

The 4th Battalion, 503rd Infantry Regiment, of the US Army departs I Corps Tactical Zone, and is now heading for III Corps Tactical Zone. From now on, the 4th Battalion will be replaced in I Corps Tactical Zone by the 3rd Battalion, 9th Marines.

DECEMBER 6

USA, *FINANCIAL STRATEGY*

The Johnson Administration discloses that it will need an additional $9 to $10 billion US in supplemental funding in order to pay for the war in Vietnam during the current fiscal year.

DECEMBER 31

SOUTH VIETNAM, *US GROUND FORCES*

The total strength of III Marine Amphibious Force in I Corps Tactical Zone now stands at 65,789 US Marines, sailors, soldiers and ARVN, as well as other Free World Forces.

SOUTH VIETNAM

1. An Giang
2. An Xuyen
3. Ba Xuyen
4. Ban Lieu
5. Bien Hoa
6. Binh Dinh
7. Bing Duong
8. Binh Long
9. Binh Thuan
10. Binh Tuy
11. Chau Doc
12. Chuong Thien
13. Darlac
14. Dinh Tuong
15. Gia Dinh
16. Co Cong
17. Hau Nghai
18. Kien Giang
19. Kien Hoa
20. Kien Phong
21. Kien Tuong
22. Khanh Hoa
23. Kontum
24. Lam Dong
25. Long An
26. Long Khanh
27. Ninh Thun
28. Phong Dinh
29. Phu Bon
30. Phu Yen
31. Phuoc Long
32. Phuoc Tuy
33. Pleiku
34. Quang Duc
35. Quang Nam
36. Quang Ngai
37. Quang Tin
38. Quang Tri
39. Sa Dec
40. Tay Ninh
41. Thua Thien
42. Tuyen Duc
43. Vinh Binh
44. Vinh Long

Key
- Saigon
- low US military presence
- medium US military presence
- high US military presence

I Corps Tactical Zone

II Corps Tactical Zone

III Corps Tactical Zone

IV Corps Tactical Zone

▲ *South Vietnam 1965–75, showing the US Army's tactical zones, levels of US military activity in the various provinces throughout the war and the names of individual provinces.*

▼ *Detachment C-4 of the 5th Special Forces Group at Can Tho in the Mekong Delta. The delta was a low-lying area of extensive rice paddies, rivers and swamps.*

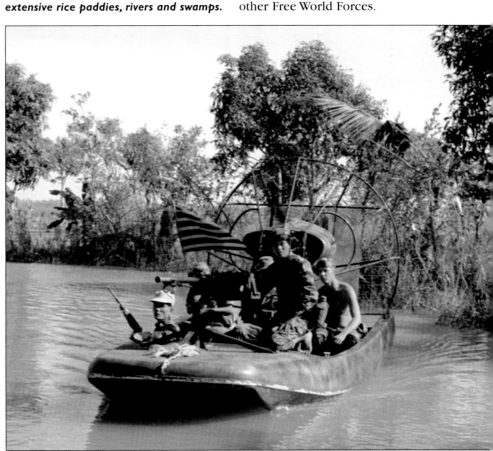

1967

A YEAR OF HARD FIGHTING

As 1967 arrived, US, South Vietnamese and Allied forces in Vietnam were locked in a war growing increasingly intense. More and more North Vietnamese Army (NVA) forces entered the fray, and as they penetrated South Vietnam, US forces upped the pace of military operations against both them and the Viet Cong. The US and South Vietnamese military undertook continuous offensives in and along the Demilitarized Zone. Marines in I Corps Tactical Zone initiated offensives to cut off NVA forces' infiltration into the Northern and Central Highlands. The leathernecks also began setting up the "McNamara Line", a series of electronic sensors and warning systems, to warn the Allies of enemy forces' movements in border areas. However, despite these measures Hanoi continued to push men and supplies down the Ho Chi Minh Trail, and in the South Viet Cong activity increased as "Charlie" waged a savage war against Saigon and its US backer.

In the Central Highlands, the US Army went over to the offensive and inflicted a series of punishing defeats on the enemy. In the area north of Saigon, the capital city of South Vietnam, US Army infantry units – such as the 1st and 25th Infantry Divisions, as well as elements of the 7th and 101st Air Cavalry along with their Army of the Republic of Vietnam (ARVN) allies – launched several major offensives designed to clear out the infamous "Iron Triangle" that had served as a major base of operations for the North Vietnamese and Viet Cong.

The US Navy, meanwhile, kept up the pressure on the North Vietnamese and Viet Cong through its interdiction campaign in the Mekong Delta and inland

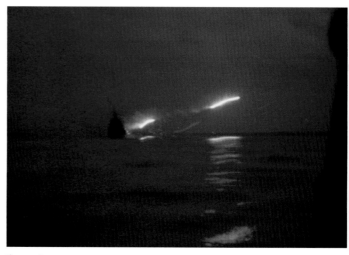

▲ Trading fire with "Charlie" in the Mekong Delta: flashes of light from a gunfire exchange with the Viet Cong make an impressive sight at night during Operation Deckhouse V.

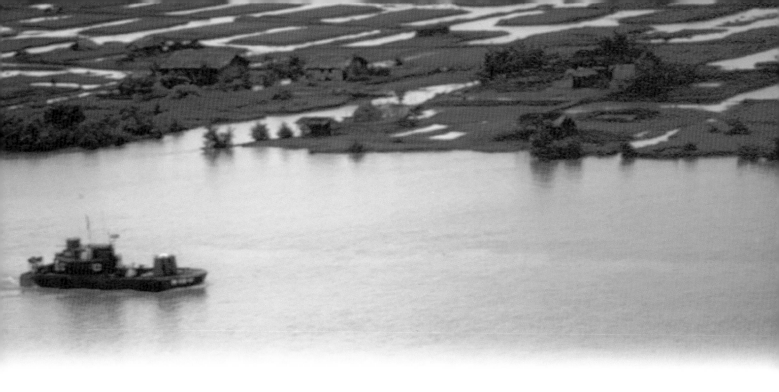

▲ *A US Navy Monitor in the Long Tau River area in the Mekong Delta, where Riverine Assault Force vessels provided fire support for US Army missions.*

waterways south of Saigon. US Navy aircraft carriers served as floating platforms for launching repeated sorties against North Vietnamese forces in support of US ground operations in and around South Vietnam's long coastline. US naval vessels likewise provided naval gunfire support for US, South Vietnamese and Allied forces (South Korean and Australian) operating in unison with US Marines and US Army in the northern military districts and along South Vietnam's long coastline.

The US Air Force also maintained a steady pressure on the enemy through its three-pronged offensive over the skies of South Vietnam, Laos, bombing missions against the Ho Chi Minh Trail, and against Petroleum, Oil and Lubricants (POL) plants in North Vietnam, as well as attacking the bridges and major rail networks which were ferrying supplies to points along the major supply routes heading straight towards South Vietnam.

On the political front, President Lyndon Johnson and his advisors struggled to maintain the pressure on North Vietnam, all the while seeking a political solution to end the war. The Johnson Administration also sought to placate the

so-called "doves" and the antiwar movement at home, which threatened to not only derail the American military campaign against North Vietnam but also to upset the "peace feelers" which the administration had sent out to North Vietnamese leaders. By so doing President Johnson hoped not only to discourage Hanoi's continued infiltration southwards, but also to end its support to the National Liberation Front (Viet Cong). But his attempts failed.

▼ *H-34 Seahorse helicopters fly in supplies and equipment to White Beach after an amphibious assault by US Marines during Operation Deckhouse V in early January 1967.*

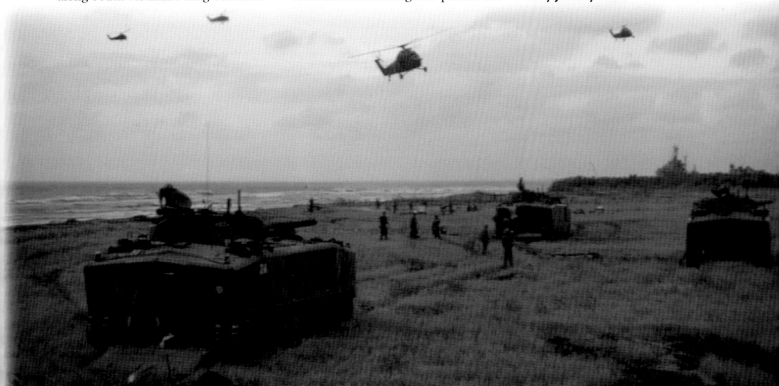

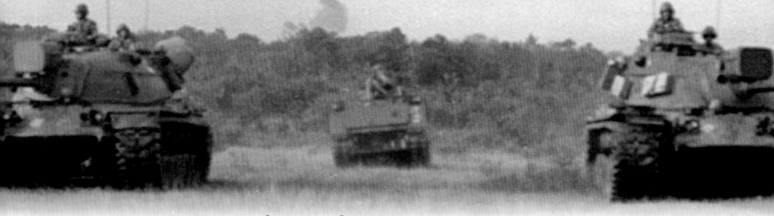

▲ M48 tanks and M113 armoured personnel carriers of the 25th Infantry Division advance in search of the enemy during Operation Cedar Falls.

JANUARY 1

SOUTH VIETNAM, *GROUND WAR*

Two brigades of the US Army's 4th Infantry Division, with contingents of the 25th Infantry Division attached, launch Operation Sam Houston in Pleiku and Kontum Provinces, aimed at the destruction of the regiments of the North Vietnamese 1st Division now operating in the two provinces from bases inside Cambodia. In a total of 95 days of sustained combat operations, the NVA loses 733 killed in action.

As 1967 began, the 3rd Marine Division, part of III Marine Amphibious Force (III MAF), was fighting two wars: a conventional one along the Demilitarized Zone (DMZ), where it confronted the regular North Vietnamese forces, and a counterguerrilla war throughout the rest of Quang Tri and Thua Thien Provinces. Although committed to both campaigns, the threat posed by NVA forces forced the Marines to concentrate on the larger, conventional war along the DMZ. At that point, US Marine strength in I Corps Tactical Zone (ICTZ) stood at a total 65,789 officers and men.

JANUARY 3

SOUTH VIETNAM, *GROUND WAR*

Republic of Korea troops begin Operation Maeng Ho 8, a 60-day search and destroy operation in Phu Yen and Binh Dinh Provinces in II Corps Tactical Zone. Korean troops kill 211 Viet Cong soldiers and capture 403.

JANUARY 6

SOUTH VIETNAM, *NAVAL WAR*

The US Marines' Special Landing Force (Battalion Landing Team, 1st Battalion, 9th Marines, 3rd Marine Division), along with some elements of the 3rd and 4th Marine Battalions, launches Deckhouse V from the USS *Iwo Jima* (LPH-2), which assaults an area of suspected Viet Cong concentrations along the coast between the Co Chien and Ham Luong reaches of the Mekong Delta. The Marines manage to kill only 21 Viet Cong, destroy two small-arms workshops and capture 44 weapons and 42.6 tonnes (42 tons) of rice. Seven US Marines are killed in action, while one South Vietnamese Marine dies in a combat-related accident.

JANUARY 8

SOUTH VIETNAM, *GROUND WAR*

The US Army launches Operation Cedar Falls, which has been planned with the objective of destroying the Viet Cong's

headquarters as well as interdicting the movement of enemy forces into the major war zones in III Corps Tactical Zone, and defeating Viet Cong units encamped there.

Like Operation Attleboro preceding it, Cedar Falls tapped the manpower and resources of nearly every US Army unit in the corps area. A series of preliminary manoeuvres brought army units into position, while several air assaults sealed off the area known as the Iron Triangle exploiting the natural barriers of the rivers that formed two of its boundaries. Then American units began a series of sweeps to push the enemy towards the blocking forces. At the village of Ben Suc, long under the sway of the Viet Cong, 60 helicopters descended into seven landing zones in less than a minute. Ben Suc was surrounded and its entire population evacuated, before the village and tunnel complex were destroyed. But the Viet Cong had fled before the heliborne assault. As Cedar Falls progressed throughout January and into February, US troops destroyed hundreds of enemy fortifications, captured

▼ Troops of the 173rd Airborne Brigade with captured Viet Cong personnel taken during Cedar Falls. Over 500 suspected Viet Cong were captured in total.

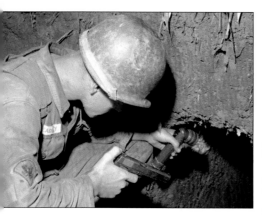

▲ Ronald Headly of the 65th Engineer Battalion checks the entrance to a Viet Cong tunnel during Cedar Falls. The Iron Triangle was riddled with tunnel networks.

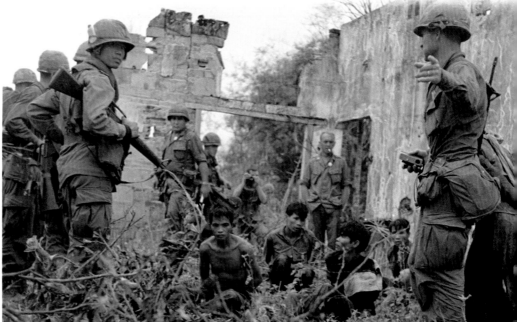

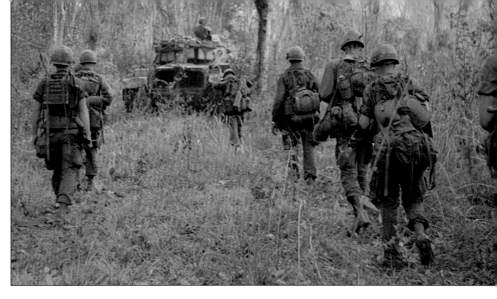

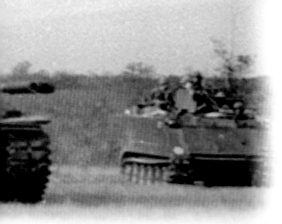

large quantities of supplies and food, and evacuated the hamlets. But contact with the enemy was fleeting. Most of the Viet Cong, including the high-level cadre of the regional command, had escaped by infiltrating through Allied lines.

JANUARY 11

SOUTH VIETNAM, *US AID*
After an inspection tour of Marine forces in South Vietnam, the Commandant of the Marine Corps, General Wallace M. Greene, tells the press that nearly one-fourth or 22 percent of the US Marine Corps is now in Vietnam.

JANUARY 26

SOUTH VIETNAM, *FORTIFICATIONS*
United States Military Assistance Command, Vietnam (MACV), headquarters completes its Practice Nine Requirements Plan for constructing a strong-

point obstacle system (SPOS) south of the Demilitarized Zone. This is the beginning of the McNamara Line.

JANUARY 27

SOUTH VIETNAM, *SOCIAL POLICIES*
The III MAF will take over the bulk of fighting the NVA, since the 2nd ARVN Division will now concentrate on the Revolutionary Development programme, otherwise known as pacification.
SOUTH VIETNAM, *GROUND WAR*
Operation Desoto begins along South Vietnam's coast near Nui Dang and Vinh

▲ *A tank of the 11th Armored Cavalry Regiment leads soldiers from the 173rd Airborne Brigade through Thanh Dien Forest during Cedar Falls.*

Binh. Operation Desoto would last nearly three months and would be assisted by the Seventh Fleet's Special Landing Force, a special task-organized Marine amphibious reaction force which was airlifted into battle off South Vietnam's coast, and provided III MAF commanders with a manoeuvrable on-call force of US Marines to execute special landing missions.

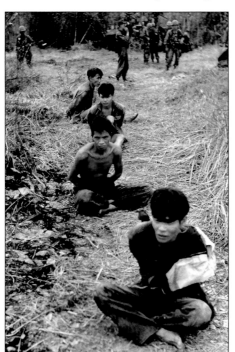

▲ *Viet Cong captured in the Iron Triangle. Though Cedar Falls was a large operation, the Viet Cong were active in the area within a week of its end.*

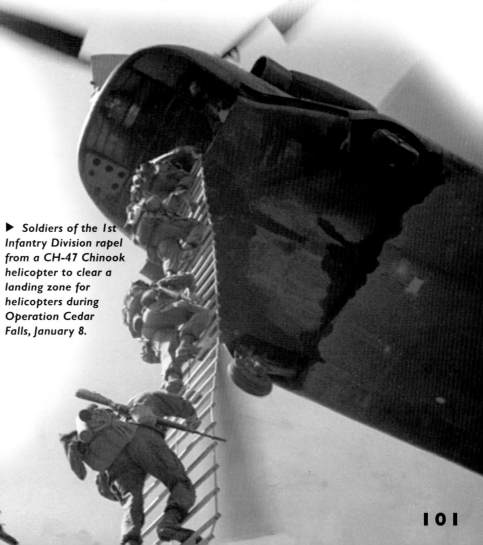

▶ *Soldiers of the 1st Infantry Division rapel from a CH-47 Chinook helicopter to clear a landing zone for helicopters during Operation Cedar Falls, January 8.*

JANUARY 31

▲ *A US Air Force forward air controller in an 0-1H Bird Dog spotter plane over South Vietnam at the end of January.*

JANUARY 31

SOUTH VIETNAM, *GROUND WAR*
Operation Prairie I ends. At its height, the operation has involved six US Marine infantry battalions, accounting for the largest number of enemy casualties in a single Marine operation to date: 1397 North Vietnamese and Viet Cong soldiers killed and 27 captured. The Marine casualties include 239 killed and 1214 wounded in action.

FEBRUARY 1

SOUTH VIETNAM, *GROUND WAR*
Operation Prairie II commences. The Marines, in conjunction with ARVN forces, once again set out to seek out and destroy all enemy forces in Quang Tri and Thua Thien Provinces and to defend the area against attack. Backed up by three infantry battalions, two reconnaissance companies and supporting units, the leathernecks are to conduct extensive patrols and sweeps by units of various sizes, including large-scale operations with infantry battalions.

FEBRUARY 8–12

SOUTH VIETNAM, *GROUND WAR*
Despite the bombing halt by US Air Force and Navy jets north of the DMZ

▶ *A US Marine of the 2nd Battalion, 5th Marine Regiment, prepares to fire his M79 grenade launcher in early February 1967.*

▲ *Sergeant William Brown of the 87th Chemical Detachment at the entrance to a Viet Cong tunnel during a search and destroy mission south of Cu Chi.*

and in South Vietnam itself, NVA and Viet Cong forces continue to launch sporadic violations of the annual Tet (New Year's) Nguyen Dan truce. US Air Force aerial intelligence reports significant enemy activity north of the DMZ, including heavy boat and truck traffic throughout the area. The North Vietnamese take full advantage of the truce to reposition, resupply and replace its personnel in South Vietnam.
SOUTH VIETNAM, *GROUND WAR*
The 1st Marine Regiment conducts its Operation Stone in Quang Nam Province. During this operation, US Marines destroy a vast network of caves, tunnels and bunkers. In the second phase of the operation, Marines surround elements of the enemy's R-20 Battalion and then conduct a sweeping operation over the cordoned area.

FEBRUARY 11

SOUTH VIETNAM, *GROUND WAR*
The 1st Air Cavalry Division commences Operation Pershing in Binh Dinh Province, where this division conducted Operation Thayer during the previous year. The operation has been designed to eliminate the enemy from this rice-rich coastal province. Operation Pershing will be a long-range offensive that will extend into 1968.

In both Thayer and later Pershing, the air cavalrymen killed 7500 of the enemy and helped establish effective

STRATEGY & TACTICS

THE BARRIER SYSTEM AND THE DMZ

One of the novel and certainly the most controversial methods implemented by the US military to stop the infiltration of men and material from North Vietnam into South Vietnam was the proposed Anti-Infiltration or Barrier System. Proposed by Secretary of Defense Robert S. McNamara, and envisioned as a 40km- (25-mile-) long "physical barrier" supported by early warning devices along its entire length, as well as carefully selected and constructed fortified positions on key avenues of approach, the "Barrier" was meant to "reduce the need for costly operations in an area constantly subjected to enemy-directed artillery and mortar fire from adjacent sanctuaries." Labelled by Marines as the "McNamara Line", and planned exclusively for the area adjacent to the Demilitarized Zone, the Barrier was to assist the US Marines to detect enemy incursions and movements at greater ranges. Backed up by infrared intrusion detectors and ground sensors, it was thought that the balanced pressure system would indicate an increase in weight, produced by a person walking or a vehicle, setting off the sensors and thus bring pre-registered artillery, air and naval gunfire onto the target or targets.

Work began on the Anti-Infiltration System in April 1967 and continued off and on until mid-1968. Work slowed during the summer and fall of 1967 and ended due largely to the diversion of the Marines by the NVA's summer and fall military campaigns. The project was "shelved" when General Westmoreland ordered an increased presence of US troops in I Corps Tactical Zone to meet the emergencies posed by the enemy in the summer of 1967. The devices emplaced by the Marines and US Army provided US intelligence with timely targets during the Tet Offensive and the siege at the Marine Corps' fire support base at Khe Sanh. Dropped from helicopters and airplanes (OV-10 "Broncos"), hung in trees, placed on river banks or buried by troops, they provided targeting data for air and artillery strikes. The portions completed by the winter of 1968, detecting an ever-increasing heavier flow of enemy men and material southwards across the DMZ, saved many US, South Vietnamese and Allied lives. As one US Congressional hearing concluded, the Barrier system permitted US troops to adopt more mobile tactics against the NVA in I Corps Tactical Zone. The sensors contributed to a difficult, and possibly the most important, task of the war: finding, fixing and destroying the enemy in a timely manner.

◀ *A B-52 being loaded with incendiary bombs prior to supporting Operation Junction City in February.*

Triangle, United States Military Assistance Command, Vietnam, had already received reports that both Viet Cong and North Vietnamese Army regiments were returning to War Zone C in preparation for a spring offensive. This time General William C. Westmoreland had hoped to prevent Communist forces from escaping into neighbouring Cambodia as they had done during Operation Attleboro.

From forward hill positions established during earlier operations, elements of the 25th and 1st Divisions, the 196th Infantry Brigade, as well as the 11th Cavalry Regiment, launch Operation Junction City, moving rapidly to establish a cordon around the war zone and conduct a sweep of the base area. As airmobile and mechanized units move into position on the morning of February 21, elements of the 173rd Airborne Brigade make the only paratroop drop of the Vietnam War,

governmental control throughout most areas of the province.

FEBRUARY 21

SOUTH VIETNAM, *CASUALTIES*
Dr Bernard Fall, noted historian of the French combat experience in Indochina,

is killed by an enemy mine on Highway 1. He was accompanying the 1st Battalion, 9th Marines, in Operation Chinook.

FEBRUARY 22

SOUTH VIETNAM, *GROUND WAR*
By the time US Army units left the Iron

FEBRUARY 25

and the first combat airborne assault since the Korean War, in order to establish a blocking position near the Cambodian border. Then, other US and Allied units enter the horseshoe-shaped area of operations through the opened end. Despite the emphasis on speed and surprise, US Army units do not encounter many enemy troops at the outset. But as the operation enters the second phase, US forces concentrate their efforts in the eastern portion of War Zone C, close to Route 13. Here, several violent battles erupt as Communist forces try to isolate and defeat individual units and to screen their comrades' retreat into Cambodia.

FEBRUARY 25
SOUTH VIETNAM, *GROUND WAR*
US Marines ask for and receive permission from General Westmoreland and the National Command Authority in Washington, D.C., to shell North Vietnamese troop and equipment positions north of the DMZ in North Vietnam. The North Vietnamese can no longer claim this area a "safe haven": General Westmoreland and the White House now consider staging and support area targets to be hit whenever and wherever they are considered to be setting the stage for an offensive operation against US and ARVN forces.

FEBRUARY 26
SOUTH VIETNAM, *GROUND WAR*
The 1st Marines begin Operation Lafayette, a multi-battalion effort, in Quang Nam Province.

▼ *The US Marines brought their own aircraft to Vietnam. This is a fully armed A-4E Skyhawk of Marine Attack Squadron 211 just prior to take-off.*

▲ *Military operations meant casualties. Here, medics at the 93rd Medical Evacuation Hospital work on a man wounded during Operation Junction City.*

FEBRUARY 28
SOUTH VIETNAM, *NAVAL WAR*
United States Military Assistance Command, Vietnam, activates the Mekong Delta Mobile Riverine Force under the command of Commander, Naval Forces, Vietnam. The US Army's 9th Infantry Division is assigned to this mission.

MARCH 2
SOUTH VIETNAM, *AIR WAR*
Two US Air Force fighter jets mistakenly bomb the village of Lang Vei in the early evening, killing 112 Vietnamese civilians and wounding 213. They also destroy 140 buildings. A US Marine battalion is rushed to the scene and assists in the evacuation of the wounded. Meanwhile, NVA artillery hits the fire support base at Khe Sanh with more than 90 rounds of 82mm mortar, killing 2 Marines and wound 17. On March 5, 14 NVA soldiers are detected by the Marines probing

the Khe Sanh perimeter. The defending Marines drive them off with claymore mines. This is the start of the first major battle for Khe Sanh, which officially begins on April 24.

MARCH 7
SOUTH VIETNAM, *GROUND WAR*
The NVA launches three mortar attacks against the Marine Corps' fire support base at Camp Carroll. The Marines estimate that the NVA threw 485 rounds at the base, including 209 spin-stabilized 122mm rockets.

MARCH 10
US ARMY, *EQUIPMENT*
III Marine Amphibious Force completes the issue of 5.56mm M-16 assault rifles to all US Marines in Vietnam. The weapon replaces the 7.62mm M-14.

MARCH 15
USA, *DIPLOMACY*
The White House announces career diplomat Ellsworth Bunker will replace Henry Cabot Lodge as US Ambassador to Saigon.

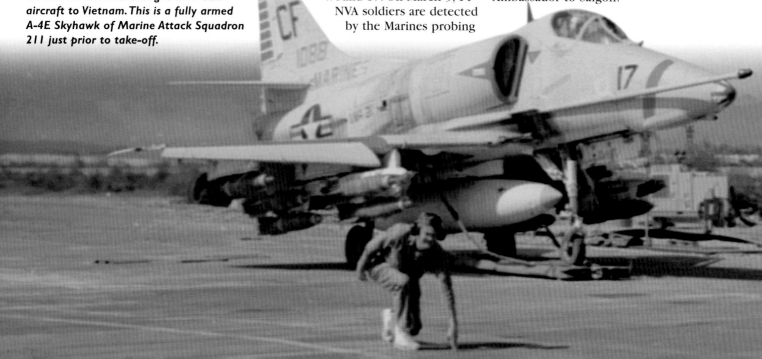

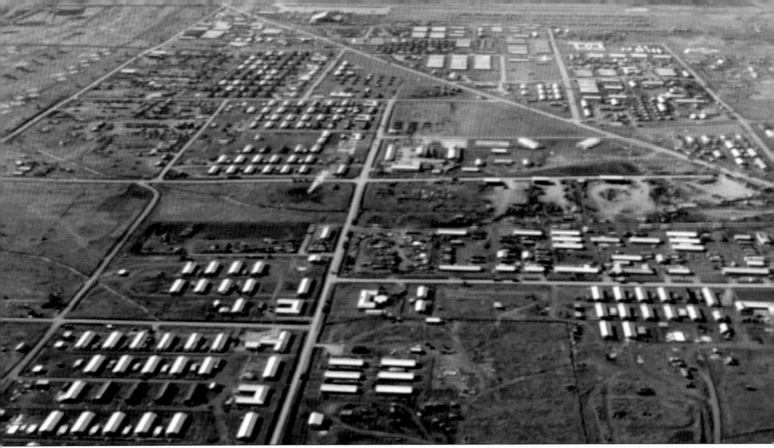

▲ *This photograph provides an example of the size of the bases the Americans built in South Vietnam: the helicopter base of the 1st Air Cavalry Division.*

MARCH 18

SOUTH VIETNAM, *US GROUND FORCES*
The first woman US Marine is assigned to United States Military Assistance Command Headquarters in Saigon. Master Sergeant Barbara J. Dulinsky will serve at General Westmoreland's headquarters in the combat operations centre.

SOUTH VIETNAM, *GROUND WAR*
At 24:00 hours Operation Prairie II ends. The Marines have inflicted 694 battle dead and 20 captured on the NVA. Marine casualties are 93 killed

and 483 wounded. Of the Marine combat deaths, one-third of those killed in action and two-thirds wounded in action have been caused by enemy mortar rounds.

MARCH 19

SOUTH VIETNAM, *GROUND WAR*
Operation Junction City. A mechanized unit of the US Army's 9th Infantry Division is attacked and nearly overrun by Viet Cong forces along Route 13 near the village of Bau Bang. The combined firepower of armoured cavalry, supporting artillery and close air support eventually causes the enemy to break contact. A few days later, at Fire Support Base Gold, in the vicinity of Souoi Da, one infantry and one artillery battalion attached to the 25th Infantry engage the 272nd Viet Cong Regiment. Behind an

▲ *A Vought F-8 Crusader fighter comes in to land. The Marines used the F-8 in the attack role to support ground forces.*

intense walking mortar barrage, enemy troops breach Gold's defensive perimeter and rush into the base. Hand-to-hand combat ensues. A disaster is averted when artillerymen lower their howitzers and fire directly into the oncoming enemy "Beehive" artillery rounds containing hundreds of dartlike projectiles.

The last major encounter with enemy troops during Junction City occurred at the end of March when elements of two Viet Cong regiments, the 271st and 70th Guard (which was directly subordinate to COSVN) attacked a battalion of the US 1st Infantry Division in a night defensive position deep in War Zone C near the Cambodian border.

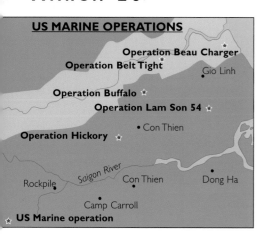

US MARINE OPERATIONS

Operation Beau Charger
Operation Belt Tight
Gio Linh

Operation Buffalo
Operation Lam Son 54
• Con Thien
Operation Hickory

Rockpile — Saigon River — Con Thien — Dong Ha
Camp Carroll
US Marine operation

◀ US Marine operations in and around the Demilitarized Zone in 1967. Despite its name, the North Vietnamese infiltrated forces across the line throughout the war.

The lopsided casualties – over 600 enemy killed in contrast to the 10 Americans killed – forcefully illustrated once again the USA's ability to call in overwhelming superior fire support by artillery, armed helicopter gunships and tactical aircraft.

MARCH 26

SOUTH VIETNAM, *US GROUND FORCES*

General Westmoreland, Commander, US Military Assistance Command, Vietnam, orders III Marine Amphibious Command to prepare a plan to locate, construct and occupy a strongpoint obstacle system south of the Demilitarized Zone.

APRIL 5

SOUTH VIETNAM, *GROUND WAR*

The 4th Marines commence a multi-battalion operation named Big Horn in Thua Thien Province.

APRIL 6

SOUTH VIETNAM, *GROUND WAR*

Two brigades of the US Army's 4th Infantry Division, along with elements of the US Army's 25th Division attached, launch Operation Francis Marion along the Cambodian border in Pleiku Province against the Viet Cong and the North Vietnamese 1st Division. In 190 days of sustained combat, the Americans kill over 1200 of the enemy.

SOUTH VIETNAM, *US ARMED FORCES*

The White House announces that from today, General Creighton W. Abrams, Jr., will serve in the post of the Deputy Commander, US Military Assistance Command, Vietnam, as General Westmoreland's assistant.

APRIL 6–10

SOUTH VIETNAM, *GROUND WAR*

The 1st Marines and South Vietnamese Rangers conduct Operation Canyon.

APRIL 12

SOUTH VIETNAM, *US GROUND FORCES*

Task Force Oregon is established in the southern part of I Corps Tactical Zone to work as a provisional division-size organization, enabling US Marine units to reinforce forces in the northernmost provinces, where enemy pressures continue to mount. Task Force Oregon initially comprises the 3rd Brigade, 25th Infantry Division, and the 196th Infantry Brigade.

▼ In the Mekong Delta the Americans established the Brown Water Navy to patrol the waterways. Here, a heavily armed Monitor leads a river assault flotilla.

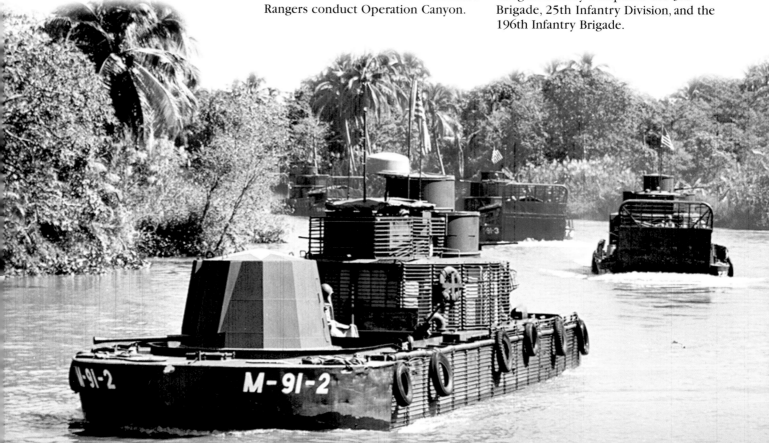

▲ *Monitors and Armored Troop Carriers of the Riverine Assault Force with their mother ship in the Mekong Delta. Note the helipad on the larger vessel.*

APRIL 19

SOUTH VIETNAM, *AUSTRALIAN AID*
Eight Australian Canberra (B-57) bombers from Squadron No 2, Royal Australian Air Force, arrive at Phan Rang Air Base.

APRIL 20

SOUTH VIETNAM, *AUSTRALIAN AID*
The 7th Battalion, Royal Australian Regiment, arrives to join the Australian Task Force in Phuoc Tuy Province.
SOUTH VIETNAM, *GROUND WAR*
US Marines launch Operation Prairie IV as a two-regiment search and destroy operation, covering the same area as previous Prairie operations in and around Quang Tri City. Units involved are the 3rd Battalion, 3rd Marines, and the 3rd Battalion, 9th Marines.

APRIL 24

SOUTH VIETNAM, *GROUND WAR*
A major battle breaks out between the Marines and the NVA near the Khe Sanh fire base. This will signal the commencement of heavy fighting between the US Marines and the NVA throughout the summer of 1967.
 In conjunction with their pressure against Khe Sanh, the NVA also stepped up its activities east of the fire base and attacked several Marine and US

Army positions around Gio Linh, Camp Carroll and Dong Ha with mortars, rockets and artillery.

APRIL 26

SOUTH VIETNAM, *US GROUND FORCES*
The Commanding General, US 1st Marine Division, turns over responsibility for the defence of the Chu Lai Air Base and logistics complex to the Commanding General of Task Force Oregon.

APRIL 27–28

SOUTH VIETNAM, *GROUND WAR*
The fighting around Gio Linh and Dong Ha is extremely savage as the NVA hurl approximately 850 rounds of artillery and 250 mortar shells at the US Marine positions around Gio Linh, while hitting the Dong Ha base with more than 50 140mm rockets.

APRIL 29

SOUTH VIETNAM, *ELECTIONS*
Throughout 984 villages in South Vietnam, 77 percent of the registered voters among the villagers turn out for local elections.

MAY 1

SOUTH VIETNAM, *US ARMED FORCES*
US military strength in South Vietnam reaches 436,000 men and women.

MAY 2

SOUTH VIETNAM, *FORTIFICATIONS*
The 11th Engineer Battalion completes a 200m- (656ft-) wide trace between

▶ *Led by a Monitor, US Navy Armored Troop Carriers transport US Army soldiers to their operating stations in the Long Tau River area of the Mekong Delta.*

▲ *Landing craft dock at the Cua Viet base to take on supplies, ammunition and equipment bound for the Dong Ha combat base in early May.*

Con Thien and Gio Linh and begins clearing a further 500m- (1654ft-) wide perimeter around each position to start construction of Secretary of Defence McNamara's planned "barrier system".

MAY 3

SOUTH VIETNAM, *GROUND WAR*
In some of the heaviest fighting of the Vietnam War to date, the US Marines seize Hill 881N, northwest of the fire support base located at Khe Sanh. This position affords a position overlooking the enemy's infiltration routes.

MAY 4

SOUTH VIETNAM, *US ARMED FORCES*
Major-General Abrams and the special

MAY 8

▶ *Vietnamese sampans spotted by a forward air control aircraft in May. These vessels were smuggling weapons and ammunition to the Viet Cong.*

Ambassador for Counterinsurgency, Robert Komer, arrive in Saigon to take up their respective duties as Deputy Commander, United States Military Assistance Command, Vietnam, and Deputy to Commander, United States Military Command, Vietnam, for Civil Operations and Revolutionary Development.

MAY 8

SOUTH VIETNAM, *GROUND WAR*
On the 13th anniversary of the fall of the French base at Dien Bien Phu, the NVA launches a major attack against the Marine fire support base at Con Thien. The outpost, less than 3.2km (2 miles) from the southern boundary of the DMZ, is on a hill only 158m (518ft) high in the middle of a red mud plain. The Marine base at Con Thien is one of the observation posts that overlooks the DMZ to the north and west, and protects the Marines' base at Dong Ha to the southeast. As a strategic terrain feature, it is thus important for the NVA to seize. Throughout the summer of 1967 it will receive the brunt of the Communists' summer offensive.

MAY 11

SOUTH VIETNAM, *GROUND WAR*
The First Battle of Khe Sanh ends as the Marines defending the fire base beat off a furious NVA attack. In the battle, the NVA loses 940 men while the Marines suffer 155 combat deaths and 425 wounded.

During the fighting, the 1st Marine Aircraft Wing flies more than 1110 sorties and drops 1930 tonnes (1900 tons) of ordnance on a series of NVA concrete-reinforced fortifications on top of Hill 881. While Marine aircraft provide ground infantry with close air sup-

▶ *General Creighton W. Abrams was appointed General Westmoreland's chief deputy by Washington in 1967.*

port during the operation, the US Air Force carries out 23 B-52 strikes – known as "arc light" strikes – against enemy troop concentrations, supply and ammunition depots, and communications. US Marine and army artillery units fire more than 25,000 rounds at the enemy in support of the Marines in and around Khe Sanh.

SOUTH VIETNAM, *US EQUIPMENT*
The Battle of Khe Sanh was the first major test of the newly introduced combat assault rifle, the M-16. The Marines have varying opinions of the new assault weapon. The light weight of the rifle, giving them the ability to carry more ammunition than with the M-14 or M-1 Garand, as well as more grenades, is viewed as a positive factor. But some Marines still prefer the heavier 7.62mm M-14 rifle. Also, the new M-16 has a tendency to jam after being fired for a long time. The Marines will overcome this problem with better ammunition and a chrome plate fitted in the chamber of the weapon. One Marine officer

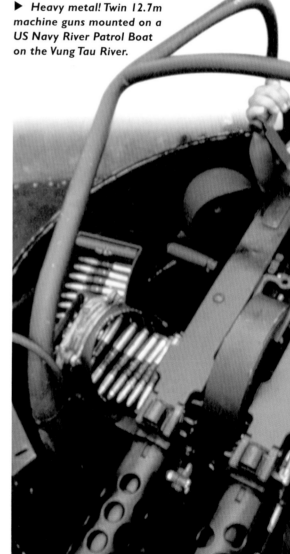

▶ *Heavy metal! Twin 12.7m machine guns mounted on a US Navy River Patrol Boat on the Vung Tau River.*

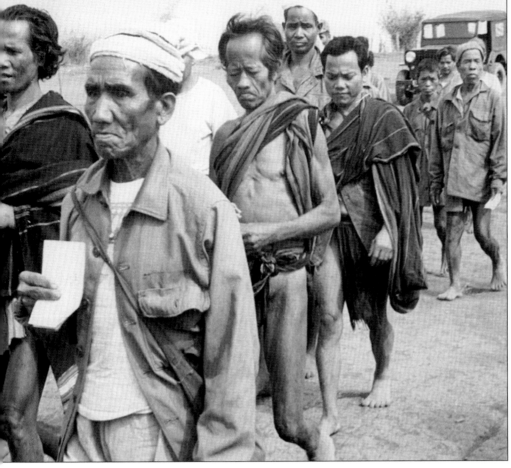

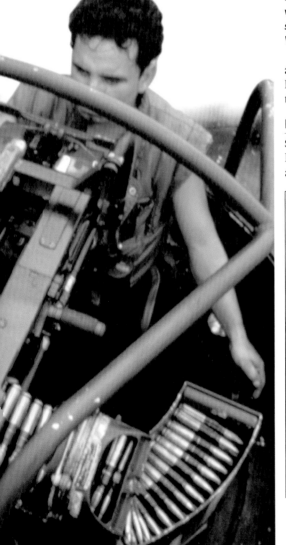

▲ Montagnard tribesmen, clutching their voting papers, make their way to a polling station in Pleiku Province to vote in South Vietnam's village elections.

attributes the success of the capture of Hill 881 to the fact that Marines have the M-16 assault rifle.

MAY 11

SOUTH VIETNAM, *US ARMED FORCES*
In the spring of 1967 the US military and non-military support of Revolution-

ary Development was merged. Mr. Robert W. Komer, a presidential assistant, was named Deputy to Commander United States Military Assistance Command, Vietnam (US Com MACV), for Revolutionary Development with the rank of ambassador. This new organization combines the former Office of Civil Operations and Revolutionary Development Support (CORDS) with MACV's Revolutionary Development Support Directorate.

MAY 13–16

SOUTH VIETNAM, *GROUND WAR*
Enemy ground action increases in and around the Demilitarized Zone as the 1st Battalion, 9th Marines, comes under heavy enemy attack with a large NVA force in well-prepared positions just south of Con Thien. The enemy fights hard and well, though breaks contact as the Marines rush reinforcements to beat off the enemy attack.

MAY 13

SOUTH VIETNAM, *GROUND WAR*
The US Marine Corps' 26th Regiment begins Operation Crockett in the Khe Sanh area.

MAY 17–18

SOUTH VIETNAM, *GROUND WAR*
During the night of May 17/18, the NVA launches heavy mortar, rocket and artillery attacks against Marine positions along the Demilitarized Zone.

▼ US Hueys fly over Quan Rhu Tuc during Operation Francis Marion, which resulted in heavy enemy casualties.

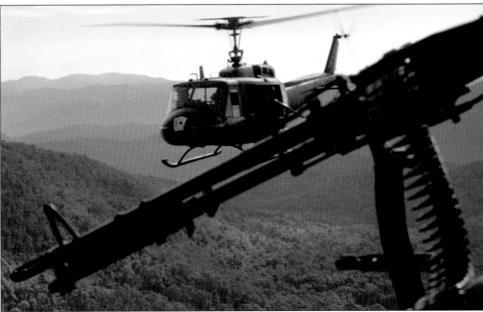

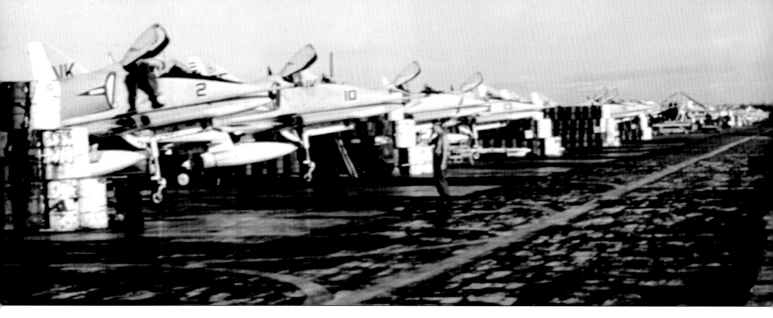

▲ *A flight line of A-4 Skyhawks at the US Marine base at Chu Lai. The mission of an A-4 squadron was to attack and destroy surface targets in support of ground units.*

Over 300 rounds hit Gio Linh within four and a half hours, killing 1 Marine and wounding 12 others. At Dong Ha, 150 enemy 140mm rockets kill 11 Marines and wound 91. The enemy shells likewise damage a considerable amount of equipment, as well as causing minor fragmentary damage to several parked helicopters on the landing strip.

MAY 18

NORTH VIETNAM, *NAVAL WAR*
In support of Operation Beau Charger, US Navy fire support ships and NVA coastal shore batteries engage

in a furious gun battle. Although the NVA shore batteries fail to hit any US ships, 10 salvoes bracket the USS *Point Defiance* (LSD-31). Return fire silences the NVA coastal batteries with no damage, after which the US Marines are able to land in support of the combined ARVN/US operation known as Lam Son-54.

SOUTH VIETNAM, *GROUND WAR*
Units of the 3rd Marine Division, augmented by Special Landing Force and Army of the Republic of Vietnam forces, begin Operation Hickory by moving into the southern portion of the DMZ in a three-pronged attack against North Vietnamese units using the area as a sanctuary. During a series of operations over an 11-day period, US Marines and South Vietnamese troops, supported by artillery, naval gunfire, tactical air

and massive B-52 strikes, kill over 780 enemy troops and temporarily impair the enemy's ability to launch offensive operations in the southern half of the zone.

MAY 19

SOUTH VIETNAM, *GROUND WAR*
During Operation Lam Son-54, the 1st ARVN (Airborne) Division's battalions engage elements of the 31st and 812th North Vietnamese Regiments.
SOUTH VIETNAM, *POLITICS*
President Nguyen Van Thieu declares his candidacy for president of South Vietnam in the national elections.

MAY 26

SOUTH VIETNAM, *GROUND WAR*
The 5th Marines begin Operation Union II in Quang Tin Province which will continue until June 5.

▼ *Winning hearts and minds: South Vietnamese trucks distribute leaflets in the village of Phouc Vinh Minh, Cu Chi District, in June 1967.*

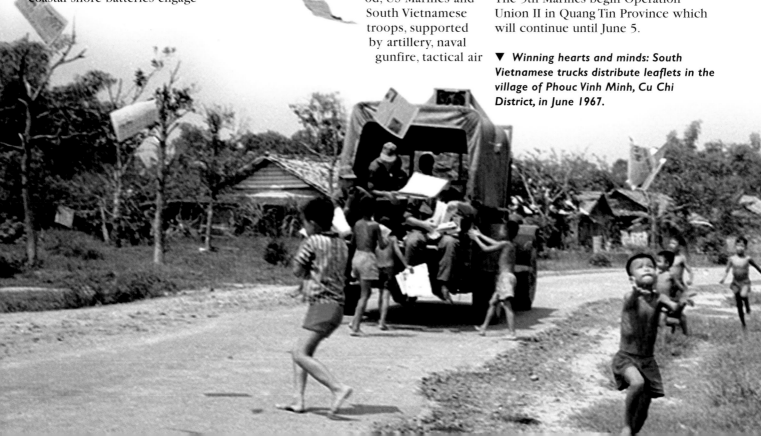

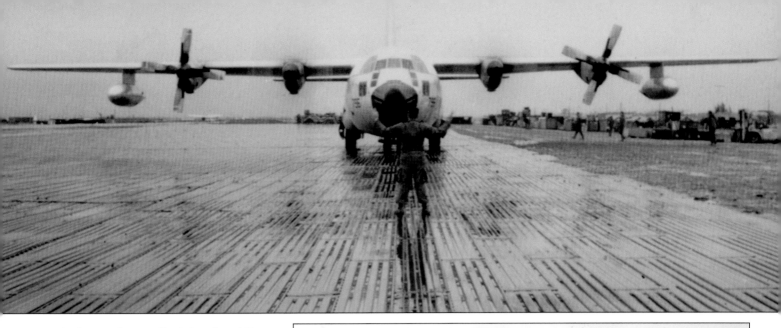

▲ A ground controller brings in a US Marine C-130 Hercules transport aircraft at the freight terminal at Dong Ha Air Base, May 1967.

MAY 27

SOUTH VIETNAM, *GROUND WAR*
Operation Lam Son ends after the 1st ARVN (Airborne) Division maintains continuous pressure on the NVA's 31st and 812th Regiments. While suffering 22 killed and 122 wounded, the South Vietnamese paratroopers inflict 342 deaths on the NVA and capture 30 prisoners and 51 weapons. Most of the ARVN's casualties are caused by enemy mortars and rockets in the area dubbed by US troops as the "rocket belt", north of Dong Ha.

MAY 31

SOUTH VIETNAM, *US GROUND FORCES*
Lieutenant-General Lewis Walt, who has led III Marine Amphibious Force in I Corps Tactical Zone, relinquishes his command to Lieutenant-General Robert E. Cushman, Jr, the decorated World War II Marine general who has been Walt's deputy commander at III MAF

▲ Hill 881 near the US base at Khe Sanh. It was the scene of heavy fighting as the US Marines dislodged enemy forces from its summit and then occupied it.

since early in the year. General Cushman is a strong proponent of the "barrier" or "McNamara Line" concept.

JUNE 1

SOUTH VIETNAM, *NAVAL WAR*
The 2nd Brigade, 9th Infantry Division, and the Mobile Riverine Force launches its first major American operation in the Mekong Delta, Operation Coronado in Dinh Tuong Province. In 54 days of offensive strikes centring on the vast waterways of the region, almost 500 Viet Cong are killed and 75 captured.

JUNE 7

SOUTH VIETNAM, *GROUND WAR*
A company sized force (150–200 Marines) from the 26th Marines engage the NVA on Hill 881 in Operation Crockett and reportedly kill 59 NVA soldiers.

JUNE 14–22

SOUTH VIETNAM, *GROUND WAR*
The 7th Marines conduct Operation Arizona with a multi-battalion force. The operation moves 1650 refugees to refugee camps at Duc Duc, headquarters of the An Hoa industrial complex 24km (15 miles) south of Da Nang.

JUNE 15

SOUTH VIETNAM, *NAVAL WAR*
Operation Market Time, conducted by the United States Navy, intercepts a North Vietnamese trawler heavily laden with arms and ammunition destined for the Viet Cong operating in the vicinity of Chu Lai.

JUNE 17

SOUTH VIETNAM, *US ARMED FORCES*
US strength in Vietnam approaches 450,000. The total strength of the Vietnamese Armed Forces exceeds 600,000, while other Free World forces total 54,000 troops. Intelligence estimates the enemy's strength at close to

ARMED FORCES

NEW ZEALAND

The government of New Zealand reasoned that commitment of forces to South Vietnam made sense because Communism threatened the country's interests in Southeast Asia. A New Zealand civic action unit arrived in Vietnam in 1964 and was replaced by an artillery battery in 1965. The battery supported the Australians in Phuoc Tuy Province. Additional New Zealand troops arrived in 1967 and integrated with the Australians to form the Australian/New Zealand (ANZAC) Battalion. Troop strength was only 517 men, but opposition to the war in New Zealand, plus the US policy of Vietnamization, led to the Kiwis being withdrawn from Vietnam in 1971.

260,000, which includes over 50,000 North Vietnamese regulars.

JUNE 18

SOUTH VIETNAM, *US TACTICS*

III Marine Amphibious Force publishes Operation Plan 11-67 that outlines the SPOS concept.

JULY 1

SOUTH VIETNAM, *GROUND WAR*

As July begins, the 1st and 7th Marines, both from the US 1st Marine Division, commanded by Major-General Donn Robertson, are operating in the densely populated area around Da Nang. Two battalions of the 5th Marines continue operations against elements of the 2nd NVA Division in the Que Son Basin. Another battalion of the 5th Marines, the 2nd, provides the security for an industrial area near An Hoa and the Nong

▼ *United States Air Force C-123 aircraft spray defoliants over the A Shau Valley. The US used a chemical defoliant, Agent Orange, in Vietnam to clear jungle areas.*

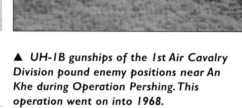

▲ *UH-1B gunships of the 1st Air Cavalry Division pound enemy positions near An Khe during Operation Pershing. This operation went on into 1968.*

Son coalmine, located southwest of Da Nang. Farther south, the nine US Army battalions which are assigned to Task Force Oregon, commanded by Major-General Richard T. Knowles, continue their operations in southern I Corps Tactical Zone. Four of the army battalions operate in and around Chu Lai, while the remainder of this force expands the Allied control over the coastal plain of Quang Ngai Province, which is a well-populated area. The Korean Marine Brigade of three battalions remains in its Tactical Area of Responsibility south of Chu Lai.

The combined efforts of these units manage to force both the North Vietnamese units and the Viet Cong main force units to pull out of their

havens which they have, to this point, enjoyed among the more populated regions, and succeed in pushing them back into the mountains.

JULY 2

SOUTH VIETNAM, *GROUND WAR*

Operation Buffalo begins on July 2, with elements of the 1st Battalion, 9th Marines, in and around the fire base at Con Thien. The operation is designed to clear the area of enemy activity, though the US Marine patrols are currently encountering less and less activity as the enemy regroups for a major attack somewhere else along the DMZ.

JULY 10–11

SOUTH VIETNAM, *GROUND WAR*

In the Central Highlands, at a place called Dak To, elements of the 173rd Airborne Brigade come under heavy enemy attack as they are conducting a

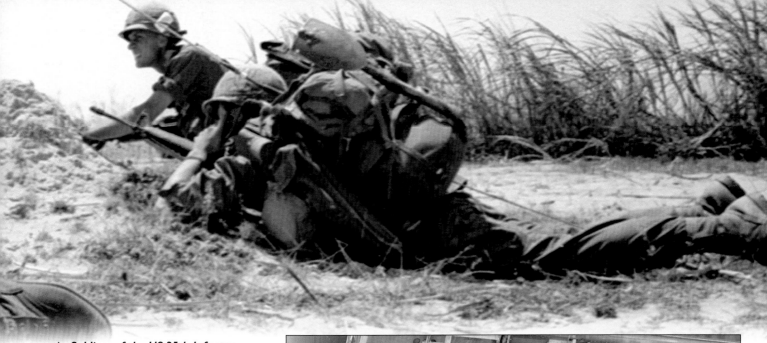

▲ Soldiers of the US 35th Infantry Regiment radio for air support while pinned down by enemy small-arms fire, just north of Duc Pho.

massive search and destroy operation. This operation was ordered to root out the NVA and the Viet Cong. Dak To is located near the US Army's fire base at Kontum.

JULY 11

USA, *POLITICS*
On the domestic scene, opposition to US involvement in Vietnam is growing. In keeping with popular opinion, Senator Mike Mansfield, (Democrat, Montana) warns the Johnson Administration that it should not escalate the war. The senator, a veteran of both the US Navy and Marine Corps, advises that the US builds a barrier of some sorts that would prevent the North Vietnamese from infiltrating into the South. Senator Everett Dirksen, (Republican, Illinois) supports the administration's war strategy and tells one reporter he would support further troop increases if asked to do so.

▲ Bombing up a B-52. It is estimated that each B-52 sortie cost $30,000 US alone. By 1967 the sortie rate for B-52s in the war was around 600 per month.

JULY 13

USA, *MILITARY STRATEGY*
President Johnson announces a "modest increase" in the number of combat troops being sent to Vietnam. There are, however, signs that the administration and the military leaders disagree on Vietnam as the troop increases are but a fraction of what General Westmoreland believes he needs to achieve success on the battlefield.

JULY 14

SOUTH VIETNAM, *GROUND WAR*
During the night of July 14/15, NVA and Viet Cong rocket units move out of "Happy Valley", southwest of Da Nang, and establish six firing positions, which are divided into two clusters of three positions each. Each firing position

STRATEGY & TACTICS

BODY COUNT

Simply stated, body count was the American calculation of the number of enemy troops killed in battle. However, prompted by Secretary of Defense McNamara and General Westmoreland, it became an indicator of whether US strategy was working in Vietnam, that strategy being to kill more of the enemy than could be replaced by infiltration or recruitment, i.e. one of attrition. This bizarre notion resulted in body counts being exaggerated, but the strategy was fatally flawed. As General Creighton Abrams, who assumed command in 1968, stated: "Body count is really a long way from what's involved in this war." Indeed, he realized that the security of South Vietnam's population was the crucial factor in the war. In addition, body counts further eroded what little support the war had in the USA.

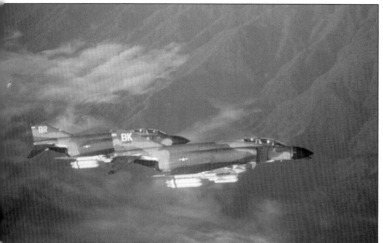

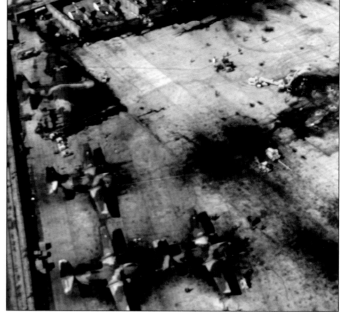

▲ *F-4C Phantoms of the 390th Tactical Fighter Squadron armed with cluster bomb units fly over the A Shau Valley to conduct a ground-support mission.*

contains six individual launcher sites. Shortly after midnight (July 14) the enemy rocket sites open up on the airfield of Da Nang. Within five minutes 50 projectiles hit the US Marine and ARVN base. Marines are quick to react after the launching of the first volley of rockets. A circling US Air Force fighter-bomber spots the first launching sites and opens fire on it, but during the attack the Marines lose 10 aircraft, 13 barracks and a bomb dump, with 40 more aircraft destroyed.

After this encounter, not only have the Communists succeeded in destroying a large quantity of material, but they have also scored a major propaganda coup, as it illustrates to the 300,000 South Vietnamese who inhabit the area that they can strike at will wherever and whenever they want. The attack also forces III MAF to make readjustments to its defensive scheme of the airfield. To counter the NVA's claim that it can strike whenever and wherever it wants, the US 1st Marine Division launches a psychological operation (PsyOps) campaign, which later proves to be effective in countering this enemy threat.

JULY 15

SOUTH VIETNAM, *GROUND WAR*
An early morning enemy rocket attack on aircraft at the southern end of the Da Nang Air Base results in heavy damage. The NVA and Viet Cong fire 50 rounds of 122mm rockets at the Marine air base, the first use of these Soviet-supplied long-range weapons. Ten jets are destroyed and 41 damaged.

SOUTH VIETNAM, *NAVAL WAR*
In another action as part of Operation Market Time, US Navy coastal surveillance forces manage to intercept a North Vietnamese trawler heavily laden with arms and ammunition which is destined for Viet Cong forces operating in the vicinity of Chu Lai.

JULY 27

SOUTH VIETNAM, *ARVN*
Premier Ky announces that the Republic of Vietnam Armed Forces will

▼ *Vietnamese suspected of belonging to the Viet Cong are rounded up for questioning by troops of the US 9th Infantry Division in July.*

▲ *US air bases were vulnerable to enemy artillery, especially mortar and rocket fire. This is the one at Da Nang after a Viet Cong attack in July.*

be increased to a total of 685,000 officers and men.

JULY 28–29

SOUTH VIETNAM, *GROUND WAR*
The 3rd Marine Division sends the 2nd Battalion, 9th Marines, reinforced with armoured vehicles, into the DMZ north of Con Thien to conduct a search and destroy mission. However, the battalion becomes ensnared by the enemy and has to fight its way out of the DMZ on the second day.

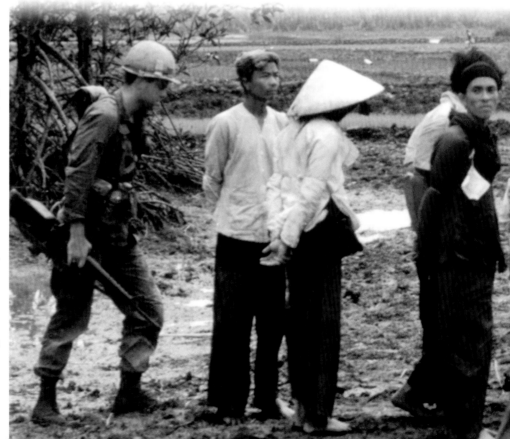

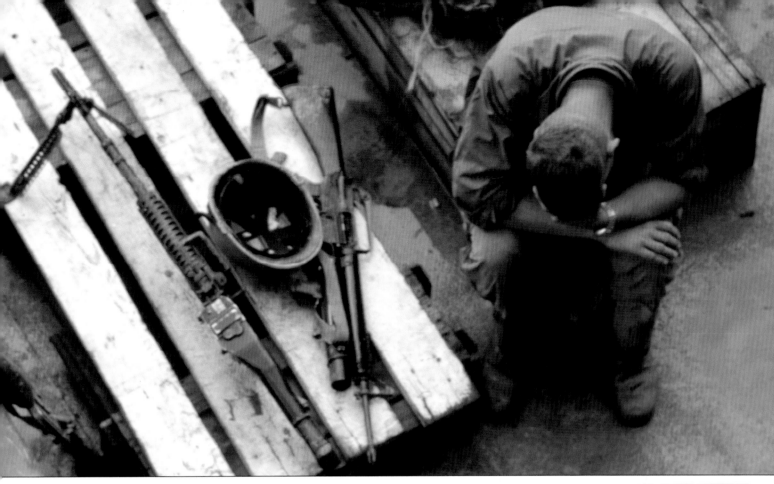

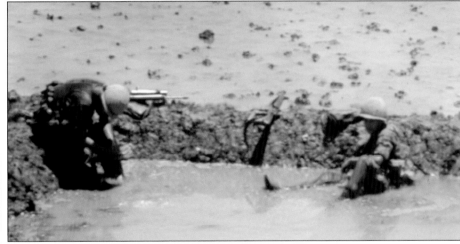

▲ The stress of war: a weary US sailor takes a break aboard a navy Monitor operating in the Long Tau River area.

▶ Soldiers of the US 9th Infantry Division man muddy positions during a mission in the Long Tau River area in July.

AUGUST 1

SOUTH VIETNAM, *US AID*
President Lyndon B. Johnson announces that US forces in South Vietnam will be increased to 525,000 officers and men.

AUGUST 3

NORTH VIETNAM, *AIR WAR*
The US Air Force reports that US warplanes have carried out 197 sorties, the highest total for a single day. Targets in these raids include Hanoi's strategic Haiphong harbour sector.

AUGUST 4

SOUTH VIETNAM, *NAVAL WAR*
In the Mekong Delta, two separate but mutually supporting naval operations commence and help drive Viet Cong tax collectors from the waterways. The US Navy's Game Warden patrols, cruising 24 hours a day, help to eliminate the tax collectors and to keep commercial traffic moving, while River Assault Groups and the River Transport Escort Group of the Vietnamese Navy provide security for major rice and commodity convoys en route from the Mekong Delta to Saigon.

AUGUST 7–11

SOUTH VIETNAM, *GROUND WAR*
The 1st Marine Division's Task Force X-Ray conducts Operation Cochise in Quang Tri Province in conjunction with the ARVN Operation Lien Kiet 122.

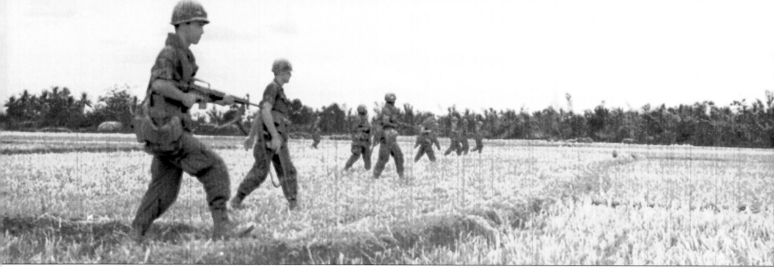

AUGUST 13–19

NORTH VIETNAM, *AIR WAR*
US Air Force B-52 bombers carry out a series of devastating 1967 raids which are aimed at the southern portions of North Vietnam. Targets include troop concentrations, industrial sites, railroad marshaling yards and truck depots. On August 19 alone the US Air Force flies 209 sorties aimed at coastal ships and NVA infiltration routes.

AUGUST 27

SOUTH VIETNAM, *GROUND WAR*
In the Mekong Delta region the Viet Cong launches a series of raids against South Vietnamese civilians in Cantho and Hojan, 48km (30 miles) south of Hue, the ancient imperial capital.

SEPTEMBER 1

SOUTH VIETNAM, *GROUND WAR*
North Vietnamese long-range artillery

▲ *Soldiers of the US 35th Infantry Division advance across a rice paddy during a search and destroy operation.*

(both 122mm and 132mm) opens a barrage against the US Marine fire base at Con Thien. The continuous attack lasts for a month and a half.
SOUTH VIETNAM, *AIR WAR*
Meanwhile, B-52 bombers conduct a series of "arc light" strikes against NVA troop and artillery positions north of the DMZ. US Army and Marine artillery pound NVA positions north of the DMZ and, ultimately, manage to relieve the pressure on Con Thien.

SEPTEMBER 4

SOUTH VIETNAM, *GROUND WAR*
Elements of the 5th Marines come under heavy attack as they attempt to relieve pressure on the Con Thien fire support base in the Que Son Basin. The Marines lose 114 men while inflicting 376 casualties on the NVA.

▼ *M113 armoured personnel carriers make their way through a rice paddy during Operation Coronado.*

STRATEGY & TACTICS

TUNNEL WARFARE

A curious feature of the Vietnam War was the Viet Cong's use of underground tunnels to serve as assembly areas, storage depots and hospitals. One of the largest tunnel networks was in the district of Cu Chi. At its peak the Cu Chi tunnel network covered some 250km (156 miles), from the Cambodian border in the west to the outskirts of what was then Saigon. Beginning in 1948 during the war for independence from the French, the tunnel network slowly expanded. Each tiny tunnel was dug by hand, sometimes at a rate of just 1–2 m (3–6 ft) per day. As the tunnels grew, arms stores, hospitals, bomb shelters and even theatres to stage politically motivating plays were added. Kitchens to supply the tunnels' occupants with food were always built near the surface, but with long chimneys carved out through the ground to diffuse the smoke from the cooking fires and release it at a distance. The tunnels connected pockets of Viet Cong-controlled territory, enabling the guerrillas to mount surprise attacks and then to vanish without trace.

The Americans were initially frustrated by attempts to destroy the tunnel network, as they could not bring their overwhelming firepower to bear. To penetrate this underground world, the American military had to take on the methods of the guerrilla soldier. Out of this came the so-called Tunnel Rats,

Tunnel Rat Sergeant Ronald Payne, 25th Infantry Division, during Operation Cedar Falls.

an élite band of volunteer soldiers, selected both for their bravery and, above all, their small stature. Usually stripped to the waist and armed with just a torch and a pistol, the "rats" would often spend hours at a time inching through the humid tunnels engaged in a deadly game of hide and seek. With each movement the "rats" would have to feel for any suspect root or wire that could detonate a carefully primed booby trap. But the "rats" were never able to eliminate all the tunnels. Today, some tunnels survive as tourist attractions, having been widened to accommodate the more bulky Western frames.

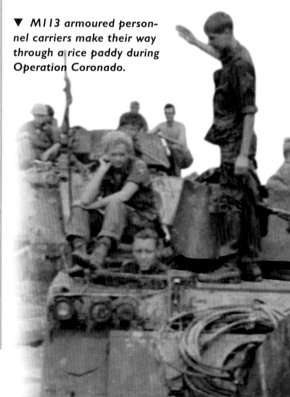

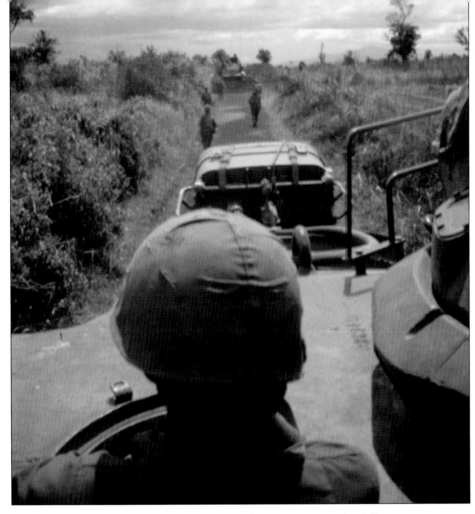

◄ *A mixed US tank and infantry column on patrol near the inappropriately named Demilitarized Zone in August.*

Oregon are engaged in simultaneous operations in conjunction with Swift.

SEPTEMBER 7

SOUTH VIETNAM, *FORTIFICATIONS*
US Defence Secretary Robert S. McNamara announces his intention to construct along the DMZ a barrier which is capable of detecting the movement and infiltration of the enemy into the area south of the Demilitarized Zone. The barrier is to be constructed with barbed wire for holding sophisticated electronic devices. There is scepticism among the Joint Chiefs of Staff. In a testimony before the Senate Subcommittee on Preparedness, Army Chief of Staff General Harold K. Johnson tells the lawmakers that the barrier will have "minimal effect" on enemy infiltration. General Wallace M. Greene, Commandant of the US Marine Corps, is more outspoken in his opposition, stating: "From the very beginning I have been opposed to this project."

SOUTH VIETNAM, *NAVAL WAR*
United States Navy Chaplain Reverend Vincent R. Cappdanno, USNR, is killed while earning the Medal of Honor, the highest US military accolade. Reverend Cappdanno was serving as chaplain with the troops of the 3rd Battalion, 5th Marines.

SEPTEMBER 4-15

SOUTH VIETNAM, *GROUND WAR*
Task Force X-Ray's Operation Swift pits elements of two US Marine battalions against a large and well-equipped force of NVA soldiers northwest of Tam Ky. After a hard fight the NVA withdraws. ARVN forces and elements of Task Force

SEPTEMBER 13

SOUTH VIETNAM, *GROUND WAR*
In Operation Coronado 5, the US 9th Infantry Division, along with South Vietnamese Army troops, engages a large force of Viet Cong soldiers. The US Air Force provides support with Air Force F-105s and "arc light" strikes from B-52 bombers and nearby artillery support.

SEPTEMBER 15-16

SOUTH VIETNAM, *GROUND WAR*
A force of US Navy riverine craft, along with elements from the US Army's 9th

▲ *Private James Hembree, 1st Air Cavalry, cools himself off in the An Lao Valley.*

SEPTEMBER 29

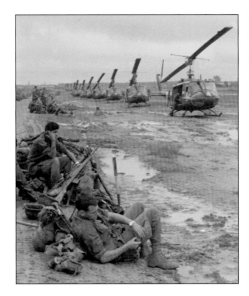

▲ Soldiers of the US 1st Infantry Division wait to board helicopters during operations in early September.

Infantry Division, all part of the River Assault Task Force, is attacked by a strong Viet Cong force along the Rachba River. Fighting ends the next day, with 69 enemy soldiers killed in action, while the American forces suffer 21 dead.

SEPTEMBER 29

SOUTH VIETNAM, *THAI AID*
The last contingents of the Royal Thai Army Volunteer Regiment, "The Queen's Cobras", arrives in Vietnam.

▼ Soldiers from the 4th Infantry Division, operating as part of Task Force Oregon, in Quang Ngai Province in early October.

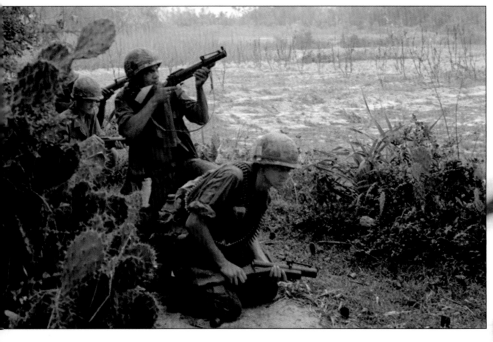

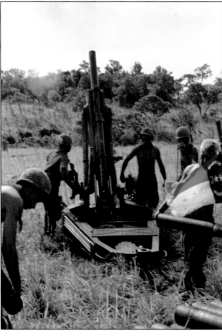

▲ A 105mm howitzer of the 319th Artillery Regiment prepares to fire against the Viet Cong northwest of Tuy Hoa on September 17.

The Thai regiment commences operations in Bien Hoa Province, just northeast of Saigon.

OCTOBER 4

SOUTH VIETNAM, *GROUND WAR*
The North Vietnamese siege of the US Marine fire support base at Con Thien is broken with severe losses to the enemy by a massive artillery bombardment and the use of tactical aircraft and B-52s which are flying "arc light"

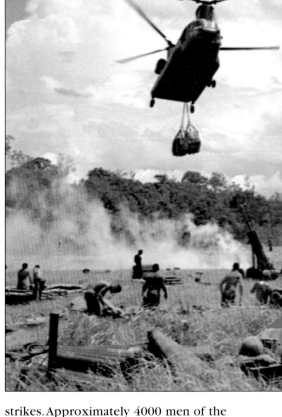

strikes. Approximately 4000 men of the US Army's 3rd Brigade, 1st Air Cavalry Division (Airmobile), launch a massive search and destroy operation in order to take enemy pressure off the Marines around Quang Tin and Quang Ngai Provinces, which are located in northern South Vietnam.

OCTOBER 5

SOUTH VIETNAM, *GROUND WAR*
The 1st Marine Regiment, commanded by Colonel Herbert E. Ing, with two full battalions moves north from its bases at Da Nang to Quang Tri to carry out a search and destroy mission.

OCTOBER 8

SOUTH VIETNAM, *AIR WAR*
The new Huey Cobra (AH-1G) armed helicopter, designed especially for the support of ground forces within

▼ A US bird of prey: the Huey Cobra gunship with rocket pods.

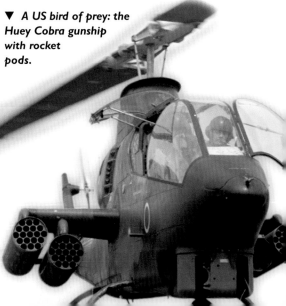

South Vietnam, enters combat for the very first time.

OCTOBER 9–NOVEMBER 8

SOUTH VIETNAM, *GROUND WAR*
Viet Cong units assault Loc Ninh, site of the South Vietnamese Civilian Irregular Defence Group (CIDG) unit and the district command post. They breach the defensive perimeter, but intense air and artillery fire prevents its complete loss. Within a few hours, South Vietnamese and US reinforcements reach Loc Ninh. Their arrival is possible due to the failure of the enemy to seize the local airstrip. When the buildup ends, 10 US Army battalions are positioned within Loc Ninh between the town and the Cambodian border. During the next two days, Allied units ward off repeated enemy attacks as Communist forces desperately try to score a victory. Tactical air support and artillery fire prevents the enemy force from penetrating the outnumbered American and South Vietnamese Army positions. At the end of the battle, over 800 Viet Cong are found dead on the battlefield. A total of 452 close air support and 8 B-52 "arc light" bomber strikes, as well as an estimated 30,152 rounds of artillery, have been directed against the enemy.

Once again, Loc Ninh served as a "lightning rod" which attracted US forces to the border and away from the cities and villages. The ongoing pattern of two wars – the one fought in the villages and the other strung out along the border – would continue, without decision.

◄ *During a search and destroy operation northwest of Tuy Hoa, a CH-47 Chinook helicopter brings in ammunition for a battery of 105mm howitzers.*

OCTOBER 11

SOUTH VIETNAM, *GROUND WAR*
Two battalions of the 1st Marines launch Operation Medina in the rugged Hai Lang National Forest south of Quang Tri City. This was an enemy base area which was suspected of harbouring elements of the 5th and 6th NVA Regiments. Special Landing Force Alpha, in conjunction with Medina, executes Operation Bastion Hill, landing the Battalion Landing Team (1st Battalion, 3rd Marines), commanded by Lieutenant-Colonel Alfred I. Thomas, in order to link up with the two battalions from the 1st Marines. Also involved are two ARVN airborne battalions. While enemy resistance is light at first, the Marines and ARVN airborne forces uncover a number of enemy base camps, 4 tonnes (4 tons) of rice, 16 weapons and a quantity of ammunition for small-arms.

OCTOBER 20

SOUTH VIETNAM, *GROUND WAR*
As part of Operation Medina the Marines flush out a company of NVA headlong into the ARVN, which acts as the "anvil" while the Marines block its escape. The ARVN paratroopers, with the help of US Marine air and artillery strikes, kill 197 NVA. At the same time, the Battalion Landing Team re-embarks aboard ship and heads down to Thua Thien Province to assist in Operation Fremont then ongoing. In the joint operations Medina and Bastion Hill the leathernecks kill a further 64 NVA, while losing 35 of their own killed in action as well as 174 wounded.

◄ *A heavily camouflaged US Navy SEAL watches for the enemy in the Mekong Delta.*

OCTOBER 24–25

USA, *ANTIWAR PROTESTS*
Two college campuses explode in protest against the Dow Chemical Corporation for its manufacture not only of napalm used by US aircraft against ground targets but also against the defoliants which are used in the campaign to deny the enemy forces' use of the jungle canopy.

OCTOBER 27

SOUTH VIETNAM, *GROUND WAR*
The North Vietnamese 88th Regiment attacks the command post of a battalion of the South Vietnamese 9th Regiment which is stationed near the village of Song Be in Phuoc Long Province. Three times the North Vietnamese rush the position, but each time are repulsed by the ARVN. When the enemy begins to fall back, the ARVN defenders leave the safety of their defensive positions in order to pursue the fleeing enemy. The enemy loses 134 men to the ARVN loss of only 13 men during an engagement in which the defenders were outnumbered by at least 4 to 1.

OCTOBER 28

SOUTH VIETNAM, *US AID*
At the far end of I Corps Tactical Zone the US Army's 198th Light Infantry Brigade, commanded by Colonel J. R. Waldie, arrives by air and sea at Duc Pho with three manoeuvre battalions. The 198th joins the III MAF in conducting joint and combined operations in I Corps Tactical Zone. The 198th is attached to the American Division.

OCTOBER 29

SOUTH VIETNAM, *GROUND WAR*
NVA artillery rounds hit the US Marines' Force Logistics Support located at Dong Ha. An estimated 60 enemy rounds destroy nearly 10,000 gallons of aviation fuel and kill 5 Marines.

OCTOBER 31

SOUTH VIETNAM, *GROUND WAR*
Operation Kingfisher ends. Since July 16, when the operation began, 1117 NVA soldiers have been killed, with 5 taken prisoner. A total of 155 weapons are captured. The Marines lose approximately 340 killed in action and have 3086 wounded in action. South of Thua Thien Province, the 3rd Marine Division terminates Operation Fremont, which had begun on July 10. Carried out by two infantry battalions for most of its duration, Operation Fremont was

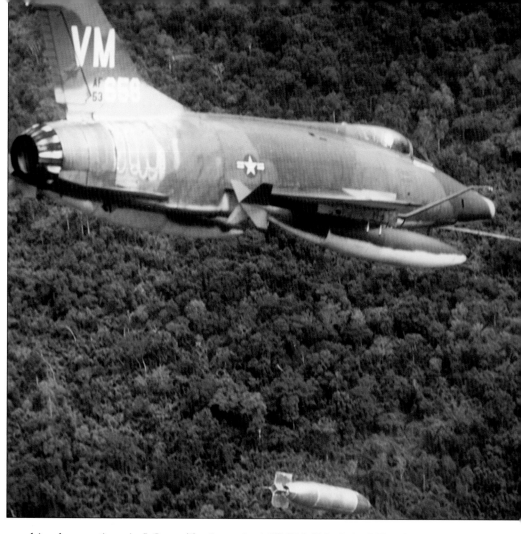

▲ *A USAF F-100 of the 352nd Tactical Fighter Squadron releases a napalm bomb over Viet Cong positions 16km (10 miles) northeast of Bien Hoa Air Base.*

◀ *A young recruit to the Armed Propaganda Team, which comprised ex-Viet Cong.*

▶ *A gunner aboard a mechanized landing craft keeps watch while taking supplies to the US Marines at Dong Ha.*

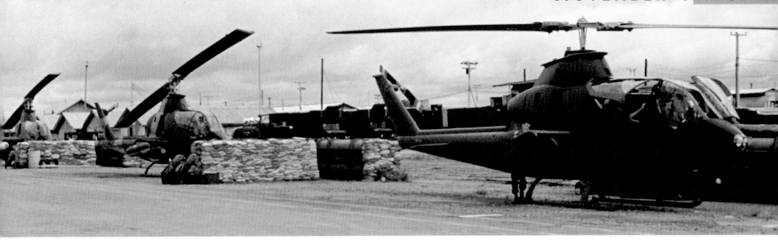

▲ *As soon as they arrived in Vietnam Huey Cobras were shipped to operational squadrons. These Cobras are in protective berms at the Bien Hoa Air Base.*

undertaken by III MAF to screen the approaches to the Hue Phu Bai area. The Marines kill an estimated 123 NVA, while losing 17 of their own killed in action and suffering 260 wounded.

NOVEMBER 1967

SOUTH VIETNAM, *US AID*
United States' military strength reaches 470,000 officers and men.

NOVEMBER 1

SOUTH VIETNAM, *GROUND WAR*
Vice-President Hubert H. Humphrey, who was in Vietnam on a three-day visit, flew to within 8km (5 miles) of the Demilitarized Zone in a four-engine transport, getting close

enough to see US artillery fire. On the ground at Da Nang, the vice-president presents the Presidential Citation Unit to the 3rd Marine Division, Reinforced, "for extraordinary heroism in action against hostile forces in five northern provinces of Vietnam during the period March 8, 1965, to September 1967."

NOVEMBER 2

SOUTH VIETNAM, *GROUND WAR*
The Viet Cong launches a series of raids against the district headquarters and refugee settlements at Dai Luc and Hieu Duc, 24km (15 miles) southwest of Da Nang. Some 22 South Vietnamese civilians are killed in the attack, while 42 are wounded and 57 counted as missing. The enemy raids destroy 559 houses and leave a total of 625 families homeless.

NOVEMBER 4

SOUTH VIETNAM, *GROUND WAR*
Operation Napoleon begins in an area blocked out at the mouth of the Cua

American officers and men in South Vietnam

The U.S. Government is waging an aggressive war against South Vietnam. It has spent billions of dollars and defamed the prestige and freedom-and-peace-loving traditions of the American people. It has caused the useless and pitiful deaths and maimings of thousands of American officers and men.

The U.S. Government has come to an impasse in South Vietnam. In order to evade the danger of a complete fiasco, it is venturing to spread the war, endangering your future more than ever.

The South Vietnamese people have won and will win.

The U.S. Government has been defeated and will be completely defeated.

DEMAND PEACE IN VIETNAM AND YOUR RETURN TO YOUR HOMELAND AND FAMILIES.

DEMAND THAT THE U.S. GOVERNMENT WITHDRAW ALL U.S. TROOPS AND ARMS FROM SOUTH VIETNAM AND LET THE VIETNAMESE PEOPLE SETTLE THEIR OWN AFFAIRS THEMSELVES.

REFUSE TO OBEY ALL ORDERS TO CARRY OUT MOPPING-UP OPERATIONS TO KILL THE VIETNAMESE PEOPLE OR ATTACK THEIR ARMED FORCES.

SYMPATHIZE WITH AND SUPPORT THE JUST STRUGGLE OF THE SOUTH VIETNAMESE PEOPLE.

THE SOUTH VIETNAM NATIONAL FRONT FOR LIBERATION

▲ *The Viet Cong use psychological warfare during the conflict. This is a leaflet left by "Charlie" in Quang Ngai Province in late 1967.*

▼ *During Operation Francis Marion in late October, troops of the US 4th Infantry Division ford a stream.*

▲ *Loading up for another ground support mission: 20mm ammunition is fed into an A-4's cannons at the US Marine base at Chu Lai in November.*

Viet River by the 1st Amphibious Tractor Battalion, and reinforced by A Company of the 1st Battalion, 1st Marine Regiment, 1st Marine Division. The Marine commanders have now decided that the security of the area is essential to the safe water transportation in the two northern provinces. Transportation by water is the means by which the greatest tonnage of supplies and equipment is now being moved.

NOVEMBER 6

SOUTH VIETNAM, *GROUND WAR*
Operation Essex begins 9.6km (6 miles) south of An Hoa in the "Antenna Valley" by the 5th Marines, commanded by Colonel Robert D. Bohn, with one

battalion west and north of where the US Army is now operating.

NOVEMBER 10–DECEMBER 21

SOUTH VIETNAM, *GROUND WAR*
With the arrival of the US Army's 11th Infantry Brigade, US Army forces in the Americal Division area of operations make it possible to move the Korean Marine Brigade northwards from Chu

▼ *US Marines and their wounded take shelter with South Vietnamese civilians during Operation Essex south of An Hoa in early November.*

▲ *Navy airman Ronald Young, aboard a UH-1B Iroquois helicopter, fires his twin .30-calibre machine guns at Viet Cong positions in the Mekong Delta.*

Lai to carry out Operation Dragon Tail, 16km (9.9 miles) from Quang Ngai.

NOVEMBER 13

SOUTH VIETNAM, *GROUND WAR*
The US Marine Special Landing Force Bravo, now assigned to the Battalion Landing Team, 2nd Battalion, 3rd Marines,

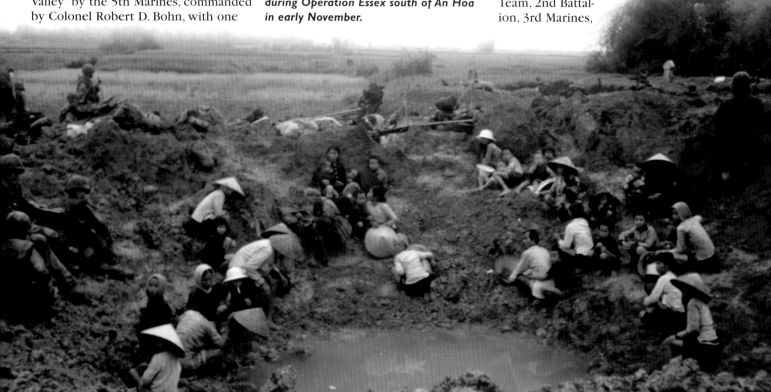

STRATEGY & TACTICS

RIVERINE WARFARE IN VIETNAM

The very nature of the war in Vietnam, particularly in the Mekong Delta region and areas south and east of Saigon, necessitated the introduction of forces capable of fighting on both the land and on the many rivers that served as a vital conduit for the local Viet Cong forces. To patrol and fight in these marshlands and numerous rice paddies in the Mekong Delta, the US Army and Navy resurrected the idea of riverine warfare employed first during the American Civil War (1861–65) by Union forces along the Mississippi River, and by the French during the First Indochina War (1946–54). The Mobile Riverine Force used a joint Army-Navy Task Force and was controlled by a ground commander. In contrast to amphibious operations, riverine warfare was an extension of land warfare with infantry units travelling by water then by trucks or tracked vehicles. Aided by a Navy River Support Squadron and River Assault Squadron, infantrymen were housed on ships which had been converted to barracks and a floating base camp. These floating camps were supported by helicopter gunships and fire support boats called Monitors. Howitzers and mortars mounted on platforms provided artillery support. The unit assigned to this mission by General Westmoreland was the 2nd Brigade, 9th Infantry Division, which began operations against the Viet Cong in the Cam Son Secret Zone, approximately 16km (10 miles) west of Dong Tam in May 1967.

Designated Task Force 117, or Mobile Riverine Force (MRF), in early 1967, it relied on a specially trained army force comprising the 2nd Brigade of the 9th Division. The MRF's naval arm, River Assault Flotilla 1, was made up of troop-carrying boats and support vessels which were divided into four river squadrons. The 26 Armored Troop Carriers (ATCs) were key boats, and some were converted to become refuellers, landing pads for helicopters, and medical aid stations. The flagships, the command-and-control boats, served as headquarters for the ground and naval force commanders. The destroyer/minesweeper of the fleet was the Assault Support Boat (ASPB), of which each squadron had 16. The MRF's main land base was Dong Tam, northwest of My Tho, while the mobile riverine base could move anywhere throughout the Delta. Another type of base, the Mobile Support Base (MSB), was built on four pontoons and included helicopter landing pads, crew quarters and mess area. Elements of the MRF contributed to the South East Asia Lake Ocean River Delta Strategy (SEALORDS) in 1968. By August 1969, the MRF had been disbanded.

The 9th Infantry Division set up bases east and west of Saigon. One brigade of the 9th Infantry Division deployed to Bear Cat while another set up camp at Tam An in Long Am Province, south of Saigon, where it sought to secure portions of Route 4, an important north-south highway connecting Saigon to the rice-rich lower Delta region. The 2nd Brigade, 9th Infantry Division, established its bases at Dong Tam in Dinh Tuong Province in IV Corps Tactical Zone. Located in the middle of the rice paddies and swamps, the army's base at Dong Tam was created by US Army engineers with sand dredged from the My Tho River. From this 600-acre base the 2nd Brigade, 9th Infantry Division, began a series of riverine operations which were not only "unique" to the US Army's experience in South Vietnam, but which also demonstrated the division's tactical and operational flexibility in its adaptation of a concept which had been designed to meet and defeat a skilled and tenacious adversary on his own terms.

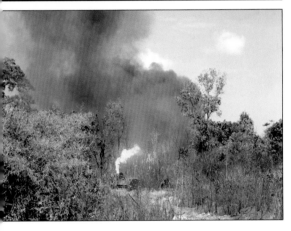

▲ Flamethrowers could be very effective in the jungle. Here, a US M-113 flamethrower burns out a Viet Cong camp near Phout Tho on November 19.

and commanded by Lieutenant-Colonel Henry English, lands in the foothills of the An Hoa area and well to the west of Dai Loc to carry out a supporting action. Also, US Marines initiate Operation Badger Hunt. The 3rd Battalion, 7th Marines, commanded by Lieutenant-Colonel Roger H. Barnard, moves in just west of Dai Loc and north of the Thu Bon River in order to carry out a supporting action. Initially the Operations Foster and Badger Hunt discover no

▶ South Vietnamese civilians were often herded into specially constructed settlements, such as this one at Dak To, to keep them away from the Viet Cong.

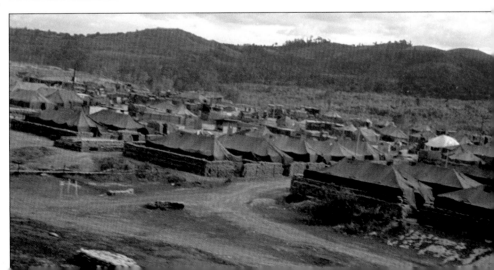

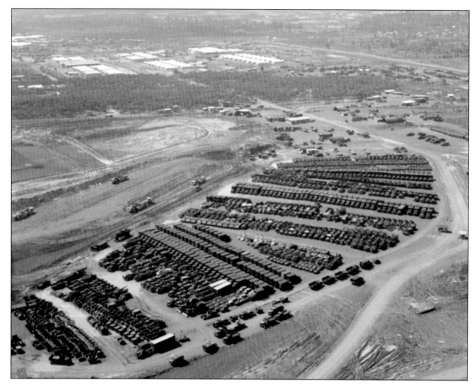

◄ *Vietnam may have been a helicopter war, but US forces also needed thousands of vehicles. This is the motor pool at Long Binh.*

enemy activity. On November 26, this changes, however, when there are heavy engagements with NVA forces. After four days of heavy fighting, the Marines kill an estimated 125 troops of the North Vietnamese and Viet Cong forces, while suffering 21 Marines killed in action and another 137 wounded.

NOVEMBER 14

SOUTH VIETNAM, *GROUND WAR*
US Marine Major-General Bruno A. Hocmuth, commanding general of the 3rd Marine Division, is killed when his UH-1E helicopter explodes and crashes

▼ *The soldier on the telephone is an air liaison officer, whose mission was to coordinate ground-support missions mounted by the US Air Force.*

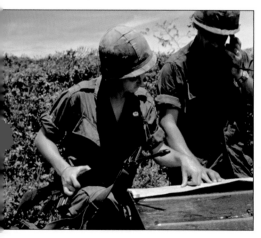

near Dong Ha, 8km (5 miles) northwest of Hue City. Major-General Rathvon McC. Tompkins, USMC, winner of the Navy Cross on Saipan during World War II and presently commanding general of the Marine Corps Recruit Depot at Parris Island, South Carolina, is named to replace him. Brigadier-General Louis Metzger serves as acting division commander until General Tompkins arrives on November 28.

NOVEMBER 29

SOUTH VIETNAM, *GROUND WAR*
The 3rd Marine Division begins clearing operations in the area between Con Thien and Gio Linh in preparation for a further development of McNamara's anti-infiltration barrier system, using three US Marine battalions in conjunction with three ARVN battalions. The next day one of the battalions, the 2nd Battalion, 9th Marines, finds and then attacks a North Vietnamese company which is entrenched 3.2km (2 miles) northwest of Con Thien. The fight begins about 13:45 hours and is over by 18:00 hours with the Marines taking the position and killing over 40 North Vietnamese Army soldiers, as well as capturing 21 weapons.

DECEMBER 8

SOUTH VIETNAM, *GROUND WAR*
In one of the largest single engagements yet to occur in the Mekong Delta, some contingents from the South

Vietnamese 21st Infantry Division trap part of a Viet Cong main force battalion along the Konh O Mon Canal, 160km (100 miles) southwest of Saigon. Helicopters lifted selected units into blocking positions while a battalion manoeuvres up the canal from the southwest. Viet Cong dead number 365 confirmed killed in action.

SOUTH VIETNAM, *US AID*
Leading elements of the remainder of the 101st Airborne Division arrive in Vietnam and locate in the zone of III Corps northeast of Saigon. Command elements of the division will be arriving on December 13.

The movement of the division would involve one of longest aerial combat deployments in the history of warfare. The 101st was not scheduled to arrive until early 1968, but due to intelligence reports that the enemy was planning an offensive, General Westmoreland asked for and received the 101st months earlier.

The 199th Light Infantry Brigade and the South Vietnamese 5th Ranger Group ended Operation Fairfax after having killed more than 1000 Viet Cong. From this point, the responsibility for the security of Saigon passed to the South Vietnamese Army.

DECEMBER 19

SOUTH VIETNAM, *US AID*
The 11th Infantry Brigade, commanded by Brigadier-General Andrew Lipscomb,

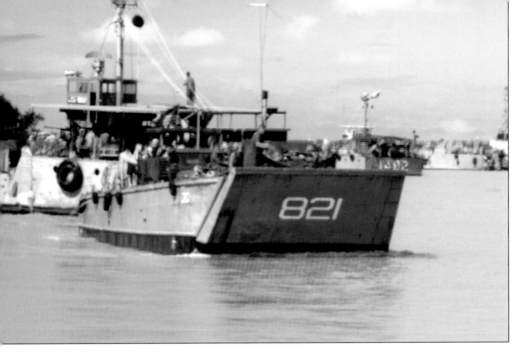

◀ This is a utility landing craft on the Cua Viet River, which was the main waterway for the transport of supplies to the US Marine base at Dong Ha.

Quang Tri Province, the 26th Marines continued to hold Khe Sanh, the 9th Marines were at Dong Ha, the 3rd Marines west of Dong Ha, and the 1st Marines at Quang Tri City. In Thua Thien Province the 4th Marines were located north and west of Hue.

A further breakdown of III MAF's forces had the 1st Marine Division with two regiments (5th and 7th) in Quang Nam Province. To the south, the Americal Division had the 196th Light Infantry Brigade, and the 3rd Brigade, 1st Cavalry Division, located west of Tam Ky in Quang Tin Province, and operating from Chu Lai and Duc Pho in Quang Ngai Province.

As of this date, military action taken by the enemy has resulted in the destruction of $1,622,348 US worth of Marine construction equipment. US Army strength stands at a total of 320,000 troops, while the US Navy has 31,000, and the US Air Force has 56,000. The US Marines are represented by a force of 78,000 and the Coast Guard by a force of 1200. Free World forces include: 6182 Australians; 47,800 South Koreans; 516 New Zealanders; 2020 from The Philippines; and 2205 officers and men from Thailand.

▼ US Marines of E Company, 2nd Battalion, 3rd Regiment, cross a muddy rice paddy at the end of 1967.

US Army, arrives at Duc Pho and is added to the Americal Division, bringing the number of brigades now in the division to five. Operation Muscatine begins the same day.

By the end of the month US soldiers reportedly had killed 58 enemy soldiers and captured 34 weapons. The army operations west of Tam Ky, Wheeler\Wallowa, also continued with the result that, when they were over on December 31, there were 3188 enemy dead and 128 prisoners of war taken and 743 weapons captured. US Army losses for Wheeler/Wallowa stood at a total of 258 killed in action and 964 wounded.

DECEMBER 22

SOUTH VIETNAM, *GROUND WAR*
The Korean Marine Brigade (known as "the Blue Dragons") moves north to a new operating area south of Da Nang and west of Hoi An in order to begin Operation Flying Dragon.

DECEMBER 31

SOUTH VIETNAM, *US AID*
III Marine Amphibious Force stands at 81,115, with 77,679 Marines and 3436 US Navy personnel. The net increase for the year has been 10,737 Marines and sailors.

The year started with 18 Marine infantry battalions in South Vietnam. By the end of the year this had been increased to 21. There were also 31 ARVN battalions, 15 US Army battalions and 4 Korean Marine battalions (a fourth had been activated this year). Altogether there were 71 Free World battalions in I Corps Tactical Zone. The 3rd Marine Division had five infantry regiments in the two northernmost provinces. In

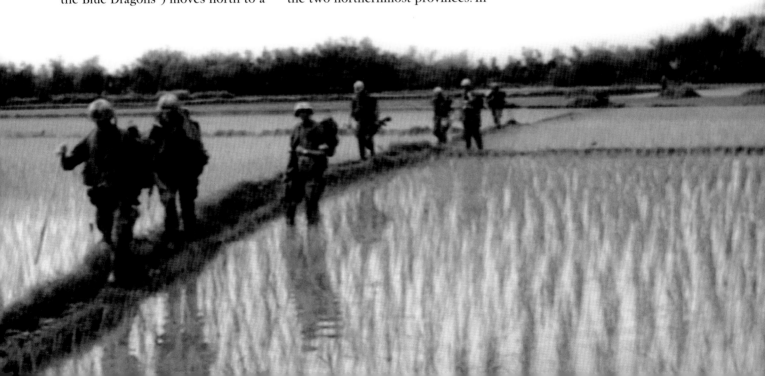

1968
TET–THE TURNING POINT

For the US military, the Tet Offensive was the turning point in the Vietnam War. Between 1965 and 1967, the war had increasingly been fought by American forces. The Army of the Republic of Vietnam (ARVN) trained and fought alongside the Americans, but it was obvious that more needed to be done to prepare it to take over control of the war. The North Vietnamese continued their preparations for a major offensive during the Tet holiday through January 1968, and the Viet Cong likewise prepared for assaults on South Vietnam's capital, Saigon, and other major cities in order to inflict psychological damage on the American military effort. The North Vietnamese still managed to maintain their monthly delivery of men and materiel down along the Ho Chi Minh Trail, in the process receiving more than their share of attention from the US Air Force and Navy in bombing and interdiction missions. These, however, failed to stop the flow of supplies.

Even as the North Vietnamese Army (NVA) and Viet Cong prepared to launch a major offensive during the Tet celebration, General Westmoreland kept up the pressure on the enemy. Despite the siege at the US Marine Corps fire base at Khe Sanh and the Special Forces camp at Lang Vei, west of Khe Sanh, as well as at bases throughout the north of the country near the Demilitarized Zone, US soldiers continued to extract a huge price in manpower from the enemy as they forged ahead with General Westmoreland's war of attrition in the hopes that Hanoi and its two sponsors, the People's Republic of China and the Soviet Union, would fold under unrelenting US pressure.

After blunting the Tet Offensive, US forces went after the enemy in an all-out offensive which General Westmoreland hoped would put the enemy on

▼ *US Marines under fire in elephant grass 13km (8 miles) south of Da Nang during a joint US-Korean operation in the middle of the Tet Offensive.*

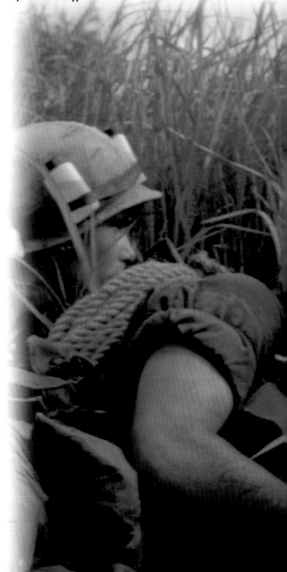

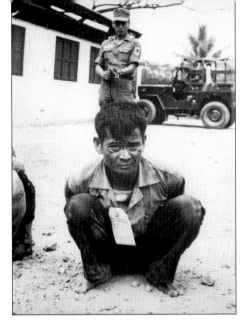

▲ *A hardcore Viet Cong member, captured in Saigon during the Tet Offensive, is watched by a South Vietnamese guard.*

the defensive once and for all. Politically, the Tet Offensive and the year 1968 in general would be one of disengagement for the United States as, before the entire nation, President Johnson placed a bombing halt on North Vietnam. The president also announced that not only was he willing to discuss peace with North Vietnam's leaders but also that, much to his countrymen's surprise, he would not seek re-election in the fall elections of 1968.

Although the Tet Offensive broke the spirit of the Johnson Administration as it sought negotiations over the fighting, militarily the Tet Offensive and 1968 in general saw the North Vietnamese take savage punishment. The NVA failed to take Khe Sanh or Hue City during two prolonged and

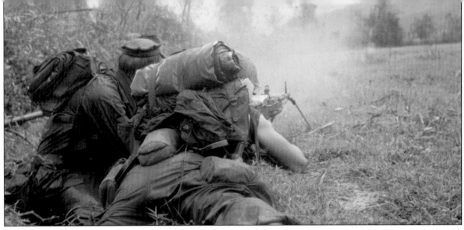

▲ *A machine-gun team from the 3rd Battalion, 5th Marine Regiment, fires on North Vietnamese Army troops during Tet.*

bloody battles with the US Marines and ARVN forces. For the Viet Cong, Tet was even more severe. The bulk of its cadres died in several major assaults against the South Vietnamese capital, Saigon, Hue City and several other major US military bases at Da Nang, Quang Tri, Bien Hoa and Qui Nhon. But Hanoi saw the Tet Offensive and 1968 as the "beginning of the end" of its quest to unify the country.

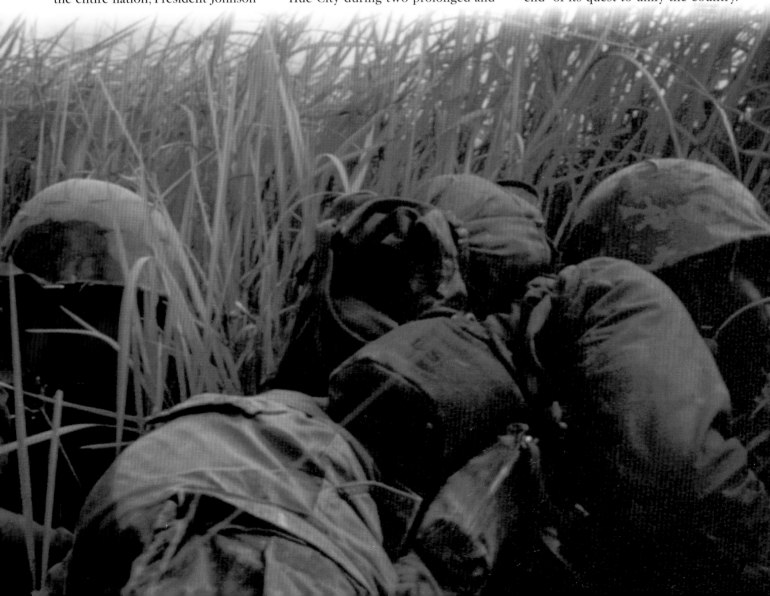

JANUARY 1

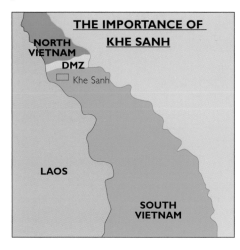

THE IMPORTANCE OF KHE SANH

NORTH VIETNAM
DMZ
Khe Sanh
LAOS
SOUTH VIETNAM

▲ *Khe Sanh had been established as a major base in 1967 astride a main infiltration route from Laos. Its occupation by US forces also prevented the NVA seizing Quang Tri Province.*

JANUARY 1

SOUTH VIETNAM, *US AID*

The US Marine Corps' troop level in Vietnam reaches 81,249. The III Marine Amphibious Force (III MAF), which is responsible for I Corps Tactical Zone, begins the year with its strength at 114,158 troops, and consists of 76,616 Marines which are divided among the 1st Marine Division, the 3rd Marine Division, the 1st Marine Aircraft Wing, and Force Logistics Command; 3538 US Navy personnel; and 36,816 US Army personnel, including the Americal Division and one brigade of the 1st Air Cavalry Division (Airmobile); as well as 88 US Air Force personnel.

▼ *A US Marine Ontos, which was armed with six 106mm recoilless rifles. As can be seen, it had a crew of three.*

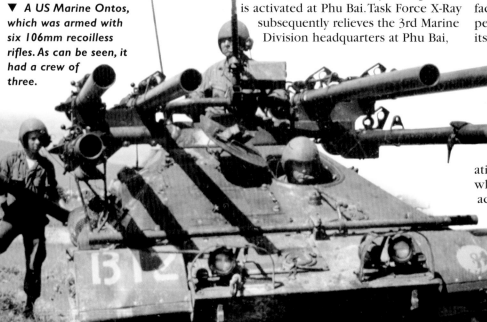

JANUARY 3

SOUTH VIETNAM, *GROUND WAR*

In an operation that began on December 28, 1967, the 5th Marines conclude Operation Auburn south of Da Nang. The operation reportedly inflicts 37 enemy casualties, with 24 Marines being killed and 62 wounded in action.

JANUARY 11

SOUTH VIETNAM, *US ARMED FORCES*

As part of Operation Checkers, in an effort to rotate units of the 1st Marine Division north to relieve the 3rd Marine Division, Task Force X-Ray headquarters is activated at Phu Bai. Task Force X-Ray subsequently relieves the 3rd Marine Division headquarters at Phu Bai,

▲ *A Montagnard village located 6.4km (4 miles) from the US base at Khe Sanh. Sites such as this came under attack during Tet.*

which then moves to Dong Ha in Quang Tri Province.

JANUARY 16

SOUTH VIETNAM, *US ARMED FORCES*

The 2nd Battalion, 26th Marines, reinforces the Marine base at Khe Sanh in I Corps Tactical Zone.

NORTH VIETNAM, *DIPLOMACY*

A North Vietnamese diplomatic representative emphatically reiterates the fact that North Vietnam will not begin peace talks until the United States halts its bombing of the North.

JANUARY 20

SOUTH VIETNAM, *GROUND WAR*

The 1st Marines end Operation Osceola I which began on October 20, 1967, in the Quang Tri City region. The operation results in 76 enemy casualties, while the US Marines suffer 17 killed in action with a further 199 wounded. The Marines also conclude Operation Lancaster I which began on November 1, 1967. The 3rd Marines launched Operation Lancaster I in order to safeguard Route 9 between Cam Lo and Ca Lu, and it ends with a reported 46 enemy casualties, while the leather-

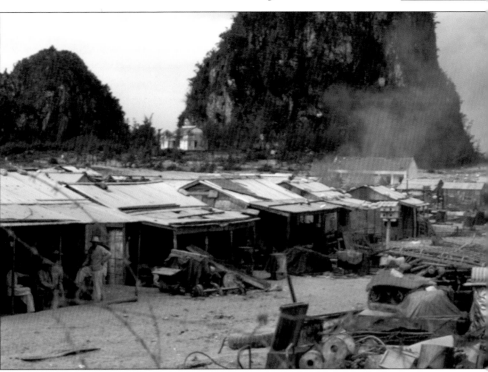

necks suffer 27 killed and 141 wounded. The 4th Marines likewise conclude Operation Neosho I which began on November 1, 1967, northwest of Hue. Operation Neosho I results in 77 enemy casualties with 12 Marines killed and 100 wounded. In Operation Scotland, a Marine patrol makes contact with a heavy concentration of NVA troops around Hill 881 South near Khe Sanh. The battle signals the beginning of the siege of Khe Sanh.

▼ *An American flame tank fires a burst of napalm at a Viet Cong position near Saigon at the beginning of 1968.*

JANUARY 21

SOUTH VIETNAM, *US ARMED FORCES*
The US Army's 1st Air Cavalry Division (Airmobile) is placed under the operational control of III Marine Amphibious Force's Commander, Lieutenant-General Robert E. Cushman, Jr.

SOUTH VIETNAM, *GROUND WAR*
The 4th Marines begin Operation Lancaster II in the same area as Operation Lancaster I was conducted. Similarly, the 3rd Marines begin Operation Osceola II in the same general area as that of Osceola I. The NVA begins to shell the US Marine fire base at Khe Sanh, as well as the other Marine out-

▲ *Many South Vietnamese refugees lived in appalling conditions. This is the Nui Kim Som camp at the base of Crow's Nest Hill, just south of Da Nang.*

posts located on the hills surrounding the base. This rocket, mortar and artillery barrage will continue for the next 77 days.

JANUARY 22

SOUTH VIETNAM, *GROUND WAR*
The 1st Battalion, 9th Marines, reinforces the Marine garrison at Khe

▶ *A symbol of the South's military effort: a statue of a Vietnamese soldier adorns a monument outside Saigon.*

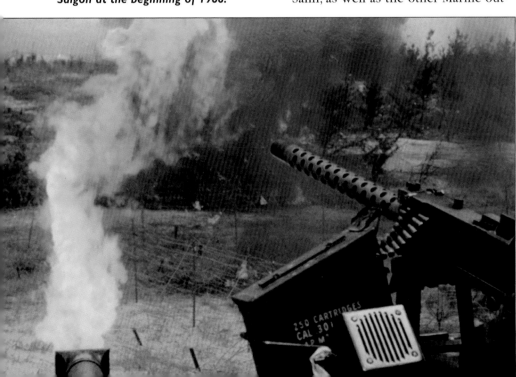

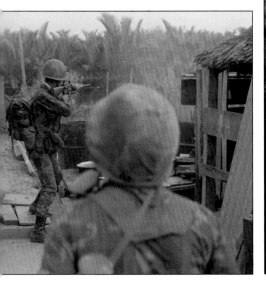

▲ The Tet Offensive. Troops of the South Vietnamese 30th Ranger Battalion on alert for the Viet Cong during a patrol in Saigon at the end of January.

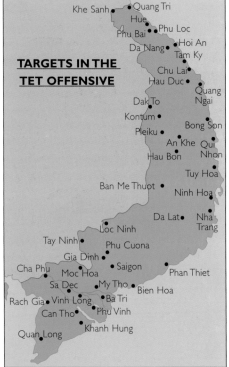

TARGETS IN THE TET OFFENSIVE

Map labels: Khe Sanh, Quang Tri, Hue, Phu Loc, Phu Bai, Hoi An, Da Nang, Tam Ky, Chu Lai, Hau Duc, Quang Ngai, Dak To, Kontum, Bong Son, Pleiku, An Khe, Qui Nhon, Hau Bon, Tuy Hoa, Ban Me Thuot, Ninh Hoa, Da Lat, Nha Trang, Loc Ninh, Tay Ninh, Phu Cuona, Gia Dinh, Cha Phu, Saigon, Moc Hoa, Phan Thiet, My Tho, Bien Hoa, Sa Dec, Ba Tri, Rach Gia, Vinh Long, Phu Vinh, Can Tho, Khanh Hung, Quan Long

▲ Major towns attacked in South Vietnam during the Tet Offensive

Sanh. At the same time, the US Army's 1st Air Cavalry Division (Airmobile) launches Operation Jeb Stuart in the northern part of I Corps Tactical Zone.

JANUARY 23

NORTH KOREA, *NAVAL WAR*
The North Koreans seize the American intelligence-gathering ship USS *Pueblo* off the coast of Korea.

SOUTH VIETNAM, *GROUND WAR*
In Vietnam, the Marine Corps' Special Landing Force Bravo, along with elements of the Battalion Landing Team, 3rd Battalion, 1st Marines, and Marine helicopter squadron HMM-165, launch Operation Badger Catch near the Cua Viet River.

JANUARY 26

SOUTH VIETNAM, *GROUND WAR*
Operation Badger Catch is renamed Operation Saline, and sees the Marines attached to Badger Catch working in conjunction with Operation Napoleon, while elements of the 1st Amphibian Tractor Battalion launch a similar effort, undertaken in order to keep the vital Cua Viet River supply line open.

▲ The lull before the storm: A US OH-6A Cayuse scout helicopter on patrol near the Cambodian border at the end of January.

JANUARY 27

SOUTH VIETNAM, *GROUND WAR*
The supposed seven-day ceasefire for the Tet holiday begins.

JANUARY 29

SOUTH VIETNAM, *GROUND WAR*
The Allied ceasefire for Tet begins in all of South Vietnam, except in I Corps Tactical Zone.

JANUARY 30

SOUTH VIETNAM, *GROUND WAR*
In pre-dawn assaults, the NVA and Viet Cong launch simultaneous attacks throughout South Vietnam, hitting US Marine, US Army and ARVN outposts in I Corps Tactical Zone especially hard. Da Nang and several cities to the south are also especially targeted by the enemy. The Tet Offensive has begun.

▼ Long Binh was one of the areas targeted by the Viet Cong during Tet. Here, US infantry and M113 armoured personnel carriers engage in a firefight.

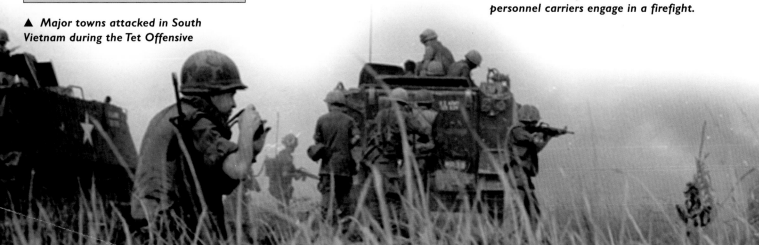

DECISIVE MOMENTS

KHE SANH

By late January 1968, US planners at every level were determined to defend Khe Sanh, despite the suggested possibility of another Dien Bien Phu. General Westmoreland gave several reasons for defending the remote outpost. It was a valuable base for monitoring North Vietnamese infiltration through Laos along the Ho Chi Minh Trail. It was also important to Westmoreland's planned invasion of Laos by which he intended physically to cut the trail. There were also non-military reasons. For example, when considering the unpopularity of the war to many Americans by 1968, there was the psychological significance of the base. While it had no intrinsic political importance, being neither a cultural nor an economic centre, to relinquish it in the face of North Vietnamese pressure would result in a major enemy propaganda victory. Admiral Ulysses S. Grant Sharp, Commander-in-Chief, Pacific, and Westmoreland's immediate superior, agreed, stating: "Withdrawal from any portion of Vietnam would make immediate and sensational news, not only through the Western news media, but also through the Communist capitals as a major propaganda item."

At Khe Sanh, the 9th and 26th Marines had the responsibility of preventing the base from falling to the surrounding Communist forces. The Marines had four infantry battalions (6000 men), an artillery battalion and numerous supporting units, including tank and antitank detachments, antiaircraft weapons, engineers, air control, communications and a host of others. Crucial to the defence was close air support provided by US Phantom jets,

▲ **US infantry cross a stream. The Viet Cong often booby trapped stream crossings, hence the leading man's nervous expression.**

▶ **The base at Khe Sanh. The dotted black line denotes the camp's main perimeter. Westmoreland wanted to defend the base to draw the NVA into a set-piece battle, much like Dien Bien Phu.**

THE KHE SANH FIRE BASE

Parachute drop zone
Helicopter bays
105mm howitzer battery
Water point
4.2in mortar battery
Airstrip
105mm howitzer battery
Main ammunition dump

JANUARY 31

SOUTH VIETNAM, *GROUND WAR*
The NVA develops its phase of the Tet Offensive throughout South Vietnam with attacks against 39 provincial capitals and major cities, including Saigon and Hue. In a single attack aimed against the US Embassy in Saigon, Viet Cong troops seize the building and hold part of it for six hours. US Marine Embassy security guards and US Army military policemen retake the building after killing all enemy sol- diers that have managed to enter the embassy compound. The 1st Brigade, 1st Air Cavalry Division (Airmobile), launches a counteroffensive via an air assault into the city of Quang Tri.

SOUTH VIETNAM, *US ARMED FORCES*
General Leonard F. Chapman, the former Commanding General, III Marine Amphibious Force, becomes the 24th Commandant

▼ **A dead Viet Cong in the grounds of the US Embassy in Saigon, January 31.**

FEBRUARY 1

▲ *Troops of the US 1st Marine Division set up a mortar in the city of Hue during the Tet Offensive, February 3.*

of the US Marine Corps as replacement to General Wallace M. Greene, Jr, who has done a truly splendid job in leading the US Marine Corps during much of the heavy fighting in Vietnam. As January ends, Operation Kentucky near the area known as "Leatherneck Square" south of the DMZ also ends, with 353 confirmed enemy casualties. The Americal Division continues Operation Wheeler\Wallowa south of Da Nang in I Corps Tactical Zone.

FEBRUARY 1

SOUTH VIETNAM, *GROUND WAR*
The 1st Brigade, 1st Air Cavalry Division (Airmobile), together with ARVN forces successfully defend the city of Quang Tri. The enemy reportedly suffers 900 confirmed casualties and 100 captured. Also, in what will be some of the heaviest fighting of the Vietnam War, units of the 1st and 5th Marines begin combat operations within the ancient Imperial capital, Hue City, in order to drive out the NVA.

USA, *POLITICS*
Vowing to end the war in Vietnam under honourable terms, Richard M. Nixon announces his candidacy for the presidency of the United States.

FEBRUARY 5

SOUTH VIETNAM, *GROUND WAR*
US Marines from the 26th Marines at the Khe Sanh Marine Corps Fire Base

▶ *A US Air Force C-130 Hercules delivers much-needed supplies to Khe Sanh. Enemy artillery rounds explode in the background.*

repel a battalion-sized attack and kill a reported 109 NVA soldiers, with 7 Marines killed and 15 wounded.

FEBRUARY 7

SOUTH VIETNAM, *GROUND WAR*
NVA units overrun the US Army's Special Forces base at Lang Vei, west of the Marine base at Khe Sanh. Meanwhile, elements of the 3rd Marines, 5th Marines, and the US Army's Americal Division engage the 2nd North Vietnamese Division in fighting around Da Nang, which Marines have given the ominous nickname "the rocket belt" due to the heavy shelling of North Vietnamese artillery units.

FEBRUARY 9

SOUTH VIETNAM, *GROUND WAR*
Units of III Marine Amphibious Force succeed in beating back the 2nd North Vietnamese Army Division's of-

▲ *A bomb dropped by a US Air F-4 Phantom explodes near the perimeter of the Khe Sanh base in early February.*

fensive at Da Nang. Military Assistance Command, Vietnam, Forward, (MACVF) under General Creighton W. Abrams, General Westmoreland's Deputy Commander and soon-to-be

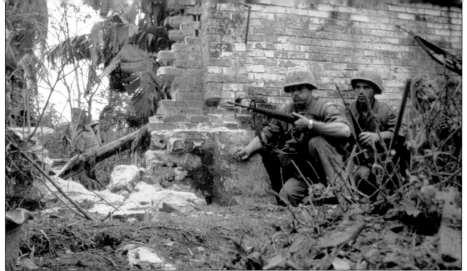

▲ Soldiers of the US 5th Marine Regiment take shelter beside a blown-out wall while waiting for the enemy to be "softened up" during the battle for Hue.

▲ Marines from A Company, 1st Battalion, 1st Marine Regiment, search for snipers while fighting in Hue.

successor, is established in I Corps Tactical Zone in order for MACV to better assess and react to the enemy's offensive operations.

FEBRUARY 13

SOUTH VIETNAM, *US ARMED FORCES*
The forward command elements and major combat units of the élite 101st Airborne Division arrive in I Corps Tactical Zone.

FEBRUARY 16

SOUTH VIETNAM, *GROUND WAR*
Operation Osceola II ends. There are a total of 21 confirmed enemy soldiers reported as casualties, with 2 US Marines killed in action and another 74 US Marines wounded.

FEBRUARY 23

SOUTH VIETNAM, *GROUND WAR*
North Vietnamese artillery gunners and mortars fire more than 1300 shells at the US Marine garrison in Khe Sanh. This will be the heaviest shelling of the Marine base during the siege of Khe Sanh.

FEBRUARY 24

SOUTH VIETNAM, *GROUND WAR*
Marines and ARVN troops finally wrest control of the ancient Citadel in Hue City from the NVA.

FEBRUARY 25

SOUTH VIETNAM, *GROUND WAR*
American forces finally declare the city of Hue secure.

FEBRUARY 29

SOUTH VIETNAM, *US AID*
Operation Saline is merged with Operation Napoleon. In order to meet

▲ Smoke and dust cover Khe Sanh during a North Vietnamese rocket attack against the base in February.

▼ When the enemy got too close to the perimeter at Khe Sanh, the Marines used small arms and flamethrowers to stop them.

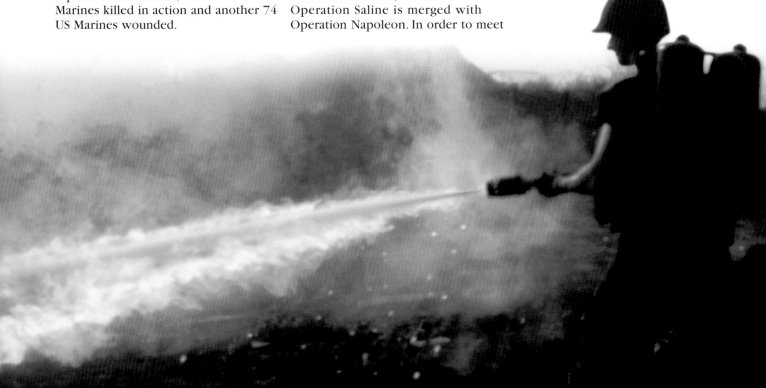

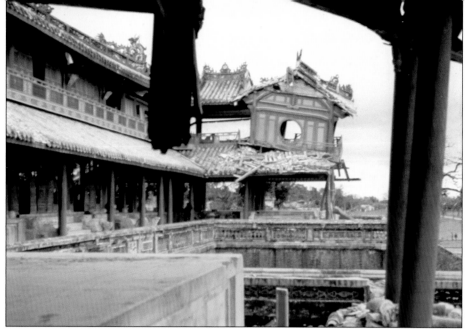

General Cushman's requests for reinforcements, and also to prevent defeat at Hue, the 27th Marine Regiment arrives in Vietnam as part of President Lyndon B. Johnson's approval for troop reinforcements by General Westmoreland and the Joint Chiefs of Staff. The arrival of the 27th Marines is part of the 200,000-strong force MACV wants to deploy a strategy of attrition. President Johnson cuts the number requested by MACV, though, citing US domestic political considerations.

SOUTH VIETNAM, *GROUND WAR*
The US Marine Operation Kentucky ends, resulting in 398 confirmed enemy

▼ *A member of the US 1st Air Cavalry Division during Operation Jeb Stuart in early March. On his back is strapped an M-72 antitank rocket launcher.*

▲ *The Old Imperial City of Hue was devastated during the Tet Offensive, especially during the US Marine operation to retake the city from the NVA.*

casualties and 90 Marines killed and 277 wounded in action.

MARCH 1

USA, *POLITICS*
Clark Clifford replaces Robert McNamara as US Secretary of Defense. McNamara had questioned the wisdom of US military involvement in Vietnam in 1967 and had lost influence in the Johnson Administration as a result.

MARCH 2

SOUTH VIETNAM, *GROUND WAR*
Operation Hue City ends successfully as the 1st and 5th Marines defeat the NVA assault on the ancient capital. The final tally of enemy dead confirmed is 1943 with 142 Marines killed in action and a further 1005 wounded.

MARCH 10

SOUTH VIETNAM, *US ARMED FORCES*
Military Assistance Command, Vietnam, Forward, is deactivated as the enemy threat to I Corps Tactical Zone subsides. Provisional Corps, Vietnam, is created. Led by Lieutenant-General William B. Rosson, USA, this command controls the 3rd Marine Division, the 1st Air Cavalry Division (Airmobile) and the 101st Airborne Division, and is subordinated to Lieutenant-General Cushman, Commander of III MAF.

MARCH 12

USA, *POLITICS*
Senator Eugene McCarthy makes a substantial showing in the New Hampshire primary, winning 40 percent of the vote,

while President Johnson wins 49 percent. Although Johnson defeats his opponent, these primary results are seen as a repudiation of his handling of the Vietnam War.

▼ *Clark Clifford, seen here during ceremonies held in the East Room of the White House in honour of McNamara, became the new secretary of defense.*

▲ In the shelter of a trench, US Marines wait for a transport aircraft to take them out of Khe Sanh during the NVA siege of the base, February 22.

DECISIVE MOMENTS

MY LAI MASSACRE

On March 16, 1968, the soldiers of C Company, 11th Brigade, Americal Division, entered the village of My Lai. Their officers reportedly told them: "This is what you've been waiting for – search and destroy – and you've got it." A few moments later the killing began. When news of the atrocity became known, it sent shockwaves through the US political establishment, the military's chain of command and an already divided American public.

My Lai lay in the South Vietnamese district of Son My, an area of heavy Viet Cong activity. C Company had learnt to loathe the place, and many of its members had been maimed or killed there during the preceding weeks. The angry soldiers, under the command of Lieutenant William Calley, entered the village in a state of readiness for engagement with the Viet Cong.

As the "search and destroy" mission unfolded, it degenerated into the massacre of over 300 apparently unarmed civilians, including women, children and the elderly. Calley ordered his men to enter the village firing, although there had been no reports of opposing fire. According to the eyewitness reports offered after the event, several old men were bayoneted, praying women and children were shot in the back of the head, and at least one girl was raped and then killed. For his part, Calley was said to have rounded up a group of the villagers, ordered them into a ditch, and killed them with machine-gun fire.

Word of the massacre did not reach the American public until November 1969, when journalist Seymour Hersh published a story detailing his conversations with Viet-nam veteran Ron Ridenhour. Ridenhour had learned of the events at My Lai from members of C Company who had been there. Before speaking with Hersh, he had actually appealed to Congress, the White House and the Pentagon to investigate the matter. The military investigation resulted in Calley being charged with murder in September 1969, two months before the Hersh story became public.

As the details of the massacre reached the American public, many questions arose concerning the conduct of American soldiers in Vietnam. A military commission investigating the My Lai massacre found widespread poor leadership, discipline and morale among US Army fighting units. One of the reasons for this was the general "dumbing down" of officer recruits. For example, as the war progressed many "career" soldiers had either been killed in action, rotated out or retired. In their place were scores of draftees whose fitness for leadership in battle was questionable to say the least. The military chiefs rounded on the draft policy, which they said provided them with a small pool of talent from which they were forced to choose leaders. They pointed to Calley as a case in point. He had been an unemployed college dropout who had graduated from the Officer's Candidate School at Fort Benning, Georgia, in 1967 – hardly a suitable candidate for command in battle.

For his part in the May Lai massacre Lieutenant Calley was sentenced to life imprisonment, but was released in 1974 following an appeal. After being issued with a dishonourable discharge, Calley entered the insurance business.

MARCH 16

SOUTH VIETNAM, *US ATROCITIES*
Troops from the US Army's Americal Division massacre more than 300 civilians, mostly women and children, in the village of My Lai.

MARCH 21

SOUTH VIETNAM, *US ARMED FORCES*
In order to better coordinate the air war over Vietnam, General Westmoreland, in keeping with the concept of the Single Air Management System, places all US Marine air assets under the control of Lieutenant-General William Momyer, USAF. General Momyer, under the terms of the Single Air Management concept, now has the re-sponsibility for coordinating and controlling all fixed-wing aircraft, including those of the 1st Marine Aircraft Wing.

MARCH 31

SOUTH VIETNAM, *GROUND WAR*
Operation Scotland which began on November 1, 1967, near Khe Sanh, ends. The operation included the defence of the besieged garrison at Khe Sanh, and results in a reported 1631 enemy casualties, as well as over 204 Marines killed in action and a further 1622 wounded in action. Meanwhile, the US Army concludes Operation Jeb Stuart, resulting in a further 3268 enemy casualties, with 284 US soldiers killed in action and 1717 wounded.

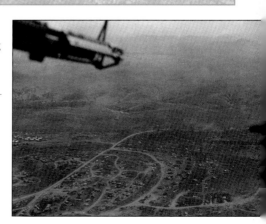

▲ The best way to see Khe Sanh: from the air aboard a heavily armed Huey. The area shown is that of the 1st Battalion, 9th Marine Regiment.

APRIL 1

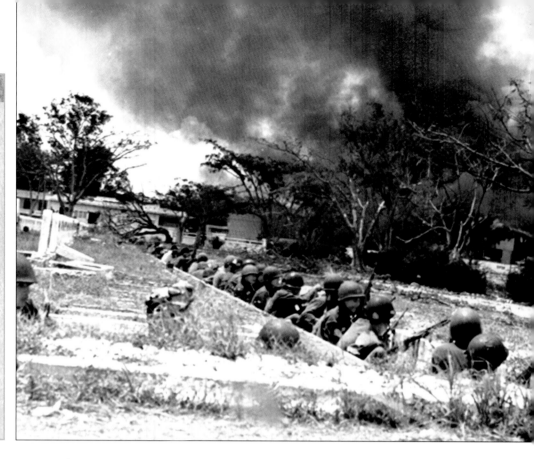

USA, *POLITICS*
President Lyndon Johnson announces a partial halt in the bombing of North Vietnam, and also that he will send an additional 13,500 troops to Vietnam, far short of the numbers which General Westmoreland has requested.

In a surprise move, President Johnson announces to the American Public: "That I will not seek, nor will I accept, another term as your President." Dropping out of the presidential election in this way, Johnson stresses that he will

▼ *In the aftermath of a 122mm rocket attack in a suburb of Saigon, residents pick through the rubble in search of survivors and belongings.*

now work towards achieving peace as an end to the war in Vietnam.

SOUTH VIETNAM, *GROUND WAR*
Operation Kentucky ends. The operation has resulted in a reported 113 enemy casualties, with 38 Marines killed and another 217 men wounded in action.

APRIL 1

SOUTH VIETNAM, *GROUND WAR*
The 1st Air Cavalry Division, together with units from the US 1st Marines and the ARVN, begins Operation Pegasus from the Marine base at Ca Lu. Operation Pegasus, it is hoped, will relieve the beleaguered US Marine garrison at Khe Sanh.

▲ *Troops of the 1st ARVN Division pinned down by Viet Cong sniper fire in the French National Cemetery in northern Saigon in late April.*

APRIL 15

SOUTH VIETNAM, *GROUND WAR*
Operation Pegasus ends with the relief and resupply of Khe Sanh, resulting in 1011 reported enemy casualties with 51 Marines killed and 459 wounded. The 1st Air Cavalry Division suffers a total of 41 killed in action and 208 wounded. With the relief of Khe Sanh and the end of Operation Pegasus, a continuation of US Marine Corps action around the base at Khe Sanh, Operation Scotland II, begins.

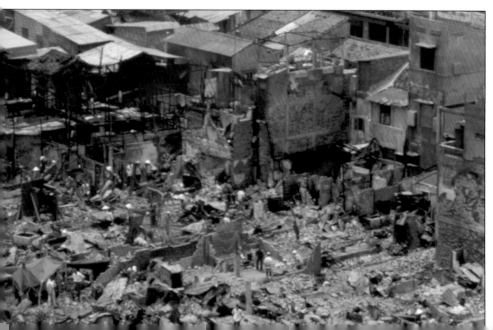

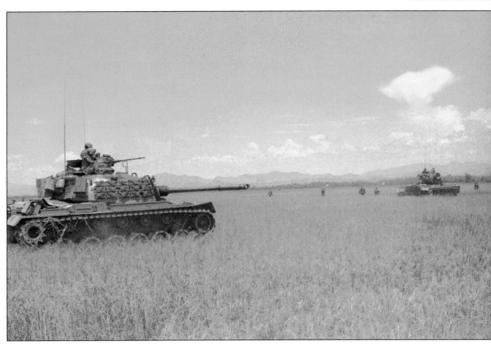

▲ *Tanks of the US 5th Cavalry Regiment, 1st Air Cavalry Division, search for North Vietnamese forces in the Dong Ha area in the aftermath of Tet.*

◄ *During Tet, ARVN troops from Task Force Alpha and Rangers of the 35th Ranger Battalion sweep Nguyen Binh Khien Street in Saigon.*

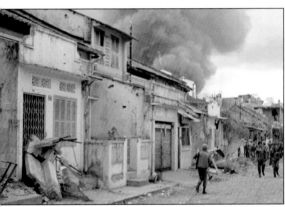

APRIL 19

SOUTH VIETNAM, *GROUND WAR*
Elements of the 1st Air Cavalry Division (Airmobile), the 101st Airborne Division and several ARVN units begin Operation Delaware/Lam Son-216 in the A Shau Valley. This operation has been designed as a spoiling assault, since US intelligence has indicated that enemy preparations are under way for another attack on Hue.

▼ *A US Marine at Khe Sanh watches an air strike by F-4 Phantoms against North Vietnamese units outside the base. Air power was crucial to the base's defence.*

ARMED FORCES

RVNAF JOINT GENERAL STAFF

The Joint General Staff (JGS), as the senior military body of the South Vietnamese Army Forces (RVNAF), was subordinate to civilian control. It was based in Saigon, and directed the war effort through the army, air force and navy chiefs of staff. The president of the republic was also minister for defence, being assisted by a secretary of state for defence. Thus the chief of the general staff, and corps and division commanders were required to report directly to the president. The latter made promotion decisions within the armed forces.

Following Diem's assassination in 1963, control of the RVNAF was through the Military Revolutionary Council, composed of the ruling junta, which bypassed the JGS. In mid-1965, political power was turned over to 10 generals who formed the National Leadership Committee (NLC). Lieutenant-General Nguyen Van Thieu became the chairman and thus the chief of state; his deputy was Air Marshal Nguyen Cao Ky, who became prime minister. During the rule of the NLC and under President Thieu, JGS worked closely with the US Military Command, Vietnam (MACV) to plan and direct military operations, but rejected a joint MACV/RVNAF command and staff arrangement. Operational guidance came from a Free World Military Assistance Council: the chief of the JGS; the senior South Korean officer in Vietnam; and the MACV commander.

APRIL 30

APRIL 30

SOUTH VIETNAM, *GROUND WAR*
The US Marine Battalion Landing Team (2nd Battalion, 4th Marines) engages North Vietnamese Army units in the village of Dai Do. Heavy fighting in this area continues until May 3.

APRIL 30–MAY 17

SOUTH VIETNAM, *GROUND WAR*
US Marine, Army and ARVN units succeed in thwarting a possible enemy assault on Dong Ha. The NVA suffers a total of 1547 casualties, while the combined force of Allies suffer 300 dead and 1000 wounded.

MAY 4

SOUTH VIETNAM, *GROUND WAR*
The 7th Marines begin Operation Allen Brook, designed to disrupt the growing enemy presence south of Da Nang.

MAY 5

SOUTH VIETNAM, *GROUND WAR*
Signalling the second major offensive of the year, sometimes referred to as a "Mini-Tet", enemy troops launch 119 rocket and mortar attacks on towns and cities.

MAY 13

FRANCE, *PEACE TALKS*
Peace talks between North Vietnam, South Vietnam and the United States begin in Paris, aimed at finding a solution to the crisis in Vietnam.

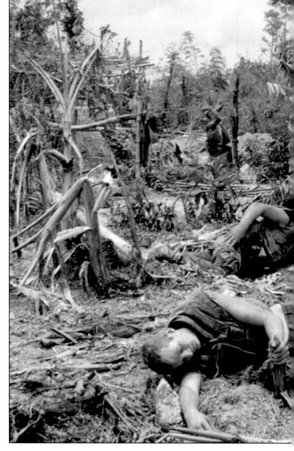

▶ *The Americans suffered many losses during 1968. These are US Marine casualties from the 7th Marine Regiment, inflicted during Operation Allen Brook.*

MAY 17

SOUTH VIETNAM, *GROUND WAR*
Operation Delaware/Lam Son-216 finally ends with a reported 735 enemy casualties, and with 142 US Army personnel killed and 731 wounded. The 1st Air Cavalry Division (Airmobile) begins Operation Jeb Stuart III along the border of Quang Tri and Thua Thien Provinces.

MAY 18

SOUTH VIETNAM, *GROUND WAR*
Battalions from the 1st Marine Division begin Operation Mameluke Thrust in the central regions of Quang Nam Province.

MAY 20

SOUTH VIETNAM, *US ARMED FORCES*
Major-General Raymond G. Davis is to replace Major-General Rathvon McC. Tompkins as Commanding General of the 3rd Marine Division.

MAY 22

SOUTH VIETNAM, *AIR WAR*
The US Marine Corps makes its first use of the North American OV-10A "Bronco". It is employed as an observation aircraft, as well as being used for counterinsurgency operations.

MAY 26

SOUTH VIETNAM, *US ARMED FORCES*
Major-General Rathvon McC. Tompkins becomes Deputy Commander of III Marine Amphibious Force, replacing Major-General William J. Van Ryzin.

MAY 27

FRANCE, *PEACE TALKS*
As peace talks between the United

KEY PERSONALITY

RICHARD NIXON

Nixon was the Republican vice-president (1953–61) under President Dwight D. Eisenhower and became president in 1968. Aiming to achieve "peace with honour" in Vietnam, Nixon gradually reduced the number of American military personnel in the country. Under his policy of "Vietnamization", combat roles were transferred to South Vietnamese troops, who nevertheless remained heavily dependent on American supplies and air support. At the same time, however, Nixon resumed the bombing of North Vietnam (suspended by President Johnson in October 1968) and expanded the air and ground war to neighbouring Cambodia and Laos. In the spring of 1970, US and South Vietnamese forces attacked North Vietnamese sanctuaries in Cambodia, causing widespread protests in the US. One of these demonstrations – at Kent State

University on May 4, 1970 – ended fatally when soldiers of the Ohio National Guard fired into a crowd of 2000 protesters, killing four and wounding nine.

After intensive negotiations between Kissinger and North Vietnamese foreign minister Le Duc Tho, the two sides reached an agreement in October 1972 and Kissinger announced: "Peace is at hand." But the South Vietnamese raised objections, and the agreement quickly broke down. An intensive 11-day bombing campaign of Hanoi and other North Vietnamese cities in late December was followed by more negotiations, and a new agreement was finally reached in January 1973 and signed in Paris. It included an immediate ceasefire, the withdrawal of all American military personnel, the release of all prisoners of war, and an international force to keep the peace. For their work on the accord, Kissinger and Le Duc Tho were awarded the 1973 Nobel Prize for Peace. Nixon ended his presidency on a sour note. Faced with almost certain impeachment for his role in the Watergate affair, he became the first American president ever to resign from office. He died on April 22, 1994.

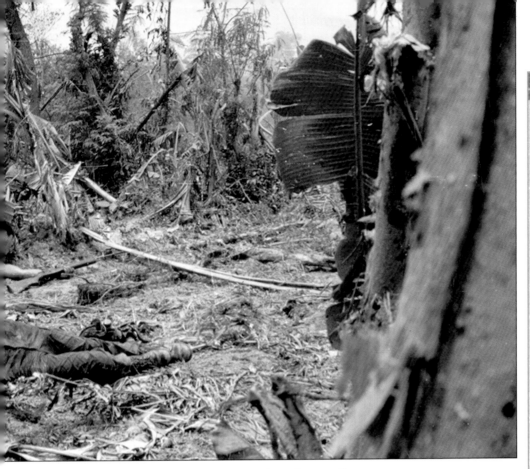

States, North Vietnam and South Vietnam break down, Marine Corps force levels in Vietnam reach 89,000.

SOUTH VIETNAM, *GROUND WAR*
Operation Kentucky results in a reported 817 enemy casualties, while 134 Marines are killed and 611 wounded in action.

JUNE 1

SOUTH VIETNAM, *US ARMED FORCES*
Lieutenant-General Henry W. Buse, Jr, replaces Lieutenant-General Victor H. "The Brute" Krulak as Commanding General, Fleet Marine Force, Pacific.

► *Senator Robert F. Kennedy was assassinated on June 5.*

JUNE 5

USA, *POLITICS*
Senator Robert F. Kennedy is assassinated in Los Angeles, CA., shortly after winning the California Democratic primary for presidential candidate.

JUNE 26

SOUTH VIETNAM, *US ARMED FORCES*
Major-General Carl A. Youngdale relieves Major-General Donn J. Robertson as Commanding General, 1st Marine Division.

JUNE 27

SOUTH VIETNAM, *US BASES*
On General Westmoreland's orders, US Marines begin to dismantle the fire base at Khe Sanh. It is then abandoned.

JULY 1

SOUTH VIETNAM, *US ARMED FORCES*
General Creighton Abrams relieves General William C. Westmoreland as Commander, US Military Assistance Command, Vietnam.

SOUTH VIETNAM, *GROUND WAR*
Operation Thor begins in the eastern portion of the DMZ as aircraft from the US Air Force, US Navy, and the Marine Corps, as well as artillery from Army and Marine artillery batteries in the DMZ sector and naval gunfire from cruisers and destroyers off the

KEY PERSONALITY

HUBERT HUMPHREY

Humphrey was born on May 27, 1911, in Wallace, South Dakota. Twice elected mayor of Minneapolis (1945 and 1947), he established the nation's first municipal fair employment practices commission and expanded the city's welfare and housing programmes. In 1944 he helped merge the Minnesota Farmer-Labor Party with the Democratic Party, and in 1947 helped found the Americans for Democratic Action. Working with them, he persuaded the Democratic-Farmer-Labor Party to expel its Communist faction. In 1948, 1954 and 1960, he was elected US senator. He was among the first to urge strong civil rights legislation, consistently supporting and initiating social welfare legislation and tax benefits for low-income groups and aid to small businesses. Among his proposals were the Peace Corps and federal old-age medical insurance (Medicare). In 1961 he became Senate majority whip. Using his expertise as a parliamentary strategist, he was instrumental in the passage of the 1963 ratification of the Limited Nuclear Test Ban Treaty and 1964 Civil Rights Act.

In 1964 he was elected US vice-president. Using his position to promote the administration's programmes in Congress, he also coordinated federal civil rights activities and chaired the Council on Economic Opportunity. In 1966, after a trip to Southeast Asia, he changed from mild opposition to the Vietnam War to full support for it, which cost him the presidency in 1968. Humphrey was reelected to the Senate in 1970 and went on to seek the Democratic presidential nomination in 1972. He died on January 13, 1978.

July 7

coast, pound enemy artillery installations in the DMZ.

July 7

SOUTH VIETNAM, *GROUND WAR*
Operation Thor ends.

July 25

SOUTH VIETNAM, *US AID*
The US Army's 1st Brigade, 5th Infantry Division (Mechanized), arrives in I Corps Tactical Zone and is placed under the operational control of III Marine Amphibious Force.

August 23

SOUTH VIETNAM, *GROUND WAR*
Operation Allen Brook ends and has resulted in a reported total of 1017 enemy casualties, with 172 Marines killed and 1124 wounded in action. Meanwhile, enemy troops mount their third major offensive by firing on 27 different Allied installations and cities, including Hue, the Da Nang Air Base and Quang Tri City. The major thrust of this effort is the city of Da Nang. But the Communists still fall short of their

▼ *A US Marine Corps M48 tank during Operation Allen Brook. This operation cost the Marines 172 dead, though enemy losses were 10 times this number.*

objective due to the resistance of US Army, Marine Corps and South Vietnamese troops.

August 24

USA, *POLITICS*
Amidst an army of anti-Vietnam War protesters, the Democratic Party meets in Chicago and nominates Vice-

President Hubert H. Humphrey as its candidate. While the delegates convene inside, the antiwar protesters outside clash violently with Chicago police for nearly four days.

September 29

SOUTH VIETNAM, *NAVAL WAR*
The US Navy's battleship USS *New Jersey* (BB 62) arrives off the Vietnamese coastline near Da Nang. The arrival of this battleship with its massive 16in guns will greatly increase the US Navy's

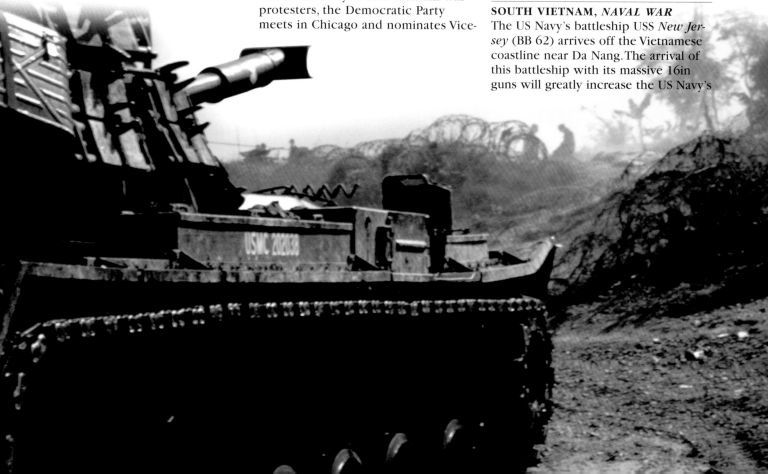

▲ The aftermath of the Tet Offensive in Hue. Militarily the offensive had been a disaster for the Viet Cong and North Vietnamese, who suffered 45,000 killed.

firepower and power projection in the eastern DMZ.

SOUTH VIETNAM, *GROUND WAR*
Operation Kentucky results in 305 enemy casualties, with 1 Marine killed and 8 wounded in action.

OCTOBER 6

SOUTH VIETNAM, *GROUND WAR*
The 7th Marines begin Operation Maui Peak in order to relieve the US Army Special Force's base at Thuong Duc in Quang Nam Province.

▲ The states of the Free World continued to send their troops to fight in Vietnam. Here, members of the Thai "Black Panther" Division arrive at Newport Docks.

OCTOBER 19

SOUTH VIETNAM, *GROUND WAR*
Operation Maui Peak ends and reportedly results in 202 enemy casualties, with 28 Marines killed and another 143 wounded in action.

OCTOBER 23

SOUTH VIETNAM, *GROUND WAR*
Operation Mameluke Thrust ends, reportedly with 2728 enemy casualties, 269 Marines killed and 1730 wounded. The 5th Marines, meanwhile, begin Operation Henderson Hill in Quang Nam Province as a continuation of Operation Mameluke Thrust.

OCTOBER 28

SOUTH VIETNAM, *US ARMED FORCES*
The US Army's 1st Air Cavalry Division (Airmobile) begins its move from I Corps Tactical Zone to that of III Corps Tactical Zone.

OCTOBER 31

NORTH VIETNAM, *AIR AND NAVAL WAR*
President Johnson announces a complete halt in both the aerial and naval bombardment of North Vietnam.

NOVEMBER 1

NORTH VIETNAM, *DIPLOMACY*
North Vietnamese officials announce that they will meet in Paris with representatives from the United States, South Vietnam and the National Liberation Front (Viet Cong) in order to begin peace talks.

ARMED FORCES

BLACKS IN THE US ARMED FORCES

The results of an investigation by the President's Committee on Equal Opportunity in 1962 on why African Americans were underrepresented in the US armed forces found uneven promotion, token integration and widespread discrimination. US involvement in Southeast Asia resulted in increased African American participation in the army, but not the abolition of discrimination within the US military. Civil rights campaigner Dr Martin Luther King maintained that black youths represented a disproportionate share of early draftees and faced a greater chance of seeing combat. There was some truth in this, for figures later revealed that though African Americans made up less than 10 percent of US soldiers between 1961 and 1966, they accounted for 20 percent of combat-related deaths in Vietnam during that period.

In Vietnam there were racial problems in rear areas after King's assassination in 1968, though not in combat units, where shared risks and responsibilities reduced racial tensions. Despite the problems faced by African Americans, it can be argued that Vietnam changed the makeup of the US armed forces for the better. African Americans reenlisted at higher rates than did whites, and the percentage of African American officers actually doubled between 1964 and 1976. That said, they still accounted for less than four percent of the total number of officers.

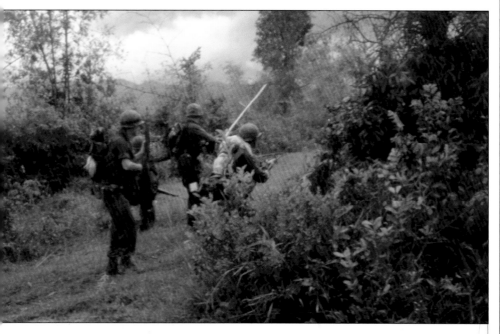

▲ US Marines engaged in a firefight with NVA troops near the DMZ. It is estimated that the NVA and Viet Cong lost around 45,000 dead in the Tet Offensive.

SOUTH VIETNAM, *SOCIAL POLICIES*
South Vietnamese Army units, aided by squads of American troops, launch an Accelerated Pacification Campaign in order to regain the trust and control of the South Vietnamese villagers and hamlets which have been lost due to the major enemy offensives during the first part of the year.

NOVEMBER 2

SOUTH VIETNAM, *DIPLOMACY*
South Vietnamese President Nguyen Van Thieu states categorically that his nation will not negotiate in Paris if the Communist National Liberation Front is given equal status with the other participants.

NOVEMBER 3

SOUTH VIETNAM, *GROUND WAR*
Operation Jeb Stuart III ends. This operation results in 2016 reported enemy casualties, with 212 US Army personnel killed and 1512 wounded in action.

NOVEMBER 5

USA, *POLITICS*
Vowing to bring "peace with honour" in Vietnam, Richard M. Nixon narrowly defeats Vice-President Hubert H. Humphrey and is elected President of the United States.

▲ US Air Force F-105 Thunderchiefs of the 34th Tactical Fighter Squadron drop 750lb bombs on NVA targets in December.

NOVEMBER 11

SOUTH VIETNAM, *GROUND WAR*
The US Army's Americal Division ends

▼ Basking in victory: the South Vietnamese flag is raised over the headquarters of the ARVN in Saigon.

▲ The spoils of victory: captured Viet Cong weapons put on display in Tan Son Nhut. The Communists had many more where these came from, though.

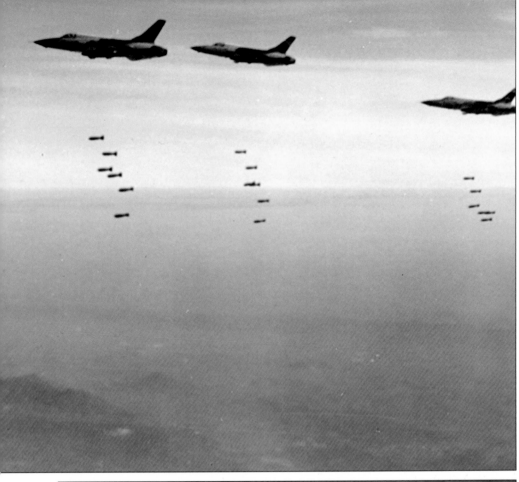

▲ *The haul of Tet: under-17 North Vietnamese prisoners taken by the Americans and incarcerated in the Bien Hoa prison camp, November 16.*

DECEMBER 6

SOUTH VIETNAM, *GROUND WAR*
Operation Henderson Hill ends, with 700 enemy casualties, and 35 Marines killed and 273 wounded in action.

DECEMBER 9

SOUTH VIETNAM, *GROUND WAR*
Operation Napoleon/Saline ends, with 3495 enemy casualties, and 353 Marines killed and 1959 wounded in action.

DECEMBER 21

SOUTH VIETNAM, *US ARMED FORCES*
Major-General Carl A. Youngdale relieves Major-General Rathvon McC. Tompkins as Deputy Commanding General, III Marine Amphibious Force, while Major-General Ormond R. Simpson relieves Major Youngdale, Commanding General, 1st Marine Division.

DECEMBER 29

SOUTH VIETNAM, *GROUND WAR*
With the Tet Offensive fresh in their memories, the US and South Vietnam announce that they will not honour any more holiday truces.
SOUTH VIETNAM, *US BASES*
Camp Carroll, which provided the Marine defenders at Khe Sanh with very effective fire support, is deactivated.

DECEMBER 31

SOUTH VIETNAM, *US ARMED FORCES*
The III Marine Amphibious Force ends the year with operational control of various combat units. The US Marines have this year inflicted a total of 31,691 combat deaths on the North Vietnamese and Viet Cong. The cost to the Marine Corps is 4618 Marines killed and 29,320 wounded in action.

Operation Wheeler\Wallowa after 14 months of battle, resulting in 10,020 enemy casualties, with 683 US Army personnel killed and 3597 wounded.

NOVEMBER 20

SOUTH VIETNAM, *GROUND WAR*
The US 1st Marines start Operation Meade River, 14.5km (9 miles) south of Da Nang, to support the South Vietnamese Accelerated Pacification Campaign.

NOVEMBER 23

SOUTH VIETNAM, *GROUND WAR*
Operation Lancaster II ends, resulting

▲ *Saigon may have been cleared, but close by the Viet Cong was still active: E-158 CS gas clusters being dropped by US aircraft 15km (9.3 miles) west of the city.*

in 1800 enemy casualties with a total of 359 Marines killed and 2101 wounded in action.

NOVEMBER 26

FRANCE, *PEACE TALKS*
President Johnson states that the forthcoming peace talks are to include the US, South Vietnam, North Vietnam and Viet Cong delegations.

1969
THE BLOODIEST YEAR

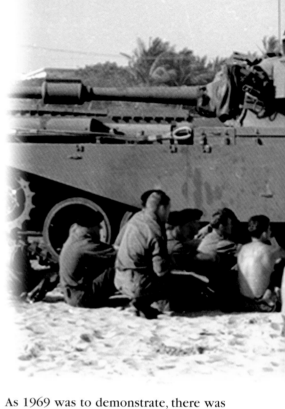

As Richard M. Nixon prepared to assume the presidency on January 20, 1969, fighting in Vietnam continued. While the Tet Offensive of late January and February had decimated the Viet Cong's infrastructure and its ranks, the war became more conventional in nature as the North Vietnamese Army (NVA) intervened to assume a greater direct involvement. It was now becoming clear that the USA was trying to disengage itself from a war that was unpopular not only at home, but also increasingly abroad. General Creighton W. Abrams replaced General William C. Westmoreland in July 1968 as US Commander MACV. He was faced with the difficult task of fighting a war that no one wanted to fight, not even the American soldiers, Marines, sailors and airmen in the field and skies above Vietnam.

As 1969 was to demonstrate, there was still a lot of hard fighting to do in Vietnam. With it came the additional task of preparing the Army of the Republic of Vietnam (ARVN) to assume more and more of the fighting as US forces began the slow but steady pace of redeployment. Yet even with the announced withdrawals of US forces, the fighting on the ground in Vietnam continued, with the tempo of operations increasing. American troops faced an even more determined adversary on the battlefields, that stretched from the Demilitarized Zone (DMZ) and Central Highlands to the marshes and rivers surrounding Saigon. US military strength in South Vietnam peaked at 539,000 men and women, but the fighting became harder as both sides now positioned them-

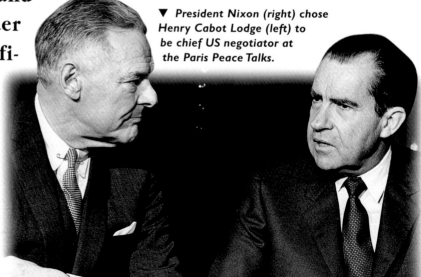

▼ *President Nixon (right) chose Henry Cabot Lodge (left) to be chief US negotiator at the Paris Peace Talks.*

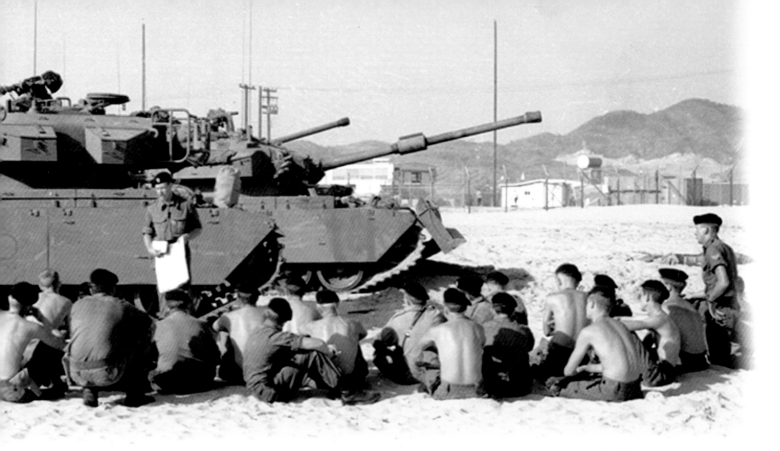

▲ *Part of the Australian effort in South Vietnam: Centurion tanks and men of the 1st Australian Regiment being briefed prior to a move to Nui Dat, February 27.*

selves for the peace negotiations, which got under way in Paris as a new US president entered office. Determined to bring "peace with honour", President Nixon and his National Security Advisor, Henry Kissinger, reassured South Vietnamese President Nguyen Van Thieu that the United States would not "cut and run" in its commitment to defend South Vietnam against the Communist aggression. But privately both Americans sought disengagement from a war that continued to take hundreds of American lives.

JANUARY 1

SOUTH VIETNAM, *ARVN*

South Vietnamese President Nguyen Van Thieu suggests to American military officials and politicians that the ARVN "was ready to replace part of the Allied force in 1969 and assume more of the fighting."

JANUARY 5

USA, *DIPLOMACY*

President-elect Richard M. Nixon names Ambassador Henry Cabot Lodge to succeed Ambassador Averell Harriman as chief US negotiator at the Paris Peace Talks. He also reappoints Ambassador Ellsworth Bunker to continue in his post in Saigon as US Ambassador to South Vietnam.

JANUARY 6-7

SOUTH VIETNAM, *GROUND WAR*

A company of the US Army's 1st Brigade, 9th Infantry Division, engages a company sized force of Viet Cong and NVA in a bunker complex 15km (9 miles) southeast of Cao Lanh. Other elements of the brigade reinforce the company during the evening. Contact continues through the night, and finally ends at 11:00 hours on January 7 as the enemy withdraws. The soldiers count 54 enemy killed in action, while the US force loses 8 soldiers killed and 11 wounded. The soldiers also capture a small number of AK-47 assault rifles.

JANUARY 14

SOUTH VIETNAM, *GROUND WAR*

A convoy from the US 25th Infantry Division, en route to Tay Ninh City, comes under automatic weapons and rocket-propelled grenade fire from an unknown-size enemy force 10km (6 miles) east of the city. The convoy security elements return fire with organic weapons, including .50-calibre machine guns mounted on M-113 armoured personnel carriers (APCs). US Army gunships and US Air Force tactical air strikes engage the enemy positions throughout the entire day. By 13:00 hours, mechanized mounted infantry elements of the

◀ *US Marines of the 2nd Battalion, 9th Marine Regiment, take time out before an operation on January 28.*

145

▲ Living in the field: a soldier from the US 101st Airborne Division washes on Hill 549, southwest of Nuc.

3rd Brigade, 25th Infantry Division, in APCs reinforce their comrades and attack the enemy force in strength. Action continues until 17:30 hours, when the enemy breaks contact and withdraws. In a sweep of the battlefield that evening, the soldiers of the 25th Division confirm 122 enemy killed in action and capture several crew-served weapons. The 25th Division suffers 7 soldiers killed and 10 wounded in the attack. Two trucks are damaged, but the convoy continues towards its destination.

JANUARY 20

USA, *POLITICS*
Richard M. Nixon is inaugurated as president of the United States, succeeding Lyndon B. Johnson.

JANUARY 22

SOUTH VIETNAM, *GROUND WAR*
US Marines launch Operation Dewey Canyon in the Da Krong Valley of Quang Tri Province, with the helicopter lift of Colonel Robert H. Barrow's 9th Marines and its supporting artillery from the US Marine Vandegrift Combat Base into the zone of operations.

JANUARY 25–26

SOUTH VIETNAM, *GROUND WAR*
An element of the US 3rd Brigade, 9th Infantry, engages an enemy force while sweeping an area 14km (9 miles) northwest of Tan An. The enemy employs small-arms and automatic weapons fire, while the infantry with organic weapons is supported by US Army helicopter gunships and artillery. Later in the afternoon, another element of the brigade is deployed into a blocking position, and approximately 1900 other elements of the brigade are air-assaulted into the area in an attempt to cordon off the enemy.

During the afternoon and night, US Air Force AC-47 "Spooky" gunships support the troops. Sporadic contact continues into the afternoon of January 26, until the enemy once again breaks off contact and withdraws. The soldiers find the bodies of 78 NVA and Viet Cong troops. In addition to the enemy casualties, one NVA soldier defects to the side of the government as part of the Chieu Hoi ("Open Arms") programme. The infantrymen also capture 20 individual and 8 crew-served

▼ A US Phantom jet bombs Viet Cong positions near the perimeter of the Bien Hoa Air Base in February.

▲ An armed US air cushion vehicle photographed on the Song My Tho River at the end of January 1969.

weapons, along with 32 rocket-propelled grenade launchers, 16 60mm mortar rounds and 14 Chinese Communist hand grenades. US casualties are 7 killed and 12 wounded in action.

JANUARY 29

SOUTH VIETNAM, *GROUND FORCES*
At 20:15 hours, a company from the 7th Marines, 1st Marine Division, observes an estimated 300 enemy moving

▲ Infantry and an M48 Patton tank of the 11th Armored Cavalry Regiment battle the Viet Cong on February 23.

south about 14km (9 miles) northeast of An Hoa. The Marines establish a blocking position and engage the enemy with organic weapons, as artillery and a US Air Force AC-47 "Spooky" gunship support the action. An element of the 5th Marines, 1st Marine Division, reinforces the Marines from the 7th Regiment in contact about 40 minutes later (20:40 hours), and the fighting continues all night until 23:15 hours, when the NVA breaks contact and withdraws. The next day the US Marines count 72 enemy dead from the three-hour fight. Six US Marines are wounded with no fatalities reported.

JANUARY 31

SOUTH VIETNAM, *US AID*
US military strength in South Vietnam numbers 539,800 men and women. The US Marine Corps' strength stands at 81,000.

▶ A line of M551 Sheridan tanks of the US 25th Infantry Division near Tay Ninh City at the end of January.

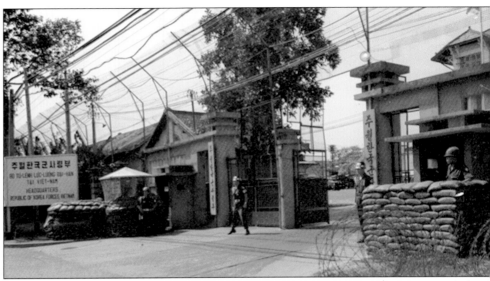

FEBRUARY 1–3

SOUTH VIETNAM, *GROUND WAR*
There are seven North Vietnamese/Viet Cong attacks launched throughout I Corps Tactical Zone. The attacks are limited probing actions aimed primarily at the Hue area and the surrounding Thua Thien lowlands.

FEBRUARY 2

SOUTH VIETNAM, *GROUND WAR*
In I Corps Tactical Zone, the North Vietnamese employ 122mm Soviet-supplied howitzers against Allied forces in southern Quang Tri Province. This is the first enemy artillery fire received in I Corps Tactical Zone since the bombing halt.

FEBRUARY 12

SOUTH VIETNAM, *GROUND WAR*
In II Corps Tactical Zone there is an indirect fire attack by the NVA and VC against Landing Zone Sarah, 13km (8 miles) northeast of Phan Thiet.

FEBRUARY 14

SOUTH VIETNAM, *GROUND WAR*
US forces in IV Corps Tactical Zone in Kien Hoa Province

▲ The heavily guarded headquarters of Republic of Korea forces on Tran hung Dao Street in Saigon.

kill 62 enemy soldiers in a firefight 5km (3.2 miles) southeast of Ben Tri City.

FEBRUARY 16

SOUTH VIETNAM, *GROUND WAR*
Allied forces observe a 24-hour ceasefire during Tet, the Vietnamese New Year. Despite the ceasefire, both Viet Cong and NVA forces commit 203 known truce violations that result in the loss of 6 US Marines killed and 94 wounded in I Corps Tactical Zone alone.

FEBRUARY 16–OCTOBER 31

SOUTH VIETNAM, *GROUND WAR*
In Operation Toan Thang (Phase III) elements of the 1st, 9th and 25th Infantry Divisions; the 199th Light Infantry Brigade; the 11th Armored Cavalry Regiment, 3rd Brigade, 82nd Airborne Division; and 1st ATF/RTAVR 1st Cavalry Division

FEBRUARY 23

(Airmobile) conduct a III Corps-wide search-and-clear operation. In the eight-month operation, US and other Allied forces confirm that 41,803 enemy soldiers have been killed in action, and 3299 of them captured. US and Free World casualties number 1533 killed in action and 10,462 wounded.

FEBRUARY 23

SOUTH VIETNAM, *GROUND WAR*
Reminiscent of last year, Communist forces launch a major offensive throughout South Vietnam, one day following the expiration of the seven-day Viet Cong-proclaimed truce for Tet. The attacks once again are considered by MACV to be probing actions throughout southern I Corps Tactical Zone. The primary enemy targets are US and ARVN forces and installations in the Quang Nam lowlands, An Hoa industrial complex, Tam Ky City, the Tien Phuoc CIDG Camp and Quang Ngai Province, where elements of the 3rd NVA Division are involved. An enemy defector indicates that there are at least four NVA regiments and Viet Cong local forces who are participating in this offensive.

Enemy rocket and mortar fire slams into Saigon. There are also several concurrent ground attacks launched by enemy forces throughout South Vietnam, with the heaviest fighting taking place in both III and I Corps Tactical Zones. The NVA and Viet Cong achieve no military gains as the attacks are pre-empted by aggressive Allied sweeping operations. At 02:00 hours on February 23, the Viet Cong and NVA launch an offensive in the Delta region. For nearly a week the enemy will continue to launch attacks against a number of US targets in both isolated and urban areas.

An NVA battalion entrenched in an extensive bunker complex seeks to halt the 9th Marines engaged in Operation Dewey Canyon. Two companies of

▼ *A symbol of the democratic process: the Senate Building in Saigon, located on Ben Chuong Street.*

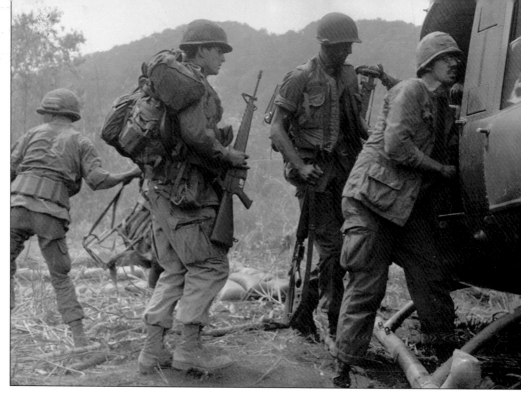

Marines, along with the combination of US Marine air and artillery, dislodge the stubborn enemy defenders, and when the fighting is completed the Marines count 105 NVA killed in action.

FEBRUARY 23–24

SOUTH VIETNAM, *GROUND WAR*
Widespread indirect fire attacks are reported throughout II Corps Tactical Zone. During the next five days the number of attacks diminishes to a low on February 27. After February 23 the focus of the enemy attacks shifts to the western highlands. Significant enemy ground probes take place at Ben Het and Polei Kleng. Also, Routes 14 and 19 are interdicted by enemy attacks.

FEBRUARY 24–25

SOUTH VIETNAM, *GROUND WAR*
Regional Forces engage enemy forces in Vinh Binh Province and kill 80 Viet Cong soldiers.

FEBRUARY 25

SOUTH VIETNAM, *GROUND WAR*
Marine Fire Support Bases Neville and Russell come under heavy enemy

▲ *Members of the US 101st Airborne Division board a UH-1D helicopter during Operation Kentucky Jumper.*

ground and mortar attacks, resulting in the loss of 30 US Marines and the wounding of 79 others.

ARVN and Popular Forces units contact an enemy force 6km (3.7 miles) northwest of Chau Doc City, resulting in 187 enemy killed.

FEBRUARY 26

SOUTH VIETNAM, *GROUND WAR*
In the early morning hours of Wednesday, February 26, a force of approximately 400 men from the 275th Regiment, 5th Viet Cong Division, infiltrate the village of Thai Hiep on the outskirts of Bien Hoa, 12km (20 miles) northeast of Saigon. MACV intelligence estimates that as many as 85 percent of the force are soldiers from the NVA.

US Air Force security forces engage the enemy forces at the perimeter of the Bien Hoa Air Base. Elements of the 5th Vietnamese Marines, 3rd Battalion, 48th ARVN Infantry Regiment, and elements of the US Army's 3rd Squadron

KEY WEAPONS

BOOBY TRAPS

The following is from a report written by a rifle platoon leader who served with the Americal Division in late 1967 and early 1968: "In the five months that the 1st Battalion, 52nd Infantry, have been in Vietnam, Viet Cong emplaced mines and booby traps have caused the greatest number of casualties. Of the 77 men wounded due to hostile action, 71 have been wounded, some minor, some seriously, by these weapons which the Viet Cong have mastered so well ... 16 of our 23 men killed in hostile action have died because of mines and booby traps. Percentage wise, this is 92 percent of all wounded and 70 percent of all killed. To say the least, the percentages are rather high."

Booby traps were an integral component of the war waged by Viet Cong and North Vietnamese Army (NVA) forces in Vietnam. These devices were used to delay and disrupt the mobility of US forces; in fact, the threat was often enough to slow any advance to a snail's pace, divert resources towards guard duty and clearance operations, inflict casualties, and damage equipment. A key component in prearranged killing zones, they could be covered by snipers to further annoy the enemy or they might be the signal to spring an ambush. The use of booby traps also had a long-lasting psychological impact on US Marines and soldiers, helping to fur-

ther alienate them from civilian populations that could not be distinguished from combatants. The fear of booby traps and mines was so great that stress created severe mental fatigue on the commanders at platoon level and the individual soldiers. Non-explosive antipersonnel devices included punji stakes, bear traps, crossbow traps, spiked mud balls, double-spike caltrops and scorpion-filled boxes. By far the most common type of booby trap was the single punji stake. Punji stakes were sharpened lengths of bamboo or metal with needle-like tips that had been fire-hardened. Often they were coated with excrement to cause infection.

Explosive devices included the mud ball mine, grenade-in-tin-can mine, cartridge trap and bicycle booby trap. Stepping on the mud ball resulted in the mine detonating. Between January 1965 and June 1970, 11 percent of the fatalities and 17 percent of the wounds among US Army troops came from booby traps and mines.

Combating booby traps was done by the destruction of underground mine and booby trap factories, use of ground surveillance radar and deploying scout teams and Kit Carson Scouts. However, the fear of booby traps never went away. They were certainly very effective weapons.

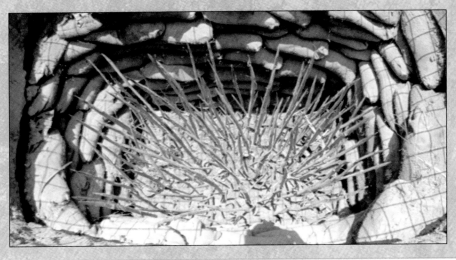

5th Armored Cavalry, move to within a half mile of the village.

In one of the best tactical operations that it will conduct during the Vietnam War, and with signs that it is ready to assume more of the fighting, the ARVN executes a perfect blocking operation and surrounds the enemy forces. As US Air Force F-100 Super Sabre jets and F-4 Phantoms, as well as Vietnamese Air Force A-1E Skyraiders, fly close air support strikes, the ARVN executes a methodi-

cal assault against the village of Thai Hiep which the NVA has already turned into a mini-fortress.

In a two-day clearing operation the ARVN forces, assisted by elements of the 36th ARVN Ranger Battalion, kill 246 enemy soldiers and capture 87 of them, in addition to capturing 100 crew-served and individual weapons. The ARVN suffers 10 killed and 100 wounded in action. The US loses one soldier killed in action. The enemy prisoners reveal to their captors that their main targets were both Bien Hoa City and the Bien Hoa Air Base.

FEBRUARY 27–28

SOUTH VIETNAM, *GROUND WAR*
During Operation Dewey Canyon, the US Marines attached to the 9th Marine Regiment un-

cover the largest single haul of enemy arms and ammunition in the war to date, a major enemy cache which is found to include four Soviet-supplied 122mm howitzers, the first ever captured in the war.

FEBRUARY 28

SOUTH VIETNAM, *GROUND WAR*
The 3rd Marine Division ends Operations Scotland II and Kentucky. During Scotland II, more than 3300 enemy troops are

▶ *A US Marine of a Combined Action Platoon instructs a Popular Forces member how to strip a Browning Automatic Rifle.*

confirmed killed in action, while the friendly casualties number 463 killed. Operation Kentucky results in over 3900 enemy and 520 US casualties.

MARCH 1–AUGUST 14

SOUTH VIETNAM, *GROUND WAR*
In Thua Thien Province, several battalions from the 101st Airborne Division (Airmobile) conduct Operation Kentucky Jumper. US paratroopers inflict 309 casualties on the enemy, while losing 61 soldiers dead as well as 409 wounded in action.

MARCH 2

SOUTH VIETNAM, *POLITICS*
Village and hamlet elections are held throughout South Vietnam. In I Corps Tactical Zone alone, the percentage of the population voting ranges anywhere from 82 percent in Quang Nam to 92 percent in Quang Tri Province. The enemy makes no attempt to disrupt voting.

MARCH 3

SOUTH VIETNAM, *US ARMED FORCES*
The US Marine Corps receives its first CH-53D assault helicopter. The CH-53D, which is intended to replace the CH-53A, introduced into Vietnam in late 1966. It, can transport 4 tonnes (4 tons) of cargo or 38 combat troops.

MARCH 7

SOUTH VIETNAM, *ENEMY STRENGTH*
Allied intelligence estimates of enemy strength place 40,000 NVA and from 60,000 to 70,000 Viet Cong in I Corps Tactical Zone, a majority of which, intelligence indicates, are in the northern provinces of the zone.

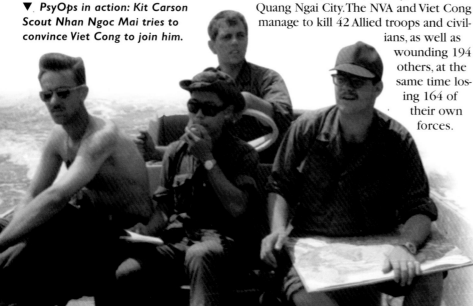

▼ *PsyOps in action: Kit Carson Scout Nhan Ngoc Mai tries to convince Viet Cong to join him.*

MARCH 8

SOUTH VIETNAM, *GROUND WAR*
Early on the morning of March 8, an enemy force, estimated to be at least battalion strength, attacks the night defensive positions of an element of the 1st Brigade, US 1st Cavalry Division (Airmobile), 6km (4 miles) northeast of Phu Khuong. The enemy employs small-arms, automatic weapons and RPG rocket grenade fire, while the sky troopers return fire with their organic weapons, supported by artillery and helicopter gunships. When the battle ends and the enemy withdraws, the American soldiers count 154 enemy bodies in the failed night attack.

MARCH 9

SOUTH VIETNAM, *GROUND WAR*
The US 1st Marine Division's Operation Taylor Common ends in Quang Nam Province. The operation, which began on December 7, 1968, accounts for close to 1400 enemy killed and 610 captured.

MARCH 16

SOUTH VIETNAM, *NAVAL WAR*
The US Navy battleship USS *New Jersey* departs from off the coast of Vietnam. Its 16in guns have provided Marines, ARVN and US Army soldiers with valuable fire support.

MARCH 19

SOUTH VIETNAM, *GROUND WAR*
The Viet Cong and NVA launch a total of 27 indirect fire and 13 ground attacks against selected military and civilian targets in central and southern I Corps Tactical Zone. The enemy's primary targets are Da Nang, Hoi An, Tam Ky, Chu Lai and Quang Ngai City. The NVA and Viet Cong manage to kill 42 Allied troops and civilians, as well as wounding 194 others, at the same time losing 164 of their own forces.

MARCH 25–30

SOUTH VIETNAM, *GROUND WAR*
The NVA suffers more than 300 killed in a series of firefights with ARVN forces 17km (10.5 miles) west of Hoi An in I Corps Tactical Zone.

MARCH 26

SOUTH VIETNAM, *US GROUND FORCES*
Lieutenant-General Herman Nickerson, Jr, replaces Lieutenant-General Robert E. Cushman, Jr, as the Commanding General, III Marine Amphibious Force.

MARCH 30

SOUTH VIETNAM, *ENGINEERING*
III Marine Amphibious Force combat engineers complete the construction of the Liberty Bridge, which spans the Song Thu Bon River, south of Da Nang.

APRIL 3

SOUTH VIETNAM, *US CASUALTIES*
The Commander, US Military Assistance Command, Vietnam, confirms that more Americans have been killed in Vietnam than during the Korean War. Vietnam has already cost the lives of 33,641 American lives since January 1961, compared to the 33,629 lost in Korea.

APRIL 4

SOUTH VIETNAM, *GROUND WAR*
US soldiers in II Corps Tactical Zone capture a Viet Cong soldier 7km (4.3

KEY WEAPONS

F-4 PHANTOM

The Phantom was in continuous production for 20 years (from 1959 until 1979). During the Vietnam war, 72 were coming off the production line every month. Although initially designed as an interceptor and later used primarily in the air-to-ground strike role, the Phantom proved to be an excellent dogfighter when the correct tactics were used. USAF, Navy and Marine Corps Phantom IIs achieved 277 air-to-air combat victories in Vietnam.

The F-4 Phantom lacked an internal gun or cannon but relied on state-of-the-art radar, long-range Sparrow missiles and short-range heat-seeking Sidewinders. Prior to Vietnam this all-missile armament was seen as quite sufficient and an internal gun obsolete. Pilots dogfighting in the skies over Southeast Asia soon found the lack of a gun a real liability. In addition, rules of engagement from the White House often put American aircrews at a disadvantage: pilots had to visually identify targets as enemy aircraft before firing.

▲ *The massive base at Lai Khe was the home of the US 1st Infantry Division, a unit that saw much action in Vietnam.*

miles) northeast of the Plei Mrong CIDG camp, who identifies his unit as the 6th Battalion, 24th NVA Regiment, and tells interrogators that elements of his regiment have redeployed to western Kontum Province.

APRIL 5–7

SOUTH VIETNAM, *GROUND WAR*
During a search-and-clear operation in Kien Tuong Province, ARVN elements kill 102 enemy soldiers. Two caches of weapons are found, totalling 21.3 tonnes (21 tons) of assorted munitions.

APRIL 7

SOUTH VIETNAM, *US SOCIAL POLICIES*
Pacification is given renewed emphasis as the Commanding General, III Marine Amphibious Force, establishes the Joint Coordinating Council in order to monitor and coordinate, as well as support, pacification and development programmes in I Corps Tactical Zone of Operations.

APRIL 10

SOUTH VIETNAM, *US ARMED FORCES*
Four AH-1G Cobra gunships arrive in Da Nang to begin air operations with Marine Observation Squadron 2.

SOUTH VIETNAM, *GROUND WAR*
Elements of ARVN units in IV Corps Tactical Zone engage a company sized force of Viet Cong in Chuong Thien Province. They kill 80 enemy soldiers.

APRIL 11–12

SOUTH VIETNAM, *GROUND WAR*
US soldiers in IV Corps Tactical Zone engage a Viet Cong Battalion in Kien Tuong Province, resulting in 97 enemy dead.

APRIL 15

SOUTH VIETNAM, *US ARMED FORCES*
Major-General William K. Jones replaces Major-General Raymond G. Davis as Commanding General, 3rd Marine Division.

APRIL 17

SOUTH VIETNAM, *US ARMED FORCES*
US Marine firepower increases with the introduction of the first 175mm guns, scheduled to replace the 155mm guns, of the US Army's 1st, 3rd and 5th 155mm Gun Batteries.

APRIL 18

SOUTH VIETNAM, *GROUND WAR*
Approximately 6km (3.7 miles) northeast of An Khe in II Corps, a US convoy and four strongpoints receive simultaneous fire, followed by a ground attack against one of the strongpoints. It is thought that the enemy are from the 18th North Vietnamese Regiment.

APRIL 19–26

SOUTH VIETNAM, *GROUND WAR*
A series of contacts with the enemy takes place about

▶ *Melvin Laird gave Hanoi conditions concerning any withdrawal of US troops from the South.*

23km (14 miles) southeast of the Tieu Atar CIDG camp in northwest Darlac Province and results in 140 NVA killed in action.

APRIL 23

USA, *ANTIWAR PROTESTS*
More than 250 student leaders from colleges throughout the United States make public statements that they will refuse induction into the armed forces so long as the war continues in Vietnam.

APRIL 25–28

SOUTH VIETNAM, *GROUND WAR*
Allied forces in I Corps Tactical Zone are subjected to intense and precise enemy sapper attacks. Allied forces suffer 17 killed and 89 wounded in action, while 64 NVA are killed in action.

APRIL 30

SOUTH VIETNAM, *GROUND WAR*
US MACV intelligence reports indicate that April has been a period of reassessment and refitting in III Corps Tactical Zone in and around Saigon. While there are sporadic attacks and limited offensives, these forces do little more than maintain an enemy presence in this area.

MAY 3

SOUTH VIETNAM, *US TROOP WITHDRAWALS*
US Defense Secretary Melvin Laird says that the United

MAY 6

States can begin troop withdrawals if any one of the following three basic conditions are met by Hanoi: (1) Agreement of mutual withdrawals; (2) sufficient improvements of the South Vietnamese Armed Forces; (3) A substantial reduction of VC/NVA activity in South Vietnam.

MAY 6

SOUTH VIETNAM, *US ARMED FORCES*
III Marine Amphibious Force, composed of the 1st and 3rd Marine Divisions, 1st Marine Aircraft Wing, Force Logistics Command, and the US Army's XXIV Corps, American Division, the 101st Airborne Division (Airmobile), and the 1st Brigade, 5th Infantry Division (Mechanized), begins its fifth year in Vietnam.

MAY 8

NORTH VIETNAM, *PEACE PROPOSALS*
The Vietnamese Communists issue a 10-point proposal for peace, the most important provision and a new element being the attempt to limit United States participation in negotiations to the subject of a unilateral withdrawal from South Vietnam.

MAY 9–11

SOUTH VIETNAM, *GROUND WAR*
US Marines cordon off a 400–600-sized enemy force which is moving north. The Marines suffer 23 killed and 58 wounded in action. The Marines inflict substantially more casualties on the

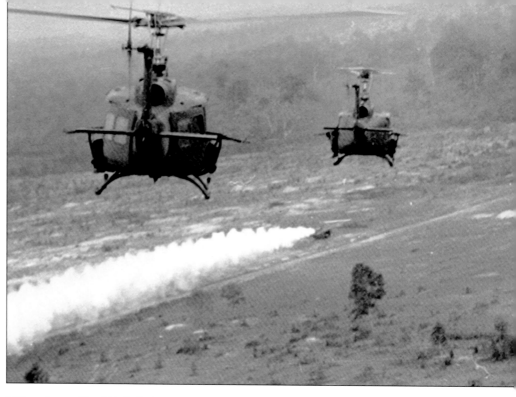

NVA, who suffer 233 killed in action and 5 taken as prisoners of war from three different NVA regiments, one of which is identified as the 36th NVA Regiment and an NVA Sapper Regiment.

MAY 10

SOUTH VIETNAM, *GROUND WAR*
Operation Apache Snow begins in the southern Da Krong Valley and ends on June 7 in the northern A Shau Valley, and involves the 9th Marines and elements of the 101st Airborne Division. During the operation, the paratroopers of the 101st Airborne Division assault and capture the heavily fortified Dong Ap Bi, or, as it later becomes known, "Hamburger Hill".

▲ *UH-1D helicopters of the US 101st Airborne Division lay a smokescreen during Operation Lamar Plain.*

MAY 12

SOUTH VIETNAM, *GROUND WAR*
The Viet Cong/NVA strike throughout South Vietnam in some of the largest number of attacks since the Tet Offensive in 1968.

MAY 16–AUGUST 13

SOUTH VIETNAM, *GROUND WAR*
Soldiers of the 101st Airborne Division (Airmobile) launch Operation Lamar Plain. They will inflict 524 casualties on the NVA.

MAY 22

SOUTH VIETNAM, *GROUND WAR*
US Marines at Fire Support Base Erskine receive incoming enemy artillery rounds. While the enemy units are unidentified, it is believed that the fire is coming from an NVA artillery regiment. This marks the first use of tube artillery by the NVA since March.

MAY 29

SOUTH VIETNAM, *GROUND WAR*
The 7th Marines' multi-battalion Operation Oklahoma Hills ends. While enemy losses during the two-month operation are placed at 596, the US Marines and ARVN forces lose 53 killed and 487 wounded in action.

JUNE 5

SOUTH VIETNAM, *GROUND WAR*
In southern II Corps Tactical Zone, the enemy conducts a limited ground and

KEY PERSONALITY

NGUYEN HUU THO

Nguyen Huu Tho studied law in Paris in the 1930s. In 1949 he led student demonstrations against the French, and organized protests in 1950 against US warships patrolling the southern Vietnamese coast. He was imprisoned and won popular acclaim for his prolonged hunger strike in protest of the war. After the Geneva Agreements divided Vietnam into northern and southern zones in 1954, Tho cooperated with Ngo Dinh Diem 's regime, until advocating nationwide elections on reunification. He was imprisoned from 1954 to 1961. He escaped with the aid of anti-Diem followers, who had recently formed the National Liberation Front (NLF), and who made Tho, a non-Communist, their full-time chairman. He served as a figurehead leader, while power in

the NLF was held by its military arm, the Viet Cong, and the veteran Communists who reported directly to the North Vietnamese leadership.

Tho helped attract a wide spectrum of South Vietnamese supporters to the NLF. In June 1969 the NLF established a Provisional Revolutionary Government (PRG) with Tho as chairman of its advisory council. The PRG in effect was the government of South Vietnam from April 1975, when the Saigon government's troops surrendered to the North Vietnamese and PRG forces. Tho was vice-president of Vietnam from 1976 to 1980, when he became acting president. In 1981 he was made vice-president of the Council of State, as well as chairman of the Standing Committee of the National Assembly. He died in 1996.

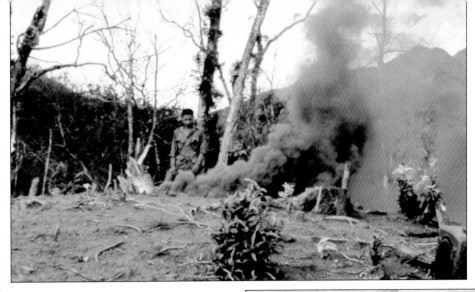

▲ *A Vietnamese medic signals for a helicopter to extract 101st Airborne Division casualties from "Hamburger Hill".*

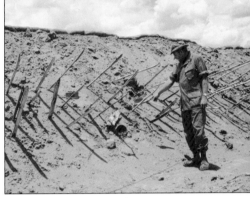

▲ *The Americans also used punjis: sharpened bamboo stakes around Fire Support Base Erskine.*

indirect fire attack against American and ARVN forces. The district headquarters at Duc Trung, south of Dalat, receives an indirect fire attack followed by a ground attack. There are 9 Allied soldiers killed and 17 wounded. A Main Force Battalion is believed responsible for the attack. Phan Rang Air Base receives 30 rounds of 82mm mortar fire and 6 of 107mm rocket fire, resulting in 12 wounded and light damage. In Binh Thuan Province, ARVN elements are attacked by a company size enemy unit, resulting in 10 enemy dead.

JUNE 8

SOUTH VIETNAM, US TROOP WITHDRAWALS

In a news conference, President Nixon announces the first troop withdrawals; a total of 25,000 by the end of August.

▶ *A 105mm howitzer of the 72nd Infantry Regiment in action.*

JUNE 8–AUGUST 15

SOUTH VIETNAM, GROUND WAR

US soldiers of the 101st Airborne Division (Airmobile) conduct Operation Montgomery Rendezvous. In the two-month-long operation, the paratroopers confirm that 393 enemy soldiers are killed in action.

JUNE 12–JULY 9

SOUTH VIETNAM, GROUND WAR

Elements of the 3rd Marine Division launch Operation Utah Mesa. In the four-week operation, the leathernecks will kill over 309 enemy soldiers and capture 7. The Marines suffer 35 killed and 178 wounded in action.

JUNE 13

SOUTH VIETNAM, US TROOP WITHDRAWALS

As part of President Nixon's 25,000-man troop withdrawal, the Secretary of Defense Melvin Laird announces that the 9th Marines, in addition to US Army and Navy units, will be among those withdrawn beginning in mid-July.

JUNE 14

SOUTH VIETNAM, GROUND WAR

US Marine, South Korean and ARVN troops begin Operation Pipestone Canyon, south of Da Nang. Before its ending in November of the same year, the North Vietnamese will lose close to 500 troops killed in action.

JUNE 15

SOUTH VIETNAM, US ARMED FORCES

The 1st Amphibian Tractor

JULY 9

KEY WEAPONS

UH-1 HUEY

In 1955 the US Army wanted a utility helicopter with a turboshaft engine. The army did not have its own aircraft development capability, so it had the US Air Force develop it. The design was based on Bell's Model 204, powered by a new Lycoming T-53 engine. It quickly proved its value and the army began taking delivery of them. In 1962, in response to the US Marine Corps' need for an assault combat helicopter, the Navy began buying them. The most widely used military helicopter, Bell's UH-1 series Iroquois, better known as the "Huey", began arriving in Vietnam in 1963. Before the end of the conflict, more than 5000 of these versatile aircraft were introduced into Southeast Asia. "Hueys" were used for a wide variety of missions, including medevac, command and control, air assault, transport and as gunships.

Battalion redeploys from Vietnam to bases in Okinawa.

JULY 9

SOUTH VIETNAM, *GROUND WAR*
ARVN elements at three points in I Corps Tactical Zone near Gio Linh are attacked by an unidentified enemy force, resulting in 47 enemy killed.

Operation Utah Mesa ends as the US Marines and ARVN inflict 314 combat fatalities on what will later be identified by a captured prisoner of war as the 304th NVA Division.

▲ *A UH-1D of the US 101st Airborne Division evacuates wounded near the Demilitarized Zone on October 16.*

JULY 14

SOUTH VIETNAM, *US ARMED FORCES*
The US Marine Battalion Landing Team's 1st Battalion, 9th Marines, sails from Da Nang for Okinawa on board ships of the US Navy's Seventh Fleet, initiating Phase I of President Nixon's 25,000-troop withdrawal plan.

JULY 20

USA, *RACE RIOTS*
Fuelled by the public knowledge that the war in Vietnam is winding down, racial tensions ignite as race riots explode at the Marine Corps Base Camp Lejeune, North Carolina, between white and black Marines, leaving one US Marine dead and serious injury to another.

JULY 28

SOUTH VIETNAM, *GROUND WAR*
At 11:20 hours, infantrymen and mechanized infantry elements of the 2nd Brigade, US 25th Infantry "Tropic Lightning" Division, engage an unknown enemy force while conducting a search-and-clear operation in an area 7km (4 miles)

▲ *The US 3rd Marine Division holds a memorial service at the Quang Tri Combat Base for the 9th Marine Regiment.*

northeast of Trang Bang 43km (27 miles) northwest of Saigon. The soldiers of the 2nd Brigade exchange heavy small-arms and automatic weapons fire as the US ground forces are supported by helicopter gunships and artillery, in addition to heavy machine guns on their armoured personnel carriers. Other elements of the brigade move into blocking positions as fighting continues until 17:40 hours, when the enemy evades and withdraws. The soldiers of the 25th Infantry Division discover the bodies of 53 NVA soldiers in the area where the battle took place. Three enemy soldiers are captured and the US infantrymen suffer 3 dead and 14 wounded.

AUGUST 1–11

SOUTH VIETNAM, *SOCIAL POLICIES*
The Combined Action Programme in Vietnam reaches its authorized strength, which has been set at 114 platoons.

Enemy activity in I Corps Tactical Zone and throughout Vietnam increas-

◀ *A tank of A Troop, 3rd Squadron, US 25th Infantry Division, on reconnaissance on August 3.*

▲ President Ho Chi Minh of North Vietnam lies in state in Hanoi following his death in early September.

es during the month of August, due to the NVA and Viet Cong initiating their "Autumn Campaign". This campaign includes widespread indirect attacks and mortar attacks on United States and ARVN forces.

AUGUST 13

SOUTH VIETNAM, *US ARMED FORCES*
The Marine Medium Helicopter Squadron 165 departs Vietnam for its base on Okinawa. This movement is conducted as part of an announced 25,000-man troop reduction. The helicopter squadron is the first major unit of the 1st Marine Aircraft Wing to leave Vietnam.

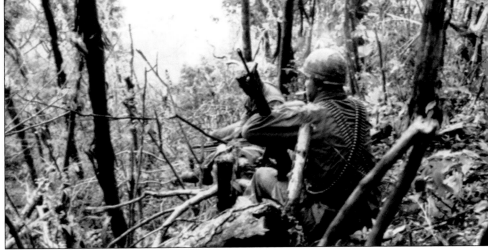

AUGUST 14

SOUTH VIETNAM,
US ARMED FORCES
The 9th Regimental Landing Team completes its redeployment from Vietnam with the departure of the 3rd Battalion, 9th Marine Regiment.

AUGUST 18

SOUTH VIETNAM,
US ARMED FORCES
The last UH-34D Sea Horse Squadron, Marine Medium Helicopter Squadron 362, leaves Vietnam. Later redesignated Marine Heavy Helicopter Squadron, it receives CH-53 aircraft. This squadron was the first unit of the 1st Marine Aircraft Wing to serve in Vietnam, arriving there in April 1962.

SEPTEMBER

USA, *RACE RIOTS*
Racial tensions again flare in the United States and in Vietnam as the African American Marines protest over what they perceive as excessive force by guards at the Camp Pendleton brig. Tensions are also evident in Vietnam as well, though are not present in any of the frontline companies.

SEPTEMBER 3

NORTH VIETNAM, *POLITICS*
The President of North Vietnam, Ho Chi Minh, dies, having inspired thousands of insurgents.

▼ Peace protesters against the Vietnam War demonstrate at the foot of the Washington Monument.

▲ A soldier of the US 101st Airborne Division takes a break near Phu Bai during a search for the Viet Cong.

SEPTEMBER 16

SOUTH VIETNAM, *US TROOP WITHDRAWALS*
President Nixon announces another troop withdrawal. Of a total reduction of 40,500, more than 18,400 would be US Marines, most of whom will come from the 3rd Marine Division.

SEPTEMBER 21

SOUTH VIETNAM, *US TROOP WITHDRAWALS*
Secretary of Defense Melvin Laird announces the deactivation of the 5th Marine Division at Camp Pendleton, California. The 26th Marines, still in Vietnam, would not be deactivated with the remainder of the division.

OCTOBER 15

USA, *PEACE PROTESTS*
Throughout the United States, Vietnam Moratoriums are held, protesting against the Vietnam War.

NOVEMBER 1

SOUTH VIETNAM, *GROUND WAR*
Operation Toan Thang (Phase IV) is launched by elements from the 1st and 25th Infantry Divisions, 3rd Brigade, 9th Division, 199th Light Infantry Brigade, 11th Armored Cavalry Regiment, 1st ATF/RTAVR, and the 1st Air Cavalry Division in III Corps Tactical Zone. The result is 5493 enemy soldiers

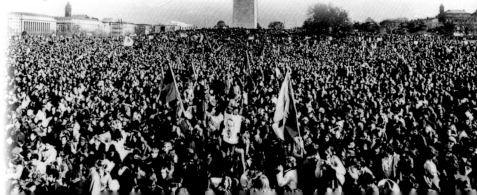

NOVEMBER 7

killed and 822 detained. US losses are 206 killed and another 1443 wounded in action.

NOVEMBER 7

USA, *ARMED FORCES*
The 9th Marine Amphibious Force is deactivated; I Marine Expeditionary Force (I MEF) is created as an amphibious ready force in the Western Pacific; 1st Marine Aircraft Wing (Rear) is activated in Japan. I MEF is to have operational control of the 3rd Marine Division and the 1st Marine Aircraft Wing (Rear).

NOVEMBER 13–15

USA, *PEACE PROTESTS*
Critics of the Vietnam War demonstrate in Washington, D.C., as protesters march from Arlington National Cemetery to the Capitol.

NOVEMBER 19

USA, *POLITICS*
The Nixon Administration's military draft lottery bill passes through Congress.

NOVEMBER 20

SOUTH VIETNAM, *US ARMED FORCES*
Marine Air Group 36 completes its move from Phu Bai to its base in Futema, Okinawa, where it assumes control of the helicopter and the observation squadrons which are redeployed from Vietnam.

SOUTH VIETNAM, *GROUND WAR*
An ARVN armoured cavalry unit, which is supported by helicopter gunships, successfully counters an enemy attempt at an

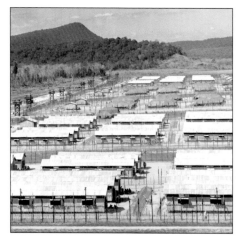

▲ *The South had a growing population of prisoners during the course of the war. This is the prison camp at Phu Quoc Island.*

ambush 23km (14 miles) northwest of Duc Lap in II Corps Tactical Zone of Operations, killing 20 NVA soldiers. A total of 11 individual and three crew-served enemy weapons are captured by the US forces.

NOVEMBER 22–23

SOUTH VIETNAM, *GROUND WAR*
The ARVN 1st Battalion, 53rd Regiment, repels an enemy attack against the unit's position about 1.6km (1 mile) to the west of Bu Prang in II Corps Tactical Zone. During the fighting some enemy troops penetrate the perimeter but are killed or repulsed by ARVN.

The following morning, the unit is again attacked by an unknown number of enemy sappers. After several hours of bitter fighting, the NVA is driven off. The bodies of 26 NVA soldiers are left behind in the two attacks and 14 individual and

▼ *Troops of the US 101st Airborne Division on patrol in early November.*

▲ *The Bob Hope Christmas Show held at Chu Lai on December 22. Presumably the sentiments did not extend to the Viet Cong.*

crew-served weapons are captured. ARVN casualties are noted as 22 killed and 16 wounded.

NOVEMBER 23

SOUTH VIETNAM, *GROUND WAR*
On this day two companies of the US 3rd Battalion, 45th Regiment, engage an estimated company sized NVA force 6.4km (4 miles) southwest of Duc Lap about mid-morning. Heavy small-arms fire is exchanged. The ARVN infantrymen attack the enemy, supported by tactical air strikes, as well as vigorous fire from several US helicopter gunships.

The fighting continues for four hours into the early afternoon; that is, until the remaining enemy withdraws. The South Vietnamese soldiers find 14 dead NVA soldiers left behind in the area, while they themselves suffer only 1 killed and 8 wounded from the day's action.

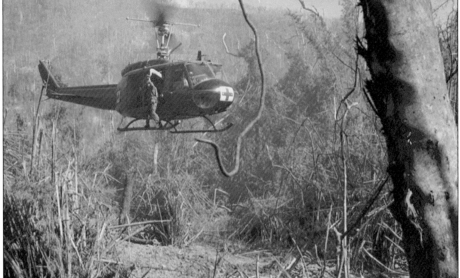

NOVEMBER 24

SOUTH VIETNAM, *GROUND WAR*

Late on the night of November 24, a Popular Forces platoon and People's Self Defense Forces successfully defend the Duc An hamlet located 9.6km (6 miles) southwest of Duc Lap, as it is attacked by an enemy force of an unknown size.

The Popular Forces and People's Self Defense Forces, with the help of ARVN and US artillery, finally succeed in beating back the attack after a four-hour firefight.

NOVEMBER 26

USA, *ARMED FORCES*

The 5th Marine Division is deactivated and the 5th Marine Expeditionary Brigade first comes into existence.

NOVEMBER 29

SOUTH VIETNAM, *GROUND WAR*

Some 8km (5 miles) west of Duc Lap in II Corps Tactical Zone, the 1st Battalion, ARVN 45th Regiment, and ARVN armoured cavalry elements are attacked by an enemy force estimated to be a company. Supported by tactical air strikes as well as artillery, in addition to the heavy weapons mounted on their armoured vehicles, they counterattack, killing 43 NVA soldiers in a five-hour battle. ARVN casualties are 6 killed and 43 wounded.

DECEMBER 1

USA, *ARMED FORCES*

The first drawing of the draft lottery is conducted; those 19-year-olds whose birthdate is September 14 and whose last name begins with a "J" will be the

first to be called into the US armed services. A very unpopular lottery, it would encourage many to dodge it.

DECEMBER 15

SOUTH VIETNAM, *US ARMED FORCES*

Major-General Edwin B. Wheeler relieves Major-General Ormond R. Simpson as Commanding General of the 1st Marine Division. There are now 55,300 US Marines in Vietnam.

DECEMBER 15

SOUTH VIETNAM, *US TROOP WITHDRAWALS*

President Nixon announces that the third round of US troop withdrawals from Vietnam is to be completed by April 15, 1970.

DECEMBER 31

SOUTH VIETNAM, *US ARMED FORCES*

At the end of 1969, the strength of the US Marine Corps in South Vietnam is 54,559 Marines.

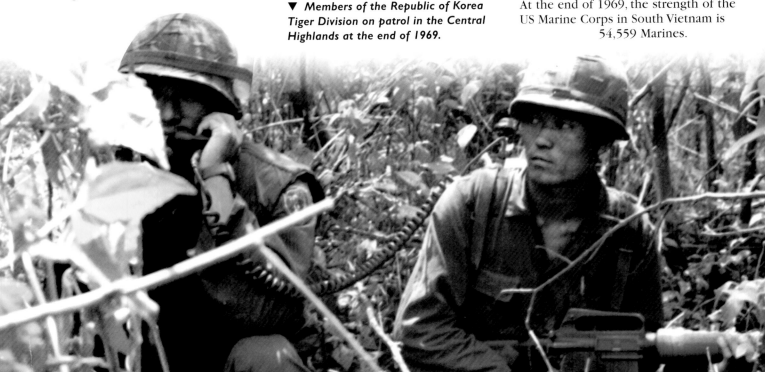

1970
RAIDS & REDEPLOYMENT

As the United States began a withdrawal from the war in Vietnam and turned the fighting over to the Army of the Republic of Vietnam (ARVN), dramatic events occurred: the crossborder raids into Cambodia, aimed at destroying the North Vietnamese Army's (NVA's) sanctuaries, an objective long sought by Westmoreland and finally acted on by his successor, General Creighton W. Abrams. However, the raids were largely disappointing in their results in terms of numbers of enemy soldiers killed. Back in the United States, though, these raids had an explosive effect on dozens of college campuses, further galvanizing the antiwar movement and leading to bloodshed on US soil.

◀ A nation in arms: women of Saigon's People's Self-Defence Force parade through the city in April 1970.

To quote General Abrams' report on the war for 1970, "the most dramatic event of the war in 1970 is the combined US/Republic of Vietnam Armed Forces' crossborder operation against the enemy sanctuaries in Cambodia. These operations form a catalyst which allows the US to meet more readily its goals set for 1970: continue to Vietnamese the war; lower the number of US casualties; withdraw US forces on schedule; and stimulate a negotiated settlement of the war." General Abrams noted that all four goals were interrelated, for as the US forces redeployed and turned over areas of operations to the ARVN, the latter found itself very capable of assuming operational control of the war.

In fact, as the United States' policy of Vietnamization went forward, the US casualty rate did drop. As the ground war wound down, from a tactical standpoint the air war was still inflicting punishing casualties on the enemy. US Air Force (USAF) B-52 bombers and tactical aircraft, plus US Navy and Marine fighter-bombers, continued to interdict the flow of supplies coming down the Ho Chi Minh Trail, as well hitting enemy troop concentrations in Laos and Cambodia. Also targeted by US and South Vietnamese aircraft were the

enemy troop concentrations inside South Vietnam. By the end of 1970, US and South Vietnamese aircraft had disrupted North Vietnam's ability to launch Tet-style offensives.

The success of the Allied tactics, both on the ground and in the air, against the sanctuaries in Laos and Cambodia, as well as the interdiction campaign aimed at the Ho Chi Minh Trail, forced the North Vietnamese to revert to guerrilla-style tactics. These tactics, however, first applied back in the early 1960s, now failed, as pacification efforts by the US Marines and ARVN paid huge dividends among the South Vietnamese peasantry, evident in the increase in the number of attacks the NVA and reconstituted Viet Cong aimed at villages and hamlets. Combined US and ARVN pressure insured that the NVA was kept on the defensive throughout 1970.

▶ **US National Guardsmen confront demonstrators against the Vietnam War at Ohio State University in Columbus.**

▼ **Into enemy territory: helicopters from the 119th Assault Helicopter Company prepare to leave on a mission into Cambodia, May 14.**

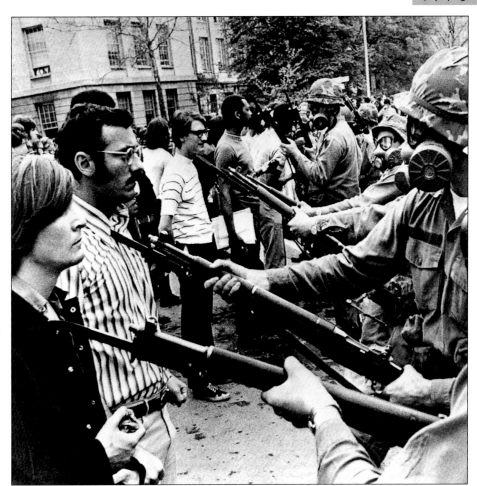

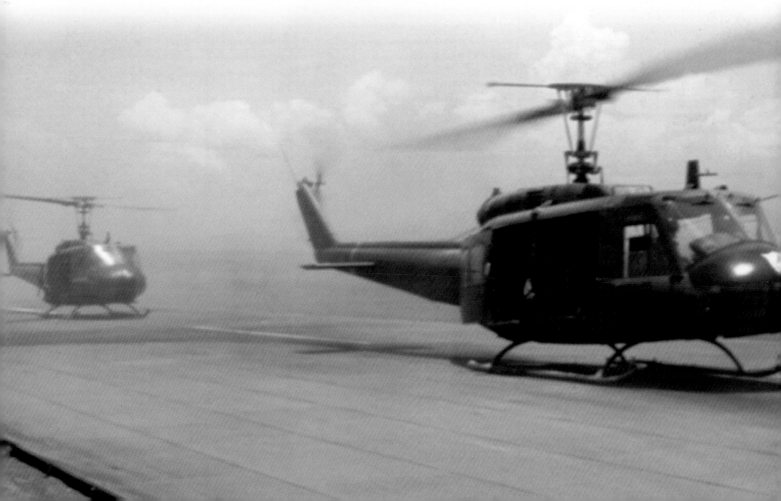

JANUARY 2

JANUARY 2

SOUTH VIETNAM, *GROUND WAR*
III Marine Amphibious Force (III MAF) operates in the Quang Nam Province. Elements of the 7th Marines, 1st Marine Division, observe 25 enemy soldiers and direct artillery fire on them, killing 20. There are no US casualties.

Elements of the US Army's 1st Brigade, 25th Infantry Division, engage an enemy force of between 50 and 70 men 9.6km (6 miles) northwest of Go Dau Ha, 3.2km (2 miles) from the Cambodian border. The infantrymen use organic weapons and are supported by helicopter gunships and artillery. The enemy returns fire with automatic weapons. Fighting lasts for about five hours and results in 15 NVA dead. There are no US casualties.

JANUARY 3

SOUTH VIETNAM, *GROUND WAR*
Operation Iron Mountain takes place in Quang Ngai Province when elements of the 11th Brigade of the 23rd Infantry (Americal) Division, in night defensive positions 8km (5 miles) south of Duc Pho, receive about 60 rounds of mortar fire along with heavy small-arms and automatic weapons fire from an unknown-sized enemy force. The infantrymen return fire with their organic weapons and are supported by helicopter gunships and artillery. The enemy withdraws by 03:50 hours that morning without having penetrated the perimeter. The American soldiers discover 29 enemy bodies in the battle area, and 9 individual weapons are captured. The Americans have suffered 7 killed as well as 12 wounded.

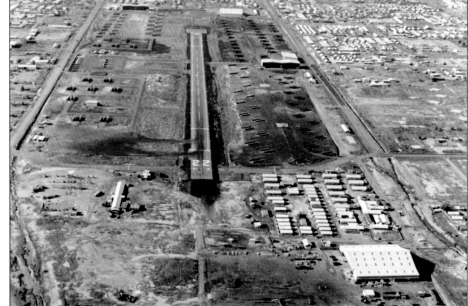

▲ *The Americans built their airfields and helicopter pads in the centre of bases to offer as much protection as possible against Viet Cong mortars and rockets.*

JANUARY 4

SOUTH VIETNAM, *GROUND WAR*
The "Toan Thang" Offensive continues in Tay Ninh Province, as elements of the 3rd Brigade, 25th Infantry Division, engage an unknown number of enemy soldiers 6.4km (4 miles) southwest of Go Dau Ha and and 4km (2.5 miles) from the Cambodian border. The infantrymen use organic weapons and the enemy fires back with small-arms and automatic weapons. US Army helicopter gunships and artillery and a US Air Force AC-119 gunship from the 14th Special Operations Wing support the troops on the ground. The US infantrymen find the bodies of five

enemy soldiers and capture four individual weapons, with no US casualties.

Meanwhile, an element of the 1st Brigade, 1st Cavalry Division (Air Mobile), engages an enemy force 11km (7 miles) southeast of Katum and 13km (8 miles) from the Cambodian border. The Americans exchange small-arms and automatic weapons fire with the NVA and Viet Cong forces, who use rocket-propelled grenades. The US confirms one soldier killed and four wounded, while the NVA suffers unknown losses.

At the same time, elements of the 7th Marines in Quang Nam Province, in night positions 16km (10 miles) southeast of An Hoa, receive about 75 rounds of 82mm mortar fire, which is followed by an enemy attack from an enemy force firing small-arms and automatic weapons. The US Marines fire back with organic weapons and are supported by artillery fire. The enemy leave 38 dead behind, while the US Marines suffer 13 killed in action and 63 wounded.

JANUARY 6

SOUTH VIETNAM, *GROUND WAR*
Operation Frederick Hill in Quang Tin Province occurs as elements of the armoured cavalry squadron of the 23rd (Americal) Division, along with ARVN Regional Forces troops, engage an enemy force 6.4km (4 miles) west of Tam Ky. Heavy small-arms and automatic weapons fire is exchanged, and the

◀ *An M48 tank of the 1st Cavalry Division (Airmobile) near the village of Troung Lan, 90km (56 miles) northeast of An Khe.*

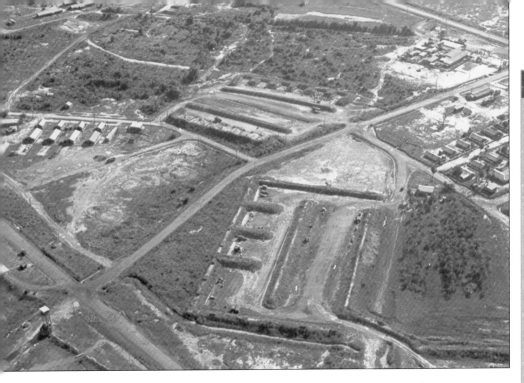

▲ *The US 25th Infantry Division was involved in sustained and heavy combat during the Vietnam War. This is its base located at Cu Chi.*

DRUGS IN THE US ARMED FORCES

After 1968, drug abuse among US military personnel in Vietnam became a serious problem. By 1973, the US Department of Defense estimated that about 70 percent of American servicemen in Vietnam had used some type of illicit drug. Drug use rose dramatically after the Tet Offensive, with marijuana being the most popular substance. Drugs were cheap in Vietnam, readily available and very pure. Heroin, for example, cost $2 US a gram and was 95 percent pure (the same amount in the USA would cost $100 US and was only around 10 percent pure). Amphetamines were also popular, either for staying alert on patrol or for parties in rear areas. Reasons for the use of drugs included combat stress, poor discipline and declining morale due to participation in a war which nobody believed they could win.

combined force is supported by helicopter gunships and artillery, in addition to the heavy weapons on their tanks and armoured personnel carriers (APCs). A US Army UH-1 helicopter is hit by small-arms fire and then crashes. There are no casualties but the aircraft is destroyed.

This will be repeated two more times as two AH-1 Cobra gunships are likewise brought down by small-arms and automatic fire from the enemy. The US soldiers kill 45 NVA soldiers, while the US suffers only 18 wounded in action. An estimated force of 100 Viet Cong attack the Marine Fire Support Base Ross, occupied by A and B Companies of the 1st Battalion, 7th Marines, the battalion's headquarters group and two artillery batteries. The Viet Cong kills 13 Marines and wound 63, while suffering 39 of its own dead.

JANUARY 7

SOUTH VIETNAM, *GROUND WAR*
Operation Frederick Hill, held in Quang Tin Province, continues as armoured

cavalry troops and infantrymen of the 196th Brigade, 23rd (American) Division, receive small-arms fire, automatic weapons and rocket-grenade fire from an enemy force 19.3km (12 miles) northwest of Tam Ky. The troopers fire back at the enemy with organic weapons, including the task force guns and heavy machine guns on their APCs, and are supported by helicopter gunships and artillery. At 15:00 hours, the enemy withdraws, leaving 39 dead. Sixteen individual weapons and seven crew-sized weapons are captured. The US suffers 5 killed and 16 wounded in action.

JANUARY 8

SOUTH VIETNAM, *GROUND WAR*
The "Toang Thang" Offensive in Tay Ninh Province continues. An infantry element from the 1st Brigade, 25th Infantry Division, reinforced with tanks from the division's armoured battalion, engages an enemy force 11.2km (7 miles)

◀ *This US 155mm self-propelled howitzer of the 2nd Battalion, 35th Artillery Regiment, provided fire support for the Royal Australian Task Force in Vietnam.*

JANUARY 9

▶ *Truck convoys were vulnerable to ambush, so the Americans used helicopters, such as these OH-6As near Can Tho, to draw enemy fire to locate any Viet Cong.*

northeast of Tay Ninh City. Fighting continues until 18:30 hours, when the enemy withdraws under cover of darkness. The soldiers find the bodies of 62 NVA soldiers in the battle area. The US suffers two dead and six wounded in action.

SOUTH VIETNAM, *SOCIAL POLICIES*
Pacification efforts are accelerated in I Corps Tactical Zone as the US Marines, building on the Combined Action Platoon (CAP) concept, formally establish the Combined Unit Pacification Program (CUPP). Under this programme Marine rifle companies deploy their squads in hamlets to work with the Regional Forces and Popular Forces, much like the CAPs did. The CUPP differs from the CAPS in that the rifle companies are not given special training, and the Marines remain under the operational control of their parent regiments, normally operating within or near the area of operations.

JANUARY 9

SOUTH VIETNAM, *GROUND WAR*
In Quang Nam Province, 13km (8 miles) east of An Hoa, an element of the 7th Marines, 1st Marine Division, observe 20 enemy soldiers moving west. The enemy moves into two caves and are kept there overnight by organic weapons fire and artillery.

At first light the Marines assault the caves. Fifteen enemy soldiers are killed

and four individual weapons captured, with two US casualties and no fatalities. In Pleiku, the soldiers of the US Army's 3rd Brigade, 4th Infantry Division, members of the 1st Field Force, find 30 storage huts which contain a huge supply of 30.5 tonnes (30 tons) of rice.

▼ *The sinews of war: belts of 20mm ammunition are loaded into a Vulcan gun mounted on a US Cobra gunship. Every fifth round is tracer.*

JANUARY 10

SOUTH VIETNAM, *GROUND WAR*
During the "Toan Thang" Offensive in Tay Ninh Province, one element from the 1st Brigade, 1st Cavalry Division (Airmobile), and the Republic of Vietnam's Civilian Irregular Defense Group (CIDG) personnel receive small-arms, automatic and rocket grenade fire from an enemy force 16km (10 miles) southeast of Katum and 14.4km (9 miles) from the Cambodian border.

The enemy forces were occupying bunkers, and the combined ground troops returned fire with unit weapons and were supported by helicopter gunships, artillery fire and US Air Force A-37 Dragonfly and F-100 Super Sabre jets. In about 15 minutes the enemy withdrew, leaving 41 dead. US casualties were three dead and three wounded. Later the same day, the same units again receive small-arms and automatic weapons fire in the area 800m (875 yards) to the south of the earlier contact. The enemy broke contact, leaving 21 dead and 1 destroyed crew-served weapon. There are very few Civilian Irregular Defense Group casualties and no US casualties in this contact. Once again, US air power proved crucial in aiding the troops on the ground.

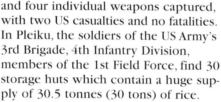

STRATEGY & TACTICS

ARMOUR

All the combatants in the Vietnam War who used armoured fighting vehicles (AFVs) did so reluctantly. One of the reasons for this reluctance was terrain. As General Westmoreland himself stated: "Except for a few coastal areas, most notably in the I Corps area, Vietnam is no place for either tank or mechanized infantry units." It was not until the arrival of the 25th Infantry Division under its forceful commander, Major-General Weyand, who insisted, despite resistance from Washington, that his division would deploy complete with all its armoured elements intact, that the US Army started to make use of both tanks and armoured personnel carriers (APCs) in a combined-arms role. Until Vietnam, the US Army's doctrine had been that infantry units should dismount before assaulting an enemy position. However, as the Army of the Republic of Vietnam (ARVN) discovered, this meant that when facing the massive amounts of firepower

that the Viet Cong and North Vietnamese Army (NVA) could bring to bear during a firefight, the attacking infantry was exposed to needless casualties, as well as losing the momentum of the attack.

Ironically, it was the ARVN which pioneered the use of mounted tactics from APCs when it first deployed the M113 personnel carrier in 1962. It was also the first to discover the need for increased firepower on the vehicle by mounting an extra .30-calibre machine gun beside the commander, fired by an exposed prone soldier lying on the roof. The South Vietnamese also discovered the extreme vulnerability of the exposed vehicle commander when manning the pintle-mounted .50-calibre machine gun in battle.

The NVA used armour during its offensives against the South in the early 1970s, mostly Soviet-supplied T-54 tanks. Both sides had proved that AFVs could operate effectively in Vietnam, notwithstanding the terrain that they encountered.

JANUARY 11

SOUTH VIETNAM, *GROUND WAR*
The "Toan Thang" Offensive continues in Tay Ninh Province as elements of the 1st Brigade, 1st Cavalry Division (Airmobile), come under small-arms and automatic weapons fire from an enemy force 19.2km (12 miles) southeast of Katum and 12.8km (8 miles) from the Cambodian border. The troopers fire back with unit weapons and are supported by helicopter gunships, artillery and tactical air strikes by F-4 Phantoms armed with iron bombs. The enemy eventually withdraws, but not before suffering 15

dead and 2 destroyed machine guns. There are no US casualties.

SOUTH VIETNAM, *US ARMED FORCES*
III Marine Amphibious Force (III MAF) formally activates the Combined Action Force (CAF) and incorporates the four combined action groups under its own headquarters, rather than through an assistant chief of staff within III MAF. The CAF includes 42 Marine officers and 2050 enlisted men, with 2 naval officers and 126 hospital corpsmen. The 20 combined action companies and 114 combined action platoons work with about 3000 Popular Forces members.

JANUARY 12

SOUTH VIETNAM, *GROUND WAR*
The "Toan Thang" Offensive in Long An Province continues as US Army helicopter crewmen from the 12th Combat Aviation Group observe an unknown number of enemy soldiers 8km (5 miles) southeast of Tan An. The enemy fire tripod-mounted machine guns at the helicopters. Rangers from the 3rd Brigade, 9th Infantry Division, on board the helicopters are air assaulted into the vicinity and engage the enemy. The US Army soldiers and air cavalrymen open fire and the enemy fires a claymore-type mine.

At 12:45 hours, an OH-6 light observation helicopter is hit by enemy ground fire while supporting the action and crashes. Helicopter gunships support the Rangers until contact is lost. The soldiers discover the bodies of 26 enemy soldiers killed, while the US Army suffers a total of one killed and seven wounded.

JANUARY 14

SOUTH VIETNAM, *GROUND WAR*
In An Xuyen Province, helicopter gunship crewmen observe three sampans

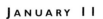

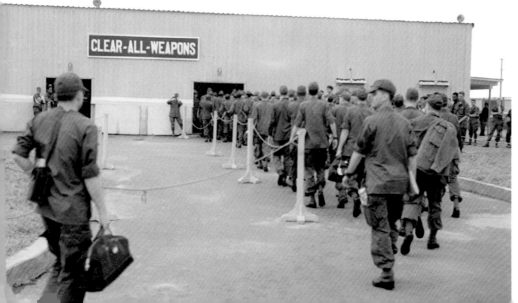

◀ *Despite Vietnamization, new troops still arrived from the US for their tour of duty. Here, Americans arrive at the Bien Hoa base for orientation.*

attempting to evade the US Coast Guard in an area 21km (13 miles) northwest of Ca Mau at the southern edge of the U Minh Forest. The helicopters receive small-arms fire from an unknown number of enemy troops in the sampans, which are engaged with aerial machine guns. Enemy automatic weapons fire continues, as naval gunfire from the US Coast Guard cutter USS *Dallas* is directed onto the enemy. In addition, US Navy OV-10 aircraft and USAF tactical aircraft strike the enemy position. The soldiers count 13 dead Viet Cong and 8 destroyed sampans, and 24 buildings destroyed. There are no US casualties.

JANUARY 15

SOUTH VIETNAM, *GROUND WAR*
In Tay Ninh Province during the "Toan Thang" Offensive, a fire support base 38.6km (24 miles) north of Tay Ninh City and 8km (5 miles) from the Cambodian border, occupied by ARVN airborne troops and an element of the US 11th Armored Cavalry Regiment, receive approximately 100 rounds of 82mm and 60mm mortar fire, followed by a ground attack by an enemy company firing small arms and automatic weapons. The combined airborne and armoured cavalry troops return fire with unit weapons, and are supported by US and ARVN artillery and gunships, as well as the heavy weapons on their tanks and APCs. During the fighting an unknown number of enemy soldiers, using satchel charges, penetrate the perimeter, but are repulsed or killed. Fighting continues until 03:00 hours when the enemy withdraws, leaving behind 19 dead. Six AK-47 assault rifles, three RPG-2 rocket-propelled grenade launchers and one RPG-7 rocket-propelled grenade launcher are captured

▲ *A US Air Force F-4 Phantom prepares to refuel in the air over South Vietnam. Air-to-air refuelling greatly extended the combat patrol time of US aircraft.*

during the battle, as is a small quantity of miscellaneous munitions. Total US casualties are one killed and seven wounded in action, while the ARVN suffers only minor casualties, with no fatalities.

Also that day, helicopter gunships from the air cavalry squadron of the 1st Cavalry Division (Airmobile) engage an estimated 15–20 enemy soldiers with unit weapons 43km (27 miles) north of Tay Ninh City and 4.8km (3 miles) from the Cambodian border. The enemy returns fire with small arms. The action is supported by tactical air and artillery. In 10 minutes, the NVA suffers nine dead, before withdrawing. There are no US casualties.

JANUARY 16

SOUTH VIETNAM, *GROUND WAR*
In Quang Ngai Province, an estimated 30 enemy soldiers attack the Chau Thuan hamlet on the Batangan Peninsula, 14.4km (9 miles) northeast of Quang Ngai City. The enemy employ small arms and automatic weapons, and 40 rounds of mixed rocket-propelled grenades and 82mm mortar shells. The hamlet is defended by infantrymen from the 198th Brigade, 23rd Infantry Division (American), as well as a US Marine and Republic of Vietnam Popular Force Combined Action Platoon, and also Popular Forces and People's Self-Defense Forces elements. Friendly forces return fire with unit weapons, supported by helicopter gunships and artillery. During the fighting, an unknown number of enemy enter part of the hamlet and fire into a number of houses. The enemy then withdraws. Four enemy

▲ *The twin-rotor CH-47 Chinook helicopter, seen here lifting a 105mm howitzer, was the US Army's workhorse.*

soldiers are killed and a pistol and rocket-propelled grenade launcher is recovered. US casualties include one killed and one wounded in action. Fourteen Vietnamese civilians are killed and 19 wounded. Twenty homes are destroyed in the firefight. Popular Forces casualties are light. All friendly casualties and damage to the village is the result of enemy, and not friendly, fire.

JANUARY 18

NORTH VIETNAM, *PRISONERS OF WAR*
A North Vietnamese spokesman says that allowing prisoners of war to send a postcard home once a month and to receive packages from home every other month is, in effect, a means of accounting for those captured.

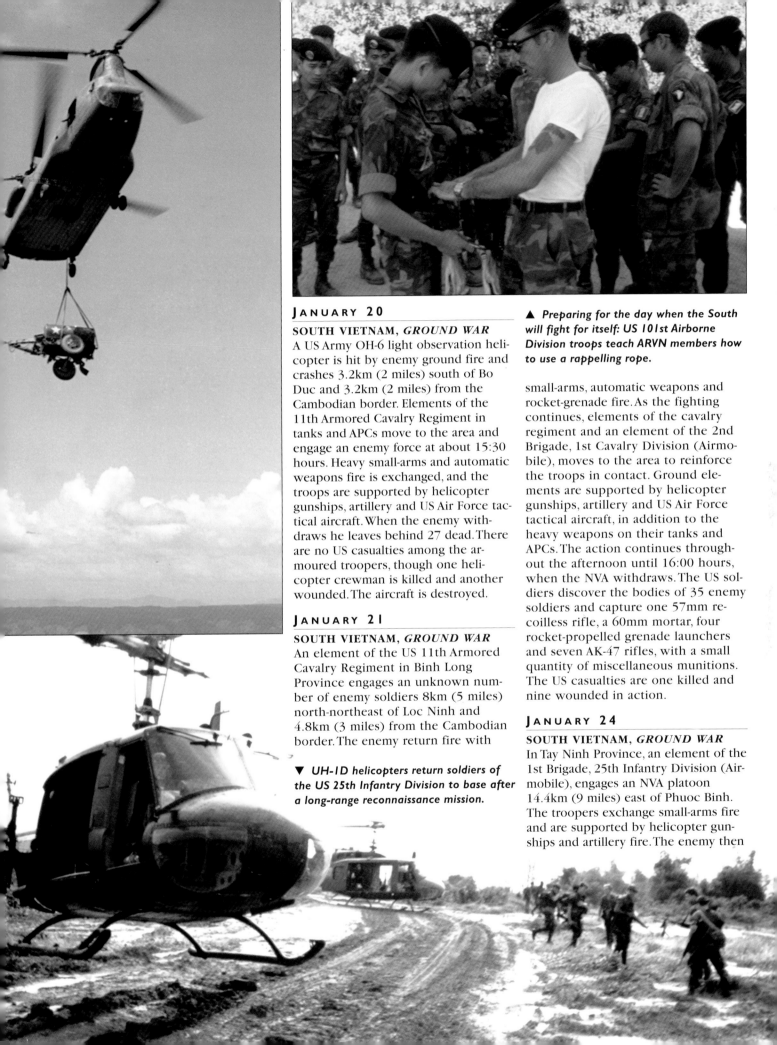

JANUARY 20

SOUTH VIETNAM, *GROUND WAR*

A US Army OH-6 light observation helicopter is hit by enemy ground fire and crashes 3.2km (2 miles) south of Bo Duc and 3.2km (2 miles) from the Cambodian border. Elements of the 11th Armored Cavalry Regiment in tanks and APCs move to the area and engage an enemy force at about 15:30 hours. Heavy small-arms and automatic weapons fire is exchanged, and the troops are supported by helicopter gunships, artillery and US Air Force tactical aircraft. When the enemy withdraws he leaves behind 27 dead. There are no US casualties among the armoured troopers, though one helicopter crewman is killed and another wounded. The aircraft is destroyed.

JANUARY 21

SOUTH VIETNAM, *GROUND WAR*

An element of the US 11th Armored Cavalry Regiment in Binh Long Province engages an unknown number of enemy soldiers 8km (5 miles) north-northeast of Loc Ninh and 4.8km (3 miles) from the Cambodian border. The enemy return fire with

▼ *UH-1D helicopters return soldiers of the US 25th Infantry Division to base after a long-range reconnaissance mission.*

▲ *Preparing for the day when the South will fight for itself: US 101st Airborne Division troops teach ARVN members how to use a rappelling rope.*

small-arms, automatic weapons and rocket-grenade fire. As the fighting continues, elements of the cavalry regiment and an element of the 2nd Brigade, 1st Cavalry Division (Airmobile), moves to the area to reinforce the troops in contact. Ground elements are supported by helicopter gunships, artillery and US Air Force tactical aircraft, in addition to the heavy weapons on their tanks and APCs. The action continues throughout the afternoon until 16:00 hours, when the NVA withdraws. The US soldiers discover the bodies of 35 enemy soldiers and capture one 57mm recoilless rifle, a 60mm mortar, four rocket-propelled grenade launchers and seven AK-47 rifles, with a small quantity of miscellaneous munitions. The US casualties are one killed and nine wounded in action.

JANUARY 24

SOUTH VIETNAM, *GROUND WAR*

In Tay Ninh Province, an element of the 1st Brigade, 25th Infantry Division (Airmobile), engages an NVA platoon 14.4km (9 miles) east of Phuoc Binh. The troopers exchange small-arms fire and are supported by helicopter gunships and artillery fire. The enemy then

JANUARY 25

withdraws, leaving behind 22 dead, while the US suffers no casualties in action.

JANUARY 25

SOUTH VIETNAM, *GROUND WAR*
An element of the 2nd Brigade, 1st Cavalry Division (Airmobile), engages an enemy platoon 14.4km (9 miles) east of Phuoc Binh. Small-arms fire is exchanged and the troopers are supported by artillery and helicopter gunships. Ten enemy soldiers are left behind dead after the withdrawal. Two US soldiers are killed in action.

JANUARY 26

SOUTH VIETNAM, *INTERNATIONAL AID*
South Vietnamese President Nguyen Van Thieu appeals to all friendly nations for continued aid, saying that he would go his own way if Allied (i.e. American) policies are not in the best interests of South Vietnam.

JANUARY 28

SOUTH VIETNAM, *US ARMED FORCES*
Troop movement for Operation Keystone Bluejay, the first redeployment of 1970, begins, and will continue until March 19. Among the ground and aviation units redeployed are the US 26th Marines.

JANUARY 31

SOUTH VIETNAM, *GROUND WAR*
III Marine Amphibious Force strength in Vietnam remains above the 50,000-man mark at 55,191 US Marines. Also, enemy traffic along the Ho Chi Minh Trail in January reportedly increases to 10 times the levels it was between September and October 1969.

In Quang Nam Province, a US Army OH-6 light observation helicopter is on the receiving end of small-arms fire from an unknown number of enemy soldiers located 12.8km (8 miles) southwest of Da Nang. A short time later, an element of the 1st Marines is air-assaulted into the vicinity where it engages 20 NVA soldiers. Helicopter gunships support these US Marines and force the enemy to withdraw. The NVA withdraws, but not before suffering 10 killed in action and 9 being taken as prisoners of war. The US Marines suffer 2 killed and 11 wounded in action.

FEBRUARY 1

SOUTH VIETNAM, *GROUND WAR*
A reconnaissance element of the US 1st Marine Division sights a reinforced

▲ *Going back to the "World". Having served their one-year tour of duty, these men are waiting for shipment back to the United States and an uncertain welcome.*

enemy NVA platoon in green uniforms and carrying packs and weapons moving south on a trail 6.4km (4 miles) northeast of An Hoa. Marine artillery fire is directed onto the location, killing 25 of the enemy. A short time later, another reconnaissance element of the 1st Marine Division sights 50 enemy soldiers moving southwest in an area 6.4km (4 miles) north-north-west of An Hoa. US Marine artillery fire is directed onto the enemy and the Marines identify 15 enemy bodies. There are no US casualties in these sporadic engagements.

Operation Geneva Park is launched by soldiers of the 198th Brigade, 23rd Infantry Division (Americal), who are in night defensive positions northwest of Quang Ngai City. They receive about 120 rounds of both 120mm and 82mm mortar and rocket-propelled grenade fire, along with heavy small-arms and automatic weapons fire, from an unknown-sized enemy force. The infantrymen fire back with organic

STRATEGY & TACTICS

FRAGGING

Fragging is the intentional harm of friendly forces by one's own soldiers. In Vietnam, fragging was usually directed towards officers and noncommissioned officers (NCOs). The name comes from the murder weapon – fragmentation grenade – which leaves no incriminating fingerprints, though other weapons were also used. It was virtually unheard of during the early phase of the US involvement in Vietnam, but it increased as leadership and discipline declined, and unit cohesion weakened due to the rapid turnover because of the one-year rotation policy. Fragging was carried out as an attempt to remove incompetent leaders who threatened the survival of other members of the unit. Fragging could also be directed against commanders perceived as being too strict. Fragging was a sign of low morale in fighting a seemingly unending war that had no purpose.

The US Army reported 126 incidents of fragging in 1969, involving 76 officers and NCOs and resulting in 37 deaths. In 1971 there were 333 incidents involving 158 officers and NCOs, resulting in 12 deaths.

weapons and are supported by artillery and a US Air Force AC-119 gunship.

The enemy withdraws after a four-hour firefight without penetrating the perimeter. The bodies of 11 enemy soldiers are subsequently found in the battle area and one enemy soldier is taken prisoner of war. US casualties are 2 killed and 19 wounded. Popular Forces casualties are very light, with no fatalities. Two Vietnamese civilians are killed and 19 wounded in the fire-fight, and later an investigation indicates that it was fire from the NVA or a Viet Cong unit that had caused the civilian deaths.

FEBRUARY 5

FRANCE, *PEACE TALKS*
At the Paris Peace Talks, the North Vietnamese produce the first letter from a prisoner of war held in South Vietnam by the Viet Cong after the United States and South Vietnamese place great pressure on opposing delegates to account for the prisoners they hold.

FEBRUARY 10

SOUTH VIETNAM, *GROUND WAR*
In Binh Duong Province, troopers from the US 1st Infantry Division engage an unknown number of enemy 8km (5 miles) southeast of the village of Ben Cat. Heavy small-arms fire is exchanged. Some American helicopter gunships and other elements of the squadron, in tanks and armored personnel carriers, reinforce the battling US soldiers. The enemy withdraws after a brief firefight, in which eight are killed in action. There are, however, no US casualties.

▲ *Soldiers from the 4th Company, 41st ARVN Battalion, conduct a jungle sweep. By 1970, the soldiers of the South were bearing the brunt of the ground war.*

FEBRUARY 17

USA, *POLITICS*
President Richard M. Nixon states that the military aspects of Vietnamization are proceeding on schedule.

FEBRUARY 19

SOUTH VIETNAM, *US ARMED FORCES*
Lieutenant-General Herman Nickerson, Jr, and Lieutenant-General Melvin G. Zias, US Army, brief General Abrams on the planned US Army takeover of I Corps Tactical Zone on March 9. General Abrams agrees to the arrangement proposed by General Nickerson, whereby III MAF, while becoming subordinate to XXIV Corps, will remain the parent unit of the 1st Marine Division and 1st Marine Aircraft Wing, thus preserving the operational integrity of the Marine air-ground team in Vietnam.

MARCH 5–9

SOUTH VIETNAM, *US ARMED FORCES*
During Operation Cavalier Beach, III MAF relocates to Camp Haskins, and XXIV Corps moves from its headquarters in Phu Bai to Camp Horn.

MARCH 9

SOUTH VIETNAM, *US ARMED FORCES*
Lieutenant-General Herman Nickerson, Jr, passes operational control of I Corps Tactical Zone to US Army General Lieutenant-General Melvin G. Zias, simultaneously passing command of III MAF to Lieutenant-General Keith B.

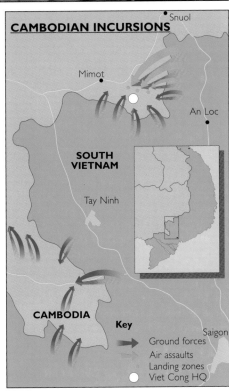

CAMBODIAN INCURSIONS

▲ *The Cambodian incursions in 1970 certainly disrupted Communist plans, but ARVN preparatory bombings robbed the missions of tactical surprise. This resulted in limited contacts with enemy units.*

▲ *Canberra's finest: troops of the 4th Platoon, 8th Royal Australian Regiment, search the village of Hoa Long, April 19,*

McCutcheon. III MAF's major elements include the 1st Marine Division (Reinforced), and the 1st Marine Air Wing, as well as Force Logistics Command.

MARCH 19

SOUTH VIETNAM, *US ARMED FORCES*
The 26th Marines, the unit which had received a Presidential Unit Citation for the defence of Khe Sanh, departs Vietnam. Following its departure, the 1st Marines are left to control the area known as the "Rocket Belt".

CAMBODIA, *POLITICS*
The US says that its recognition of Cambodian sovereignty will continue, following the seizure of power from Prince Norodom Sihanouk by General Lon Nol. General Lon Nol is pro-United States. However, he is a weak leader whose rule will be a disaster for Cambodia.

MARCH 26

SOUTH VIETNAM, *US ARMED FORCES*
The Combined Action Force is placed under the operational control of XXIV Corps while remaining under the administrative control of III Marine Amphibious Force.

APRIL 1

USA, *ARMED FORCES*
Starting in April, Headquarters Marine Corps announces that it will no longer accept draftees, and re-institutes voluntary enlistments to fill its ranks.

APRIL 14

SOUTH VIETNAM, *US ARMED FORCES*
Major-General C. F. Widdecke relieves Major-General Edwin B. Wheeler as Commanding General, 1st Marine Division, and as Deputy Commander of III MAF.

APRIL 21

SOUTH VIETNAM, *US AID*
President Thieu announces that the Vietnamese can gradually assume greater control and responsibilities as the Americans withdraw from South Vietnam, but that the South Vietnamese require more military and economic aid from its allies.

APRIL 23

SOUTH VIETNAM, *US ARMED FORCES*
The US Marines' 1st Force Service Support Regiment is closed down and transferred to Camp Pendleton, USA.

APRIL 29

CAMBODIA, *GROUND WAR*
Both the ARVN and US Army forces conduct huge search and destroy operations in a dozen base areas in Cambodia adjoining II, III and IV Corps Tactical Zones in South Vietnam. A US-Vietnamese naval task force also sweeps up the Mekong Delta in order to reopen a supply line to Phnom Penh, the Cambodian capital.

◄ *Cambodian Premier General Lon Nol (right) greets Vice-President Nguyen Cao Ky of South Vietnam during the latter's visit to Phnom Penh.*

APRIL 30

CAMBODIA, *GROUND WAR*
President Richard M. Nixon announces that several thousand American troops supporting the Cambodian invasion have entered Cambodia's "Fishook" area bordering South Vietnam in order to attack the location of the headquarters of the Communist military operation in South Vietnam. American advisors, tactical air support, medical evacuation teams and logistical support are also provided to support the incursion.

In support of the Cambodian operation is Brigade B from the Vietnamese Marine Corps which, on May 9, crosses the Cambodian border and at 09:30 hours lands at Neck Luong to begin its phase of the operation. Allied troops in Cambodia are increased to 50,000 by May 6. Withdrawal of the American units from Cambodia is complete when the 1st Cavalry Division (Airmobile) returns to South Vietnam on June 29. In the United States, there is a large public outcry against this incursion into Cambodia.

MAY 1–31

SOUTH VIETNAM, *TERRORISM*
The Viet Cong progressively returns to guerrilla warfare and terrorism in 1970 as a result of the increased Allied military pressure. During May, the Viet Cong in Quang Nam Province

▲ *The US 5th Special Forces Group was an integral part in the training of ARVN personnel. This is a platform for the swing harness at the Special Forces airborne training school at Dong Ba Thin.*

kills 129 civilians, wounds 247 and kidnaps 73. Most of the latter actions are undertaken to forcibly recruit males into the Viet Cong.

MAY 3

SOUTH VIETNAM, *GROUND WAR*
III MAF approves a 1st Division request to demolish the Da Nang Anti-Infiltration System (DAIS), or the Barrier System, the line of minefields, cleared land, barbed wire fences and electronic sensors that had been developed in 1966–67 to stop enemy infiltration into the "Rocket Belt" area and across the DMZ. Never fully constructed, the Barrier System is regarded as ineffective by the Marines.

MAY 4

USA, *PEACE PROTESTS*
As the US and ARVN interdiction and cross-border raid into Cambodia continues, college campuses explode in a wave of antiwar protesting. The most serious incident occurs at Kent State University in Kent, Ohio, as National Guardsmen, called out by Governor James Rhodes, kill four students.

USA, *POLITICS*
The Senate Foreign Relations Committee publicly accuses President Nixon of usurping the war-making powers of Congress by allowing American troops to participate in the ARVN's invasion of Cambodia. A day later, President Nixon responds by saying that American troops will go no further than 31km (19 miles) inside Cambodia and will be withdrawn by July 1, 1970. Congress

▲ *The body of Jeffrey Miller lies in a pool of blood after being shot by National Guardsmen at Kent State University.*

will pass the War Powers Act in 1973 which limits a US President's ability to undertake military action without Congressional approval.

MAY 6

SOUTH VIETNAM, *GROUND WAR*
Que Son District Headquarters in Quang Nam Province receives some 200 rounds of mortar fire, followed by a ground attack of an enemy force estimated at greater than battalion strength. US Marines of H Company, 2nd Battalion, 5th Marines, supported by artillery, aid the besieged Regional Forces and Popular Forces. The South Vietnamese lose 10 killed and 41 wounded, and 1 US Marine is killed, while the enemy lose 27 killed in the attack.

CAMBODIA, *GROUND WAR*
In Cambodia, a brigade-sized task force of the US Army's 25th "Tropic Lightning" Division launches an operation

▼ *US F-4 Phantoms of the 37th Tactical Fighter Wing at Phu Cat Air Base after a mission in March.*

into an enemy sanctuary west-north-west of Tay Ninh City. This action is a continuation of the previously announced action taken by III Corps forces of the ARVN in order to deny the enemy use of supply and training bases in the "Parrot's Beak" area of Cambodia. The centre of the operation is approximately 29km (18 miles) from Tay Ninh City. Initial reports indicate that nine NVA have been killed. Total US losses include one killed and nine wounded in action.

Elements of the US 1st Cavalry Division, which is operating in the "Fish Hook" area of Cambodia along with ARVN forces, commences operations against enemy sanctuaries in Cambodia 37km (23 miles) north of Phuoc Binh,

▼ *M113 armoured personnel carriers of the 11th Armored Cavalry Regiment in Cambodia in May during an attempt to locate and destroy the Viet Cong HQ.*

Phuoc Long Province. Elements of the US 11th Armored Cavalry Regiment, which is also involved in the "Fish Hook" operation, begin operations in Cambodia in a combined operation with elements of the 5th ARVN Division in an area 16km (10 miles) north of Loc Ninh, Binh Long Province. This is a continuation of the combined US/ARVN operations initiated in the "Fish Hook" area of Cambodia in order to neutralize enemy supplies and base areas which pose a threat to US and South Vietnamese forces in III Corps Tactical Zone.

MAY 7

CAMBODIA, *GROUND WAR*
In Cambodia, elements of the US Army's 2nd Brigade, 1st Cavalry Division (Airmobile), engage an enemy force while operating in Cambodia 38.6km (24 miles) northwest of Phuoc Binh. The air cavalrymen exchange small-arms and automatic weapons fire with the NVA. Once again, US forces are

supported by artillery, helicopter gunships, an Air Force AC-119 gunship and tactical air strikes by the US Air Force. The enemy loses 24 soldiers killed in action, while the US suffers 8 killed in action.

An aviation element from the US 4th Infantry Division observes a platoon-sized enemy force in a large bunker and hut complex, 77km (48 miles) west-northwest of Pleiku City, about 3.2km (2 miles) inside Cambodia. The helicopter crew calls in close air support, and US Air Force jets kill 15 enemy soldiers and destroy 41 structures and 22 bunkers.

MAY 8

SOUTH VIETNAM, *GROUND WAR*
A reconnaissance element of the 1st Marine Division receives small-arms fire from an undetermined-sized enemy force shortly after being inserted into an area 24km (15 miles) west of An Hoa in Quang Nam Province. The US Marines engage the enemy with organic weapons, and at about 19:45 hours helicopter gunships kill 13 of the enemy. The Marines are extracted at 20:15 hours and artillery fire kills four more NVA soldiers. There are no US casualties.

Elements of the 2nd Brigade, 1st Cavalry Division (Airmobile), discover two significant enemy weapons and munitions caches while operating in the area 27km (17

▲ *More US troops and armoured vehicles pour into Cambodia. The results of the Cambodian mission were largely disappointing, with minimal enemy losses.*

(5 miles) inside Cambodia. The first cache is discovered at about 10:30 hours in a bunker complex, and contains the following: 6 122mm rocket launchers, 54 122mm mortar rounds, 60 122mm rockets and nearly 2 tonnes (2 tons) of other ordnance, including small-arms ammunition.

MAY 9

CAMBODIA, *GROUND WAR*
US forces are participating in the ARVN IV Corps operation in the Mekong River Corridor, initiated this morning. US forces are providing combat support, including medical evacuation, helicopter gunship and artillery support, as well as tactical air strikes. In addition, 30 US Navy River Patrol Boats, US Navy helicopters and a US Navy OV-10 Bronco observation/close air support aircraft, along with US advisors, are accompany-

ing ARVN and South Vietnamese naval forces during this ground and riverine operation. The mission of the operation is to neutralize VC/ NVA sanctuary bases located in the area. US forces are not authorized to proceed into Cambodia beyond the limits established by President Nixon. US casualties during this operation are one killed and one wounded in action.

JUNE 11

SOUTH VIETNAM, *TERRORISM*
In order to terrorize the villagers of Phou Thanh, a village near the Ba Ren Bridge where the CUPP team Number 9 of the 1st Platoon, A Company, 7th Marines operate, elements of the V-25 Main Force Battalion and the T-89th Sapper Battalion (Viet Cong) attack at 02:00 hours, killing 74 civilians, many of them women and children, as well as wounding 60 seriously and destroying 156 houses.

Thanh My Hamlet, 8km (5 miles) southwest of Hoi An, is attacked by the VC/NVA, resulting in 150 civilians killed and 60 wounded. In destroying the hamlet, the enemy leaves behind 16 dead.

JUNE 13

SOUTH VIETNAM, *GROUND WAR*
In Quang Nam Province, a Combined Unit Pacification Program (CUPP) team, made up of personnel from a Regional Forces Company and Marines of the 5th Marines, 1st Marine Division, receives heavy ground fire from an enemy force 31km (19 miles) southwest of Da Nang. The enemy employs small-arms fire, rocket grenades and satchel charges. The team returns fire with organic weapons and receives fire

▼ *One of the 162 River Patrol Boats that was given to the South Vietnamese Navy in June. This vessel is leaving the dock at Go Dau Ha.*

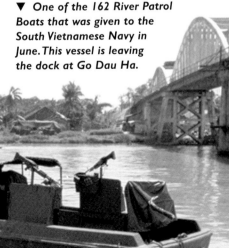

STRATEGY & TACTICS

CLOSE AIR SUPPORT
Close air support (CAS) is air action in operations against hostile targets on the ground that are in close proximity to friendly forces and that require detailed integration of each air mission with the fire and movement of ground forces. Close proximity means that friendly forces and/or noncombatants are close enough to the target that care must be taken to avoid casualties from air-delivered weapons. During the Vietnam War, US gunships destroyed more than 10,000 trucks and were credited with many life-saving close air support missions.

Close air support was usually provided by tactical fighters and fighter-bombers, which were controlled by forward air controllers in light, propeller-driven spotter aircraft. Ironically, given their strategic role, US B-52 bombers were also used to support ground operations. In addition, ground troops were supported by fixed-wing gunships which were armed with rapid-firing miniguns.

support from US Marine 81mm mortar and artillery batteries. Contact is lost when the enemy withdraws with unknown losses. The Marines suffer three killed and four wounded. Regional Forces casualties are light.

JUNE 21

SOUTH VIETNAM, *GROUND WAR*
Da Nang is hit by 9 122mm rockets, killing 7 civilians and wounding 19, and destroying 7 houses.

JUNE 22

SOUTH VIETNAM, *US NAVAL FORCES*
The US Navy turns over 273 combat boats to the Republic of Vietnam Navy in ceremonies in Saigon. The craft includes 162 River Patrol Boats (RPBs), 75 River Assault Craft (RACs), and 36 Patrol Craft Fasts (PCFs), or "Swift Boats". This turnover brings to 525 the number of US Navy craft transferred to the Vietnamese Navy since June 1968.

JUNE 25

NORTH VIETNAM, *AIR WAR*
A US Navy A-7 aircraft, escorting unarmed US reconnaissance aircraft over North Vietnam, conducts a "protective reaction" against an enemy antiaircraft installation which has fired on it but missed. The shooting by the US Navy

▲ *The air war was as relentless as ever: a Viet Cong position being pounded by helicopter gunships of the US 61st Assault Helicopter Company.*

A-7 – the second of such incidents when US Navy aircraft, operating under the new rules of aerial engagement established in May – is the result of the jet being "locked on" by NVA radar-controlled antiaircraft positions northwest of Vinh in southern Nghe An Province of North Vietnam. There is no damage to the US Navy jet.

JUNE 26–27

CAMBODIA, *GROUND WAR*

The withdrawal of US units participating in the punitive expedition into Cambodia continues with the return to the Republic of Vietnam of a battalion-sized unit of the 2nd Brigade, 1st Cavalry Division. Other elements of the 11th Armored Cavalry Regiment and the 1st Cavalry Division complete their assigned operations in Cambodia and return to the Republic of Vietnam.

JUNE 27

CAMBODIA, *GROUND WAR*

MACV announces that the cumulative results of the combined US and Armed Forces of the Republic of Vietnam operations in Cambodia indicate 4764 enemy killed. In addition, 9081 individual weapons, 1283 crew-served weapons, and 5400 tonnes (5314 tons) of rice have been captured or destroyed. The totals are exclusive of those predominantly RVNAF operations continuing or concluded in the "Parrot's Beak" area, Se San Base Areas and

the Mekong River Corridor. US casualties in all of the Cambodian operations are 399 killed and 1501 wounded. In view of the massive efforts involved, the Cambodian incursions are somewhat of a disappointment.

JUNE 30

SOUTH VIETNAM, *US ARMED FORCES*

The US Naval Support Activity at Da Nang is deactivated

JULY 2

SOUTH VIETNAM, *ARMED FORCES*

In order to strengthen the administration of the armed forces, President Nguyen Van Thieu incorporates both the regional and the popular forces into the South Vietnamese Army, and redesignates the Corps Tactical Zones as Military Regions (MRs).

Under the reorganization by Thieu, the corps deputy commander will conduct major military operations in the MR. At the same time, his deputy regional commander, who is responsible for territorial defence and pacification, will head the Regional Forces (RFs) and Popular Forces (PFs). Concurrently, Military Assistance Command, Vietnam, and the Vietnamese Joint General Staff are completing plans to incorporate the Civilian Irregular Defense Group into the ARVN Border Defence Ranger Battalions.

JULY 3

SOUTH VIETNAM, *GROUND WAR*

The Hai Lang Popular Forces platoon, RF Group 1/11's Companies 121 and 122, and CAPs 4-3-2 and 4-1-2, located 9km (5.6 miles) southeast of Quang Tri City, are attacked by an enemy force of unknown size. Supported by gunships and artillery, the Allies kill 135 NVA and Viet Cong and capture 74 weapons, at the same time losing 16 killed and 6 missing in action.

JULY 6

USA, *CONGRESSIONAL REPORTS*

A US Congressional fact-finding mission to South Vietnam files a report expressing optimism about ending the war. The report notes, however, that South Vietnam's economy, based on the culti-

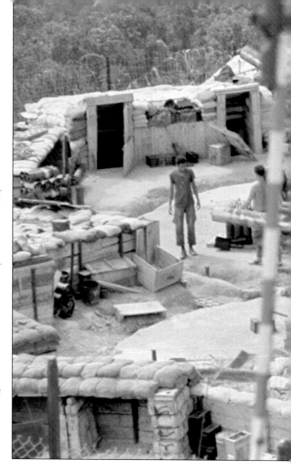

▲ *The 105mm howitzer was one of the most useful weapons deployed by the Americans during the war. These examples belong to the 101st Airborne Division.*

vation of rice, will not be able to support the war effort on its own.

JULY 7

SOUTH VIETNAM, *GROUND WAR*

In Thua Thien Province, elements from XXIV Corps' 2nd Brigade, 101st Cavalry Division, engage an undetermined-sized enemy force 42km (26 miles) west of Hue. Enemy losses are 6 killed, while US casualties are 3 killed and 19 wounded in action. Meanwhile, Major-General George W. Casey, Commanding General, 1st Cavalry Division (Airmobile), and six other US Army personnel riding in the general's UH-1 are shot down by enemy gunners. All are killed in the subsequent crash, and their remains are not recovered until July 11.

JULY 8

SOUTH VIETNAM, *GROUND WAR*

In Quang Nam Province, elements of the 101st Airborne Division engage the

◀ *The Americans continued to mount naval operations along the Vietnamese coastline. Here, an F-4 Phantom leaves the deck of USS America for a patrol over the Gulf of Tonkin.*

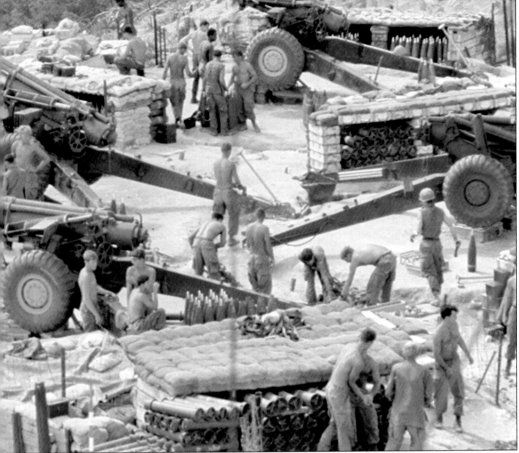

 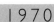

REGIONAL POLITICS

SOUTH KOREA

After the US, South Korea contributed the most troops to South Vietnam, though ironically it was not a member of SEATO. Under the "Many Flags" programme, South Korean troops first arrived in February 1965. They were deployed in II Corps' sector, between Nha Trang and Da Nang. The pride of the South Korean Army, the Capital Division, arrived in Vietnam in October 1965, and by the end of 1969 there were 47,872 South Korean troops serving in the South. Such commitment did not come cheap. The US paid more than $900 million to the Seoul government between 1966 and 1970. Washington paid more to ensure that South Korea deployed two divisions in South Vietnam until 1973. The South Koreans were tough, well-led soldiers, but their orders from Seoul to take as few prisoners as possible won few hearts or minds. They were also guilty of numerous atrocities against Vietnamese civilians.

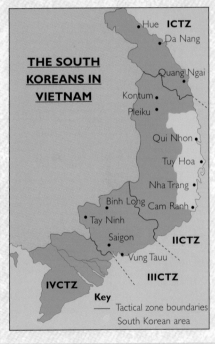

THE SOUTH KOREANS IN VIETNAM

Hue ICTZ
Da Nang
Quang Ngai
Kontum
Pleiku
Qui Nhon
Tuy Hoa
Nha Trang
Binh Long Cam Ranh
Tay Ninh
Saigon IICTZ
Vung Tauu
IVCTZ IIICTZ
Key
— Tactical zone boundaries
South Korean area

▲ *Elections in South Vietnam. Passers-by study a tally board of winning senate slates outside Saigon City Hall. The elections were marred by Viet Cong bombs.*

NVA in a vicious eight-hour battle near Khe Sanh in northern Quang Tri Province. The US casualties are 4 killed and 7 wounded, while the paratroopers succeed in killing a confirmed total of 139 NVA soldiers.

JULY 15–16

SOUTH VIETNAM, *GROUND WAR*
Elements of the 5th Marines launch Operation Barren Green. This operation will take place in the northern Arizona Territory, south of the Vu Gia River, in order to prevent the VC/NVA from collecting the ripened corn from this fertile farming region. The US Marines are opposed by elements of the NVA's élite 38th Regiment.

JULY 16

SOUTH VIETNAM, *GROUND WAR*
US Marine units, primarily from the 7th Marines, begin Operation Pickins Forest, south of An Hoa in the Song Thu Bon Valley.

AUGUST 16

SOUTH VIETNAM, *GROUND WAR*
Elements of the 5th Marines launch Operation Lyon Valley. This operation is to be conducted in the mountains which border the northern Arizona Territory, in order to further limit the movement of food and supplies to the NVA's 38th Regiment.

AUGUST 20

SOUTH VIETNAM, *US ARMED FORCES*
A US Department of Defense study reports on the use of illegal drugs by US servicemen during the Vietnam war, and concludes that about three out of every ten US servicemen who are interviewed have either smoked marijuana or taken other illegal drugs during their time in Vietnam.

AUGUST 30

SOUTH VIETNAM, *POLITICS*
In elections held throughout South Vietnam, 30 South Vietnamese senators are elected in voting that is characterized by terrorist attacks by Viet Cong sappers and charges of fraud. Forty-two civilians are killed.

SEPTEMBER 1

SOUTH VIETNAM, *US ARMED FORCES*
Reflecting the scaled-down nature of military operations, some tactical areas of responsibility are realigned, as the 7th Marines and other combat and service support units stand down.

With the deactivation of all Combined Action Platoons outside of Quang Nam Province, XXIV Corps returns operational control of the Combined Action Force to III MAF.

SEPTEMBER 5

SOUTH VIETNAM, *US ARMED FORCES*
The 5th Marines began shifting elements of its infantry battalions in order to assume responsibility of the 7th Marines' area of operations in the Que Son area. Meanwhile, the 7th Marines prepares to stand down from combat operations.

SEPTEMBER 21

SOUTH VIETNAM, *US ARMED FORCES*
The headquarters of the Combined Action Force, which has been located at the Marine base at Chu Lai, is deactivated. This will leave only the 2nd CAG operating in Quang Nam Province. Approximately 600 US Marines and Navy corpsmen, have seen the integration of their operations with 31 Popular Forces and 3 Regional Forces platoons; these indigenous forces are distributed throughout the province of Quang Nam.

▼ *M48 tanks of the 3rd Squadron, 11th Armored Cavalry Regiment, make a sweep north of Fire Base Bandit II.*

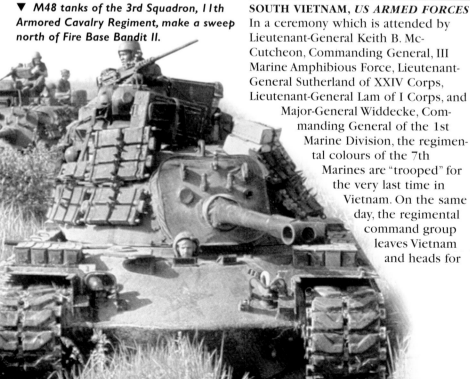

▲ *An M88 tank recovery vehicle of the 11th Armored Cavalry Regiment during a reconnaissance mission north of Fire Base Bandit II, November 24.*

SEPTEMBER 23

SOUTH VIETNAM, *GROUND WAR*
United States and South Vietnamese military forces working together come across a large weapons cache and rocket-assembly point located in An Xuyen Province. Included in the find are 350 disassembled Soviet SKS rifles, as well as many other assorted weapons and ammunition.

SEPTEMBER 30

SOUTH VIETNAM, *US ARMED FORCES*
By the end of September, the 1st and 5th Marines, and the 2nd Battalion, 7th Marines, are the only manoeuvre units from the 1st Marine Division remaining in the field.

OCTOBER 1

SOUTH VIETNAM, *US ARMED FORCES*
In a ceremony which is attended by Lieutenant-General Keith B. McCutcheon, Commanding General, III Marine Amphibious Force, Lieutenant-General Sutherland of XXIV Corps, Lieutenant-General Lam of I Corps, and Major-General Widdecke, Commanding General of the 1st Marine Division, the regimental colours of the 7th Marines are "trooped" for the very last time in Vietnam. On the same day, the regimental command group leaves Vietnam and heads for

its home base, located at Camp Pendleton in California.

OCTOBER 8

SOUTH VIETNAM, *US ARMED FORCES*
Military Assistance Command, Vietnam, completes its plans to redeploy a further 40,000 troops back home to the United States by the end of this year, in a move which will leave a total of 344,000 US troops stationed within South Vietnam.

OCTOBER 14

SOUTH VIETNAM, *US ARMED FORCES*
At the request of Colonel Clark V. Judge, the commanding officer of the 5th Marines, the 1st Marine Air Wing decentralizes its helicopter support. This is done by dispatching a total of six CH-46Ds, four AH-1G gunships, one UH-1E command and control aircraft, and a CH-53 to Landing Zone Baldy on a daily basis. This will give Colonel Judge's Marines mobility and tactical flexibility.

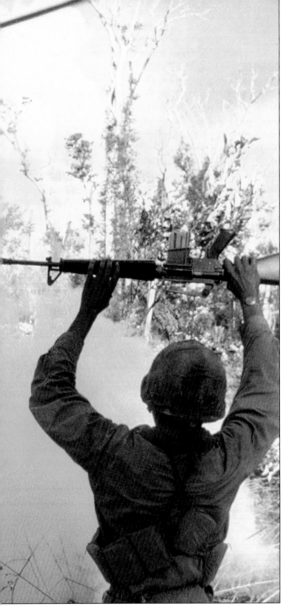

◀ A soldier of the US 1st Air Cavalry Division guides in a UH-1D helicopter during an operation in the South at the end of 1970.

OCTOBER 15

SOUTH VIETNAM, *US ARMED FORCES*
The last US Marines leave their base at An Hoa and turn it over to the ARVN.

OCTOBER 22

SOUTH VIETNAM, *GROUND WAR*
Employing the 51st ARVN Regiment, the 1st Ranger Group, the 2nd and 3rd Troops of the US Army's 17th Armored Cavalry Squadron, over 300 Regional Forces and Popular Force platoons, the People's Self Defense Force, and the national police in a province-wide offensive against the Viet Cong, Lieutenant-General Lam launches Operation Hoang Dien. This is one of the most ambitious, essentially South Vietnamese pacification operations to date.

OCTOBER 31

SOUTH VIETNAM, *US STRATEGY*
MACV promulgates the Allied Campaign Plan for 1971, which reflects the changing emphasis of the war and the South's increasing assumption of the war effort, including pacification, in light of the redeployment of American forces from Vietnam.

NOVEMBER 19

NORTH VIETNAM, *GROUND WAR*
US Special Forces conduct a joint raid aimed at the Son Toy Prisoner of War Camp, 32km (20 miles) west of Hanoi, in order to liberate Americans held by

▲ Lieutenant-General Hoang Xuan Lam commanded the ARVN's I Corps. He also investigated alleged American atrocities in Quang Ngai Province.

the North Vietnamese. Apparently, the NVA had been alerted beforehand and had moved the prisoners.

NOVEMBER 21

SOUTH VIETNAM, *US ARMED FORCES*
Task Group 79.4 is redesignated the 31st Marine Amphibious Unit (31st MAU). US Marines will no longer designate their amphibious ready units as the "Special Landing Force Alpha".

NOVEMBER 23

NORTH VIETNAM, *GROUND WAR*
US Secretary of Defense Melvin R. Laird reports that a joint American force has conducted an unsuccessful helicopter raid on the empty Son Toy Prisoner of War camp, 32km (20 miles) west of Hanoi, on November 19.

DECEMBER 1

SOUTH VIETNAM, *US ARMED FORCES*
The 1st Marine Division's strength, over 28,000 at the start of the year, now stands at 12,000 US Marines and sailors.

DECEMBER 3

SOUTH VIETNAM, *US ARMED FORCES*
American strength in Vietnam is down to 349,700, the lowest number since October 29, 1966.

DECEMBER 10

USA, *MILITARY STRATEGY*
President Richard M. Nixon warns that if North Vietnamese forces increase the level of fighting in South Vietnam as the American forces withdraw, he will resume bombing targets within North Vietnam.

▼ The search and destroy missions carried on unabated: soldiers of the US 4th Infantry Division on board a Huey for yet another operation against "Charlie".

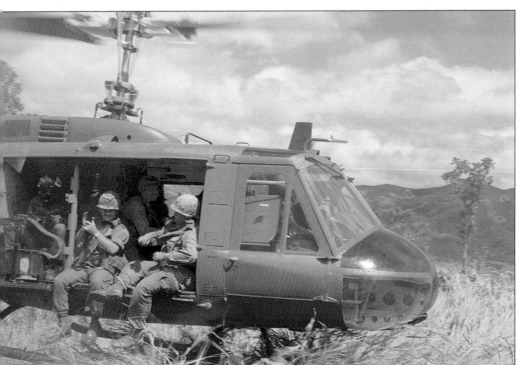

1971-1975
A BRIEF INTERLUDE TO A VIOLENT END

Between 1971 and 1974, the bulk of US ground and air elements departed South Vietnam and turned the war over to the Army of the Republic of Vietnam (ARVN). But the North was gearing up its war effort, and in 1972 the North Vietnamese Army (NVA) launched its Easter Offensive. The operation failed, and the Paris Peace Accords signed in January 1973 seemed to guarantee the survival of South Vietnam. However, each side accused the other of violating the truce, and fighting continued. But with the withdrawal of US forces, the South lacked air support to blunt the NVA. When the North launched a major offensive in early 1975, the ARVN crumbled and the NVA rolled into Saigon.

◄ *A big welcome home for US servicemen who were "guests" of Hanoi: two young well-wishers at the Miramar Naval Air Station welcome home prisoners from Vietnam, March 30, 1973.*

Even as the war became "Vietnamized", the North Vietnamese Army (NVA) and a reconstituted Viet Cong reverted to a campaign of terrorism and intimidation against South Vietnamese civilians in a renewed bid to undermine the confidence and stability of President Thieu's government. As the United States turned its attention to ending the war and domestic political problems brought on by the Watergate scandal (1973-74), Hanoi launched its first major offensive during March and April 1972, known as the "Easter Offensive". Supported by US ground advisors and aircraft flying non-stop close air support strikes against waves of North Vietnamese tanks and armoured vehicles, the ARVN put up a spirited defence and later launched a series of offensive operations that forced the North Vietnamese to seek a de facto armistice. Determined to be re-elected and finally end the Vietnam War, President Richard M. Nixon and his National Security Advisor, Henry Kissinger, used both force and diplomacy in their bid to end the conflict and achieve what the president called "peace with honour". Using both a "velvet" glove (diplomacy) and an "iron fist" (a massive bombing campaign) aimed at Hanoi itself during Christmas 1972, the United States finally brought an uneasy lull to the war in 1973. The final acts of the Vietnam War occurred as North Vietnam launched its all out winter offensive in January 1975, and ended with North Vietnamese tanks storming through the gates of the South Vietnamese Presidential Palace to take over the whole of Vietnam in April 1975.

◀ *South Vietnamese President Nguyen Van Thieu addresses the opening session of the SEAMEO Conference in Saigon, January 11, 1971. Seated behind the Vietnamese president are foreign delegates.*

JANUARY 6, 1971

SOUTH VIETNAM, *US AID*

US Secretary of Defense Melvin R. Laird says that "Vietnamization" is running well ahead of schedule and that combat missions by American troops will end the following summer.

JANUARY 11–MARCH 29, 1971

SOUTH VIETNAM, *GROUND WAR*

US Marine Operation Upshur Stream is conducted by the 1st and 3rd Battalions of the 1st Marines in and around "Charlie Ridge", near Da Nang in the so-called "rocket belt". Contacts with the 575th North Vietnamese Artillery Battalion result in 13 NVA being killed and 32 individual weapons captured.

JANUARY 23, 1971

SOUTH VIETNAM, *US ARMED FORCES*

The Commander-in-Chief, Pacific, approves the "standing down" of Amphibious Ready Group "Bravo" from January 29 to May 1, 1971. Amphibious Ready Group "Alpha" will be on 120-hour alert status.

JANUARY 30, 1971

SOUTH VIETNAM, *GROUND WAR*

Phase I of Operation Lam Son-719 begins. Elements of the US Army's 1st Brigade, 5th Infantry Division (Mechanized), advance from Fire Support Base Vandegrift towards Khe Sanh. On February 8, the ARVN enters Laos to begin Phase II. South Vietnamese forces sweep areas of operation from March 7 to 16 during Phase III, and begin Phase IV, the withdrawal, on March 17. The last South Vietnamese troops leave Laos on April 6.

FEBRUARY 3–MARCH 29, 1971

SOUTH VIETNAM, *GROUND WAR*

During the the South's Operation Hoang Dien 103, units of III MAF, 1st MAW, 2nd ROKMC, 51st ARVN Regiment, 146th Popular Forces Platoon and 39th Regional Forces Company sweep the Da Nang TAOR lowlands and fringes, killing 330 enemy. The Allies lose 46 soldiers, including 2 US Marines and 99 wounded, but kill over 690; the US Marines alone claim to have killed 152.

FEBRUARY 8, 1971

LAOS, *GROUND WAR*

President Thieu announces that some units of South Vietnamese troops have gone into Laos in order to interdict the enemy supply routes and troop concentrations as part of Operation Lam Son-719. At this point, no American troops or advisors working with the ARVN have so far crossed the border into Laos.

JANUARY 1, 1971

SOUTH VIETNAM, *ARMED FORCES*

The South's allies cease to have Tactical Areas of Responsibility (TAOR). Instead, only the Vietnamese have them, while Allied units are now assigned Tactical Areas of Interest (TAOIs), although these generally encompass the same areas as their former TAORs. Henceforth, the ARVN will assign areas of responsibility to Allied commands.

JANUARY 1–31, 1971

SOUTH VIETNAM, *GROUND WAR*

Enemy activity is in apparent decline. In January 1970, Allied forces sighted 4425 enemy troops, but from September through December 1970, the Allies claim that a total of only 4159 sightings of the enemy have been recorded.

▼ *The US 327th Infantry Regiment prepares to leave South Vietnam, January 1972.*

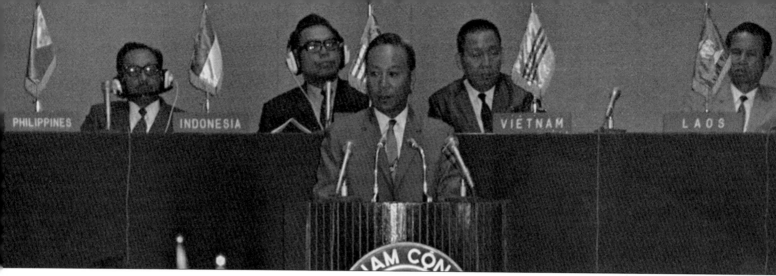

PHILIPPINES INDONESIA VIETNAM LAOS

FEBRUARY 12, 1971

NORTH VIETNAM, *NAVAL WAR*

Amphibious Ready Group Alpha/31st Marine Amphibious Unit (ARG/MAU) arrives off the coast of North Vietnam, 80km (50 miles) east of the city of Vinh, where the Tonkin Gulf incident occurred back in 1964. From now until March 6, the ARG/MAU conducts daily amphibious and communications exercises to divert North Vietnamese forces into thinking that the US Marines are preparing to conduct either a raid or an amphibious landing against North Vietnamese forces. This operation is conducted while Lam Son-719 is in progress.

FEBRUARY 17, 1971

SOUTH VIETNAM, *GROUND WAR*

The MACV commander directs that from May 1 to June 30, during Operation Keystone Robin Charlie, the whole of the 3rd Marine Amphibious Brigade will be deployed.

MARCH 2, 1971

LAOS, *GROUND WAR*

The South Vietnamese Marine Brigade 147 makes a heliborne assault into Laos during Operation Lam Son-719 at Fire

Support Base Delta, and relieves the ARVN forces which are currently operating there.

MARCH 24, 1971

USA, *INTELLIGENCE*

The US Department of Defense announces that the North Vietnamese have started to move Soviet-supplied artillery into the western end of the Demilitarized Zone (DMZ).

MARCH 29, 1971

SOUTH VIETNAM, *GROUND WAR*

The 38th North Vietnamese Regiment surfaces from its mountain hideouts near An Hoa and proceeds to launch a two-battalion attack against the district headquarters of Duc Duc, Phu Da and Thu Bon hamlets. Showing signs that its operational capabilities have made vast improvements, and without any US assistance, the 51st ARVN Regiment successfully counterattacks, and expels the 38th NVA Regiment from these hamlets following four days of savage fighting.

APRIL 7, 1971

SOUTH VIETNAM, *US AID*

In a further sign that the ground role of US forces is

▼ *A Military Policeman of the US 101st Airborne Division searches a truck driver for illegal drugs. Drug taking was rife among US service personnel in the early 1970s.*

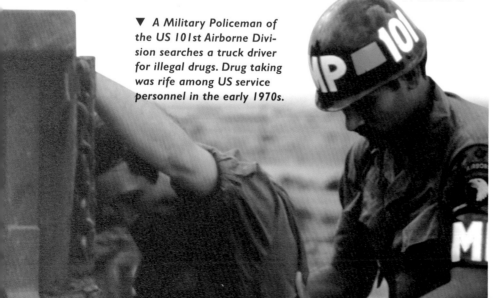

▲ *Despite US expressions of solidarity, the government of President Thieu (centre) faced a very uncertain future.*

over, President Nixon announces further troop cuts in American forces in Vietnam and states that they will be gone by June 30. Among US Marine forces named in these cutbacks are the 3rd Marine Amphibious Brigade and the 1st Battalion, 1st Marines.

APRIL 7–12, 1971

SOUTH VIETNAM, *GROUND WAR*

So as not to give the impression that the United States has given up on its South Vietnamese ally, the US 1st Marine Regiment launches a five-day offensive, called Operation Scott Orchard, in the area west of An Hoa. The Marines comb the areas around Pickens Forest and Catawba Falls. A 105mm and 155mm howitzer battery are set up at Fire Support Base Dagger as five companies, under the operational control of the 2nd Battalion, 1st Marines, are then inserted into the area. After five days of operations, only scattered resistance is encountered. Four NVA soldiers are killed and 12 individual weapons captured. The US Marines suffer only minor casualties.

APRIL 13, 1971

SOUTH VIETNAM, *US ARMED FORCES*

The US Army's 196th Light Infantry Brigade, which will be the last US ground combat element in Quang Nam Province, moves into the Que Son area.

14 APRIL 1971

SOUTH VIETNAM, *US AID*

III Marine Amphibious Force,

▶ *The fighting went on: Private Edward Sellere, US 25th Infantry Division, prepares for a mission southwest of Xuan Loc.*

under the command of Lieutenant-General Donn J. Robertson, along with the 1st Marine Division and 1st Marine Air Wing, leaves Vietnam. It has been "in-country" since May 6, 1965. The 3rd Marine Amphibious Brigade (MAB) is officially established in the Republic of Vietnam.

Lieutenant-General Robertson, Commanding General (CG), III MAF, relocates to Camp Courtney, Okinawa, and Major-General Armstrong, the Commanding General, 1st Marine Air Wing (MAW), assumes command of all units remaining in the Republic of Vietnam. He reports to the Commanding General, XXIV Corps, for operational control as CG, 3rd MAB. Command of the 1st MAW passes to Commanding General, 1st Marine Air Reserve (Rear), and Major-General Widdecke, CG, 1st Marine Division, relocates to Camp Pendleton.

APRIL 15, 1971

SOUTH *VIETNAM, US AID*
The strength of the 3rd Marine Amphibious Brigade on its activation is 1322 Marine and 124 US Navy officers and 13,359 Marine and 711 US Navy enlisted men. The ground combat element is the 1st Marines and the air element consists of two aircraft groups: Marine Air Group 11 and Marine Air Group 16. The 3rd Marine Amphibious Brigade in-

cludes numerous combat support and service support units. The last four CUPP squads of M Company, 3rd Battalion, 1st Marines, are deactivated, ending the CUPP programme. In the 18 months of its existence, the CUPP programme has accounted for 578 enemy killed while the Marines have lost 46 killed in action.

APRIL 20, 1971

SOUTH VIETNAM, *US AID*
Included in President Nixon's announced troop cuts, VMA(AW) 225, the last A-6 Intruder Squadron, stands down in preparation for its return to its base at US Marine Corps Air Station, El Toro, California.

APRIL 29, 1971

SOUTH VIETNAM, *US ARMED FORCES*
At the US Embassy compound in Saigon, Ambassador Ellsworth Bunker presents E Company, Marine Security Guard Detachment, with the "Meritorious Unit Commendation for meritorious service as the immediate defense and security force for the US Mission, Saigon, RVN, from February 1, 1969 to December 31, 1971." The Marine Security Guards played a pivotal role in the defence of the US Embassy in Saigon in January 1968 during the Tet Offensive, and will repeat that pivotal role during the evacuation from Saigon on April 29, 1975.

APRIL 30, 1971

SOUTH VIETNAM, *US AID*
President Nixon welcomes home the 1st Marine Division at Camp Pendleton, California. The 3rd Marine Amphibious Brigade (MAB) includes the following

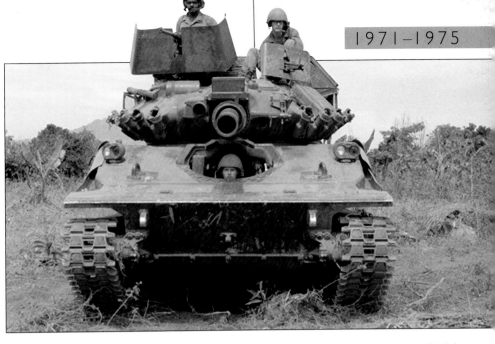

▲ *An M551 Sheridan tank of the US 11th Armored Cavalry Regiment near Hung Loc in early 1971.*

units: Headquarters, 3rd MAB, Regimental Landing Team 1, which includes the 1st Battalion, 1st Marines; 2nd Battalion, 1st Marines; and 3rd Battalion, 1st Marines. The US Marine Security Guard Detachment comes under the overall command of Sub-Unit 1, 1st Anglico, and the Marine Advisory Unit, as the only US Marine Commands remaining in Vietnam. The 3rd MAB also has attached air assets.

MAY 3–4, 1971

SOUTH VIETNAM, *US AID*
Marines from the US Marine Corps Base, Quantico, VA., and Camp Lejeune, North Carolina, deploy to Washington, D.C., in order to assist the police in controlling antiwar protestors.

MAY 7, 1971

SOUTH VIETNAM, *US AID*
The 3rd MAB units cease all ground combat as well as fixed-wing aviation operations in Vietnam.

MAY 11, 1971

SOUTH VIETNAM, *US AID*
The 2nd Combined Action Group headquarters is deactivated, signalling the end of US Marine Corps pacification and civic action campaigns in South Vietnam.

MAY 12, 1971

SOUTH VIETNAM, *GROUND WAR*
Operation Imperial Lake, the last major US Marine operation, ends with 305 NVA/Viet Cong killed. The Marines lose 24 killed in combat operations.

June 4, 1971

June 4, 1971

SOUTH VIETNAM, *US ARMED FORCES*
The 3rd Marine Amphibious Brigade turns over its last bases in Vietnam to the US Army at Camp Books.

9 June 1971

SOUTH VIETNAM, *US ARMED FORCES*
Lieutenant-General W. G. Dolvin, US Army, relieves Lieutenant-General J. W. Sutherland, US Army, as Commanding General, XXIV Corps.

June 21, 1971

SOUTH VIETNAM, *US AID*
As American units redeploy back to bases in the United States and throughout Asia, the US military strength in the Republic of Vietnam is down to 244,900.

June 26, 1971

SOUTH VIETNAM, *US ARMED FORCES*
The 3rd Marine Amphibious Brigade deactivates its headquarters.

June 27, 1971

SOUTH VIETNAM, *US AID*
With the deactivation of the 3rd Marine Amphibious Brigade, the US Marine participation in the Vietnam War is over after six years and three months of conducting combat operations. Only Marine advisors to the South Vietnamese Marine Corps (VNMC) remain in the country.

July 9, 1971

SOUTH VIETNAM, *US AID*
US forces are no longer obligated to defend the region south of the DMZ at the 17th Parallel. The US Marine Corps and US Army first moved into the area in 1965 in order

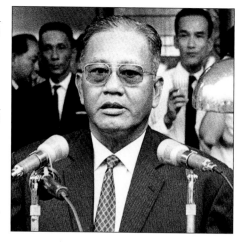

▲ *South Vietnamese General Duong Van "Big" Minh announced his candidacy for the presidency in September 1971.*

to reinforce the 1954 Geneva Convention Agreement, which prohibited ground or artillery attacks from this buffer zone.

July 9–11, 1971

USA, *DIPLOMACY*
US National Security Advisor, Dr. Henry A. Kissinger, visits the People's Republic of China in preparation for President Nixon's historic trip.

July 12, 1971

SOUTH VIETNAM, *US AID*
American troop strength in South Vietnam stands at 236,000, decreasing at a rate of about 14,000 men per month.

July 19, 1971

SOUTH VIETNAM, *US AID*
The redeployment of all the major US Marine Corps units from South Vietnam is complete.

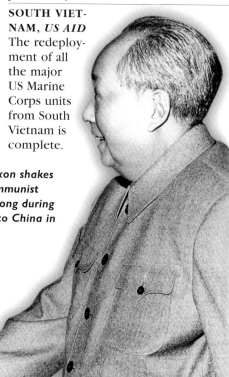

◄ *President Nixon shakes the hand of Communist leader Mao Zedong during his historic trip to China in February 1972.*

August 18, 1971

SOUTH VIETNAM, *AUSTRALIAN & NEW ZEALAND AID*
Both Australia and New Zealand announce the withdrawal of their combat forces from Southeast Asia.

August 25, 1971

SOUTH VIETNAM, *US AID*
The US Army's 173rd Airborne Brigade withdraws from South Vietnam.

August 27, 1971

SOUTH VIETNAM, *US AID*
The US Army's 1st Brigade, 5th Infantry Division (Mechanized), withdraws from Vietnam. It had operated along the western area of the DMZ since January 1971.

October 3, 1971

SOUTH VIETNAM, *POLITICS*
President Nguyen Van Thieu is re-elected president for another four-year term. The election is marked by protests and Viet Cong violence.

November 12, 1971

SOUTH VIETNAM, *US AID*
President Richard M. Nixon announces that American military forces are now taking a purely defensive stance while leaving the ARVN to conduct offensive military operations.

November 26, 1971

NORTH VIETNAM, *AIR AND NAVAL WAR*
Frustrated over Hanoi's refusal to talk, as well as by their stalling at the Paris Peace Talks, President Nixon authorizes the US Air Force and the Navy to resume their bombing missions over North Vietnam.

▲ When North Vietnam stalled at the Paris Peace Talks, Nixon resumed the bombings. This is a damaged bridge in Hanoi.

▲ A surgical air strike in action: an F-4 drops Mk 84 laser-guided bombs over North Vietnam in November 1971.

NOVEMBER 29, 1971

NORTH VIETNAM, *SOVIET AID*
North Vietnamese leaders sign an agreement with the Soviets in Moscow for economic and military assistance.

DECEMBER 31, 1971

SOUTH VIETNAM, *US AID*
The strength of American forces in South Vietnam is down to 156,800. As of this date, 45,626 Americans have been killed in action while on duty in South Vietnam.

▼ As the US began to withdraw from Vietnam, the burden of the fighting fell increasingly on the soldiers of the South.

JANUARY 1, 1972

SOUTH VIETNAM, *US AID*
General Leonard Chapman, Jr, Commandant of the Marine Corps, is succeeded in office by General Robert E. Cushman, Jr. Both Marine officers served as commanding generals of III Marine Amphibious Force in South Vietnam.

JANUARY 12, 1972

LAOS, *GROUND WAR*
The Communist forces in Laos capture the city of Long Chen, using Soviet-supplied armour and artillery.

JANUARY 25, 1972

SOUTH VIETNAM, *PEACE PROPOSALS*
A new American-South Vietnamese peace initiative is announced by Presidents Nixon and Nguyen Van Thieu.

FEBRUARY 21, 1972

USA, *DIPLOMACY*
President Nixon arrives in the People's Republic of China. After meeting with Chinese leaders, including Mao Zedong and Chou En Lai, the US changes its Pa-

cific strategy by announcing a reduction in the US military presence on Taiwan. President Nixon in turn asks for Beijing to press upon the North Vietnamese leaders that the time for peace in now.

MARCH 10, 1972

CAMBODIA, *POLITICS*
The pro-US Lon Nol is declared the President of Cambodia.

SOUTH VIETNAM, *US AID*
The US 101st Airborne Division withdraws from South Vietnam, and is the last US division to leave South Vietnam.

MARCH 23, 1972

FRANCE, *PEACE TALKS*
The Paris Peace Talks are suspended by the US delegation, who inform the North Vietnamese that they will be resumed only when North Vietnam is serious about discussing specific issues.

MARCH 30, 1972

SOUTH VIETNAM, *GROUND WAR*
A major North Vietnamese offensive, called the "Nguyen-Hue" Offensive or

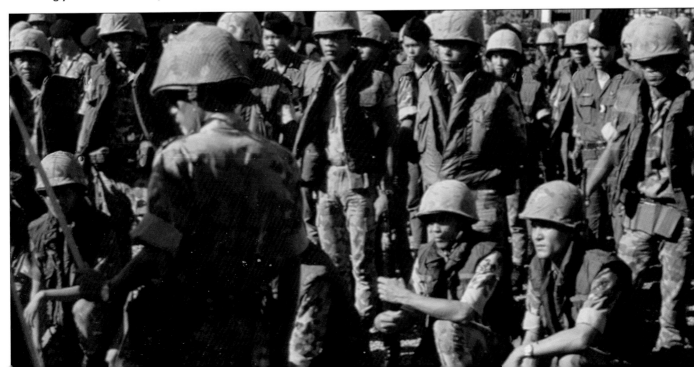

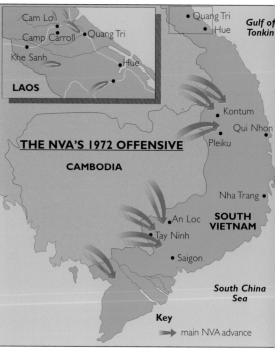

THE NVA'S 1972 OFFENSIVE

Cam Lo · Camp Carroll · Quang Tri · Khe Sanh · Hue · LAOS · CAMBODIA · Kontum · Pleiku · Qui Nhon · Nha Trang · An Loc · Tay Ninh · SOUTH VIETNAM · Saigon · South China Sea · Quang Tri · Hue · Gulf of Tonkin

Key → main NVA advance

▲ *In the Easter Offensive of 1972, the North Vietnamese committed virtually their entire army to an invasion of the South. The South held – just.*

"Easter Offensive," begins. The total US military strength in the South is 95,000 military personnel, of which only 6000 are combat troops. The task of countering the offensive falls almost entirely to the ARVN.

Attacking on three fronts, the NVA pours across the DMZ and out of bases from inside Laos to threaten Quang Tri, South Vietnam's northernmost province. In the Central Highlands, enemy units move into Kontum Province, forcing the ARVN to abandon several border posts before it can contain the offensive.

APRIL 1, 1972

SOUTH VIETNAM, *US AID*
The US Marine landing force and the amphibious ready groups from the US Seventh Fleet arrive off the South's Military Region 1.

APRIL 2, 1972

SOUTH VIETNAM, *GROUND WAR*
Viet Cong and NVA forces strike Loc Ninh, south of the Cambodian border on Highway 13, advancing towards An Loc along one of the main invasion routes towards Saigon. A two-month battle ensues until the North's units are forced to withdraw to their bases inside Cambodia.

By the late summer, the "Easter Offensive" is over. In a slow, methodical counteroffensive, the ARVN quickly recaptures Quang Tri City and most of the lost province. What turns the tide of victory for the ARVN is the massive US supporting firepower provided by US air and naval forces.

APRIL 3, 1972

SOUTH VIETNAM, *US AID*
A US Marine Reconnaissance squadron detachment arrives at Cubi Point in the Philippines in order to support renewed air operations over Southeast Asia.

▲ *One of the camps set up in the South for refugees. This is the entrance to the one at Da Nang in May 1972.*

APRIL 5, 1972

SOUTH VIETNAM, *GROUND WAR*
The NVA continues its attacks on Loc Ninh in Military Region 3.

APRIL 6, 1972

SOUTH VIETNAM, *US AID*
Marine Aircraft Group 15 arrives at Da Nang. Lieutenant-General John D. Lavelle, US Air Force, is recalled from command of the Seventh Air Force for exceeding the rules of engagement by ordering the unauthorized bombing of targets in the North.

APRIL 7, 1972

NORTH VIETNAM, *AIR WAR*
As NVA forces tighten their grip around Loc Ninh, they also besiege An Loc. The bombing of North Vietnam is resumed. The French Gov-

▼ *US troops take a breather. By early 1972 there were only 6000 US combat troops in South Vietnam.*

ernment is petitioned by the North Vietnamese in an effort to halt the bombing.

APRIL 8, 1972

SOUTH VIETNAM, *US AID*
The 9th Marine Amphibious Brigade arrives in the Gulf of Tonkin.

APRIL 15, 1972

NORTH VIETNAM, *AIR WAR*
The bombing of Hanoi and Haiphong in North Vietnam is

resumed for the first time since 1968.
Bombing restrictions are also lifted for
most other targets.

APRIL 15–20, 1972

USA, *PEACE PROTESTS*
A wave of protests occurs in the United
States as a result of the increase in
fighting in Southeast Asia. They begin at
the University of Maryland, resulting in
800 National Guardsmen being ordered
onto the campus. Hundreds of students
have been arrested across the country.

APRIL 22, 1972

USA, *PEACE PROTESTS*
There are massive peace protests
across the country, with around 60,000
marchers in Washington alone.

APRIL 23, 1972

SOUTH VIETNAM, GROUND WAR
The NVA captures Dak To in Military
Region 2. So far, 250,000 South Viet-
namese civilians have fled their
homes. US deaths in the offensive
number 6, while 3000 South Viet-
namese have died.

APRIL 27, 1972

SOUTH VIETNAM, *GROUND WAR*
A major NVA attack occurs against
Quang Tri City in Military Region 1.
The North Vietnamese are using Sovi-
et-supplied T-54 tanks, which help
them to take Dong Ha outside the city.
Casualties among South Vietnamese
troops are heavy.
FRANCE, *PEACE TALKS*
The Paris Peace Talks resume at the re-
quest of the Communist delegation but
there is still no progress.

APRIL 28–MAY 2, 1972

SOUTH VIETNAM, *GROUND WAR*
NVA attacks commence on outlying de-

▶ *ARVN troops sit on a captured T-54
tank in Saigon, May 14, 1972, during a
parade to bolster public morale.*

▲ *A US C-47 aircraft burns at Da Nang
after being hit by North Vietnamese rock-
ets during Hanoi's spring 1972 offensive.*

fences of Hue in Military Region 1. A
worrying development for Saigon is the
desertion of its troops from the front.
The 3rd Division, for example, has col-
lapsed completely, and its men have
fled south.

MAY 1, 1972

SOUTH VIETNAM, *GROUND WAR*
NVA and Viet Cong forces capture
Quang Tri City, which is the first
provincial capital taken during the of-
fensive. It is a disaster for the South, as
80 percent of Hue's population flee
south to Da Nang.

MAY 3, 1972

SOUTH VIETNAM, *GROUND WAR*
NVA and Viet Cong capture Bong Son
in Military Region 2.

MAY 4, 1972

FRANCE, *PEACE TALKS*
The Paris talks are again suspended in-
definitely by the American and South
Vietnamese delegations after the 149th
session. The reason, according to the
US and South Vietnamese delegations, is
a "complete lack of progress".

MAY 8, 1972

NORTH VIETNAM, *NAVAL WAR*
Haiphong and other North Vietnamese
harbours are mined by the US Navy.
The mining and aerial bombing will
only cease when all US prisoners of
war are returned and an international
ceasefire begins. President Nixon then
offers to withdraw all US forces from
Vietnam if a ceasefire is agreed upon.
USA, *PEACE PROTESTS*
In response to the mining operations,
large-scale antiwar demonstrations have
erupted in the US, with violent clashes
against police and National Guardsmen.

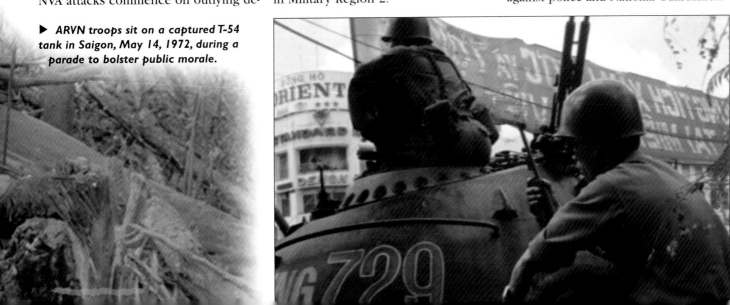

MAY 11, 1972

MAY 11, 1972

SOUTH VIETNAM, *POLITICS*
President Thieu declares martial law in response to the panic which has been sparked by the Communist offensive. The president also lowers the draft age to 17 and recalls 45,000 excused draftees.

MAY 14–25, 1972

SOUTH VIETNAM, *GROUND WAR*
Major NVA attacks on Kontum Province in Military Region 2 take place.

MAY 16, 1972

SOUTH VIETNAM, *US AID*
The US Marine Aircraft Group 12 arrives at Bien Hoa Air Base.

MAY 17, 1972

SOUTH VIETNAM, *ARMED FORCES*
Colleges and universities in the South are closed to allow for the conscription of students. This is an unpopular move; antiwar students have already died in clashes with National Guardsmen.

KEY PERSONALITY

LE DUC THO

Le Duc Tho was one of the founders of the Indochinese Communist Party in 1930. For his political activities he was imprisoned by the French between1930 and 1936 and again between 1939 and 1944. After his second release he returned to Hanoi in 1945 and helped lead the Viet Minh and the Communist Vietnam Workers' Party. He was senior Viet Minh official in southern Vietnam until the Geneva Accords of 1954, and from 1955 he was a member of the Politburo of the Vietnam Workers' Party, or the Communist Party of Vietnam, as it was known after 1976. During the Vietnam War Tho oversaw the Viet Cong insurgency that began against the South Vietnamese Government in the late 1950s. He carried out most of his duties during the war while in hiding in South Vietnam. Tho is most famous for his part in the ceasefire of 1973, having served as special advisor to the North Vietnamese delegation during the Paris Peace Conferences between 1968 and 1973. He eventually became his delegation's principal spokesman, negotiating the ceasefire agreement that led to the withdrawal of the last American troops from South Vietnam. It was for this accomplishment that he was awarded the Nobel Peace Prize. He died in 1990.

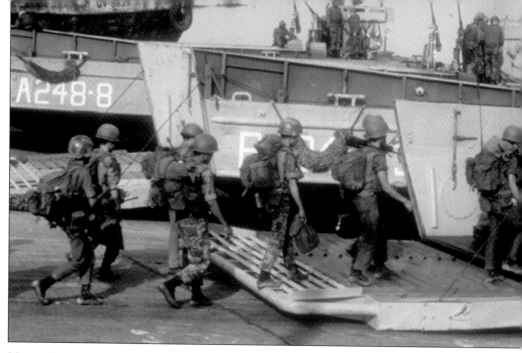

MAY 19, 1972

NORTH VIETNAM, *CHINESE AND SOVIET AID*
Soviet and Chinese delegations arrive in Hanoi to discuss military and economic support measures for the North.

MAY 22, 1972

USA, *DIPLOMACY*
President Richard M. Nixon meets with Soviet leader Leonid I. Brezhnev in Moscow to discuss arms limitations and the war in Vietnam. The Soviets are unbending in their support of the North.

JUNE 17, 1972

USA, *POLITICS*
The Democratic National Committee offices in the Watergate Hotel, Washington, D.C., are burgled. It is later established that the burglars had been hired by Nixon's Committee to Re-Elect the President.

JUNE 18, 1972

SOUTH VIETNAM, *GROUND WAR*
An Loc is finally relieved by South Vietnamese forces.

JUNE 19, 1972

SOUTH VIETNAM, *GROUND WAR*
A South Vietnamese counteroffensive begins in Military Region 2.

JUNE 21, 1972

SOUTH VIETNAM, *US AID*
American troop strength in South Vietnam is down to 60,000.
THAILAND, *AIR WAR*
US Marine jets conduct combat sorties from bases in Nam Phong, Thailand.

▶ *General Frederick C. Weygand was the last Commander, Military Assistance Command, Vietnam.*

▲ *ARVN Rangers board US landing craft manned by US Marine gunners for a mission in early September 1972.*

JUNE 26, 1972

SOUTH VIETNAM, *US AID*
The US Army's 3rd Brigade, 1st Cavalry Division (Airmobile), withdraws from South Vietnam.

JUNE 28, 1972

SOUTH VIETNAM, *GROUND WAR*
The South Vietnamese counteroffensive begins in Military Region 1.

JUNE 29, 1972

SOUTH VIETNAM, *GROUND WAR*
The US 196th Infantry Brigade withdraws from Vietnam, the final US Army ground combat element to withdraw. General Frederick C. Weyand, US Army, becomes the last Commander, Military Assistance Command, Vietnam, succeeding General Creighton W. Abrams.

JULY 13, 1972

FRANCE, *PEACE TALKS*
The Paris Peace Talks resume after a 10-week break. A solution to the situation in Vietnam is even more pressing.

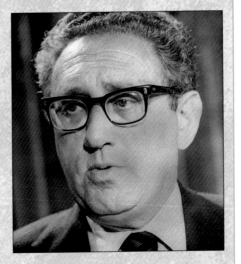

AUGUST 18–19, 1972

SOUTH VIETNAM, *GROUND WAR*
The NVA attacks Que Son and then captures Fire Support Base Ross in Military Region 1.

SEPTEMBER 1, 1972

USA, *ARMED FORCES*
Admiral Noel A. M. Gayler, USN, becomes Commander-in-Chief, Pacific, replacing Admiral John S. McCain, Jr, US Navy.

SEPTEMBER 16, 1972

SOUTH VIETNAM, *GROUND WAR*
Quang Tri City is recaptured by South Vietnamese forces.

SEPTEMBER 26–27, 1972

FRANCE, *PEACE TALKS*
Dr Henry Kissinger and a North Vietnamese negotiator, Le Duc Tho, hold a series of meetings in Paris.

OCTOBER 8, 1972

FRANCE, *PEACE TALKS*
A breakthrough in the Paris Peace Talks is announced by US National Security Advisor Kissinger. One of Hanoi's senior leaders, Le Duc Tho, has agreed for the first time that the Thieu regime can remain in existence and negotiate with North Vietnam, after a ceasefire, for a political settlement in the country.

▲ *Helping the ARVN: F-4Ds of the USAF's 8th Tactical Fighter Wing on a bombing mission over the South.*

OCTOBER 19–20, 1972

USA, *DIPLOMACY*
Dr Kissinger and President Thieu hold discussions in Saigon concerning Hanoi's offer.

OCTOBER 24, 1972

NORTH VIETNAM, *AIR WAR*
Operation Linebacker I ends when the bombing north of the 20th Parallel is curtailed as a peace gesture.

NOVEMBER 7, 1972

USA, *POLITICS*
In the presidential elections, President Richard Nixon is re-elected president of the United States, defeating Senator George McGovern.

NOVEMBER 11, 1972

SOUTH VIETNAM, *US AID*
Direct US Army participation in the Vietnam War concludes with relinquishment of the logistical base at Long Binh to the South Vietnamese.

NOVEMBER 20–21, 1972

FRANCE, *PEACE TALKS*
More private talks are held between Dr Kissinger and Le Duc Tho, the North Vietnamese negotiator, in order to design a final peace agreement.

DECEMBER 13, 1972

FRANCE, *PEACE TALKS*
Talks between Dr Kissinger and Le Duc Tho reach a standstill. Thieu has demanded that Hanoi withdraws its troops from the South, or at least recognize Saigon's sovereignty over the South.

KEY PERSONALITY

HENRY KISSINGER

The son of German immigrants, Kissinger received his PhD in 1954 from Harvard University, becoming professor of government in 1962 and director of the Defense Studies Program from 1959 to 1969. He also served as a consultant on security matters to US agencies from 1955 to 1968, spanning the administrations of Dwight D. Eisenhower, John F. Kennedy and Lyndon B. Johnson. Appointed by President Nixon as assistant for national security affairs in 1968, he eventually came to serve as head of the National Security Council (1969–75) and as secretary of state (September 1973–January 20, 1977). He initially advocated a hardline policy in Vietnam, helping to engineer the US bombing of Cambodia (1969–70), but went on to play a major role in Nixon's "Vietnamization" policy. On January 23, 1973, following months of negotiations with the North Vietnamese Government in Paris, he initiated a ceasefire agreement that provided for the withdrawal of US troops and outlined the machinery for a permanent peace settlement between the two Vietnams. He was awarded a joined Nobel Peace Prize with Tho for this achievement.

DECEMBER 14, 1972

DECEMBER 14, 1972

USA, *DIPLOMACY*
President Nixon warns he will resume bombing if the peace negotiations are not resumed.

DECEMBER 18–29, 1972

NORTH VIETNAM, *AIR WAR*
Operation Linebacker II is launched against Hanoi and Haiphong in what become the "Christmas Bombings".

DECEMBER 31, 1972

SOUTH VIETNAM, *US AID*
US troop strength in South Vietnam stands at 24,200.

JANUARY 8–12, 1973

FRANCE, *PEACE TALKS*
Dr Kissinger and Le Duc Tho proceed with their private talks.

JANUARY 15, 1973

NORTH VIETNAM, *AIR AND NAVAL WAR*
With progress in the peace talks, Nixon declares an end to all US offensive operations against the North Vietnamese.

JANUARY 27, 1973

FRANCE, *PEACE TALKS*
The United States, the Republic of Vietnam (South Vietnam), the Democratic Republic of Vietnam (North Vietnam), and the Provisional Revolutionary Government of Vietnam (Viet Cong) sign a peace agreement in Paris, France. The Paris Peace Accords provide for three commissions to oversee the implementation of the agreements, and resolve any differences that may arise. The commissions were the four-party Joint Military Commission (JMC) representing each of the belligerents, a two-party JMC representing North and South Vietnam, and an International Commission of Control Supervision (ICCS) consisting of representatives from Canada, Poland, Hungary and Indonesia.

JANUARY 28, 1973

SOUTH VIETNAM, *ALLIED AID*
The final withdrawal of Allied forces from South Vietnam begins.

JANUARY 30, 1973

USA, *POLITICS*
Melvin R. Laid is replaced by Elliott Richardson as US Secretary of Defense.

FEBRUARY 21, 1973

LAOS, *GROUND WAR*
A ceasefire is reached in Laos.

FEBRUARY 25, 1973

CAMBODIA, *GROUND WAR*
Task Force Delta commences combat sorties into Cambodia.

MARCH 27, 1973

SOUTH VIETNAM, *GROUND WAR*
This is the last day of the 60-day ceasefire period, during which the North Vietnamese release American prisoners of war. The United States turns over to the South Vietnamese its military bases and withdraws its forces from South Vietnam.

MARCH 29, 1973

SOUTH VIETNAM, *US ARMED FORCES*
The US Military Assistance Command, Vietnam (USMACV), officially ceases to exist. It is replaced by the US Defense Attaché Office (DAO). Also, the US Marine Advisory effort ends. The release of prisoners of war held by the Communists and the departure of all American forces from South Vietnam is completed.

MAY 22, 1973

FRANCE, *PEACE TALKS*
Dr Kissinger and Le Duc Tho conclude their talks on a Vietnam truce agreement.

JUNE 13, 1973

FRANCE, *PEACE TALKS*
The United States, South Vietnam and North Vietnam, as well as representatives from the Viet Cong, put their signatures to the implementation agreement to the Paris Peace Accords. Peace now seems to have arrived in Vietnam.

DECISIVE MOMENTS

PARIS PEACE ACCORDS

The terms of the Paris Peace Accords signed in January 1973 were: an immediate ceasefire throughout North and South Vietnam, the withdrawal of all US forces within 60 days, all US bases to be dismantled within 60 days, all prisoners would be released, and all foreign troops would be withdrawn from Laos and Cambodia. The South Vietnamese would have the right to determine their future, but North Vietnamese troops could remain in the South, although they would not be reinforced. The 17th Parallel would remain the dividing line until the country was reunited by "peaceful means". This agreement was augmented by a second, 14-point accord signed in June. In August the US Congress proscribed any further US military activity in Indochina. However, the North and South denounced each other for violating the truce, and fighting broke out once more.

▼ American delegates at the Paris Peace Talks in 1973. The talks finalized the US withdrawal but signalled the end of the South.

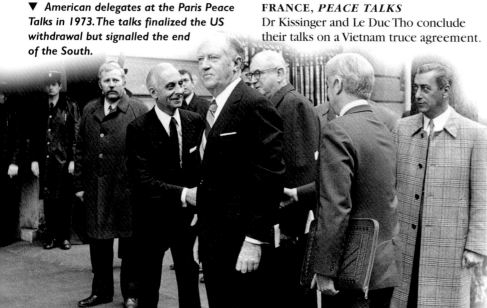

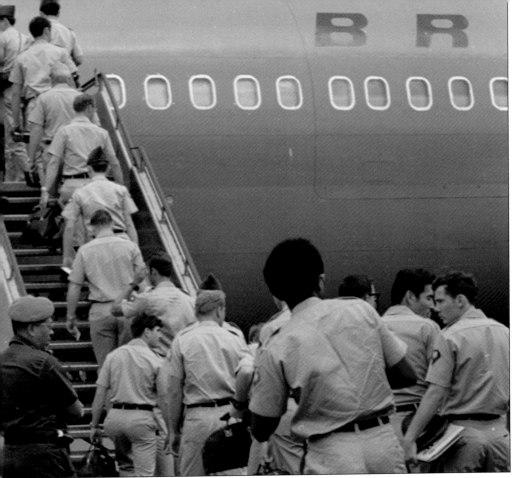

▲ When the Americans left Vietnam there were hundreds of service personnel listed as missing. They were not forgotten.

◀ US troops board an aircraft in Saigon as part of the last withdrawal of American forces from the South, March 1973.

JUNE 24, 1973

USA, *DIPLOMACY*
The US Ambassador to Saigon, Ellsworth Bunker, is replaced by Graham Martin as US Ambassador to South Vietnam.

JULY 1, 1973

SOUTH VIETNAM, *US AID*
The new fiscal year begins with a large reduction – from $2.2 billion US to $1.1 billion US – of American assistance to South Vietnam.

JULY 30, 1973

SOUTH VIETNAM, *US AID*
Less than 250 US military personnel – including the 50 at the DAO – remain in South Vietnam, the maximum number allowed by the Paris Peace Accords. This total number excludes the US Marine Security Guard Detachment at the US Embassy.

AUGUST 1973

USA, *LEGAL*
A US district court rules the secret war in Cambodia "unconstitutional" and issues an injunction against the Nixon Administration's right to wage it, though a lower appellate court issues a "stay" against this injunction.

▶ As part of the peace process, Hanoi repatriated South Vietnamese prisoners, such as these former ARVN soldiers.

AUGUST 14, 1973

SOUTH VIETNAM, *US AID*
Congress declares the cessation of US-funded military actions in Southeast Asia. US Marine air combat operations from Nam Phong end.

SEPTEMBER 21, 1973

SOUTH VIETNAM, *US AID*
The US Marines depart Nam Phong.

OCTOBER 1973

USA, *POLITICS*
The US Congress, over the "veto" of President Richard M. Nixon, passes the War Powers Act, designed to limit the

ability of the Chief Executive to wage war without Congressional approval. The bill is sponsored by Senator Jacob Javits of New York. The act stipulates that "in the absence of a formal declaration of war by Congress, a president could initiate hostilities under only four conditions: to repel an attack on the United States, to protect American armed forces overseas, to protect the lives of Americans living abroad, or to fulfill the specific statutory military obligations of the United States recognized in formal treaties." Even so, this action cannot be continued for more than 60 days without Congressional consent, after which Congress must be notified, and only 90 days without a formal vote from Congress.

DECEMBER 15, 1973

SOUTH VIETNAM, *GROUND WAR*
Communist troops ambush a JMC-sanctioned "Missing in Action" recovery

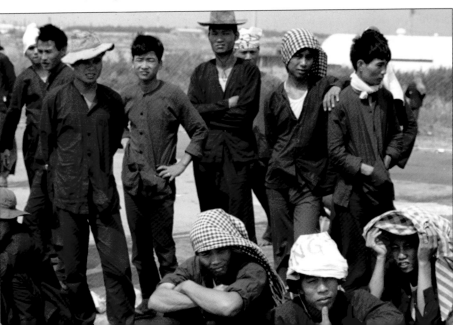

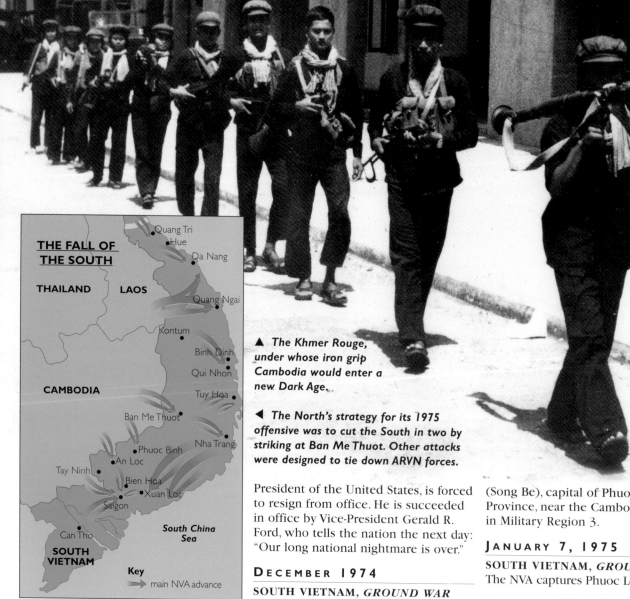

The map on the left:

THE FALL OF THE SOUTH

THAILAND LAOS

Quang Tri
Hue
Da Nang
Quang Ngai
Kontum
Binh Dinh
Qui Nhon

CAMBODIA

Tuy Hoa
Ban Me Thuot
Nha Trang
Phuoc Binh
An Loc
Tay Ninh
Bien Hoa
Xuan Loc
Saigon

Can Tho

SOUTH
VIETNAM

South China
Sea

Key
→ main NVA advance

▲ *The Khmer Rouge, under whose iron grip Cambodia would enter a new Dark Age.*

◄ *The North's strategy for its 1975 offensive was to cut the South in two by striking at Ban Me Thuot. Other attacks were designed to tie down ARVN forces.*

mission, killing a US Army officer and wounding four American and several South Vietnamese soldiers.

JUNE 1974

USA, *ARMED FORCES*
US Marine Anthony Lukeman replaces Lieutenant-Colonel George E. Strickland as Chief, VNMC, Logistics Branch, Navy Division, DAO.

JULY 1, 1974

SOUTH VIETNAM, *US AID*
Fiscal Year 1975 begins with funding for South Vietnamese military forces set at $700 million US, down from $1.1 billion US.

AUGUST 8, 1974

USA, *POLITICS*
Caught up in the Watergate scandal, President Richard M. Nixon, the 35th

► *South Vietnamese civilians board a US ship as the South collapses under the Northern onslaught, April 5, 1975.*

President of the United States, is forced to resign from office. He is succeeded in office by Vice-President Gerald R. Ford, who tells the nation the next day: "Our long national nightmare is over."

DECEMBER 1974

SOUTH VIETNAM, *GROUND WAR*
The North Vietnamese Army's 968th Division moves onto South Vietnam's Central Highlands from Laos, the first overt deployment of a North Vietnamese division into the South since the ceasefire agreement.

DECEMBER 31, 1974

SOUTH VIETNAM, *GROUND WAR*
NVA units encircle Phuoc Long City

(Song Be), capital of Phuoc Long Province, near the Cambodian border in Military Region 3.

JANUARY 7, 1975

SOUTH VIETNAM, *GROUND WAR*
The NVA captures Phuoc Long Province.

JANUARY 27, 1975

CAMBODIA, *GROUND WAR*
The last Allied Mekong River convoy from South Vietnam goes into the Cambodian capital of Phnom Penh. The Cambodian Communists, known as the Khmer Rouge, have halted resupply efforts to General Lon Nol's embattled government, which is now fighting inside the capital.

▲ Notwithstanding this memorial outside Saigon, the sacrifice of those who fought in Vietnam was quickly forgotten.

MARCH 10, 1975

SOUTH VIETNAM, *GROUND WAR*
The NVA attacks Ban Me Thuot at the start of its 1975 Spring Offensive.

MARCH 19, 1975

SOUTH VIETNAM, *GROUND WAR*
The South Vietnamese Army abandons Quang Tri City and its province.

MARCH 24, 1975

SOUTH VIETNAM, *GROUND WAR*
Quang Ngai City and Tam Ky falls to the advancing NVA. The next day, Hue City falls to the NVA.

MARCH 26, 1975

SOUTH VIETNAM, *GROUND WAR*
The NVA captures the former US Marine Base at Chu Lai.

MARCH 30, 1975

SOUTH VIETNAM, *GROUND WAR*
The NVA enters Da Nang City and captures the Da Nang Air Base.

APRIL 12, 1975

CAMBODIA, *US EVACUATION*
US Marines of the 9th Marine Amphibious Brigade (9th MAB) execute Operation Eagle Pull, the evacuation of Americans and other foreign nationals from Phnom Penh, Cambodia, just before the the city falls to the Khmer Rouge.

APRIL 21, 1975

SOUTH VIETNAM, *POLITICS*
President Nguyen Van Thieu resigns as President of the Republic of Vietnam (South Vietnam) and leaves Saigon destined for Taiwan, leaving control of the government to his vice-president, Tran Van Huong.

APRIL 28, 1975

SOUTH VIETNAM, *POLITICS*
General Duong Van "Big" Minh becomes the last president of South Vietnam.

APRIL 29, 1975

SOUTH VIETNAM, *US EVACUATION*
US Marines of the 9th MAB execute Operation Frequent Wind, the evacuation of Americans, foreign nationals and various Vietnamese officials and citizens from Saigon to ships of the US Seventh Fleet lying off the coast of South Vietnam. Pivotal in this evacuation are US Marine Security Guards at the US Embassy, who are the last to be evacuated to the awaiting ships.

APRIL 30, 1975

SOUTH VIETNAM, *GROUND WAR*
The North Vietnamese Army enters Saigon (now named Ho Chi Minh City) and arrests General Minh. It also places his cabinet under arrest. Organized South Vietnamese resistance from the ARVN now collapses.

MAY 12, 1975

GULF OF THAILAND, *NAVAL WAR*
A gunboat of the new Cambodian Khmer Rouge regime seizes the US container ship SS *Mayaguez* in the Gulf of Thailand.

MAY 14, 1975

GULF OF THAILAND, *NAVAL WAR*
US Marines of Battalion Landing Team, 2nd Battalion, 9th Marines, flying in US Air Force helicopters, make a helicopter assault on Koh Tang Island off the Cambodian mainland where the crew of the *Mayaguez* is believed to be held by their Communist captors. At the same time, Marines from D Company, 1st Battalion, 4th Marines, board the *Mayaguez* only to find it deserted. The Cambodians in the meantime release the crew of the *Mayaguez*, who are later recovered at sea by the US Navy ship USS *Wilson*.

MAY 15, 1975

GULF OF THAILAND, *NAVAL WAR*
The US Marines withdraw from Koh Tang island. The American forces sustain a number of casualties, including 15 killed in action, 3 missing in action, 49 wounded, and 23 others killed in a related helicopter crash. US forces inflict an unknown number of casualties.

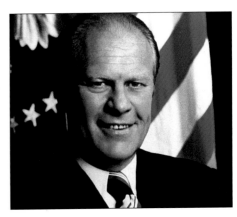

▲ President Gerald Ford brought an unhappy chapter in US military and political history to an end.

▼ One of the legacies of the Vietnam War was an exodus of refugees from the South, the so-called "Boat People".

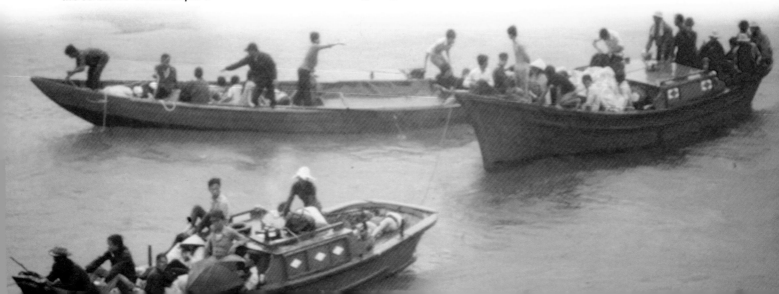

CONCLUSION

From the perspective of the early twenty-first century, the Vietnam War seems an awfully long way away. The events of World War II, which ended almost 60 years ago, are much easier to understand than the events of a conflict that ended just 25 years ago. Where were the frontlines? Why, in over 10 years of fighting, were there so few battles that can be illustrated accurately on a map?

If the Vietnam War is difficult to understand for us, however, it was also difficult for the participants to make sense of. This difficulty ran from the top to the bottom. How did Lyndon B. Johnson, great reforming president and the man whose major achievement was to enact key civil rights legislation, allow himself to be vilified as a baby burner? Why did sensible senior military men allow the US armed forces to get pulled into a conflict in which the centres of enemy power were effectively untouchable, and in which their key technical advantages could be nullified?

For the man on the ground, the problems were worse. Think of some of the difficulties facing the average US "grunt" confronted with a Vietnamese village from which sniper fire has just killed his buddy. He knows that there are influential people at home who disapprove of the war. He knows that the government of South Vietnam is shaky, run by a man who avowedly confesses Adolf Hitler as his great hero. And he knows that all the black-pajama-clad peasants he will soon have to interrogate will appear blank and inscrutable, and that they are also at threat from the Communist terror machine if they give any information away.

Now, this is not ideal as a psychological background for the average soldier.

With this set of pressures acting on them, it is no wonder that US servicemen in Vietnam adopted a new way of thinking about war, a unique language almost, in which to express their views about the difficult conditions in which they were operating. However, if their perspective was difficult, imagine how difficult it must have been for the Vietnamese people, who died in enormous numbers, suffered horribly and were the victims of atrocities committed by both sides. For some Vietnamese, of course, the perspective was clear: it was to do with a Communist nationalist revolution, inspired by the ideas of Mao Zedong, interpreted by Ho Chi Minh. There were millions of Vietnamese who believed this, and the strength of this belief was a key factor in the eventual success of the Communist North. However, millions more were not wedded to this ideology, and merely had to suffer.

Yet there are two important perspectives on the Vietnam War that we can now identify, and that explain some of its complexities, and its legacy. The first of these lies in the background to the conflict – the Cold War. This ideological conflict, between the the Western democracies on the one hand and the Communist nations on the other, lay at the heart of the Vietnam War. The "domino theory" that Communism would inevitably move, like a virus, from one nation to another, informed much of Western thinking in the early 1960s. However, by 1975 Asia was a very different place from how it had appeared to Western strategists in the early 1960s. By 1975, two important

processes were well under way. The first of these was within the Communist world itself. By the late 1960s, it was clear that there was no monolithic Communist bloc. The deep split between China and the Soviet Union revolutionized world affairs. US president Richard Nixon was able to oversee US withdrawal from Vietnam at the same time as he was visiting Red China – an act that would have been unthinkable for him when vice-president in the 1950s. The two processes were intimately linked, not directly but indirectly in terms of a changing view of the world.

The second of these world perspectives that changed utterly from 1962 to 1975 was the status of the newly independent nations of Asia. Instead of a set of dominos ready to topple, key countries in Asia became increasingly to seem a natural part of the capitalist world.

What happened in Vietnam during the late 1960s and early 1970s was part of this process, hard though it may have been to identify it thus at the time. In 1975, the Communist triumph in Vietnam was not a catastrophe in the context of the Cold War, and nor was it part of the collapse of Asia to Communism. But in 1965, it would have seemed both of these things.

The second way of looking at Vietnam is in terms of the way that the US military views the world. Vietnam showed that eternal military verities cannot be gainsaid: that a coherent, achievable aim is at the heart of any strategy. It is to be hoped that such rational approaches to the enormous difficulties of formulating military strategy continue to inform the commanders of the world's greatest war machine.

Index